WORDS FROM HELL

WORDS FROM

HELL

UNEARTHING THE DARKEST SECRETS
OF ENGLISH ETYMOLOGY

JESS ZAFARRIS

Chambers

First published in Great Britain by Chambers in 2023
An imprint of John Murray Press

This paperback edition published in 2024

1

Text design by Craig Burgess

A CIP catalogue record for this title is available from the British Library

Paperback ISBN 9781399808217
ebook ISBN 9781399808224

Typeset by KnowledgeWorks Global Ltd.

Printed and bound in the United States of America

John Murray Press policy is to use papers that are natural, renewable and recyclable
products and made from wood grown in sustainable forests. The logging and
manufacturing processes are expected to conform to the environmental regulations
of the country of origin.

John Murray Press
Carmelite House
50 Victoria Embankment
London EC4Y 0DZ

www.chambers.co.uk

John Murray Press, part of Hodder & Stoughton Limited
An Hachette UK company

For Drew, who knows my naughtiest secrets

CONTENTS

WELCOME TO (WORD) HELL

Humans can be … messy.

Our bodies are weird and gooey. We can be petty, violent, cruel, exclusionary, selfish, malicious, destructive, and power-hungry.

Then again, with just a dash of self-awareness, all of the above can be wildly, morbidly, bizarrely entertaining.

As a result, an absolutely gobsmacking number of the words we use reflect just how truly depraved we are—even many of the ones that seem perfectly harmless at first glance.

But that's why you—you voyeur of vitriol, you ogler of the abhorrent, you rubbernecker of naughtiness—are here, reading this treasure trove of all that is detestable about the magically multifaceted and brazenly bawdy English language.

Keep your wits about you as you proceed through these pages: Some of the words you will meet in this book will be surprisingly dark and nefarious; others offbeat, curious, or disgusting; still others unrepentantly libidinous—but all are terribly, horribly interesting, and even hilarious.

Word Hell Is Heaven for Language Lovers

I was, until the publication of this book, a children's book author. My first work, *Once Upon a Word*, is a loving ode to interesting, wholesome, kid-friendly word origins. It's lovely, if I do say so myself, and absolutely nothing like this book.

In truth, I had never styled myself as a creator of anything for children because I knew—from an education rooted in the development of the English language through literature and anthropology, a decade

and a half of etymology research, and a few years of building a word-curious audience across my blog, *Useless Etymology*, as well as TikTok and other social media platforms—that this language is riddled with dirty secrets and wickedness of every imaginable variety.

In sharing many of the wonders and quirks of etymology with these audiences, it has been my delight and joy to unearth many of their most sinister and captivating secrets, much to the jolly chagrin of my viewers and readers.

Take "melancholy," for instance, which literally means "black bile."

Or "sinister," which isn't really that sinister at all—except for the fact that it's rooted in the demonization of people who are left-handed.

And you simply would not believe how many words are derived from semen.

An Excessively Brief History of Lurid Words

OK, so these words aren't actually from Hell.

Modern English boasts a twisted family tree. It's not a single language emerging from or belonging to a single culture. Granted, most languages aren't, but English has endured (or initiated) a few dramatic identity crises and as a result has *issues* with things like spelling and grammar and, you know, having only one word for a thing. It's always been a swirling salmagundi of shifting rules, spellings, and priorities.

Or, more simply, as speculative fiction reviewer James D. Nicoll famously wrote in 1990:

> We don't just borrow words; on occasion, English has pursued
> other languages down alleyways to beat them unconscious
> and rifle their pockets for new vocabulary.*

Much of the story of English etymology begins with Old English, which is a Germanic language. Germanic languages, which include

* James D. Nicoll, "The Kings's English" (1990). Newsgroup: rec.arts.sf-lovers.

German, Dutch, Afrikaans, Swedish, Danish, and Norwegian, all belong to an even broader classification called Indo-European languages.

Indo-European languages include Greek and Latin, Hindi, Urdu, Spanish, Bengali, French, Russian, Portuguese, and many more. These languages all share ultimate, hypothetical—yet extremely well-evidenced—Proto-Indo-European roots to which the words in these languages can be traced. (From here on out, we will abbreviate Proto-Indo-European to PIE, as most etymology dictionaries do.)

Old English was spoken from 450 CE until about a century after the Norman invasion—or "conquest," depending on whom you ask—of England in 1066 led by William, Duke of Normandy, also (and more appropriately for the purposes of this book) known as William the Bastard.

As the Norman French established themselves as the ruling class over the Old English-speaking Anglo-Saxon populace, a massive influx of Latin-derived Old French words created Middle English, which was spoken from 1150 up to the beginning of the 15th century (give or take). As a result, about 50–60 percent of Modern English words have Latin origins. (Note: Although only about 25 percent of our vocabulary today is from Old English, it is still considered a Germanic language due to its grammar and structure.)

In the process, many Old English- and Germanic-derived words were relegated to a level of perceived "simplicity" that persists in the way we gauge class and sophistication through language today.

For instance, compare the Old English-derived word "house" (Old English *hus*) and the Old French-/Latin-derived "mansion." In Old French, *mansion* (the precursor to the French word *maison*, from the Latin *manere*, "to stay, abide") meant the same thing as the word "house" does today. But thanks to the power imbalance between the Norman ruling class and the Old English-speaking Anglo-Saxon populace, "mansion" now implies a filthy-rich lifestyle, while "house" usually implies a humbler structure, or a more neutral term for a home.

Also of note: A majority of English profanities are Germanic in origin. Much more on that later.

Next came Early Modern English, which arose in the 15th century and lasted until the 17th century—that is, the language of William Shakespeare and his contemporaries, who wrote in perfectly understandable English by modern standards, but with sense shifts and now-uncommon terms such the second-person singular pronoun "thou" and its possessive, "thy."

Thanks to writers such as (but certainly not limited to) dear William, English has a storied history of crafting some truly extraordinary insults, which we'll savor and play with in a later chapter.

Throughout these periods of lexical influx, additional words were introduced from other languages as well, with medicine, science, athletics and art often borrowing from Greek, which is now the source of about 5–6 percent of English words—including the word "gymnasium," whose root means "naked" (no, really).

Modern Standard English (the language in use now) came into being in the 17th century. At that point, now bloated and convoluted with words from French and Latin and Greek—not to mention a sprinkling of Old Norse—English just couldn't kick the habit. *Oxford Dictionaries* says it's likely that English has more words in it than most other world languages just by virtue of having ransacked them from somewhere else.

One aspect of this broad vocabulary is much darker: With the rise of imperialism, English pillaged and plundered additional vocabulary from languages all over the world—some that, through the brutality and bacteria of colonizers, no longer exist.

For instance, more than a hundred languages once spoken in North America have undergone language death, which means they have no native speakers and no spoken descendant languages. Similarly, around three hundred Aboriginal languages were spoken in Australia before Europeans arrived. Today, roughly one-third of those have died out.

Most of these language deaths were due to cultural assimilation as a result of colonization, as well as—well, murdering everyone who once spoke the language. This phenomenon is called linguicide.

I bring this up because—although by virtue of writing this book I'm inviting you to cackle at the naughtier side of the language—it's vital to be circumspect about the darker aspects of etymology, and

amid the humorous histories you'll also encounter truly inhuman horrors with all-too-serious consequences. I believe these more harrowing stories and implications to be critical to this narrative because such knowledge allows us to choose our words with more kindness and respect, not to mention precision and prudence, in our day-to-day interactions.

Choose Your Etymological Adventure

All that said, etymology is an illuminating lens through which to view human history—made all the more rewarding and captivating when you peer beneath a word's surface to find its history wriggling with immorality, mayhem, and farce.

One additional, important note before we begin: Not all of these words are "bad" per se. Many have been used pejoratively. Many have secret and sordid histories. Many simply give names to things that have been regarded as taboo in their past or continue to be in the present. Some are mischievous, while others are just plain creepy.

So join me on this entertaining, enlightening, and occasionally harrowing journey, and choose any path you wish. Forge straight ahead, or flip to any page at your leisure: The stories herein are brief, self-contained, and easily digestible (though some may disrupt your digestion).

CHAPTER 1

THE GOOD, THE BAD, THE BLEEPED

THE ORIGINS OF OBSCENITIES AND SWEAR WORDS

Let's start with the Big Ones—the words that are most commonly considered swear words or curse words and are most often censored in media, plus a smattering of other rude terms.

Anyone with a passing interest in this topic is also likely aware of George Carlin's 1972 "Seven Words You Can Never Say on Television" routine, which identified "shit," "piss," "fuck," "cunt," "cocksucker," "motherfucker," and "tits" as emblematic of censorship (though words from "bitch" to "goddammit" to "asshole" have also been subject to bleeps).

Because words such as "cocksucker," "motherfucker," and "tits" are less widely considered to be "cuss" words today, we'll focus on more contemporarily renowned four-ish-letter words: shit, fuck, piss, cunt, dick, bastard, bitch, ass, and the like. (But don't worry, we'll get to the rest in future chapters, along with other, more targeted slurs that are often censored.)

But *why* are these words considered swears or curses or cusses, and what makes them different from, for example, racial epithets and other words you don't say in front of Grammy? (Grammy, if you're reading this, I'm sorry.)

One factor is the classism embedded into the multilingual roots of English that we discussed in the introduction: Old English- and Germanic-derived words are more likely to be termed vulgar, crude, or simplistic than French- and Latin-derived terms due to Norman influence. Much as an Old English-derived "house" is considered more humble and common than a French-derived "mansion" despite their similar literal meanings, the term "shit" is considered ruder than "defecate," even though there is nothing inherently obscene about "shit."

1

Language that has been deemed offensive or obscene is dubbed an "oath" (Old English *að* "judicial swearing, solemn appeal to a deity") by the same logic as deeming terms "swear words" (Old English *swerian* "take an oath"). Swearing a promise or taking an oath—by the name of a deity or otherwise—is not inherently a bad thing, but to violate one's oath or to swear disingenuously is blasphemy or betrayal, and that's where the extension to swear words and oaths lies.

Consequently, many phrases called "oaths" throughout history have been religious in nature, including, in Christian cultures for example, taking the name of God or Christ "in vain."

The same sense is embedded in the concept of "cursing," which implies the invocation of gods, spirits, and other forces to wreak misfortune on others. The use of the word "curse" for words and evil spells may also be related to the term "course" as a word for a list of liturgical prayers involving the recitation of a list of sins and offenses worthy of excommunication.

There have been some attempts to distinguish between "swearing" and "cursing." For instance, Victorian multihyphenate John Ruskin defined swearing as "invoking the witness of a Spirit," and cursing as invoking the Spirit's "assistance […] in a mischief you wish to inflict." Ruskin also suggested that those who use the terms interchangeably are "ill-educated and ill-tempered people […] who are merely vomiting empty words indecently."[*]

On Obscenity

What is an obscenity? What does obscene mean—both literally and etymologically?

Both aspects of the question are debated. The Latin word *obscenus* meant much the same thing as the English term does—"offensive"— though earlier it also carried the meaning "ill-fated" or "not promising." Its root is uncertain, but it may be *caenum*, "filth," which, when combined with the prefix *ob-*, here meaning "in front of"

[*] John Ruskin, *Fors Clavigera: Letters to the Workmen and Labourers of Great Britain* (Sunnyside, Orpington, Kent: George Allen, 1871).

or "toward," would give the word the sense of "tending toward filth" (or, in the alternate Latin sense, "likely to go to shit").

Obscenity laws have historically been wide-ranging and largely arbitrary, much like the subject of much legal debate. Most have addressed art and literature, while "indecency" (Latin *in-* "not, opposite of" + *decere* "to be fitting or suitable") has been applied more to human behavior.

The 1748 novel *Fanny Hill: Memoirs of a Woman of Pleasure* touched off some fascinating debates and, ultimately, legislation about the obscenity and/or indecency of erotic fiction. While the genre itself is ancient, with the earliest known examples found in ancient Sumerian cuneiform, *Fanny Hill* is widely considered the first instance of English pornography in novel form. Its author, John Cleland, was arrested in 1749 along with his publishers and printer for "corrupting the King's subjects."

The text provides many glorious examples of the range and depth of erotic euphemisms in English:

> I twist my legs round his naked loins, the flesh of which, so
> firm, so springy to the touch, quivered again under the pres-
> sure; and now I had him every way encircled and begirt; and
> having drawn him home to me, I kept him fast there, as if I
> had sought to unite bodies with him at that point. This bred
> a pause of action, a pleasure stop, whilst that delicate glutton,
> my nether mouth, as full as it could hold, kept palating, with
> exquisite relish, the morsel that so deliciously ingorged it.*

The book was gleefully banned far and wide, from the U.K. to Massachusetts, where the Supreme Court declared that the book aimed to "debauch and corrupt" the citizenry of the state in 1821.

Up until 1959, publishing "obscene" material in Britain fell under libel laws, but the Obscene Publications Act created a new offense just for publishing more adult or sexual content, even if it didn't smear any particular person or institution.

* John Cleland, *Fanny Hill: Memoirs of a Woman of Pleasure* (Harmondsworth: Penguin, 1985).

In the 1960s, cases surrounding D. H. Lawrence's 1928 novel *Lady Chatterley's Lover* opened the door for wider publication of erotic fiction.[*]

In the U.S., the landmark cases *Roth v. United States* (1957) and *Miller v. California* (1973) attempted to codify obscenity, the parameters of which are now outlined in "The Citizen's Guide To U.S. Federal Law on Obscenity."

The latter case created the "Miller test," a three-part means of examining the difference between "erotic" (and therefore protected by the First Amendment) and "obscene":

(a) whether the average person, applying contemporary community standards would find that the work, taken as a whole, appeals to the prurient interest

(b) whether the work depicts or describes, in a patently offensive way, sexual conduct specifically defined by the applicable state law

and (c) whether the work, taken as a whole, lacks serious literary, artistic, political, or scientific value.[†]

"Tests" were big in determining the parameters of obscenity. Before the Miller test, the Wepplo test (1947) defined it as material that "has a substantial tendency to deprave or corrupt its readers by inciting lascivious thoughts or arousing lustful desires," and the British 1868 Hicklin test ruled that it is material that aims "to deprave and corrupt those whose minds are open to such immoral influences."

In the U.S., George Carlin's aforementioned routine led to the landmark *FCC v. Pacifica Foundation* case in 1978, in which the Supreme Court ruled that "repetitive and frequent" use of the words he discussed could be subject to punishment in broadcast media. Broadcast in particular has been subject to greater regulations around indecent language and other content due to its ability to enter "the privacy of the home" without viewers' (especially parents of young children) complete informed consent to the content of the broadcast.

[*] *R v. Penguin Books Ltd* (1961).

[†] "Three Prong Obscenity Test," *Professionalism in Computing*, Virginia Tech.

On Profanity

The word "profanity," unlike "obscenity," is restricted to words. "Profanity" itself is from the Latin *profanus* "unholy, not sacred, not consecrated," which is thought to literally mean "out in front of the temple" (*pro* "before" + *fanum* "temple"), implying something outside of what is holy and therefore sinful.

Profanities have, in history, included religious oaths and instances of taking gods' names in vain as well as foul language and expletives—so they are more literally "words from Hell" than many others in this book.

An expletive (literally that which "fills out," from Latin *ex-* "out" + *plere* "to fill") was originally a word or phrase meant to achieve the correct meter in a line of verse. The use of emphatic cries such as "O!" or "Fie!" for this purpose in Shakespearean verse evolved the meaning to "an exclamation," especially an oath, by the 19th century. Its continued use and evolution are, in part, thanks to transcripts of the tapes from the 1972–4 Watergate scandal in which the phrase "expletive deleted" was used in place of President Richard Nixon's swearing.

Thanks to landmark decisions from the 1940s to the 1960s in U.S. law, the use of expletives alone is not prosecutable, but using profane language to incite violence or harass people is. Some local ordinances, such as an infamous one in Myrtle Beach, South Carolina, prohibit profane language, with punishments ranging from fines to short amounts of jail time.

For the classist reasons we've already explored, profanities have a habit of being Germanic in origin ("shit," "fuck") while Latin- and French-derived words tend to be the more clinical alternatives ("feces," "intercourse").

With that context in mind, let's dive into some of the most infamous profanities of today and yesteryear.

Ass

It's time to answer that age-old question—which came first: ass the donkey, or ass the butt?

You may be surprised to learn that these two senses of the word "ass" are ultimately from different etymological sources.

The donkey version came first.

Most Indo-European languages have a variation on "ass" as a word for a donkey, and most of them come from the Latin *asinus*. The Latin, in turn, is probably originally a loanword from Sumerian or a related language.

The Latin *asinus* is also the source of the word "asinine," which we use to mean "stupid" but literally means "like an ass." And it's also the source of the word "easel," as in the stand used by artists, with the implication being similar to that of a sawhorse.

Ass as a word for "butt" is a variation of "arse", which evolved from the Old English *ærs*, referring to an animal's hindquarters (*see* butt).

Some scholars suggest that the butt sense of ass isn't technically recorded until the 1860s in nautical slang, but that seems unlikely because poets had been rhyming "arse" with words like "class" and "pass" since at least the 1500s, even before the modern British accent became less rhotic (i.e. softened the pronunciation of the letter *r* after a vowel).

Plus, in Shakespeare's *A Midsummer Night's Dream* (1600), ass puns are everywhere, and there is at least one that implies a triple entendre of "donkey," "buffoon," and "butt."

I must to the barber's, monsieur; for me thinks I am marvellous hairy about the face; and I am such a tender ass, if my hair do but tickle me, I must scratch.

Act 4, Scene 1, lines 22–6

That said, the argument that the word "ass" showed up as a variant of "arse" in the 1800s makes some sense because the loss of the *r* before the *s* also happened in several other American English word variations around that time. "Arse" is still the standard spelling in the U.K.

Bitch

Using this word to refer to female dogs extends beyond Old English (*bicce*) into Old Norse (*bikkjuna*, a word for female dogs, foxes, and

wolves). In Middle English, the term *bicched* (that is, "bitched") was used as a participle meaning "cursed" or "bad," much in the way we might use "fucked" or "fucked up" to describe something ruined today.

It was first applied as a contemptuous insult to women in the 1400s and, according to the 1811 *Dictionary of the Vulgar Tongue*, was "the most offensive appellation that can be given to an English woman, even more provoking than that of whore." It is also recorded as an insult for men as early as the 1500s, both with and without the "son of" addendum that in many cases essentially functions as a "your momma" joke. "Bitch" has, in some contexts, been defanged and transformed into a more affectionate or familiar term, especially among women and in LGBTQIA+ culture, beginning in the early 1900s.

As a verb, "bitch" is relatively recent, first recorded in the 1930s, a variation of the adjective "bitchy."

Cunt

We'll get to additional terms for female genitalia in the coming chapters, but predating terms such as vagina, pussy, and vulva in English is "cunt," a true icon of offensive language.

It's recorded in Middle English (with varying spellings including *conte*, *counte*, *queinte*, and *queynte*) at which point it was not so vulgar as it is now—though it was a dash bawdy and plenty punned upon.

Indeed, from the 13th to 16th centuries, several English towns boasted streets aptly called *Gropecuntlane* where one could go to find sex workers. (Spelling variations included *Groppecountelane* and *Gropekuntelane*.)

But the term is almost certainly even older, given the fact that Germanic languages including Old Norse and Middle Dutch have similar words such as *kunta* and *kunte,* respectively.

The English word might be from the Latin *cuneus*, meaning "wedge," or it could be related to the Latin *cunnus* (*see* cunnilingus in Chapter 3). All of the above might be from a PIE root meaning "hollow place," or one meaning "woman," or still another meaning "gash" or "slit."

Although it's found in medical writing up to the year 1400, shortly thereafter it took on a naughtier connotation, as evidenced

by the fact that most respected writers started to avoid it—and the Gropecuntlanes of the world rebranded to more neutral monikers such as Grape Lane in York.* Still, literature is full of gags that subtly or not-so-subtly reference the term. In Geoffrey Chaucer's *The Canterbury Tales* we find:

> Now, sire, and eft, sire, so bifel the cas,
> That on a day this hende Nicholas
> Fil with this yonge wyf to rage and pleye,
> Whil that her housbonde was at Oseneye,
> As clerkes ben ful subtile and ful queynte;
> And prively he caughte hire by the queynte,
> And seyde, "Ywis, but if ich have my wille,
> For deerne love of thee, lemman, I spille."

"The Miller's Prologue and Tale," lines 163–70

Translation:

> Now, sir, and again, sir, it so happened
> That one day this clever Nicholas
> Happened with this young wife to flirt and play,
> While her husband was at Oseneye,
> For clerks are very subtle and very clever;
> And intimately he caught her by her crotch [cunt],
> And said, "Indeed, unless I have my will,
> For secret love of thee, sweetheart, I die [or "spill"]."

"Queynte" here means "a clever, curious thing" or "an elegant, pleasing thing"—but it's also playing on the word's similarity to "cunt," and "spill" here also implies the spilling of … well, the clerk's emissions.

Later, in the mid-1600s, we see the same thing happening in Andrew Marvell's "To His Coy Mistress" (published posthumously in 1681):

* Keith Briggs, "OE and ME *cunte* in place-names," *Journal of the English Place-name Society* 41 (2009), 26–39.

Thy beauty shall no more be found;
Nor, in thy marble vault, shall sound
My echoing song; then worms shall try
That long-preserved virginity,
And your quaint honour turn to dust,
And into ashes all my lust;
The grave's a fine and private place,
But none, I think, do there embrace.

And, of course, there's Shakespeare's *Twelfth Night* (1601–2):

By my life, this is my lady's hand: these be her very C's, her
U's and her T's and thus makes she her great P's.

<div align="right">Act 2, Scene 5, lines 76–9</div>

And in *Hamlet* (1599–1601):

Hamlet: Lady, shall I lie in your lap?
Ophelia: No, my lord.
Hamlet: I mean, my head upon your lap?
Ophelia: Ay, my lord.
Hamlet: Do you think I meant country matters?

<div align="right">Act 3, Scene 2, lines 119–23</div>

I could go on.

The *Classical Dictionary of the Vulgar Tongue* by Francis Grose cemented "the monosyllable" as a euphemism for "cunt" and lists many entries as synonyms for the word, including: "black joke" (as in the phrase "her black joke and belly so white"), "bottomless pit," "brown madam" or "miss brown" (possibly referring to pubic hair), "bun," "Eve's custom house" (because it's "where Adam made his first entry"), "Miss Laycock," and "tuzzy-muzzy."

In the case of "bun," that's a reference to "bunnies," or rabbits—or, more specifically, "coneys" which is the Middle English word for a rabbit and was also often used as a euphemism or pun corresponding to "cunt" or "cunny."

The entry for "monosyllable" in the same book lists the definition "a woman's commodity."

And it didn't stop there: John S. Farmer and William E. Henley's *Dictionary of Slang and Its Analogues* from 1966 includes 552 synonyms for "the monosyllable" including "heaven," "Hell," "low countries," "nature's tufted treasure," "Fumbler's Hall," "seminary," and "aphrodisiacal tennis court."

Fuck

Many armchair etymologists, particularly the online variety, like to claim that this word is an acronym for "fornication under consent of the king" or "for unlawful carnal knowledge."

This is plain nonsense.

In fact, the word "fuck" is centuries—perhaps even upward of a millennium—older than any acronym. (Due to a lack of standardization and consistency around spelling, technology, brand names, and style guides, acronyms—initialisms that form words—were almost nonexistent until the mid-19th century.) Not to mention that the words "knowledge" (*cnawlece*) and "king" (*cyning*) were spelled quite differently when "fuck" is thought to have first been used. And while its spelling varied, no version of "fuck" from that time ended in a *c*. As a matter of fact, "fuck" and its cognates in other Germanic languages all have different spellings that make no sense with these acronyms.

Because this word has always been relatively taboo, it's difficult to trace when exactly it was first in use, but it's certainly of Germanic origin, and it's recorded in Middle English with various spellings. Generally, it, or at least a form of it, is thought to have existed in the Old English language—and that would be before Latin-derived words like "fornication," "consent," or "carnal" entered English.

Among the more credible theories, some think our modern spelling is an evolution of the Middle English *fyke*, meaning "to move restlessly, to fidget or to flirt." This would mean it's from a Germanic source describing rapid movements, which would connect it to German and Dutch words for fuck (Middle Dutch *fokken*, German *ficken*). This theory is also supported by the fact that other Old English words for rapid movements were also used for sex: for example the

Old English *swifan* "to move lightly over, sweep," which is related to the modern word "swivel."

George Carlin claimed that it is from the Middle English *firk* "to press hard, beat." He was incorrect, but his research isn't at fault—his source is. Joseph T. Shipley first included this theory in his 1984 book on word origins. However, as we've just been over, this word is recorded in Old English, so a Middle English origin is simply not possible.

However, other etymologists believe it came to Old English via a similar Scandinavian source, which would connect it to Norwegian and Swedish words such as *fukka* "copulate," or the Swedish dialectal *focka* "copulate, strike, push," and *fock* "penis."

The proper name John le Fucker is recorded in Middle English, and the surname certainly existed prior to that, though John's unfortunate name is thought to have had a different meaning entirely and to not imply someone with a prolific sex life. For instance, philologist Carl Buck suggested that the name is meant to imply "John the Restless" and his name is a variation on Middle English words such as *fike*, "fidget."

There's also a popularly shared theory that the term "fuck you" is somehow derived from or associated with the term "pluck yew." The story is entertaining, but also false: It says that the French (in various conflicts depending on who's telling the story, but often at the 1415 Battle of Agincourt) would cut off the middle fingers of English archers wielding bows of yew. So, to taunt the French, English archers who hadn't yet been captured would "flip the bird" and yell things such as "We can still pluck yew!" The Modern English phrasing aside, there is absolutely no evidence that this happened—aside from some finger-chopping, which may have occurred—and the middle finger's associations with obscenity far predate that battle. In Latin, it was known as the *digitus impudicus*, or "indecent, impudent finger," since it's supposed to look like a cock (the finger) and balls (the rest of the hand).

"Fuck" became less specifically sexy and grew into both a generic emphatic adjective and a word implying destruction, ruin or a general mess of things—as in "fucked up" or just "fucked"—likely around the mid-1800s, when England and the U.S. made it cool by outlawing it in print (in 1857 and 1873, respectively).

In recent years, the word has lost some of its intensity in many contexts—not to mention a great deal of its precision in definition—and is now often simply used for emphasis. Its range of meaning and usage is due to its perceived obscenity, which in turn may be due to the fact that it sounds like the very slappiest part of the sex act itself.

Pairing the term with "mother," as in "motherfucker/ing," serves as a means of conveying the ultimate act of depravity (implying a man fucking a mother, either his or someone else's, who is implied to be kind and caring). This term and variants such as "motherfucking" are recorded as early as 1906, but could easily have been in verbal use earlier.

As the natural result of people fucking around with swear words, it is now the proud parent of related terms such as "fuckery" (1950s, probably modeled after much earlier words such as "foolery").

One can give fucks, be so fucked, find out the consequences of fucking around, fuck with people, or fuck them over. Fucks can even be holy, or one can simply "fuck that."

These and other amorphous, emphatic, and casually vulgar uses of the word are all mid- to late-20th-century terms, increasing in frequency and creativity since laws around profanity began to ease restrictions on such terms in publishing, music, and media. While initially used (at least in part) for shock value, the widespread use of "fuck" outside of specifically sexual contexts—or an angry tone of voice—has somewhat defanged it.

What the fuck, indeed.

Piss

The Old English word for urine was *hland*. "Piss" entered English in the 1300s, a gift from the Normans (*pissier*), ultimately from the colloquial Latin *pissiare* of the same meaning. This word would replace the Old English word and indeed was considered somewhat less vulgar than it is today—though not entirely, given that the word is imitative of the sound of pissing.

More polite alternatives such as "urinate," from the Classical Latin *urina*, were introduced around a century later, and "pee" arrived in the 18th century as an abbreviation of "piss."

Idioms such as "pissing" time or money (often "away"), implying flagrant waste, are recorded as early as the 1500s. At the time, the more common term was "piss money on the walls," specifically implying wasting one's money on alcohol and then pissing it out. This idiom also gave rise to its use in phrases such as "getting pissed" as a term for getting drunk (*see* Chapter 7).

The term "pissed off" is likely a result of its use as an intensifier, particularly when pointing out unpleasant qualities. For example, it intensifies "poor" in "piss-poor," which may also imply someone who smells like urine due to homelessness and inspired the similar term "piss-ugly," in which it is purely an intensifier.

To be "pissed off" may alternatively be a derivative of the mid-20th-century term "full of piss and vinegar," suggesting someone who has a nasty attitude and is therefore ready to fight.

Shit

Just like the word "fuck," shit is not an acronym or an abbreviation. It, too, is many centuries older than the earliest acronyms.

Yet in the same vein, one interesting, yet false, origin suggests that some types of manure had to be stored on a vessel's higher decks when being shipped so that they wouldn't get wet. Therefore, they were stamped with "ship in high transit," or "S.H.I.T."

This myth has been around for a long time—but nowhere near as long as the word "shit." And there is absolutely no documentation of this stamp or abbreviation in ships' manifests or mercantile records.

Unlike "fuck," we have clearer evidence of this word's origins: It comes from the Old English word *scitan*, which was a verb, not a noun, which means that it did not describe poop but the act of pooping. The noun form in Old English was *scearn*.

We can trace the word "shit" back to a definite Proto-Germanic root—the same one as Dutch (*schijten*) and German (*Scheiße*) words for the stuff. The root means to cut or to split, based on the idea that the process of defecating separates your waste from your body (or perhaps that turds come out in segments).

In Middle English, when "shit" became a noun, it was used specifically for diarrhea, though it expanded to any form of poop by the 16th century.

The primarily British variation "shite" appeared in the 18th century as a playful and dialectical variation that serves as a slightly minced version of the profanity.

In the past century, "shit" has been used to add emphasis or casual vulgarity to a variety of terms, and as a result it can sometimes seem to mean nearly anything.

For example, something bad can "be shit" (very bad or unpleasant) or be "the shit" (extremely good). It can be a general cry of frustration, or one of excitement or wonder. One can shit bricks or the bed, go apeshit, endure a shitstorm, or engage in an activity for "shits and giggles." And one can certainly be a shitheel or a sack of shit if one gets shitfaced and starts enough shit.

Many of these phrases are relatively recent, and, much like "fuck," accelerated in usage and inventiveness as restrictions on vulgar speech in popular media were eased.

However, a few are a bit older: Robert Frost referred to his scatological writings as "shitticism." "Up shit's creek" is recorded in the mid-1800s and is thought to be a more vulgar variation of the American phrase "to row (someone) up Salt River," which means "to send to political defeat" due to a possibly apocryphal story about the Republican statesman Henry Clay missing a speaking engagement in Louisville, Kentucky, when a Democratic boatman delayed him on his way up the Salt River.

✑ Why Science is Shit

In 14th-century English, "science" referred to any type of book learning and was used as a word for general cleverness or skillfulness.

The narrower sense we use today, where science is differentiated from disciplines like history, philosophy, math, art, and so on grew more focused in eighteenth-century academia. Before that, what we would call science today, at least as far

as English labels went, fell under the umbrella of philosophy, which also covered the natural sciences.

The word "science" comes from the Latin *scientia*, which was used to mean "knowledge" or the quality of being an expert. But the Latin word's literal meaning was to distinguish or separate one thing from another. The Latin base word is *scindere* "to cut, divide."

Predictably, science and its etymological predecessors also appear in words like omniscient, "all-knowing," and prescience, "foreknowledge."

The distinguishing sense is also apparent in the word "conscience," literally meaning "a joint knowledge" of the difference between right and wrong.

The PIE root of "science" also means "to cut," and that means that it shares a root with words including "schism" and "schizophrenia," literally "a splitting of the mind." That also means "science" is distantly related to "shit," which, as we have learned, is waste that is "separated from the body."

———

Tits

Although fairly mild by today's standards, this word has been used in a crass, derogatory, or diminishing way in reference to women for much of its history—enough to make George Carlin's naughty list.

Its origins are perfectly innocent: *Titt* was simply an Old English word for a nipple or breast and, in Middle English, a variant of "teat" (from Old French *tete*). However, this sense faded from use for a couple of centuries, so the insulting sense may not have a direct connection to the Old and Middle English words beyond associations with "teat."

Around the 1500s, it began appearing as a word for any small thing, such as a titmouse (a type of bird whose name is unrelated to

"mouse" but is more or less a compound of tit as in "small thing" and the Old English *mase*—which also means "small thing").

"Tit" is recorded in this sense in reference to many types of small animals, including smaller horses, but was mostly applied to birds before it became a nickname for small girls and young women. Although at this point the fundamental sense was simply "small," in most contexts it was used in a belittling or condescending way toward women.

It was around the 1700s that "titties" and "tetties" began to appear in colloquial English as a word for breasts.

SAYING IT WITHOUT SAYING IT: MINCED OATHS

Of course, these most infamous curse words barely scratch the surface of the curses, profanities, and lewdness that infuse the English language.

Don't fear, there's more to come on the naughtier side of the language, but it's worth noting that one can even swear without swearing at all: To "mince an oath" or to "mince words" is much the same as mincing onions, basil, or beef. Like the culinary sense of reducing something to smaller pieces, to mince words is to verbally minimize a subject or talk around it to avoid expressing its full importance. When applied to an oath, it reduces the severity or intensity of the inappropriate term.

Given the implication of swearing by a deity or something sacred, an oath that has been minced often removes the name of the religious figure from the equation.

These can be as simple as shortening "Jesus" to "gee" or may involve alternative epithets such as transforming "goddammit" to "gosh darnit." I once had a friend who regularly substituted "Jesus Christ" with "cheese and rice."

Of course, the oath need not be religious to be minced. For every swear word, half a dozen or more epithets are bound to crop up.

A few entertaining minced oaths

Criminy

This mild oath could be based on the Italian *crimine*, meaning "crime," but it may alternatively be a conflation of the word "Gemini," as in the Zodiac constellation, with "Christ." The idea is that, instead of the name of Jesus or Jesu Domini, you'd say "Gemini" as a minced oath variation, rather like God versus "gosh." (This use of "Gemini" is well attested in English, German, and Dutch, so it's more than a fanciful assumption.) Over time, the *j* or *g* sound may have been replaced with the *cr* sound in "Christ."

Jiminy

This word, which appears in phrases such as "jiminy cricket" and "jiminy Christmas" but has also been in use alone since the 1800s, is probably an intentional misspelling and mispronunciation of "Gemini," which, as we've learned, is a minced religious oath. The "cricket" variation was more widely popularized in the 20th century by the Disney iteration of the *Pinocchio* story. (The character was originally called Il Grillo Parlante, or "the talking cricket.")

Great Scott!

Who is Scott, and what makes him great?

There are two theories about this cry of amazement. One is that it's a mincing of "great God!" which is entirely possible, but another theory suggests that it might be an Anglicization of the Austrian greeting *Grüß Gott*, meaning "good day," or more precisely "(may) God bless (you)." The term arose in the Victorian era and may have been introduced as a reference to Austrian royalty and their connections to Victoria and Albert.

Sacré Bleu

This is a borrowing from French that means "holy/sacred blue" but is a minced oath intentionally intended to rhyme with "sacré Dieu!"

It's more often an English stereotype or satirical take on French oaths than an actual French oath.

Jack Squat

The use of "squat" alone to mean "nothing" is from the 1930s, and is probably derived from the sense of squatting to defecate—so it's a minced oath of "shit" as a word for something worthless.

As for the "jack" in both "jack squat" and "jack shit"...

"Jack" often appears in personifications (jack-of-all-trades, jack-o'-lantern, and Jack Frost), and that's because for many years it was a generic, all-purpose male name. Jack was your "average Joe" or "guy" of the 16th–18th centuries—a name that was definitely not associated with high-society types, but rather with commoners or even scoundrels and tricksters. For example, "jack-out-of-doors" was a 17th-century term for a vagrant, and a "jack-snip" was a tailor whose work was shoddy (a sense we see in the term "jacked up," or messed up).

And in line with that logic, when you add jack to another word, it can also imply a smaller, meaner, or more common version of that thing.

Starting in the 14th century, it was common in colloquial English to see words like jack-brick or jack-bowl—a small brick and a small bowl, respectively. This sense lingers on in words like jackdaw, a word that could be said to mean "a small daw" or a common daw.

And the word "jackass" also implies both male donkeys and small donkeys, as well as people who act unpleasantly foolish or otherwise ass-like.

That implication is also connected to the jack card suit, which is the lowest-value face card.

So "jack shit" or "jack squat" refers to "nothing" or something small or worthless because it literally implies a turd that's even smaller and more worthless than regular turd.

However, jack/Jack isn't exclusively a diminutive/reductive—he can imply a clever folkloric trickster too, like the jack-in-the-box or jack-o'-lantern (*see* Jack-o'-lantern, in Chapter 10).

Tarnation

What in tarnation?!

Yosemite Sam, Sandy the Squirrel, and other characters of a stereotypically Texan or Southwestern persuasion have a habit of saying this phrase when they're flabbergasted or upset.

Although it was widely popularized by Warner Bros. cartoons, the word "tarnation" is much older. It first arose in 1784 as a variation of the word "darnation." Just like "darn" is to "damn," "darnation" was a milder way of saying "damnation," which was a much stronger profanity in the 1700s than it is today due to its associations with blasphemy.

The *t* in tarnation was influenced by another 18th-century profanity, "tarnal." Tarnal was a corruption of the phrase "by the eternal," which basically meant the same thing as "by God!" To use "tarnal" in a sentence, you might say something like "Sam paid a 'tarnal high price for his dillydallying."

Zounds, Gadzooks, and Egad

Zounds, a 16th- and 17th-century cry of alarm or anger, is a religious oath, short for "by God's wounds!" It references the wounds of Jesus Christ on the cross.

Similarly, **gadzooks**, which appeared around a century later, is short for "God's hooks," or the nails with which Jesus was hung on the cross. An earlier form of this oath is "godsookers."

The "gad" in "gadzooks" is the same one found in **egad**, which was originally spelled "I gad," perhaps suggesting the same thing as the modern "my God." That same "gad" was quite popular in 17th-century oaths, which had a penchant for fancifulness and abstraction, appearing in words such as "gadsbobs," "gadsnouns," and "gadsbudlikins."

CHAPTER 2

THE BODY PROBLEM

HOW WORD ORIGINS REVEAL OUR SELF-DISGUST

Unfortunately, we're repulsed by ourselves—and for good reason.

Human beings are squelchy.

We belch, we fart, we sneeze, we vomit, we poop. And that's just the stuff that comes out of us. Inside, we're full of squishy, slick, slimy, and—dare I say—*moist* things.

What's more, the words we use to describe our viscera are both disgusting in themselves and rich with weird and wonderful stories.

The word "moist" is a case in point: 10–20 percent of the American population is repulsed by it. This phenomenon is called **word aversion**.

Research from Dr. Paul Thibodeau at Oberlin College, Ohio, attempted to identify whether it is an association with bodily functions that causes word aversion or something about the phonological properties of the words themselves.[*] With "moist," it could be both or either. The word just gets worse the farther back you go: It's thought to be from the Latin *mucidus* "slimy, moldy, musty," and is ultimately related to the word "mucus." Maybe that's what makes us recoil. Or maybe it's the way it makes our faces move.

Speaking of which, "disgust" is an example of an **unpaired word**. That's when a word is commonly used with a prefix or suffix, but not on its own. Think: "whelm," which in its Old English form meant the same thing as "overwhelm" but is now rarely seen without its hyper-dramatic affix *over-*. ("Underwhelm" is an 18th-century spinoff.) Similarly, one can be disgusted, things can be disgusting, one can feel

[*] Paul H. Thibodeau, 'A moist crevice for word aversion: in semantics not sounds', *PLOS ONE*, April 27, 2016. https://doi.org/10.1371/journal.pone.0153686

disgust. But when's the last time you were just "gusted"? The root word here is the Latin *gustare*, meaning "to taste," so "disgust" means quite literally the same thing as "distaste." In fact, "taste" is the more figurative word here, origin-wise: Its root, the Latin *taxare*, means "evaluate" or "handle," suggesting the gastronomic pleasure of experiencing food as a multisensory phenomenon. (Unpaired words will come up again.)

Words for body parts and the things that come out of them are a curious function of the English language because they are fundamental to our very existence, but our interiors have been dramatically misunderstood throughout medical and anatomical history. Their names are fairly eclectic: Many body parts and fluids have retained frank and physical Germanic names ("blood" for instance), while others have adopted names from the Greeks, whose research and practices were foundational to Western medicine, and from subsequent scientific Latin terms. Many make perfectly logical sense. A few are wondrous and imaginative. Others are esoteric. Some are just plain gross.

In the following pages you will unlock the true horrors of the human meatsack through the magical ways we discuss aspects of our insides—as well as the complicated and problematic dynamics of our own minds.

THE SAGA OF THE FOUR HUMORS: OUR MOIST INTERIORS

Before we dive into our discussion of organs and the slime within and surrounding them, we must first understand **humorism**—also known as humoralism or humoral theory.

Humor

The word "humor" is from the Latin word *umere*, meaning "be wet, moist." (There's that word again!) It slipped into English via the Old North French word *humour*, which both meant "liquid, dampness" and referred to the four humors.

Humorism explained human emotional and behavioral tendencies in terms of four types of liquid: blood, phlegm, choler/yellow bile, and black bile.

The concept of humorism is thought to have originated in ancient Egyptian medicine and was systemized by ancient Greek physicians and philosophers. One leading theory suggests that the four humors were based upon the observation of blood clotting in a glass container: After sitting an hour, four different layers can be seen in the blood. The concept derives primarily from the works of Hippocrates (ca. 460–ca. 370 BCE), who is credited with identifying the four fluids/humors, and Galen (129–ca. 216 CE), who described human behavior as a balance of temperature and dryness or moistness.

Additionally, thanks in large part to the writings of Theophrastus (ca. 371–ca. 287 BCE), one of Aristotle's students, it was thought that various problematic character qualities and moods were caused by an imbalance of these liquids in the body. These also culminated as a way to generalize differences in temperament/disposition among various demographic groups. Humorism evolved over centuries and cultures, with some details shifting over time, but a recurring aspect of the theory was that each humor was connected to: a bodily organ, an element (earth, air, fire, or water, as identified by Empedocles), a personality type or emotional quality, and a degree of temperature or moistness. Some writings also connected them with seasons, ages, and planets, such that humorism in a sense became astrology for body goo.

Here, for your morbid pleasure, is a brief examination of each one of the humors through an etymological lens.

Blood

An extremely old word, **blood** is from the Proto-Germanic *blodam*, which in turn came from the PIE root *bhlo-to*, likely meaning "to swell, gush, spurt," "that which bursts out." (That root, interestingly, is related to *bloma*, or "flower," which offers the same sense of blossoming outward.)

As one of the four humors (the sanguine humor), blood was associated with the element air, and Hippocrates connected it, understandably, with the heart. Renaissance humorists, however, connected it to the liver—and, indeed, medieval poets associated the liver (a Germanic word whose

PIE root likely means "to stick, adhere") with such emotions as much as the heart.

The early medical practice of "bleeding" a sick person was thought to help relieve an imbalance of blood. People with too much blood were thought to be sanguine—overly happy or prone to fall in love.

Phlegm

This word originally glopped into English in the frothy form *fleem*. *Fleem* is a 14th-century word meaning "viscid (glutinous, sticky) mucus."

Fleem came from the Greek *phlegma*, which—you guessed it—was one of the four humors and meant "humor caused by heat" thanks to its etymological parent, *phlegein*, "to burn."

Contradictorily, though, the phlegmatic humor was often associated with moistness and water. Hippocratic humorism proposed that phlegm originated in the brain, while in Renaissance and Elizabethan times, it was associated with the lungs. Either way, an imbalance was thought to cause apathy—hence the Modern English definition of "phlegmatic" as "cool, calm, self-possessed" or "cold, dull, apathetic."

Choler/Yellow Bile

Choler brings to mind the disease cholera, an infection of the small intestine that killed an estimated 38 million people between 1817 and 1824 during its height in India (and plenty more after that). Also a 14th-century word, choler originally meant "bilious of temperament or complexion"—with bilious here meaning that you looked a bit green or queasy. The word derives from the Greek root *khole*, or "bile," which in turn came from *khloros* "pale green, greenish yellow."

Choleric then came to mean "easily angered or hot-tempered" by the late 1500s. Thus, people deemed to have too much yellow bile were thought to be irritable and quick to anger. This humor was associated with the element of fire. Hippocrates connected it to the liver, though

later humorists would associate it with the spleen, which led to the use of "spleen" as a word for "anger."

In Old English, the word for the spleen was *milt*, which is still in use as a word for the spleen of animals used for food—and the semen or sperm sacs of fish, which is also often used in cooking. "Milt" is thought to be from a PIE root meaning "soft," which gives the modern-day terms the sense of "soft parts."

Melancholy/Black Bile

You'll notice the same *chol* syllable in "choleric" and "melancholy," and that's no coincidence. Literally meaning "black bile," "melancholy" is composed of the Greek *melan*, or "black" (which you might recognize in the word "melanin," a pigment in skin, hair, and eyes) plus *khole*, which is just *chol* spelled differently.

Predictably, people with too much black bile were thought to suffer from depression. Associated with the element earth, Hippocrates connected black bile to the spleen, while Renaissance and Elizabethan humorists would connect it to the gallbladder. Gall is from the Old English word for "bile," while bile is from Latin. Exhibiting gall originally meant to behave in an embittered way, suggesting too much bile. The newer sense of unpleasant boldness is built on this etymological foundation.

After medical science progressed and humorism was proven to be a rather arbitrary means of diagnosing … well, most things, the word "humor" became much less fluid-focused and lost much of its association with biology, but retained its connection to moods.

Hence, by the early 1500s, "humor" became a general word for a state of mind, as in a "good humor" or a "bad humor." The sense of "humor" as in something funny or witty emerged from this "moody" sense in the 1600s: Originally, the idea of humor as a form of entertainment suggested something that suits one's mood or humor, and then evolved to mean that which puts one in a "good humor," or

cheers you up. Similarly and for the same reason, to "humor" someone is to do something in accordance with their mood.

On that note, let's take a closer look at a few icky, body-centric words that have some humorous, horrifying, and intriguing history behind them.

Artery

This word is from the Greek *arteria*, which meant both "trachea" or "windpipe" and "artery" because arteries were thought by ancient physicians to be air ducts, given that they did not contain blood post-mortem during autopsies. Its literal sense is something "raised," much like the word "aorta" (*aortē* in Greek), which Aristotle and others used to mean a strap by which something (the heart) was hung or held up.

Belly

The word "belly" and its Germanic relatives originally described things used for holding other things—leather bags, pouches, bellows, husks, purses, and more. It was extended to the stomach area in the 1200s as a means of poking fun at the especially large bellies of people whose weight was attributed to overindulging at the dining table, and was extended to gut areas of any size in the 1300s.

Bladder

Much like intestines, bladders—typically those of cows, sheep, and pigs—have enjoyed many uses in history. Imagine, for instance, kicking around an inflated bladder for fun. Their applications in cuisine had been wide-ranging, from storage to central recipe features such as the Anglo-French method of cooking chickens in bladders. You could even fill them up like a pastry bag and use them to squidge food into exciting patterns.

This word's Old English predecessors not only referred to the organ but also to blisters and pimples. Its Proto-Germanic root means "something inflated," and shares a root with the word "balloon"—and "bollocks."

Brain

There are a few theories about the origin of the word "brain."

The Old English word for brain was *brægen*. Indeed, *brægnloca* was an Old English word for head, and it literally means "brain-locker."

Most etymology dictionaries will tell you that "brain" is probably from the PIE root *mregh-m(n)o-* "skull, brain," which would make it cognate with Greek *brekhmos* "front part of the skull, top of the head."

A more interesting alternative, from Professor Anatoly Liberman, is that it is related to Old French and Celtic words meaning "refuse, rubbish, rejected matter" because many cultures believed animal brain matter to be just fat or some other sort of nonessential body goo—and not very good to eat. Other etymologists have connected it to German words meaning "rotten or pulpy mass."

Liberman also suggested that the original root of the word "brain" is PIE *bhragno* "something broken," because your brain is wrinkly, and the wrinkles make it look cracked. This theory *definitely* makes sense at times.

✐ Brain-squirts

Ever had a moment of sudden stupidity or memory loss and called it a "brain-fart"? That's a relatively new coinage, but 350 years ago there was "brain-squirt," meaning "a feeble or abortive attempt at reasoning."

Its first recorded instance is a 1654 entry from the *Diary of Thomas Burton*, who was a British MP under Oliver Cromwell. It reads:

for the other arguments, of fears and jealousies, he conceived they were but bugbears and brain-squirts, things not to affright such an assembly into any change in their councils.*

Brain-squirts. Real word. Used by politicians in the 1600s. On second thought, that makes sense.

Boggling the Mind

Brain-squirts can be mind-boggling. Boggle comes from *bugge*, a Middle English word for "specter," which is the root of the word "bogeyman" as well. It also influenced the use of the word "bug" for an insect, implying that people have always found insects frightening, and the word "boggart," which was a general word for a mischievous and malevolent spirit or monster long before it appeared in the Harry Potter series.

It could have also influenced the British profanity "bugger," but that word is specifically from a Latin word for a Bulgarian because they were rumored to be "heretics and sodomites."

That all means that to be mind-boggled originally meant to be frightened out of your wits as if you had seen a ghost. This led to the sense of feeling completely confounded or having one's mind blown that we have today.

————

Bowels, Entrails, and Intestines

It's no secret that sausages are often made using intestines, but the word "bowels" took the opposite route. It entered English in the 1300s, and is originally from the Latin *botulus*, meaning "sausage."

In humorous Greek poetry, the bowels were associated with extreme passions including love and anger, but a Hebrew association

* Guibon Goddard's Journal: November 1655, pp. lx–cii, from the *Diary of Thomas Burton Esq*; vol. 1: *July 1653 – April 1657* (London: H. Colburn, 1828).

between the bowels and gentler forms of love including kindness, pity, and benevolence came into 14th-century English through translations of the Bible. Therefore, for a short time, "bowel" meant "tenderness" or "compassion."

> Put on therefore, as the elect of God, holy and beloved,
> bowels of mercies, kindness, humbleness of mind, meekness,
> longsuffering;
>
> 1 Colossians 3:12 KJV

"Entrails" also emerged in Middle English. This word for guts sounds like it would have something to do with the long, trailing shape of intestines—in Old English, the word for intestines was *hropp*, or "rope"—but instead literally means your "insides," from the Latin *interaneus*, meaning "internal." The spelling of the English word is thanks to the evolution of the Latin term into *intralia*, which became *entrailles* in Old French before making its way to English.

"Intestines" emerged in the late 1500s, from the Latin *intestines*, similarly meaning "internal" or "inward." (Serendipitously, the 19th-century term "innards" is a variation on "inwards.") The implication is the same: One's intestines are one's "insides."

Burping, Belching, and Eructation

The word "belch" has been around since Old English as *bealcan*, which also meant "to swell" or "to heave" (probably in the gastric sense). In the 18th century, it's also recorded as a nickname for truly awful beer.

"Burp" is a more recent addition to English, first appearing in the U.S. within the last century, but is similarly onomatopoeic.

For a more polite-sounding (read: Latin-derived) alternative, "eructation" horked itself into English in the 16th century from the Latin *eructare* "to belch forth, vomit," literally "to belch out." Much like the other two, however, the base verb *ructare* is also thought to be imitative, meaning it mimics the sound of what it describes.

Diarrhea, Gonorrhea, Hemorrhoids, and Rheumatism

The notoriously consonant-stuffed spelling of the word "rhythm" is thanks to its Greek source, *rhythmos*, which has many meanings including movement, symmetry, arrangement, disposition, and even soul.

The Greek verb *rhein* and its original PIE root both mean "to flow," and the English word "stream" is also ultimately from the same root.

This is all very beautiful, especially given rhythm's role in music and poetry.

However, most English words that come from this same root are surprisingly disgusting—words like diarrhea (literally a "flowing through"), gonorrhea ("flowing seed"), hemorrhoids ("flowing blood"), and rheumatism ("a flowing" or general drippy discharge).

While we're on the subject, gonorrhea is known as "the clap" due to the French name for the disease, *clapier bubo*, literally an inflamed lymph node in the groin (bubo) caused by visiting a *clapier*, or "rabbit's nest," a euphemism for a brothel that refers to the prolific sex lives of rabbits.

☞ And Speaking of Gonorrhea ...

Safe sex saves lives and keeps your bits free of sexually transmitted infections, but in case you need additional incentives to use sufficient protection, enjoy these harrowing etymology facts about a few more gnarly, itchy, scratchy conditions.

Chlamydia is from a Latinization based on the Greek *khlamys*, meaning "mantle" or "military cloak" due to the fact that it "cloaks" the nucleus of an infected cell.

Herpes literally means "creeping" and is a direct borrowing from Greek. While herpes is most frequently associated with sexually transmitted infections such as genital herpes today, the word crops up in the medical terminology for several other skin conditions. In Greek, *herpes* was a word for shingles, today called herpes zoster (*zoster* is from the Greek for "belt" or "girdle" due to the common location of the disease). The word itself suggests that these are skin conditions that spread.

Syphilis is named after a character named Syphilus, the unfortunate protagonist of the 1530 poem *Syphilis, sive Morbus Gallicus*, or "Syphilis, or the French Disease." In the poem, a shepherd shouts at the sun for being hot, and the sun responds by unleashing the venereal disease upon the world. "With joints apart and flesh erased, / Thus was the shepherd flailed and thus debased." The shepherd's name may be intended to literally mean "pig-lover."

———

Drool

This word is thought to be a contraction of the word "drivel," which in its Old English form (*drefllian*) was another word for slobber and nose drippings. Indeed, "drivel"—meaning "nonsense"—is thought to evoke the drooling of children and, on its darker side, people impacted by intellectual disabilities.

Fallopian Tube

Nothing about the word Fallopian has anything to do with the function or location of these tubes. In fact, Fallopian is just a term for a variety of body parts described by 16th-century Italian anatomist Gabriele Falloppio (1523–62), including the Fallopian canal (which is located in the skull) and the Fallopian ligament (which is located in the pelvis but has nothing to do with the tubes). The canal and the ligament, which are standard nongendered human parts, have since acquired other, more descriptive names (the facial canal and the inguinal ligament), but perhaps predictably, the tubes, which are specific to the female reproductive system, are still just named after the same person.

Fart

This word for passing gas has been around since Old English (as *feortan*) and is thought to be imitative in origin, related to a variety of other words for the same bodily function including the Old Norse *freta*, French *pet*, Greek *perdein*, Russian *perdet*, German *Furz*, and many more.

☞ Fart Facts

Rap (which is from the same source) also meant "fart" in the 15th century.

Raspberry, referring to the sound made with the lips and tongue, is British rhyming slang: "raspberry tart"—"fart."

Cutting the cheese, which literally refers to the smell emitted when first slicing into a ripe wheel of a pungent cheese, is a 20th-century invention, but "cut" has been associated with farting since the early 1800s. To "cut no cheese" is also recorded in the 1800s, but with the meaning "to hold no weight or significance," suggesting not being "worth a fart."

Flatulent has been a word describing a bout of burping and farting since the 16th century, from the Latin *flatus*, which was both a word for a fart or any sort of expulsion of air.

More words for farts, with rather obvious reasoning behind them, include: toot, vapors, wind, gas.

———

Gut

Colloquially, your gut is both your paunch and the bowels piled up behind it. In Old English, its predecessor *guttas* carried the same meaning, but literally meant "a channel," and is related to words including "gush," "gust," and "geyser."

Hymen

This word is a direct borrowing from Greek, in which it means "membrane."

It was first described in the 1500s by anatomist Andreas Vesalius (1514–64) in *De humani corporis fabrica* (On the Structure of the Human Body; 1543), which was radical for its depictions—both illustrative and written—of anatomy based on Vesalius' dissections of corpses.

Curiously, there is also a Greek god of marriage known as Hymen. However, although this god has since been associated with the hymen by influence of folk etymology, in ancient Greek culture they were evidently not associated with one another.

Etymology aside, people with vaginas are not juice boxes. Many cultures have perpetuated the idea of the hymen as some sort of chastity seal that indicates a woman's "purity" as a means of controlling her sexuality for the benefit of men. The hymen is a stretchy tissue within the vagina, usually in a crescent shape, that may or may not have some additional segments of membranous tissue extending over the vaginal opening at an individual's birth. This membranous tissue can tear during intercourse, which can cause bleeding, but doesn't always. The most common type of hymen found in most people with vaginas is a crescent-shaped band that goes from one or two to ten or eleven o'clock, widening around six o'clock when the person is lying on their back. The rest of the vaginal canal is open and uncovered. If the opening is fully covered by the hymen (which is found in only one to two out of 1,000 infants and is known as an imperforate hymen), it is often considered a medical condition and must be corrected via a hymenectomy before the individual can use tampons or have intercourse.

Influenza

This word (and the short form "flu") is first recorded in English as a name for infectious diseases in the 1700s, borrowed from Italian during an outbreak of a disease called *influenza di catarro*, or "epidemic of catarrh," which is from the Greek *katarrhous* meaning "head cold" or literally "a flowing down." *Influenza* as a word for epidemics in Italian is older, from the Latin *influentia*, which could refer to any epidemic or something resembling the flu. That's where it gets a bit less medical and rather more mystical: While the word does suggest "flowing (fluids)," it also suggests the "influence" of the stars, with their positions causing both ill fortune and illness.

Menstruation

This word literally means "the monthlies," both in English and the original Latin *menstruare*. It entered English in the 1600s as the noun "menstruation," with the verb "menstruate" appearing shortly thereafter as a back-formation—though in Middle English *menstrue* was used as a noun borrowed directly from French. The original meaning

of "menstruate" was "to make something dirty with menstrual blood" rather than to simply discharge it from the body—an echo of common, misogynistic, and multicultural associations between menstruation and uncleanliness. In Old English, the term was *monaðblot*, meaning "month-blood."

Mucus

This word is an adoption from Latin, in which it meant more or less the same thing but also included a wider array of slimy substances. The Latin word for blowing your nose, *emungere*, shares the same root.

In Old English, the word for mucus was *horh*, which is thought to reflect—well, horking a loogey (both imitative words themselves). In Middle English, it was *mucilage*, a variation on the Latin.

Pancreas

This word, which was first used for animal pancreases served as food (also known as "sweetbreads"), disturbingly means "entirely flesh," describing the consistency of the pancreas, which looks like a lump of bloodless meat.

Pernicious

Here's a horrifying feather for your vocabulary cap: "Pernicious" typically describes something that slowly and subtly ruins your life. It's sometimes used in medical contexts when the body can't properly absorb vitamin B_{12}, causing a recurring problem.

But there's nothing particularly slow or gradual about the word's etymology, which is way more startling and aggressive: It's from the Latin *pernicies*, which literally breaks down to components *per*, here as an intensifier meaning "completely," and *necis* "violent death, murder." That's not an exaggeration. *Per* in this context means "forward" or "through," in the sense of something running you through like a goddamn spear through the heart.

The other part of the word is *necis*, which in Latin was a word for "violent death" or "murder." It's a cousin of the term *necare*, "to kill," which shows up in fun words like "necromancy," "necrotic" and "noxious" (though it's also part of milder words including "obnoxious," "nuisance," and "nectar").

Plethora

Ever felt a bit puffy or had red patches on your skin? Beginning in the 1500s and extending all the way to the 1800s, doctors might have told you that you had plethora, a medical term referring to any number of conditions they believed were caused by an excess of bodily fluids—such as the four humors. In fact, plethora is still a medical term describing a flushed face. That was the original meaning of the word "plethora," which comes from the Greek word *plethore*, meaning "fullness," and it wasn't extended to refer to things other than bodily fluids until the 1700s.

Poop

Poop is funny. It's a stinky lump we helplessly squeeze from our bodies on a (hopefully) regular basis. Farts are funny. They are smelly gasses that vibrate our sphincters so hard that it makes a *ffpplllttthhht* noise.

We have *many* words for the substances that come from our rear ends and for the act of releasing them.

Curiously, the oldest sense of the word "poop" itself is that of the stern of a ship (as in "poop deck") in the 15th century, from the Old French *poupe*, and ultimately the Latin *puppis*, both words for the stern. The first thing to poop was the sea: "pooping" was the breaking of waves over the stern.

As a word for human waste, "poop" is first recorded in the 18th century as a word for a quiet fart (much like "toot") and then later as the whole turd and its expulsion. This usage is probably not related to the earlier nautical one, but is rather imitative of the sound of defecation.

᧘ Origins of Other Shitty Words

Defecate emerged from this sense in the 1800s, but existed as early as the 1500s as a word for clearing dregs and impurities from other substances.

Dung is an Old English term for manure used as fertilizer, or to insulate underground rooms. Interestingly, this word may have altered the spelling of "dungeon" for a strong underground cell; it used to be *donjon*.)

Excrement, 1530s, is from the Latin *excernere*, meaning "to discharge," or literally "to sift out" (Latin root: *cernere* "sift, separate"). In English, it first referred to anything the body secreted before its meaning narrowed to poop only in the 18th century.

Feces, from the Latin *faeces*, meaning "dregs" or "sediment" (but not poop), with that meaning extending into English in the 1400s. It was first applied to excrement in the 1600s in English.

Fewmet is a word for poop from a game animal, arising in the 15th century and literally meaning "steamy stuff," from the Latin *fumare*, "to smoke, steam."

Flux is a word for flowing, from the Latin *fluxus*, but was introduced in English specifically as a name for excessive flowing of bodily fluids, such as in the context of dysentery.

Manure is etymologically the mildest of these words and originally meant "to cultivate" using manual labor. It's related through the Latin *manus* to the word "manual," as well as words such as "maneuver" and "manufacture." It was extended to dung through the process of putting animal waste and compost into the soil to fertilize it.

Ordure, a late 14th-century adoption meaning either excrement specifically or filth generally, is from the Old French *ord* or *ort*, meaning "filthy" or "foul," and ultimately from the Latin *horridus*, giving it connections to words such as "horrid" and "horrible."

Scat, a shortening of "scatology," from the Greek word-forming element *skat-* "dung."

Turd has been around since Old English as *tord*, which carried the same meaning. It's from a PIE root meaning "to split," suggesting something separated from the body. (*See* shit, in Chapter 1.)

Puke

"Puke" is thought to be imitative of the sound of vomiting. It surely existed earlier, but in writing it is first thought to be found in Shakespeare's *As You Like It* (1599) as Jaques describes the seven "ages of man" in the "All the world's a stage" monologue.

At first the infant
Mewling and puking in the nurse's arms.

 Act 2, scene 7, lines 139–40

In the 1700s, "puke" became a noun as well: not vomit itself, but a medicine that induces vomiting. The sense of the material vomited up was applied later, in the mid-1900s.

"Puke" is also a nickname for someone from Missouri, as a result of an 1830s conflict between the state and its neighbor Illinois over the Galena lead mines in northern Illinois. Migrants from Missouri—whom Illinois governor Thomas Ford (1800–50) apparently called "all her worse population"—"puked" into the area seeking work.

Rectum

The word *rectum* in Latin means "straight," and if that sounds strange, that's because it is an abbreviation of the full phrase *intestinum rectum*, or "straight intestine," since it's comparatively straighter than the rest of the intestines, which are decidedly unstraight. However, the human rectum isn't really *that* straight. The phrase is a loan translation from Greek (*apeuthysmeon enteron*), with the original name given to this part by Galen, who had only dissected animals with straight rectums. Notable relatives include "correct", "regulate", "regal", and "rectify."

Skeleton

Dem bones dem bones dem dry bones … The word "skeleton" is Greek, from the full Greek phrase *skeleton soma*, meaning "dried-up body" or

"mummy." *Skeletos* alone means "dry" and comes from a root meaning to parch or wither.

Skin

This word is heavily entwined with the act of peeling the outer layer of the body away. "Skin" is an Old Norse word for an animal hide that entered English in the 13th century, and its PIE root *sken-* means "to peel off." *Hyd*, or "hide," was the Anglo-Saxon term for the same thing, as well as the epidermis of a human, while the process of skinning was *flean* "to flay." Although initially used for animals, "skin" was extended to humans, fruits, and vegetables in the 14th century.

The creepy term "by the skin of [one's] teeth" is from Job 19:20 KJV: "My bone cleaveth to my skin and to my flesh, and I am escaped with the skin of my teeth."

This passage details Job's suffering and disease, and a very simple translation is: "I'm skin and bones, and all the flesh I have left [keeping me alive] is my gums." Thus the phrase has metaphorically been extended to any sort of narrow escape from death, the law, and other unpleasant fates.

Snot

This word for mucus from the nose (Old English *nosu*, with the same meaning) is from the Old English *gesnot* which, very simply, means stuff that comes out of your snout. "Snout" is from the Middle Dutch *snute*, a word for the same thing, and the *ge-* prefix is attached to nouns measured in amounts rather than quantities. (That is, you may have two apples, but you cannot count the number of snots you have.)

In Old English, the related and corresponding verb *snite* meant "to pick one's nose" or wipe it on something.

The source of "booger" is unknown, but it's also recorded as "bugger," which perhaps might suggest a relation to the British slur for people who engage in so-called "sodomy"—and a homophobic comparison between objects in holes (*see* bugger, in Chapter 5).

Stomach

The term "stomach" can refer to either the particular organ or the overall belly area (e.g., "how to get a flat stomach in ten totally practical steps!"). It can also be a verb meaning "digest" or figuratively "endure," as in "Can you stomach learning about the words in this chapter?"

Its multipurpose usage is even more pronounced in the word's history. Variously in Latin (*stomachus*) and Greek (*stomachos*), the term has referred to a variety of body parts—throats, esophagi, the stomach itself, and more—as well as emotions and physical input connected to ingestion and flavor, with the Latin word describing having taste for something, or a like or dislike of it. In the theory of the humors, it was also thought to be the source of pride and indignation. The literal sense of the Greek word is "mouth" or "opening," from the root *stoma*, meaning "mouth" that also lingers in today's medical sense.

Words for internal organs and general parts of the body are often interchangeable in other Indo-European languages as well, though in English we borrowed the Greek word *gastros* for a chubby (external) gut or paunch to refer to internal *gastric* functions.

In Old English, the word for stomach (and later for throats and gullets) was *maga*, which survives in the Modern English word "maw," which typically refers to the gaping mouth of a beast.

The term "tummy" is basically a baby-talk variation of "stomach."

Throat (and other throaty words: neck, throat, gullet, gulp, and esophagus)

The Old English *þrote*, which meant much the same thing as its grandchild "throat," is cognate with several other Germanic words for the same body part. In Old English, the Adam's apple was called the *þrotbolla*, literally "throat boll" (where "boll" refers to the round seed of a plant, such as a cotton boll).

Gullet, which means much the same thing, emerged in the 1300s and is ultimately from the Latin *gula*, meaning "throat" or "appetite," suggesting that this is a body part used for "gulping down" food. It

passed through French as *golet*, which also referred to other throat- and tubelike things including the necks of bottles, gutters, and small creeks.

The predecessor of "neck" is the Old English *hnecca*, though *hals* and *sweora* or *swira* were more common words for the same body part. *Hnecca* was more associated with both literal and figurative yokes, burdens, and servitude, with the poetic senses perhaps contributing to the longevity of "neck" over the other Old English words.

The word "esophagus" (the earlier and alternative Modern English spelling is oesophagus) was introduced in the late 1300s from the Greek *oisophagos*, which is composed of the elements *oisein* (a variation of *pherein*) "to carry" + *phagein* "to eat"—so the organ that carries your chewed-up food (to your stomach).

Tongue

This word has existed since Old English as *tunge* with most of today's senses: the muscle itself, speech, the language of a people, and more. Its modern spelling is curious, though, because it's an overcorrection—an attempt to reflect its correct pronunciation. However, that spelling is, in the words of the *OED*, "neither etymological nor phonetic, and is only in a very small degree historical."

The verbal sense of the word, to "tongue" a physical object, from a sore in the mouth to a partner's naughty bits, dates back to the mid-17th century, though it's recorded as early as the 14th century as a word for a verbal lashing. For instance, one might be "tongued" out of an establishment for bad behavior.

Vomit

Vomit is a fairly straightforward word. It's from the Latin *vomitare*, which described habitual vomiting, and originally *vomere*, meaning to puke or spew a single time. There are, however, some interesting related words. The Romans, for instance, were big into **bulimia** (from the Greek *boulimia*, "ravenous hunger"): It wasn't uncommon for hours-long banquets to be punctuated by bouts of vomiting to make room for more feasting. One, possibly apocryphal, theory holds that this gave us the word *vomitorium*, which in Roman days was

the entrance to an amphitheater where attendees would flow forth, but which was later, in English, applied to the place where Romans apparently went to vomit.

Another interesting related word is **ignivomous**, meaning "spitting or vomiting fire."

Womb

Womb was a much broader term in earlier incarnations of English, describing not just the organ for reproduction, but also the entire belly and its contents, including the bowels. **Note:** It is not related to the word "woman."

Our (Not So) Private Parts

It's no accident that our genitalia and the other parts of our body that we consider private—or at least that we think ought to be covered in public—have more names, from the scientific to the vulgar, than most other parts of our body. (We'll get to sexy words shortly.) The word "genital" and its Latin predecessor, *gentalis*, simply meant "pertaining to reproduction or birth," though in Latin it was not a word for the organs used for reproduction—that was an English addition.

Here's a look at some of the language surrounding those bits we conceal, but love to talk about nevertheless:

Anus

What is literal and medical in English was often figurative and metaphorical in Latin. Case in point: *anus*, which in Latin referred to the same part of the body but literally meant "ring."

Breasts and Boobies

Breast itself is from the Old English *breost*, which was (much like today) both a word for any person's chest or mammaries. It's thought

to be from a PIE root meaning "swell" or "sprout," suggesting both the rising and falling of the chest when breathing and the growth of mammaries.

The more interesting part of the story, as with "penis" and "vagina" below, has to do with all the nicknames we've come up with for this part of the human body.

Bosom, a generally acceptable term for both mammaries and the general chest area, has existed since Old English (as *bosm*) and is thought to be either from a PIE root meaning to "grow" or "swell," or from another meaning "arm." In the latter case, the idea is of the area enclosed by the arms and the chest, which would make sense in terms like "bosom friends," and other usages in Old English—for example, it's recorded as a word for "womb" and for a ship's hold in addition to "breast." In fact, until the 20th century, "bosom" was far more commonly used to refer to a nongendered chest rather than a boobalicious one.

Curiously, before **hooter** was associated with breasts—breasts so beautiful or large that they make men hoot—in the mid-1900s (and further immortalized by the opening of the first restaurant of that name in Clearwater, Florida, in 1983), it was most often associated with noses, presumably for the same reasons a "honker" or other beaky words like "aquiline" are associated with noses. This nasal sense still appears in modern British English.

Boob is pretty recent as a term for squishy, chesty funbags, and was uncommon until the 1920s. But "boobies" and "bubbies," on the other hand, appeared as words for breasts as early as the late 17th century, probably based on baby-talk.

An earlier sense of the singular "boob" is that of a stupid person, itself a shortening of "booby," which has been a word for a stupid person since the late 1500s. It's from the Latin *balbus*, meaning "stammering" and is therefore related to the word "barbarian," which comes from a root imitative of the (supposedly) unintelligible speech of foreigners (*see* barbarian, in Chapter 5).

⟿ Additional Types of Boobies

The bird known as a **booby** is named after the foolish person called a booby because both are stereotypically clumsy on their feet.

A **booby prize** (1880s) is the prize given to the person foolish enough to have lost a game.

A **booby trap** (1850s) is a prank played upon a booby—a person foolish enough to be pranked.

———

Butts and Booties

Butt is quite the lexical workhorse. The earliest recorded sense of butt, from the 13th and 14th centuries, is the rounded end of something or a thick, rounded object—not a "thicc" end, and not the rear end of a human. Around the same time, the verb "butt" was a word for the act of striking someone or something with such an object.

At the time the noun was typically spelled *butte*, much like the modern word for a big, steep hill-like land formation, which harks back to the word's Old English predecessor, *buttuc*, a word for a small piece of land or an end.

Given the Old English spelling, it may come as no surprise that it ultimately evolved into the word "buttocks," a 14th-century word for the posteriors of humans and animals with visible butt cheeks (e.g. horses and pigs).

Beyond land formations, some of the first short and/or rounded things called butts included casks of wine, liquor, and ale, as well as the blunt ends of objects such as weapons and tools. The "barrel" sense has relatives across many Indo-European languages and may also have been influenced by the Latin *buttis* "cask." Indeed, a butt was a legal unit of measurement for casks, though the amount varied widely by region.

Its first use for the rear ends of living (or formerly living) things was that of animals—the rounded rump on livestock and sometimes the meat from that region or other rounded cuts of meat, for example.

"Pork butt" or "Boston butt," on the other hand, is located above a pig's shoulder and is named for the fact that these cheaper cuts

of meat were stored and shipped in barrels, especially in colonial New England. In an interesting reversal, in Middle and early Modern English, "ham" was as commonly applied to the rear of the human leg—hence, hamstring—as it is to the cut of meat from a pig's rear end now.

"Buttocks" persisted for human bums until the 19th century, when it was shortened to "butt." One exception: "Butt" was also the 14th-century word for several species of flatfish.

Booty is an old, old concept, and whether you're talking about a pirate's booty (treasure), or a pirate's booty (butt), or a pirate getting booty (sex), all the booties are from the same source, implying something you want—and something you take.

The Middle English *bottyne* was a word for plunder taken from an enemy; it's from the Old French *butin* of the same meaning, but it's ultimately from a Germanic source, perhaps related to the German *bute* "exchange" or to the Old English *bot* "help, advantage." This is the same sense found in the phrase "to boot," as in the emphatic phrase "to boot."

When it comes to bodies, booty has two senses: It can be a mild, G-rated noun for a rear end, or it can refer to sex, as in "getting booty." The latter reflects the idea of sex as plunder, and while it has been infused with the same leering "plunder" sense in its past, it's been reinfused with horny playfulness thanks to its use in 1980s and 1990s hip hop.

Clitoris

Congratulations, you've found it!

This word, which emerged as a medical Latin term in the 1600s, is from the Greek medical word for the organ, *kleitoris*, which is thought to literally mean "small hill." The related verb *kleitoriazein* meant "to touch or tickle the clitoris," for obvious reasons. (In German, *der Kitzler* "the tickler" is also slang for a clitoris.)

In less medical Greek, the clit was called *nymphē* "bride, young woman," or *kystho-korone*, "crown of the vagina."

The 16th-century anatomist Mateo Realdo Colombo (ca. 1516–59) once had the audacity to claim he had discovered the clitoris for the

first time ever, presumably followed by the sound of every woman around him quietly snickering. Colombo—who was a contemporary of Gabriele Falloppio, the similarly exasperating namesake of the Fallopian tubes—called the clit the *amor veneris*, or "(venereal) pleasure of Venus."

Crotch

The earliest recorded meaning of this word is "pitchfork," a sense that came from the Old North French *croche*, a shepherd's crook. Despite the fact that the modern sense of the area between the legs leverages the "pitchfork sense" (literally the fork of the legs), the word itself more accurately means "hook."

Groin

This word is from the Old English *grynde*, meaning "abyss," but with a likely secondary meaning of "depression" or "hollow," which suggests the position of this area of the body as a depression or an area farther inward than the abdomen and the thighs. Its spelling was likely influenced by "loin" (*see* loin).

Nipple

This word was first spelled *nyppel* or *neble* and is probably a diminutive of the term *neb*, referring to bills, beaks, and snouts, which gives "nipple" the literal sense of "a little thing that projects or pokes out." It was a word for the fixture on mammals before it was applied to either industrial parts shaped like nipples or even the nipples on baby bottles. In the 1500s, another common term for (especially a woman's bright and attractive) nipples was "cherrilets."

Penis (and beyond)

A verbal history of humanity suggests that people with dicks, historically, are a bit preoccupied by them. They expend a great deal of verbiage on the ideal qualities of dicks, from shape to size, often paying

them much more attention than those who enjoy having them in them. (Granted, the mileage of the ideal dick varies. Judging by their artwork, Greeks weren't so fond of big ones, but Romans were.) This obsession is also heavily reflected in other aspects of our language. After all, we do tend to talk about things we love, and especially if they're a little naughty.

As a result, English has an absolutely mind-boggling number of words for dicks. Just ... so many words for dicks. This whole book could just be about dicks and dick-adjacent words.

Although there are also many words for the vagina and vulva, dick-ish words tend to be—shall we say?—more self-congratulatory than more—vulvar words, which is of course a result of the patriarchal social structures that have shaped many English-speaking societies.

Let's start with the one most doctors use: **penis**.

This standard clinical word for the male sex organ didn't enter English until the 1670s, but it's a direct borrow from Latin. While *penis* did refer to the equipment in Latin, it was also a word for a tail. This sense connects "penis" to the words "pencil," which was origi-nally a word for a fine paintbrush, and "penicillin," whose cells are paintbrush-like.

Fun fact: Our old pal Sigmund Freud is, of course, the progeni-tor of the dubious concept of "penis envy," which he first wrote about in his 1908 article "On the Sexual Theories of Children." (Yikes.) The article and his later works theorize that girls experi-ence anxiety when they realize they don't have a penis, and hold up the phallus as a symbol of the masculine ideal and "a survival of the boyish nature that they themselves once possessed." The humorous transparence of his own hyperfocus on the organ was, evidently, lost on him.

An earlier English word for male parts is the iconic **cock**. One of the first-known instances of this word in English is in the com-pound word *pilkoc*, which appears in the 14th-century Anglo-Irish book *The Kildare Lyrics* in a poem that begins "Elde makiþ me geld," or "Old age makes me gelded," and complains about the impotence of old age:

Y ne mai more of loue done
mi pilkoc pisseþ on mi schone

That is:

I may no longer make love,
my penis pisses on my shoe

Thereafter "pillicock," "pil-cok," and "pillock" appear frequently. Precisely what the first syllable is meant to imply is unclear, but it could be related to "pillar" or "pillory."

The crux of the word, though, and the part that prevailed starting in the 1600s, is "cock," which is an association with male fowl such as roosters ("rooster" was also a euphemism for "penis" in the 1800s) due to their strutting attitude and fighting spirit. The actual personalities of people with cocks aside, bellicosity has long been associated with male vigor and the penis itself, or *membrum virile* in Latin.

(Curiously, roosters themselves don't have penises, but bumps in their cloacas called papillae by which they pass sperm to hens through a "cloacal kiss.")

Because it has been used in slang contexts for so long—and because Norman French influence on English granted Latin terms a degree of propriety while relegating many Germanic terms to a sense of simplicity or even rudeness—over time, the Latin term "penis" overtook it as the more medical and polite term, while cock became the more casual (and rather vulgar) term for the organ. As a result of its saucier sense, the use of "cock" in other, less sexual contexts become less frequent. For example, roosters are less often called "cocks" outside of jokes and cockfighting, a haystack was once called a "haycock," and a weathervane was once more commonly called a "weathercock." (Granted, other more neutral usages, such as badminton shuttlecocks, have persisted.)

But the word has proliferated in vulgar contexts, with terms like "cock-tease" and "cocksucker" showing up as early as the late 1800s.

✑ More Dickish Etymology

Boner, 1912, originally baseball slang for a gaffe or a mistake, short for "bonehead," extended for obvious reasons (and baseball bat associations) to erect penises a few years later. "Bone-on" and "hard-on" are earlier variations from the 1800s.

Caramba, 1830s, most often seen in the phrase "¡Ay, caramba!" with the word being a minced oath of *carajo* "penis," from the Latin *caraculum* "little stake" or "little arrow."

Choad or **chode**, mid-1900s, possibly from the Navajo word *chodis*, meaning "penis," or from a Hindi and Bengali word for "copulate."

Dick, 1550s, short for Richard, which was one of the most popular names for English men at the time, and therefore came to mean "fellow" (much like "guy" or "Jack") and was extended metonymically to penises.

Dong, late 1800s, maybe suggesting the clapper of a bell, or a similar play on "dingus," which was used to mean "thing" before it became an insult.

Glans, 1600s, this word for the head of the penis is a borrowing of the Latin word for "acorn."

Johnson, 1860s, a variation of the earlier "John Thomas."

Member, 1300s, possibly modeled after Latin *membrum virile*, also less commonly a word for women's bits and for any other limb, suggesting a "member" of the body's collective whole.

Phallus, 1600s, ultimately from the Greek *phallos*, a word for both actual penises and carvings of them used in Dionysian worship and later throughout Roman culture (*see* fascinate, in Chapter 3).

Schlong, 1960s, from the Yiddish *schlang*, "snake."

Wiener, ca. 1900, short for *Wienerwurst*, meaning "sausage from Vienna."

Pudendum or Pudenda

These terms refer to the external genitals—technically of any sex, but most often a woman's vulva. It may be singular (pudendum) or plural

(pundenda) and still refer to the same section, and it's often used in scientific contexts.

It's in Latin where the word's history takes an unpleasant turn: It literally means "a thing to be ashamed of," from the Latin *pudere*, "to make ashamed" or "to be ashamed." Similarly, in Old English, the word *scamlim*, or "shame-limb," was used for the same parts, probably as a translation of the Latin word.

Semen

It's literally fucking everywhere—which is to say, quite a few words in English derive from the Latin word *semen*.

In very basic terms, the Latin word means "seed," but just like in English that's also another word for gentlemanly fluids. It also meant a whole lot of other seed-centric and genetic-related things in Latin: seeds of plants, characteristics of nature, offspring, progeny in general. And it also referred to figurative concepts including "origin, essence, principle, or cause." (This is also not unheard of for the word "seed" in English.)

It's no secret that European societies have historically been largely patriarchal, with many institutions and concepts named by the men who had the power to name things. And oh boy, they did not hesitate to disseminate this Latin word all over the place.

Indeed, speaking of "disseminate," it's among the words derived from "semen," with Latin origins meaning "to propagate in every direction."

Another one is the word "seminal," as in "a seminal work of literature." So, in the same way that dude juice strongly influences your genetics, George Orwell's *Nineteen Eighty-Four* (1949) dramatically influenced the lens through which most people view government overreach and impacted the next generation of dystopian literature.

The most distressing of them all, though, has to be "seminary," which is connected to the Latin *semen* through the idea of a "plant nursery" or, figuratively, "breeding ground," where the faith and knowledge of priests and ministers are grown, so to speak.

☟ More Seminal Etymology

Cum is generally regarded as a 20th-century spelling of "come," which
is, by contrast, quite old: Its first known usage in the sexual sense is
in puns from 17th-century songs.

Discharge literally means "to unload," from the Latin *carricare* "to load a
wagon or cart."

Jizz (earlier jism or jasm) is from the late 19th century and meaning
"energy" or "spirit" (*see* jazz, in Chapter 3).

Sperm literally means "that which is sown." While *semen* is Latin for
seeds and, well, semen, *sperma* is Greek for the same thing (and was
also adopted into Late Latin).

Spunk is a Scottish borrowing from the 1500s meaning "a spark,"
which certainly explains the sense found in "spunky" starting in
the 1700s (which now occasionally has a diminutive sexist edge).
It's originally from the Gaelic *spong*, which had a range of senses
but in this case leveraged the one meaning "tinder." As to the sense
pertinent to this chapter—that of "semen," that's not entirely clear,
but it may imply the spark or sudden intensity of orgasm.

Testicles

Does one testify upon testicles? Probably not.

There's a commonly stated theory that the words "testify," "testi-
mony," and "testament" refer to the historic practice of ball-fondling
while making oaths and other promises.

Dr. Dario Maestripieri, Professor of Comparative Human Develop-
ment, Evolutionary Biology, and Neurobiology at the University of
Chicago, wrote in *Psychology Today* that "In ancient Rome, two men
taking an oath of allegiance held each other's testicles, and men held
their own testicles as a sign of truthfulness while bearing witness in
a public forum."* Furthermore, some Jewish and Christian scholars
interpret the phrase "put your hand under my thigh" from Genesis

* Dario Maestripieri, "'Testify' comes from the Latin word for testicle," *Psychol-
ogy Today*, December 11, 2011. https://www.psychologytoday.com/gb/blog/games-
primates-play/201112/testify-comes-the-latin-word-testicle

24:2–9 as a call to put one's hand under one's body (i.e. testicles) to demonstrate subservience.

The problem is, all this might be made up. Etymologists consider the connection between the term "testify" and ball-fondling ceremonies "groundless." Even if it's not, it probably doesn't have much to do with the words themselves. We don't have any written or illustrated records of this happening in Rome—and given the frequency with which Romans put genitals in their artwork, you'd think this would have come up, especially if it happened in a public forum. Meanwhile, plenty of biblical scholars think the thigh-grasping, ball-fondling interpretation of that passage in Genesis is not literal (or specifically testicle-focused). The Hebrew terms in this passage also don't specifically connect words for nuts and vows.

But it's easy to see why the evidence has led speculative, curious people to believe this theory: The Latin word *testis* had two meanings: "witness" and "testicle." The question is whether one is a special application of the other, or whether they're homonyms.

This theory starts to get a bit saggy when we discover that the "witness" application is recorded earlier, meaning that it's not derived from the nuttier sense. *Testari* was a verb describing many types of witnessing—or literally *attesting* to agreements—including willing property to offspring and more. Words like "testify" and "testament" are thought to be from the PIE root **tri-st-i-*, suggesting a "third person standing by" to bear witness to an agreement (and not specifically with the touching of balls).

The scrotal application of *testis* may be a special application of this earlier sense in which the balls "bear witness" to the fact that the individual bearing them is male. This is supported by the earlier Greek words *parastatai*, "testicles," and *parastates*, meaning "one that stands by." But other scholars believe that the Greek might have nothing to do with "witnessing," but with the fact that the balls "stand by" the dick as comrades in arms or supportive pillars—in which case the legal sense of the later Latin words wouldn't apply.

Yet another theory—this one supported by the *OED*—suggests that the ballsy sense of *testis* may be more closely related to *testa*, meaning "shell" or "pot" since they contain all the goods.*

* *Buck v. Barnhart.*

Related: The word **scrotum** is, quite literally, a sack or purse for the testicles and the projectile material stored there. This word was adopted directly from the Latin *scrotum*, which literally meant "purse," from the earlier *scortum*, meaning "skin" or "hide," with spelling influence from *scrautum*, a word for a leather quiver for arrows.

✑ More Scrotal Etymology

Bollocks or **Ballocks** is older than nearly any other word for testicles in English (including "testicle"), with *beallucas* "little balls" recorded in Old English. The Old English word is the direct predecessor of "bollocks," and "balls" is a shortening of it.

Nuts first appeared as a word for balls in the 1900s. The explanation is simple: they look like nuts.

Gonads didn't appear in English until the late 1800s, coined in modern medical contexts from the Latin *gonas*, originally from the Greek *gonos*, which carried a whole range of reproductive senses from "off-spring" to "birth" to "race" or "stock." It ultimately shares a root with words such as "gender" and "genus," both implying birth.

———

Vagina

Vagina is a Latin word, but it's one of those that was adopted into English well after the Norman invasion by scientists and physicians—and it's a euphemism. In Latin, *vagina* did not refer to genitalia at all, but to a "sheath," and most commonly not a sword sheath but a sheath for an ear of grain, such as a hull or a husk. (Of course, it's not at all surprising that the body part would be described in terms of the "sword" it's designed to hold.)

Meanwhile, **vulva**, the outer part of female genitalia, is also directly from Latin. In Latin, *vulva* was a word for the uterus or any part of the genitals. It's thought to originally be from the verb *volvere* (and therefore related to words like "revolve" and "revolution") with the idea being that the womb (or the outside of the genitals) serve as "wrappers" or things that surround and enclose.

↝ More Vagtastic Etymology

Cooch and the earlier **coochie** were popularized by Willie Dixon in his 1954 song "Hoochie Coochie Man," which is rich with innuendos. An earlier variation, "hoochy koochy," is first recorded in the context of the 1893 World's Fair, where dancers performed a belly dancing-inspired number of that name inspired by a performer known as Little Egypt (actual name: Fahreda Mazar Spyropoulos), though whether she was actually there is debated. The name of the dance may have been influenced by the stage name of a minstrel show performer named Hoochy-Coochy Rice, or from the 1850s song "The Ham-Fat Man," which includes the phrase "Hoochee, kouchee, kouchee."

Crevice, 1300s or earlier, a word for the vulva as early as it was a word for any other sort of cleft or narrow opening in English, from Old French *crevace* of the same meanings.

Fanny, 1800s, thought to be from the name of the main character in the erotic, widely censored novel *Memoirs of a Woman of Pleasure*, usually known as *Fanny Hill* (1748).

Gash, mid-1700s pejorative for the vulva, earlier for generic gashes, from Old North French *garser*, "to cut, slash," ultimately from Greek *kharassein* "carve, cut."

Minge, early 1900s, possibly a Romany word from the Armenian *mēǰ* "middle."

Naff, mid-1800s, back-slang shortening of "fanny."

Quim, unknown origin, first a neutral word for female genitalia (1600s), then as an insult for women ca. 1935

CHAPTER 3

EROTIC ETYMOLOGY

THE HORNIEST WORDS IN THE ENGLISH LANGUAGE

"Those who restrain desire do so because theirs is weak enough to be restrained."

—William Blake, 'The Marriage of Heaven and Hell' (1790–1793)

People are horny—which is, depending on your perspecctive about overpopulation, fairly good, because it took a lot of sex to make the billions of us who have lived on earth over the last few millennia. We as a species have a spectacular amount of sex, and we think about it even more than we do it, but we also tend to be pretty embarrassed about how much we do it and think about it, and as a result, we have absolute titloads of words—from the scientific to the euphemistic to the straightforward to the straight-up offensive—for our naughty bits and all the slappy things we do with them.

After all, **fuck**, the absolute monarch of swear words in English, is, in at least some instances, a verb for bumping uglies.

One critical note: The objective with this chapter is not to pass judgment on sexual preference but to point out all the words that, at some point or another, surround the humpy things we do with our bodies, many of which have historically been taboo according to some folks—even if many of those folks had their heads up their asses.

Adultery

This word doesn't (etymologically) involve any adults.

Both "adult" and "adultery" are Latin-derived, and they have the same Latin prefix (*ad-* meaning "toward"). But that's where their relationship ends: They have completely different Latin roots. While the

word "adult" adds the prefix *ad-* to the Latin *alescere* meaning "to be nourished or to grow," the root of "adultery" is *alterare*, meaning "to alter." (In fact, it's a cognate with the word "alter.")

This root gives the word "adultery" the sense of moving in a direction that alters from the moral path. The Latin base verb also meant "to corrupt" more generally, and wasn't just limited to cheating on your spouse. That's also why we have the word "adulterate," which means to corrupt or lower the quality of something by adding another substance to it.

For once we can blame this confusion on Latin rather than English because the spelling overlap of *adult* and *adultery* existed in Latin long before the English words existed.

And you'd think that perhaps one influenced the other and caused the spelling shift, but that doesn't appear to be the case. The Latin word *adultus* didn't carry the same degree of connection we have in English between the word "adult" and sexy naughty things, such as "adult films" or "adult content."

They simply overlap in spelling because the prefix *ad-* has a habit of assimilating and modifying the spelling of the syllables it's connected to. (For example, the "d" in *ad-* is altered to a different letter, as in "abandon," and doubled in words such as "accelerate" and "affirm," in both English and their Latin predecessors.)

Bawdy

This word literally means "dirty," from the Welsh *baw*, meaning "dirt" or "filth" (adjective *bawaidd*). It was used pretty much exactly the same way "dirty" is used today in a sexual context: To "talk bawdy" was the same as to "talk dirty" in the 1500s. A "bawdy-basket" was essentially a peddler of old-timey porn—someone who sold dirty books and songs, and a "bawdyhouse" was a brothel.

Climax

We use the word "climax" as a synonym for "orgasm" in part thanks to British author, paleobotanist, and women's rights activist Marie Stopes (1880–1958). But the word itself comes from the Greek *klimax*,

literally "ladder," and was mostly used to designate a rhetorical device until the 1700s, when it was extended to narrative structure.

In rhetoric, it refers to clauses that rise to a peak through the repetition of keywords. Many biblical passages demonstrate this with leapfrogging clauses.

Martin Luther King Jr.'s "I Have a Dream" speech includes several incredibly powerful iterations of rhetorical climax, using the repetition of the phrase "we can never be satisfied." The speech builds in intensity from the rhetorical question "When will [civil rights activists] be satisfied?" to the conclusion "No, no, we are not satisfied, and we will not be satisfied until 'justice rolls down like waters, and righteousness like a mighty stream.'"

In literature, as we all know, the climax is when the conflict or tension reach the highest point. A literary climax is one point—the highest point—while a rhetorical climax is the act of climbing to that point.

Around the 1880s, people started—very fairly—comparing this buildup and release to a toe-curling, bowel-wriggling, heart-thudding orgasm. Typically at the time it was part of a larger phrase—for example, "climax of orgasm."

"Climax" was solidified as a standalone phrase for an orgasm in the early 1900s by Stopes, who has many "firsts" in her biography: For example, she was the first woman faculty member at the University of Manchester, and she founded Britain's first birth control clinic.

Leveraging its rich history in narratives and storytelling that make us word nerds horny as hell, she pushed for the use of the word "climax" as a less sterile, more exciting way of describing orgasm. Basically, she made women having orgasms not just okay, and no longer simply the subject of leering and inaccurate medical writings (*see* orgasm), but also cool and fun.

(But before you go praising her too hard, note that she, like many late 19th- and early 20th-century pro-sexuality scholars and pioneers, was a proponent of eugenics.)

Coitus

The root of this Latin word is *coire* (*com* "together" + *ire* "to come, to go"), so it literally and appropriately means "a coming together."

Despite its serendipity and all the punnery that might happily result, the Latin sense is of "meeting," not "cumming together."

Although the term already held its copulatory sense in Latin, it was primarily used to describe the attraction of magnets and gravitational forces in Middle English.

The term *coitus interruptus*, the notorious (and dubious) pull-out method of contraception, is first recorded in the 1800s. Around the same time, *coitus reservatus* appeared, which is basically edging (delaying orgasm to prolong sex).

Concubine

This word has a particular connotation today thanks to its biblical and literary usage, but initially it was a bit different. The word is made of the Latin components *com* "with, together" and *cubare* "to lie down."

In some Greek and Roman cultures and situationships, concubines were recognized by law as secondary spouses, which led to the sense of the word we have today. In Roman culture in particular, there was a hierarchy of sexual relationships: *matrimonium* (marriage), followed by *concubina* or *concubinus* (both men and women could be concubines), and then *adulterium* (general violation of the marriage bed) and *stuprum* (sex with a sex worker). The distinction between a concubine and a married partner usually hinged upon the legal, social, and emotional intention of having a family together.

Yet in English, when the word itself entered the language in the 1300s, the culture didn't have such an established place for such a variety of extramarital sexual relationships, and Anglo-Saxons weren't as openly accepting of same-sex relationships, so a "concubine" became a word for a woman who lives with a man and copulates with him without being married to him. Renaissance literature was responsible for associating the term "concubine" with mistresses and owned women in far-off lands.

THE BIRDS AND THE BEES

Birds and bees are associated with spring, and spring is associated with life and procreation because it's when everything comes out and starts getting it on. Also, you know, birds lay eggs and bees pollinate things, adding an additional layer of gendered and reproductive association.

This idea of birds and bees as a metonymic device for spring, and therefore for sex, has been around since at least the 1600s.

There's also an 1825 poem by Samuel Taylor Coleridge that made have helped popularize "the birds and the bees" in this sense. This is the first verse of the very moody poem "Work Without Hope":

> All Nature seems at work. Slugs leave their lair—
> The bees are stirring—birds are on the wing—
> And Winter slumbering in the open air,
> Wears on his smiling face a dream of Spring!
> And I the while, the sole unbusy thing,
> Nor honey make, nor pair, nor build, nor sing.

Basically, he's feeling bummed out because it's spring and everything else is out and about—the bees are making honey, the birds are singing, everybody's getting laid—except for him.

Cunnilingus

This word is refreshingly literal given its elements *cunnus*, "vulva," and *lingere*, "to lick." In Latin it would literally refer to the person who does the vulva-licking rather than the action itself, but that didn't seem to matter much to the 19th-century physicians who brought it to German and English. Similarly and more entertainingly to English speakers, "lick-twat" was a 17th-century term with the same literal meaning.

Cunnus looks rather like the word "cunt" (*see* cunt, in Chapter 1), but it's most likely from an entirely unrelated PIE root meaning "to cut" (as in a gash), or possibly another meaning "to cover" or "conceal" (referring specifically to the anatomical role of the vulva).

In his 1905 book *Studies in the Psychology of Sex*—which is problematic for many reasons and riddled with racism but nonetheless a progressive look at case studies around sexuality for its time—Henry Havelock Ellis (1859–1939) notes that cunnilingus has been popular among both different-sex and same-sex partners in practically every human civilization. Ellis also refers to the act of cunnilingus, which he also calls sapphism (*see* lesbian) or *in lambendo lingua genitalia alterius* (licking the genitals of another's tongue), as "the extreme gratification" between women who prefer women. (Ellis will come up several times in this chapter, but if sounds like he'd be fun at parties, think again: He was also a vice president of the Eugenics Society and referred to people who were not white as belonging to "lower races.")

Cuck, Cuckold, and Cuckqueen (cuckquean)

A cuckold—traditionally a man whose wife or significant other cheats on him—is named after the cuckoo bird, a species known for being "brood parasites"—leaving their eggs in the nest of other birds, leaving them to raise their offspring.

This observation about cuckoos has also led to allegations that the female cuckoo bird frequently changes mates—though whether she does so more frequently than other birds is difficult to ascertain. Also conveniently absent from this narrative is the fact that female cuckoos have evolved to disguise themselves to look older and more like males to avoid frequent harassment from males. (So the core lesson here is that cuckoos of any gender are creepy and toxic by human standards.)

Throughout English linguistic history, this term has been spelled in a variety of ways including *kukewald* and *cokewold*, all adaptations of the Old French *cucuault*, which is essentially the French word for cuckoo (*cocu*) with a pejorative suffix, which implies "ardent" (*see* -ard, -art).

Although the term **cuckqueen**, referring to the female equivalent of a cuckold, seems like a modern development, it's actually quite old: The variation **cuckquean** is recorded as early as the 1500s.

However, in recent years, this term has also spawned a wealth of toxic and petty derivative portmanteaux, including "cuck" as a general insult and variations such as "cuckservative" for U.S. conservatives. All of the above, and everything in between, are obviously pejoratives suggesting someone who has been duped, emasculated, or taken advantage of, often as a result of their own attitude or choices.

Just to add insult to injury, "cuck" is also recorded as early as the mid-15th century as a vulgar word for the act of shitting. This sense is—at least originally—unrelated to cuckoos and cuckoldry, instead emerging from the Old Norse *kuka*, meaning "feces," which shares a PIE root with words like "caca," which is a borrowing from Spanish.

Depravity

This word literally means "completely crooked." Here the *de-* prefix functions as an intensifier for the Latin *pravus*, meaning "crooked." In Latin *depravare* meant to "distort" or "disfigure."

Depravity has been used fairly arbitrarily as a moral judgment throughout its lifetime, but appears in contrast to terms such as "heinous" and "cruel" in legal contexts as a means of describing the extremity of crimes. Indeed, a U.S.-based research project called the "Depravity Standard," which has been active since the early 2000s, seeks to determine what factors make a crime "depraved" vs. "cruel" and to what degree those aggravating factors should impact sentencing.

Deviant

The root of this word is the Latin *via*, meaning "way" or "road," so to be a "deviant" or engage in "deviant" behavior is to literally stray "off the (moral) path." "Deviant" and "deviate" have been in English since the 1400s but weren't specifically associated with sexual deviancy until the early 1900s. In U.S. law, "deviance" is a subjective term, but is applied as an aggravating factor in cases of sexual violence or other sexual violations, as well as establishing patterns of sexual misconduct.*

* *Bemboom v. State*, 326 S.W.3d 857, 864 (Mo. Ct. App. 2010), *Ertley v. State*, 785 So. 2d 592, 593 (Fla. 1st DCA 2001).

Dildo

The word "dildo" has been pleasuring English-speaking mouths and other, less linguistic orifices since the 16th century. Trouble is, no one precisely knows how it got here, much like the patient who arrives at the hospital with one lodged in their rectum.

One theory is that it could be from the Italian *deletto*, meaning "delight," and related to the English words such as "diligent" and "elegant" as well as, entertainingly, "sacrilege" and "elect," via the Latin root *legere* "to choose."

Another, less elegant theory is that it's a corruption of the English "diddle," which might actually be right, but probably not in the way you think.

Prior to its use as a word for a sex toy, "dildo" shows up in ballads, madrigals, and plays (especially frolicsome or sexy ones) as a nonsense word along the lines of "fa la la" or "hey diddle diddle." It is also occasionally recorded as a word for a refrain in such a ballad.

Other Middle and Elizabethan English variations, which ranged in meaning from lover to ditty to sex toy, included *dildoides*, *dildidoes*, and *dillidoun*.

Elizabethan playwright Thomas Nashe (1567–ca. 1601) solidified the meaning of the word as a sex toy in the gleefully erotic poem "The Choise of Valentines, Or the Merie Ballad of Nash His Dildo" (1592 or 1593).

The poem is narrated by a man enjoying a sexy romp with his lover, who is a prostitute. After the couple enjoy a hip-jerking, leg-flailing mutual orgasm, the lady is still unsatisfied—but the narrator finds that his "faint-hearted instrument of lust [...] falselie hath betrayde our equale trust" (i.e., he can't stay hard), so he hands over his trusty dildo and describes her launching into a lengthy and bittersweet ode to it as she joyfully gets herself off:

My little dilldo shall suply their kinde:
A knaue, that moues as light as leaues by winde;
That bendeth not, nor fouldeth anie deale,
But stands as stiff as he were made of steele;
And playes at peacock twixt my leggs right blythe,
And doeth my tickling swage with manie a sighe.

For, by saint Runnion! he'le refresh me well;
And neuer make my tender bellie swell.

Ejaculate

This word literally means "to shoot out" like a projectile from a weapon, from the Latin elements *ex-* and *iaculum*, "javelin, dart," literally "something thrown" (root: *iacere* "to throw"). Curiously, the word referred to the expulsion of semen almost a century before it's recorded as a word for a sudden verbal exclamation.

Erotic

> Just erotic. Nothing kinky. It's the difference between using a
> feather and using a chicken.
> Terry Pratchett, *Eric* (London:Victor Gollancz, 1990)

This word is derived from the name of the Greek god of love, especially carnal love, Eros. The word entered English in the 1600s but took off in the Freudian era when psychology turned sexy. English is relatively short on single words for different flavors of love (compared to, say, Arabic, which has more than 50). The ancient Greeks had multiple words for love as well, but divided them into four categories:

Erao referred to passionate, physical love and desire.
Phileo described general affection including familial and friendly love.
Agapao was for content, happy affection.
Stergo was typically love with power dynamics, as of the love of a parent
 for a child or a ruler for a subject.

 FANCY WORDS FOR SEXY THINGS

Bathukolpian

Also spelled "bathykolpian," this word describes full, luscious breasts. It literally means "deep-bosomed" and is composed of the Greek elements *bathys* "deep" and *kolpos* "breast."

Callipygian

This Greek-derived word means "having beautiful buttocks" (*kallos* "beauty" + *pygē* "rump, buttocks") and was originally used to describe a particularly juicy-assed statue of a woman usually identified as Aphrodite, which is commonly known as the Callipygian Venus. The statue shows her lifting up her garment, called a peplos, revealing her shapely posterior. It's thought to be a marble copy of an earlier bronze, and the marble version was discovered without its head. Her head was restored in the 16th century, and the restorer took the liberty of positioning it so that she too is examining her lovely bum (*see* booty, in Chapter 2).

Concupiscence

This word for lustfulness is from the Latin *concupiscere*, "to desire eagerly," with the root *cupere* meaning "to long for." It shares this root with the name of the Roman god Cupid.

Ithyphallic

This is a word for a type of meter used in ancient Greek poetry, and it is named after the Greek *ithyphallos*, a large model phallus carried around during the festivals of Bacchus. It literally means a penis that is pointing straight upward. The poetic meter is named after the member because it was the meter used in Bacchic hymns sung while hauling around the big dong. In Victorian English, this adjective, ithyphallic, was also often used to describe things and behaviors that were grossly vulgar and indecent.

Muliebrity

A synonym for "femininity" or "womanhood," this word arose in English as a female equivalent of "virility" in men in the late 1500s. It is from the Latin *mulier*, meaning "woman"—but in a borderline misogynistic way because it's thought to be related to *mollis*, meaning "soft" or "weak." Variations on this word in English history include muliebral, meaning "womanly" or "pertaining to a woman," mulibrious, meaning "effeminate," and mulierosity, meaning "overfondness for women."

Rantallion

This word, recorded in the 1785 *A Classical Dictionary of the Vulgar Tongue* by lexicographer Francis Grose, is said to mean "one whose scrotum is

so relaxed as to be longer than his penis," or, in Grose's words, someone "whose shot pouch is longer than the barrel of his piece." The origin of this word is unknown because most recorded references to it simply direct back to Grose's somewhat creative dictionary, but there are other, similar words recorded earlier, including rantipole, which typically meant a "rude, wild person," especially a child, or in the case of the phrase "to ride rantipole," it referred to the woman-on-top or "cowgirl" sex position. It could be that the uniting factor in all these words is the verb "rant," which now has a negative connotation—suggesting loud, angry and irrational speech—but was originally a positive word, meaning "to be jovial and boisterous." (Hence, rantallion would imply "big-dick energy" but more focused on the balls, and rantipole would imply people having a good loud time.) The "rant" relation would also connect it to the word "randy," which is a variation on the pleasantly loud and jovial sense of "rant" as well (*see* randy).

A similar word structure is found in "rapscallion," a fanciful extension of "rascal," as well as "rampallion"—the now-rare, 17th-century female equivalent of "rapscallion"—which implies a woman "run rampant."

Fellatio

Although fellatio is usually associated with the sucking of dicks, the word itself does not inherently imply the presence of a penis. It's a relatively recent word in English, introduced in the late 1800s in medical and scientific contexts, but ultimately drawn from the Latin *fellare*, "to suck."

The fellow who introduced it was the aforementioned medical scholar Henry Havelock Ellis, who wrote many of the first medical works on homosexuality and transgender psychology—both of which he classified under "sexual inversion"—in addition to exploring exciting topics such as autoeroticism and psychedelics.

He also wasn't the first to use that Latin root in the oral sex context: Before him, German philosopher Friedrich Karl Forberg (1770–1848) wrote a book, *De figuris Veneris* (1824), that L. C. Smithers translated into English as the *Manual of Classical Erotology* (1899).

This text included the words *fellator* (a man who sucks dick), *fellatrix* (a woman who sucks dick), and *fellation* (the act)—though notably not the more common modern term *fellatio*.

Fetish

Fetishes weren't originally sexual—well, not exclusively anyway.

In addition to being another word for a kink, a fetish is any object or charm that is thought to be imbued with supernatural powers or to represent a god and, therefore, be worthy of worship. It came to English in the 1600s from the Portuguese *feitiço* "charm, sorcery, allurement" or, as an adjective, "artificial." Indeed it's related to "artificial" (*ars* "art" + *facere* "to make, do") via the Latin root *facere*. A couple of centuries earlier, this Latin word had yielded the Middle English word *fetis*, which meant "cleverly made" or "elegant" and "neat," a compliment directed toward both objects and people.

The Portuguese derivatives began to imply cleverly made magical items in the Middle Ages, but that sense entered English after Portuguese sailors used *feitiço* to describe charms and talismans made by the people they encountered in Africa.

By the 1800s, "fetish" had become more figurative and general, describing anything someone blindly reveres, a concept that was extended to sexual interests in the late 1800s by Henry Havelock Ellis.

Freak

People ruined the word "freak" by being extremely judgmental.

"Freak" first cropped up in English around the mid-1500s—and perhaps even earlier as *freking*—but at the time it described a very sudden shift of the mind. It has two possible origins: It may be from Middle and Old English words for moving nimbly or dancing, implying capriciousness and a mind that leaps outside of the norm. Middle English also had the adjective *frek*, meaning "eager" or "zealous," which establishes a logical connection to our usage of "freak" to refer to someone passionately interested in a topic or hobby.

It was not a pejorative term at all, but instead meant something more charmingly mischievous and implied flights of fancy and

unusual, interesting things—until the 1800s, when terms like "freak of nature" and "freak show" made their way into circuses and variety shows. Even then, the idea was initially an interesting curiosity rather than something to be mocked and derided. Instead, it was viewers' discomfort with some of the people and creatures put on display for their differences—people with albinism, people of short stature, women with facial hair, people born without limbs, and so on—that infused "freak" with its pejorative connotations.

Even in the early 1900s, being a "freak" wasn't inherently negative, but instead often implied unusually intense passion. For example, "Kodak freak" was a common term for a photography enthusiast around 1908, and it wasn't an insult. People self-identified as freaks rather proudly.

But that intensity ultimately led to today's usage. In the early 20th century, the term "freak" extended to people who were deemed overly passionate due to their sexual interests, and to people who were overly dependent on drug use—with both termed "freaks" in the past century.

Essentially, we ruined the word "freak" by freakshaming people—but fortunately it has regained some of its offbeat positivity in recent years, with pop culture infusing the word with the same positivity and pride as terms such as "nerd" and "geek."

Frisky

The Middle English adjective *frisk* originally meant "lively, merry, or animated," which is why it appears in this word for either general liveliness or frolicsome horniness. The less fun verb "to frisk"—as in the pat-downs police officers perform—is meant to reflect the motion of the hands involved.

Hedonism

The Greek Cyrenaics, who first appeared under the leadership of Aristippus of Cyrene (ca. 435–356 BCE), believed that pleasure was intrinsically good, and that physical pleasure was the equivalent of doing good—with the acknowledgment that altruism and social good can cause pleasure as well. These were the minds who first lauded

hedonism. The word itself is from the Greek *h‾edone*, meaning "pleasure." The term "hedonist" was first applied to people much later in history, when the school of thought was revitalized in the early 1800s.

Hooker

This word existed in a range of other contexts that involve hooks, such as fishing and boxing, before it was associated with prostitutes. It's also a surname for families known for fishing or agriculture. But as far as the connection to sex work goes, the most likely origin is also the most predictable: A hooker is someone who fishes for clients.

However, there are some entertaining alternative theories: It's often referenced that part of its popularity is thanks to unpopular and somewhat incompetent Civil War general Joseph "Fighting Joe" Hooker (1814–79), whose headquarters were known for gambling and partying—with prostitutes, of course. Another unlikely theory is that "hookers" are named after Corlear's Hook, known as "The Hook," in New York City in the mid–1800s, known for its "houses of ill-fame frequented by sailors."*

Horny

Arousal has been associated with horns since the days of ancient Greece, when satyrs featured in bawdy comedies and frolicked with nymphs in myths. The term "horny" in English is first recorded in the 1800s, but in prior centuries terms like "to have the horn" (implying an erection) proliferated in this context. Indeed, "horn" has been a euphemism for a penis since the 1600s. The word "horn" itself has been around since Old English and referred to any hornlike projection, including a mountain or an instrument originally made of animal horns.

Starting around the 1400s, you'll often find illustrations of cuckolded men growing horns on their head (*see* cuckold). It might simply be an expression of mockery in the sense of horny behavior

* John Russell Bartlett. *Dictionary of Americanisms*. New York: Bartlett and Welford, 1848.

making a fool of the wronged spouse, but, according to German linguist Hermann Dunger, this imagery plays off the word "cock" (*see* cock), and an alleged and horrifying custom of "engrafting the spurs of a castrated cock on the root of the excised comb, which caused them to grow like horns."

Incest

This word has a very specific sense today—sex with a family member—but originally it could describe any form of unsanctioned sexual activity, unchastity, or lecherous behavior. It's from the Latin *incestum*, which carried both the general and specific senses, from the elements *in-* "not" and *castus* "pure" (also the root of the word "chaste," which interestingly makes "incest" the opposite of "chastity").

Intimacy

This word is from the Latin *intimus*—that is, the word *in* with a superlative ending—meaning "inmost" or "deepest," with its noun form used as a word for a very close friend. It was, rather innocently, first used for emotional affection before it was extended euphemistically to sex in the 1600s. This sense is retained in phrases such as "an intimate setting."

Irrumation

This 19th-century word for fellatio is rarely seen today, and that may be in part because, etymologically, it has a bit of an identity crisis. Although it has most often been used to refer to having someone put your dick in their mouth, its original (and literal) meaning is to have someone suck on your tits. It's from the Latin word *irrumare*, meaning "to give suck," which is rooted in the Latin *ruma*, meaning "teat" or "woman's breast." In Latin it was more about feeding babies, but English made it sexy, first using it for sucking (erotically) on boobs before it was extended shortly thereafter to sucking cocks.

KINKS AND PARAPHILIAS

The word "kink" is first recorded in relation to rope, hair, and other strands, denoting a literal deviation in the path of a straight thread. It was extended figuratively to deviations in threads of thought and reason, and one of its first recorded instances with this meaning was in the writings of Thomas Jefferson (1743–1826), who, although no stranger to hanky panky, meant "kink" in that mental sense:

> Should Congress reject the nomination of judges for four years & make them during good behavior, as is probable, then, should the judges take a kink in their heads in favor of leaving the present laws of Louisiana unaltered, that evil will continue for their lives, una-mended by us, and become so inveterate that we may never be able to introduce the uniformity of law so desirable.*

Jefferson isn't commenting on the curliness of these judges' hair, and they aren't about to get freaky, but he is instead suggesting that they are—or may be—acting on an irrational, impulsive whim.

Today's firm connection between "kink" and sexual interests that deviate from the norm came later, in the mid-1900s.

A bit earlier, in 1913, kinks of the sexual variety were dubbed "para-philias" (Greek/Latin *para-*, here meaning "beside" or "aside" + *philos* "loving") by Austrian ethnologist and sexologist Friedrich Salomon Krauss (1859–1938). In the 1980s, the American Psychiatric Association added paraphilias to its *Diagnostic and Statistical Manual of Mental Disorders* (*DSM*), which effectively made it a more clinical and morally neutral term than the word that was favored previously—perversion.

The 2013 edition of the *DSM* really only digs into the paraphilias that are still considered disordered—that is, kinks that need treatment because

* Thomas Jefferson to John Breckinridge, November 24, 1803, from *The Works of Thomas Jefferson in Twelve Volumes*. Federal Edition. Library of Congress. Collected and edited by Paul Leicester Ford.

they are harmful. These can range in extremity from exhibitionism and scatologia (the impulse to make obscene phone calls to strangers) to the ones that do both mental and physical harm—think paedophilia (Greek *pedo-*, a word-forming element typically meaning "boy" or "son") and zoophilia (from Greek *zoion* "animal") or bestiality.

Anil Aggrawal, a professor of forensic medicine, included a list of sexual pathologies in his book *Forensic and Medico-legal Aspects of Sexual Crimes and Unusual Sexual Practices* (2008)—547 of them, to be precise.

Here are just a few of the more imaginative ones, either generally or etymologically speaking (far be it from me, a rampant etymophile, to kink shame here):

Forniphilia: Turning a human being into a piece of furniture—e.g., tying them up and sitting on them (presumably from the same root as "furniture," the French fornir "to furnish," purportedly coined by erotic and BDSM community figure Jeffrey E. Owen, also known as "Jeff Gord")

Kleptophilia: Stealing (Greek kleptes "thief, a cheater")

Klismaphilia: Enemas (Greek klúsma, "enema")

Macrophilia: Gigantism and excessive growth (Greek makros "long, large")

Mechanophilia, mechaphilia: Cars and machines (Latin mechanicus "of or belonging to machines or mechanics")

Melolagnia: Music (Greek melos "song" + ending -lagnia, "lust, coitus," from Greek lagneía "sexual intercourse," also used to create words for paraphilias)

Microphilia: Very small people or very small body parts

Narratophilia: Obscene words, presumably your preferred paraphilia given that you are in the midst of this book (Greek smikros "small")

Omorashi: Having a full bladder or wetting oneself (Japanese word, お漏らし meaning "to wet oneself")

Peodeiktophilia: Exposing one's penis (Greek peos "penis" + deiknunain "to show")

Lascivious

Someone who is lascivious is jazzed to get down and dirty—and in a fun way. The Lattin *lascivus* implied lewd playfulness and a penchant for sexy frolicking. The PIE root of this word, *las-, means "eager," "wanton," or "unruly."

Lecherous

A lecher is literally a "licker," an adoption from French but originally Germanic in origin. The association between licking and sexual indulgence suggests sexual gluttony. In Middle English, a woman lecher was called a *likestre*, or literally "lickster," following the pattern of words like "spinster" (*see* spinster).

Lewd

This word originally had a far more innocent meaning: In Old English, its earliest sense was "uneducated" (or "nonclerical," as in one not educated by the Church). In the 14th century, this sense of someone unlettered was extended to the, shall we say, baser instincts of humanity through a sense of something "coarse" or "rude," and therefore "lustful."

Loin

This word today can refer to a cut of meat from the side of an animal, or to a human being's junk. But why? These are two different bodily regions. In 14th-century English, this was not the case: On both humans and animals, the loin area was the lower side of the torso. It was extended to genitalia because, in English biblical translations, it was used as a word for the area of the body that should be covered by clothing—and, in menswear of that time, that typically included the lower torso down, perhaps even suggesting the area where clothes would be bound or belted. Therefore, the "loins" became the entire part of the body that must be covered to achieve decency (on a man, for the most part, but by extension also referring to a woman's

genitalia as well)—a concept that, of course, evolves with fashion conventions.

Lust

Much like its definition, this word is ancient and largely unchanged since its oldest forms. It was the same in Old English; its Proto-Germanic root is *lustuz*; and its PIE root is *las-*, all of which described horniness and desire. In English it also carries a sense of desire for things other than sex, but of a specific type. Lust is greedy, needy. That pejorative sense appeared in late Old English, though its tone depended on context. For instance, in Middle English it meant as much "a source of pleasure or delight" as it did a ravenous appetite or desire for something or someone.

Masturbate

Although in today's more sex-positive culture, a bit of masturbation here and there is considered a pretty healthy and normal way to reduce stress and pass your private time, history hasn't always held the most generous view of the practice—and that discomfort is reflected in the word. It literally means "manual defilement" or "manual dis-honor"—and it comes with a dash of the disturbing. The base elements we're likely fapping with here are the Latin *manus*, "hand," and *stuprare*, meaning "to defile." The latter element is a variation of *stupere* "to be stunned or stupefied," and may have also shifted in spelling thanks to influence from *turbare*, meaning "to disturb or confuse."

Euphemisms and slang terms for masturbation throughout history are a special kind of entertaining: In the 1800s, you might have used words like "frig," "chuff," "claw," "handle," "indorse" (an alternate spelling of "endorse," as if signing with an ink pen), "milk," or, if you have a vagina, "digitate." These came in among longer phrases includ-ing "mounting a corporal and four" (the corporal being the thumb, obviously), "to dash one's doodle," and "keeping down the census."

Additional epithets for masturbation range from the judgmental and sterile (self-abuse, self-pollute, self-service) to the less formal, such as beating, jerking, whacking or jacking/jilling off, or cranking/rubbing

one out. Then, of course, there are the imitative options, such as fap and wank. Some get even more creative. For example, one might, depending on the equipment involved: play pocket pool, buff the muffin, bash the bishop, flick the bean, choke the chicken, pet the kitty, play the clitar, whittle the whalebone, polish the pearl, flog or wax the dolphin, spank the monkey, or ring the devil's doorbell.

Merkin

This word, curiously, has been around since the 1500s, originally spelled *mawkine*, which was a variation of the word "malkin," another name for a mop. False body hair in that region was apparently worn as early as the 1400s by prostitutes whose hair had been shaved to eliminate pubic lice or venereal disease.

 UNEXPECTEDLY SEXY

Fascinate

If you're "fascinated" by something, you are literally spellbound by it. It comes from the Latin word *fascinare* meaning "to bewitch" or "to enchant." It was originally used to refer to the power of witches and mythical creatures to enthrall you. The more positive connotation—to hold someone's attention in a delightful way—didn't come around until the early 1800s, almost two hundred years later.

But if you look back a bit farther, the origin of the Latin *fascinare* isn't entirely clear. It may come from a blend of Greek and Latin terms that imply "speaking malice" or inciting envy but that doesn't have strong evidence behind it.

The more likely theory is that the Latin *fascinare* is related to the Latin *fascinum*. It makes sense, right? But this is a word for a penis or a dildo. It specifically referred to the "divine phallus," a symbol that appears all over Roman effigies and amulets and was meant to invoke the protection of

the phallic god Fascinus. So, in a sense, to fascinate someone isn't just to enchant or bewitch them, but to use magic penis powers on them.

Furnace

The word "furnace" is hot in more ways than one, and it has a lot more to do with sexy architecture than you might expect. Etymologically speaking, a furnace isn't just physically hot, it's also, er, *hot*.

You can likely guess why the word "furnace" is a bit naughty by looking at its Latin source: *fornus*, which meant an oven or a kiln.

Given this Latin word, what would you guess is a corresponding verb that might go with it in English, retaining the link to fire and heat?

If you guessed "fornicate," you're right on the money.

Both "furnace" and "fornicate" are ultimately from a PIE root meaning "to heat or make warm."

Funny enough, though, the word "fornicate" doesn't derive from this root because sex is hot—at least, not exclusively for that reason. It also has quite a bit to do with architecture.

The Latin *fornix* is a term for an "arch, a vaulted opening, or a covered walkway," so named due to its resemblance to the domed shape of a traditional brick oven, or *fornus*. The part of your brain called the "fornix" is also named because it is arch-shaped and even has what are called columns or pillars.

But the Latin *fornix* was also a word for a brothel, because the arches under the Circus Maximus and other large event venues were popular places for sex workers to hang out. And what does one do when one meets a person hanging out under a *fornix*? One fornicates. (This was probably also a bit of a pun even in Latin because the idea of sex being "hot" is a really old concept.)

Even in English, around the twelfth century "furnace" was also used figuratively to mean "a flame of love."

Gulf

A "gulf" is literally a boob of the sea. It's originally from the Greek *kolpos*, which also referred to bays and gulfs, but literally means "bosom," a reference to the curved shape of the geographical feature.

Gym

That's gym as in "gymnasium," the place where you go to work out, train, or play sports. Gymnasium is a Latin word, originally from the Greek *gymnasion*.

As you probably know, the ancient Greeks were big into sports—and the sexy strong people who played them. To more effectively show off that physicality, in the Olympics and other competitions, athletes performed in the nude—except, of course, for the olive oil they rubbed all over themselves to more attractively gleam. Which is why this Greek word, and by extension today's English words "gym" and "gymnasium," literally mean "a place to train naked." The base word *gymnos* means "naked."

But, of course, the gymnasium wasn't just about sexy bods—it was also about sexy minds, which is why in Greek and Latin a gymnasium was also a name for a school—presumably one to which most people wore clothes.

So unless you're part of a nudist colony or your gym has quite a lax dress code, etymologically you're using the gym in the wrong way. (At the very least, bring this book with you next time so you can learn something while you're on the elliptical.)

There was also a group of ancient Indian philosophers called *gymnosophistaí* by the Greeks, so known because these "wise men" went around "naked." They believed clothing and many kinds of food to be detrimental to purity of thought.

Jazz

It's no coincidence that the name of this musical genre resembles the word "jizz." These words are both variations on terms like "jism," "gism,"

and "jasm," all from the 1800s, and all of which not only referred to semen but also carried senses like "vitality," "energy" and "spirit," both in a general sense and in a sexually empowered and vivacious sense. But this vitality isn't always masculine, despite the connection to semen: "Gism" is recorded in the late 1800s meaning "virility," but "jasm," which is recorded in the 1860s, specifically described energy and sexual vitality in women.

This may not come as a surprise, given the sheer sexiness of jazz music's sound, as well as its role as a means of artistic self-expression in Black American history. Yet, despite the connection between all of these words, "jazz" didn't begin specifically as a sexy word. Its first recorded use is in phrases such "jazz [something] up," which was originally baseball slang.

According to jazz scholar Dr. Lewis Porter, the word was first used to describe music in 1915. Ragtime musicians, especially pioneers such as Jelly Roll Morton, are credited as the first jazz artists, but the use of the word "jazz" to describe them was retroactive. The word was first applied by Chicagoan fans to New Orleans trombonist Tom "Red" Brown's band, and later the name was extended to the preceding artists.

Pollution

If a time traveler from before the 1850s arrived and heard people talking about pollution, they'd have a very strange idea of what exactly was clogging up the waterways. That's because in the 14th century, long before it was associated with environmental contamination, the word "pollution" meant "semen," specifically semen released via masturbation. Later, it was extended to any sort of defilement or the act of profaning something— much in the same way many religious figures preached that masturbation was profane or an act of self-defilement. The word literally means "to smear before," from the Latin *polluere* (made up of a variation on *pro-* and *leuere* "to smear") (*see* masturbate).

Sinus

Although today "sinuses" is used to refer to those passages in the nose and ears and face that plug up every springtime when things bloom, the meaning of the Latin *sinus* was much broader, referring to any fold, bend,

or curve—of the body, of cloth, of the land (as in a bay or gulf), and of much more besides. In particular, the word often referred to the folds of cloth that swagged about the chest in Roman-style clothing, which meant that it was colloquially used to refer to boobs, as well as emotions associated with love, affection, and intimacy.

Vanilla

The word "vanilla" is originally from the Latin *vagina*. (No wonder they're both so fun to lick.) In Latin, the word most commonly meant the sheath, husk, or hull of a seed, plant or ear of grain. It entered Spanish as *vaina*, "sheath," whose diminutive is *vainilla*—so a vanilla plant or bean is a "little pod or sheath" (*see* vagina).

Therefore it's a bit counterintuitive that "vanilla" today can be used to describe the simplest or most basic version of something, especially sex and unmodded video games. This usage would have made no sense to 16th-century European imperialists, for whom vanilla and chocolate from Central and South America were a delicacy. This "basic" sense is a solidly 20th-century development, when vanilla had long been a fixture of ice cream shops.

Nasty

This word is thought to be a shortened form of the Old French *villenastre*, which adds a pejorative Latin ending onto "villain" (*see* villain). Alternatively, it may be related to words such as the Dutch *nestig*, meaning "dirty" or literally "like a bird's nest." The word originally referred to anything foul, filthy, or dirty, either physically or spiritually—a sense that later extended to moral filth in the sense of something indecent.

Naughty

You probably know that the word "naught" means "nothing." So naughty means "nothing-y"?

Well, yes! And for a couple of interesting reasons.

Naughty is from the Old English *nawiht,* literally "no wight." *Wight* was used to mean "creature" (which J. R. R. Tolkien evoked with his "barrow-wights" in *The Lord of the Rings*) but it could also generally mean any "thing." Thus, "naught" is literally an older way of saying "no thing," or "nothing."

In the 14th century, the word "naughty" was more literal. It meant "needy" and described people who had nothing. Around the same time, the word "naught" was also a word for an evil act, likely based on the idea that someone who is evil is lacking in goodness and morality. Indeed, long have theologians argued that wickedness is simply an absence of good, much as darkness is an absence of light.

So today's sense of "naughty" is closer to "naught" and its evocation of moral bankruptcy.

But there's an element of class bias here as well, based on the assumption that someone who has nothing is prone to criminal acts— or has somehow even earned an impoverished lot in life because they are morally undeserving.

We also see something similar with today's use of the word "basic" as a negative judgment. It's not specifically classist, but is used pejoratively or as a judgment of another person's "ordinary" behavior. Indeed, the word "ornery" is a contraction of "ordinary" and implies someone whose behavior is supposedly "low-class."

Orgasm

This word is ultimately from the Greek *orgasmos,* which means "excitement" or "swelling" and was used in contexts such as animals in heat or ripening fruit, both of which are common in imagery connected with human sexuality and horniness. When it began to appear in English in the 17th and 18th centuries, it most often described women's orgasms, which were the frequent subject of both lewd works of poetry and diction and medical writings:

> The Venereal Orgasm is a strong sensation of pleasure, in
> the clitoris, extended through the organs of generation, and

communicated to the whole frame, exciting in it tension, and spasm, and attended with:

1. Turgescence, redness, and heat in the organs.
2. A spasmodic contraction of them, particularly of the fimbriae, upon the ovaria.
3. A sudden evacuation of mucus, called emission, from the glands of the external parts, vagina, and cervix uteri.
4. Generally, with the reception of the semen masculinum into the womb, and probably with its communication to the ovaria, in fruitful coitions.

Edward Foster, *The Principles and Practice of Midwifery*, 1781

Many physicians attested that women needed to climax in order to conceive—a reflection of Galen's model of reproduction, which suggested that both male and female "seed" mixed as a necessary part of the process.

On the plus side for women of the period, this meant that physicians recommended that women orgasm for their mental health. On the other hand, it was also thought that if a woman—especially a lascivious one—did not orgasm frequently, her build-up of "female seed" might drive her to "frenzy" (*see* hysteria).

Because of retention of the sexual fluid, the heart and surrounding areas are enveloped in a morbid and moist exudation: this is especially true of the more lascivious females, inclined to venery, passionate women who are most eager to experience physical pleasure. [...] the man's strong and vigorous intercourse alleviated the frenzy.

Abraham Zacutus Lusitanus, *Zacuti Lusitani Praxis medica admiranda*, 1637

Around the same time, "orgasm" was also used to refer to other violent or abrupt bodily or emotional functions:

[Among] the most famous Physicians, […] 'tis their constant Opinion that Humours ought to be purged in the Orgasm, though they be never so crude.

>1722 essay on bleeding and purging in the
>treatment of diseases

Related: The French phase *la petite mort* is recorded as early as the 16th century, first in reference to fainting spells, then it was extended to its current use as a euphemism for an orgasm, perhaps initially as a reference to the headiness of climax or the moments following.

Orgy

This word's origins are far more mundane than its modern usage: It comes from the Greek *orgia*, which simply means "secret rites" and is thought to come from the same root as *ergon*, meaning "work." Its association with sexy celebrations was thanks to rites and licentious revelries dedicated to Dionysus—though it didn't show up in English until the 1600s, when a look back at the Classics unearthed this gem and gave it new meaning.

Perverted

Words like "pervert," "perverted," and "perverse" are derived from the Latin *perversus*, meaning "turned away" or "askew," suggesting turning away from a moral path. Its verb form, *pervertere*, meant "to corrupt."

In Old English, the word *forcerred* (also literally "turned away") meant the same thing as "perverse."

Until the 1800s, "pervert" and "perverted" weren't specifically sexual, but more generally meant "corrupt," "wicked," or "immoral."

Pornography

The Greek elements of this word give it the literal meaning "to write about prostitutes," though even in Greek *pornographos* generally refers to images rather than words. Either way, sex workers are key to this

word. The Greek *pornē* was a word for a prostitute (and a *porneion* was where you went to purchase time with one), though this sense is euphemistic because it literally means "bought" or "purchased."

Although the Greeks are known in the art world for their elegant depictions of nudity, there were also several notable and enthusiastic *pornographoi* (pornographic illustrators) among their ranks—including, apparently, otherwise respectable artists like Parrhasius and Aristides of Thebes. But, in general, while the Greeks were a bit scandalized by full-blown horny art, the Romans really ran with it and generated an absolute mountain of porn that is still enjoyable to this day (though, of course, many of even the most innocuous nude sculptures were subject to "The Great Castration" by Pope Pius IX in 1857).

Still, it's truly remarkable just how *much* porn the Romans produced. Brothels were a key part of Roman life—they were even legal and taxed like any other business, though sex workers themselves were not treated so generously—and on the walls of many of them can still be found vestiges of horny art to help set the mood. But it didn't stop there: Romans frescoed erotic art on the walls of public baths, in temples dedicated to the gods known for partying (e.g., Bacchus), and even in their private homes.

⟡ A Pornocracy for the Ages

Ever heard of the tenth-century *senatrix* (female senator) Theodora and her daughter Marozia? They exercised immense influence upon the Roman government and the papacy for almost 500 years.

Theodora was described by contemporary historian Liutprand of Cremona as a "shameless harlot [… who] exercised power on the Roman citizenry like a man."

Theodora strategically positioned one of her daughters, Marozia—also a *senatrix* and *patricia* of Rome—to become the mistress of Pope Sergius III. This ultimately resulted in their son becoming Pope John XI after Marozia helped depose and arrest her political opponent, Pope John X. After that, two of

Marozia's grandsons, two great-grandsons, and one great-great grandson also became pope.

Eighteenth-century historian Edward Gibbon—who was famously unsuccessful in the romance department—described Theodora and Marozia's influence over these generations of popes as a "pornocracy," literally "rule by harlots/whores."

———

Promiscuous

This word originally had nothing to do with sexual activity but instead described people and things that were jumbled, confused, mixed up, or disordered. It's originally from the Latin *promiscuus*, meaning "mixed, indiscriminate" (*pro-* "toward" + *miscere* "to mix").

This sense persisted from the 1600s to the mid-1800s, when that "indiscriminate" and "mixed" sense began to suggest mixing indiscriminately with more than one person.

Prostitute

This word, which entered English in the 1500s, is from the Latin verb *prostituere*, which literally means "to place or stand in front of" (*pro* "before, in front of" + *statuere* "stand, establish") but was most commonly used to mean "expose publicly" and therefore also implied to make oneself exposed or available to sex work.

Today, due to its often pejorative and gendered usages throughout history, as well as its association with trafficking and pimping, "sex worker" is considered a more neutral term for people in related professions.

☞ The Social Evil

In the 1800s, the term "social evil" was a euphemism for sex work and the venereal diseases, abortions, and other medical issues that sometimes resulted from it (and, importantly, from the way in which sex workers were marginalized). Sex workers were treated at what became known as "social evil

hospitals" (also called "porniatria" in at least one medical journal), which have a dark history.

In 1870, St. Louis, Missouri, famously instituted what became known as the "Social Evil Law," which made prostitution legal in the city and licensed brothels and sex workers as legitimate businesses, in part to reduce the spread of venereal diseases. Given the stigma surrounding sex work at the time, you may be unsurprised to find that this law was repealed after just four years, but during that time the infamous Social Evil Hospital opened to treat women sex workers—because, of course, this law was created under the stubbornly blinkered assumption that all prostitutes are women—and a House of Industry where they received questionably moral reeducation and other vocational training. The Social Evil Hospital was later renamed the Female Hospital before it was razed and converted into what is now Sublette Park.

Pussy

Did "pussy" originally refer to cats or to pudenda?

Maybe both—although the earliest sense of a word spelled this way was the adjective meaning "full of pus." But that's more of a homonym and has little to do with the other senses.

The oldest meaning of the word that you're thinking of, according to the written record, was that of a small, furry animal—a cat or even a rabbit, first recorded in the early 1500s. As far as cats are concerned, it's thought to initially be an imitative word for the "pspsps" sound used to call cats in many languages, which in turn is perhaps imitative of a cat's hissing.

After that, the term was used metaphorically to link women and girls to cats starting in the early 1600s. The connection between cats and women in this word, as well as terms such as "catty" and "cat fight" appears to have the same rationale as pet names for lovers and children, but with added lewdness: Cats are small, soft, and cute, and—perhaps relevantly—females are known for having

quite loud sex when in heat. As such, "pussy" spent a century or two attempting to decide whether it was a compliment (implying "small and cute") or an insult (implying "unpleasantly catlike" in personality or sexual behavior). It's also recorded in the 18th century as an insult for effeminate or gay men due to that association with femininity.

The point at which it became a word for genitalia is unclear. It was certainly in use by the 1800s, but this sense may have been much, much older—even older than that of cats, rabbits, and catlike women—because the Old Norse *puss* meant "pocket" or "pouch," which ultimately also gave us the early 20th-century American word "puss" as a term for the face and lips (also seen in the term "sourpuss" for someone with a bad attitude). Puns from the 1600s and earlier also seem to indicate that this sense was known in casual contexts.

Many armchair etymologists have speculated that "pussy" is somehow linked to the temptingly similar term "pusillanimous." This is a myth: The two words are unrelated. Much like the English word, the Late Latin *pusillanimis* meant "cowardly" or "weak-spirited" (*pusillis* "weak, little" + *animus* "spirit, courage"). "Pusillanimous" is recorded in English as early as the 1500s, but much like today, this word was not well known or used outside of academia and literature. Evidence suggests that the Germanic/Old Norse sense of *puss* is far more likely to have given us "pussy" than these Latinate terms for weak people—which is, in a way, a somewhat refreshing departure from misogynistic language that associates weakness with femininity.

Randy

This word is most likely from the Scottish *rand*, meaning to "rave," which is another form of the word "rant." Initially, "rant" did not hold as much of today's negative connotation but implied raucous, boisterous speech and behavior. It took on its more pejorative edge as that behavior became associated with beggars, vagrants, and women who misbehave in such egregious ways as having fun, making noise, and speaking their mind—naturally behavior associated with fallen women such as prostitutes.

Raunchy

In its first recorded uses, this word was decidedly unsexy. It first meant "sloppy," "careless," or "dirty"—as in actual dirt, not sexy dirt, though, of course, words like "dirty" and "filthy" have extended to sexy things in much the same way "raunchy" has been. It's a pretty recent term, first appearing in the 20th century, and it's thought to be an adaptation of the Mexican Spanish *rancho* ("ranch"), which, before it was associated with cowboy chic, simply referred to a dirty collection of huts for herders and laborers. Its dirtier sense arose around the 1960s, after Hollywood Westerns made ordering a bunch of cows around sexy for cinephiles.

Romance

When it first entered English in the 13th or 14th century, this word had only a tangential connection to love and sex. Its first sense in English was that of a hero's journey, especially a knight's. This sense and the word in general came to English from the Old French *romanz*, meaning "verse narrative," but it had a secondary meaning: "the vulgar or vernacular language." In that context it first referred to writing in a Romance (Latin-derived) language, or "in the Roman style."

The shift from "Roman-style" writing to chivalric tales was due to the medieval-era popularity of stories about extraordinary journeys and heroism shared among common people, in contrast to more dry, religious, legal, and generally less fanciful Latin texts. That is, the stories of the Roman populace rather than Latin formal writings and speech.

Because heroic tales often involved knights earning the love of fair ladies and generally showing courtly manners and morals, the term "romance" began in the 17th century to refer to love stories. From there, the typical love story narrative structure became a fixture of poetry and prose, and evolved into its own genre. Still, we retain the "Roman" sense in phrases such as the Romance languages.

Scatological

This word, now describing anything related to feces and often implying a sexual or obsessive interest in it, is from the Greek *skatos* "pertaining

to excrement" and the English element -logy, "study," giving it the literal meaning "study of excrement." This definition aligns especially with its original meanings: Starting in the 1870s it was primarily a word for obscene literature (fecal-focused or otherwise), but was also recorded more literally referring to the science of fossilized dung.

THE VIRGINITY GAP: A THOUGHT EXPERIMENT

The term "lexical gap" refers to an instance in which a language lacks a word for a concept that is hypothetically allowable by the grammatical rules of the language.

Why bring this up now? Because there is no specific, singular English noun for someone who is not a virgin.

Now obviously the concept of virginity is a complete social construct. People are not fundamentally altered by the mere union of their naughty bits with someone else's. But if we're going to persist in using the word "virgin," and the concept of virginity is going to remain a thing, what word would you use for any non-virgin, regardless of how much sex they've had?

There are many words to describe people with an extensive amount of sexual experience, some derogatory (whore, slut, lecher, harlot), some congratulatory (playboy/girl, stud, casanova, dynamo), some in between (rake, libertine). So after the first time you have sex, what do you become? Boinkt? Copulist? Sexateur? Fucker?

Screw(ing)

The sexual sense of the word "screw" is thought to be from the Latin *scrobis*, meaning a groove, ditch, or trench, and therefore also a vagina. Alternatively, it may come from the Latin *scrofa*, meaning "breeding sow" or literally "digger, rooter" because of the holes they dig when

rooting. It was a noun for much of its lifetime; its use as a verb for having sex is a 20th-century development. That said, it wasn't a leap: Prostitutes were called "screws" in 18th-century cant.

Seduce

This word originally had little to do with sex, but rather with feudal politics and betrayal. The Latin verb *seducere* was the act of persuading a servant, a lord, or other person of power to abandon their current allegiances and take up with someone else. Its components (*se-* "aside, away" + *ducere* "to lead") give it the literal meaning "to lead away." The sexual sense arose in the 16th century, originally with the specific meaning of persuading a virgin woman to have sex and therefore abandon her chaste allegiance to God.

Sex

This word was first used in its genital assignment sense in the 14th century, well before it was applied to the act of copulation. It's thought to be from the Latin *secare*, meaning "to divide or cut," which would connect it to words like "section" and "sect" and imply a division between the male and female sexes.

If you ever come across the term "the sex" in literature from the 16th and 17th centuries, it's probably referring to women as a whole, based on the same notion as women being "the fairer sex."

The more fun and less binary term "have sex," as in intercourse, is surprisingly recent: It's not recorded until the early 1900s (i.e., to "have sex" is to unite the two sexes), followed closely by the coinage of the adjective "sexy."

Skullduggery

Today this word refers to any unscrupulous or trickstery behavior, but it was once more specific. It's a corruption of the 18th-century Scottish word *sculdudrie*, meaning "adultery," or, a bit later, anything obscene or bawdy. It's thought to be a euphemism, but the word's literal meaning is unknown.

Smut

This word, which originally referred to a literal stain in English, is from a Germanic root meaning "grease" or "dirt." It became associated with indecency and obscene writings and art in the 1600s.

Virgin

This word's meaning was originally a bit more specific than it currently is (someone who has never had sex). In 12th-century English, virgins were more Mary-like:They were unmarried or chaste women who were known for their piety and therefore had a degree of power in the church. However, by the 1300s, "virgin" had become more general and taken on today's meaning. Its etymological predecessors, however, already held that sense.The word comes from the Latin *virginem*, which meant "fresh" or (creepily) "unused" as an adjective and also referred to an unwedded girl or woman who has not had sex. "Virgin" is cognate with "Virgo," the star sign represented by Astraea, the Greek virgin goddess of justice, innocence, purity, and precision who was the last immortal to leave Earth when the gods fled to Olympus during the Greeks' Golden Age of Man.

Wanton

This word, which most often appears as an adjective describing hopelessly lascivious people (especially women) today, has also, at various points in its history, been a noun for said people, as well as a verb expressing the frolicsome revelry of such a person.

It was originally a Middle English compound word: *wan-towen*. The "wan" element means "wanting" or "lacking," while the *towen* element is a past participle meaning "trained" or "disciplined."

To be wanton is fairly simply to be "undisciplined" or otherwise a bit feral.

Gender Identity, Sexuality, and Romantic Preferences

Although the following terms are not inherently sexual today, and simply straightforwardly describe gender and preference, they each come with a complicated history that is deeply entangled with sexuality and bias—and worth examining for their problems and power dynamics.

Cis and Trans

In the word "cisgender," the prefix is a Latin preposition meaning "on this side," and it is the opposite of the preposition "trans," which means across or "on the other side."

Obviously, we use trans- as a prefix in a ton of words, like transport, "to carry across"; translucent, literally "to shine through to the other side of"; and transcontinental.

Prior to the term "transgender," and starting around 1910, many trans people were described using the term "transvestite," which obviously is inaccurate because it only implies gender norms in terms of dress, which is stupid and subjective anyway. The term "transsexual" came next, coined in 1953 by German American sexologist Harry Benjamin (1885–1986), who was one of the first physicians to take gender identity preferences and gender dysphoria seriously. The first recorded appearance of the term "transgender" was actually in U.S. magazine *TV Guide* in 1970, in an article discussing the film adaptation of Gore Vidal's novel *Myra Breckinridge* (1968), which is about a transwoman. Previous instances had described her as "transsexual."

Cis does not often appear in other English words, but there are a few: "Cisalpine," for example, is recorded as early as the 1540s, and it means "south of the Alps"—literally "on this side of the Alps" if you're Italian.

"Cisgender" first appeared in psychological journals in the 1990s, and the use of the prefix is attributed to German sexologist Volkmar Sigusch (1940–2023), who used the term "cissexual" (*zissexuell* in German) as the opposite of the term "transsexual." That second term is a bit charged now, but it was the earlier term,

appearing in the 1950s, and in the early 1990s it was still more common than the word "transgender" in discourse around gender identity. The article, "Transsexuals and Our Nosomorphic View" (where "nosomorphic" literally means "disease-shaped") aimed to dispel the misconception that identifying as transgender is a mental illness.*

And then, in 2009, an article by Kristen Schilt and Laurel Westbrook more formally firmed up and popularized the use of the words "cis" and "cisgender."

Due to its literal meaning, some people have critiqued the use of the word "cisgender" for being heteronormative. Generally speaking, we tend to lack terms for heterosexual and cisgender people that don't convey some sense of the default or the norm.

After all, gender identity is far more complicated than being on one side or another, and the word "cisgender" was set up as a deliberate opposite of the term "transgender." It was generally well intended, however, because, at the time the term surfaced, many people were still unfamiliar with the idea of gender identity as a spectrum, rather than simply being transgender or not transgender.

Drag

The use of this term, originally in reference to men in opulent women's clothing, is thought to derive from the idea of long (and fabulous) skirts trailing on the floor, and was probably first used in the context of theater performers—a sense, of course, that is retained in the drag shows of today. Today, most drag queens agree that "drag is for everyone," so the gender identity of the person in the outfits is less important than the glamor of their typically over-the-top feminine-inspired outfits. The term "drag king" has also been applied to people who dress in exaggeratedly masculine clothing in similarly performative contexts.

* V. Sigusch, "Die Transsexuellen und unser nosomorpher Blick" [Transsexuals and our nosomorphic view]. *Zeitschrift für Sexualforschung* 4 (1991), 225–56 and 309–43.

Gay

What a ride this word has been on. It's no secret that the earliest sense of the word, which was borrowed from the Old French *gai* of the same meaning, was pure merriment and happiness. Although it first entered English as a name (also implying someone pleasant and charming) as early as the 12th century, as an adjective it's first recorded some 200 years later. From its role in describing scintillating personalities it shone into other, related senses, recorded as a word for opulence, vividness, and elegance in dress and decoration.

It was this over-the-top sense, which stuck around for the next few centuries, that first took it into romantic and sexual preference—and, at the same time, gave it a sense of immorality—but first in a gender-nonspecific way: From at least the 1600s to the 1800s, "gay" could suggest overindulgence and promiscuity of any kind. Indeed, the term "gay house" was a euphemism for a brothel.

In the 1800s, the term took on a slangy or euphemistic connotation for men who prefer men in connection to gentlemen's culture. (The usual term, both as a pejorative and more generally, in the 1700s and early 1800s was the noun "molly," from a pejorative sense of the Latin *mollis* intended to mean "soft, effeminate, unmanly, or weak.") It was solidified in common parlance due to its use amid the rise of psychological studies of sexual preferences in the late 19th to early 20th centuries, as well as the earlier slang term "gay cat," a word for a young vagrant man who was new to the tramp or hobo lifestyle and often the subject of abuse by more experienced tramps and hobos—and was associated (correctly or not) with homosexuality. This, along with connotations of prostitution (especially but not always specifically regarding male prostitutes) through the 18th and 19th centuries, secured it as both a word for men who prefer men and as a pejorative.

"Gay" reclaimed its joy, glamor, and power, while, of course, retaining its association with homosexuality and broadening its application to encompass lesbian women in some cases, with the rise of the Pride movement, whose beginning is typically considered to be June 1969 following the Stonewall Riots. The term "queer" has, in the past decade or so, become a more common and neutral term for people in LGBTQIA+ communities.

Its brief stint as a basic term of disapproval without direct reference to romantic and sexual preference—for example in the phrase "That's gay"—is a recent invention, not appearing until the past few decades, and hopefully on its way to fading into memory given its insinuation that being gay isn't a wonderful thing.

Incel

The "incel," or "involuntary celibate" online subculture is dominated by men today, but was initiated in 1993 by a woman, known only by her first name Alana, when she created a website called "Alana's Involuntary Celibacy Project," which became a community for "anybody of any gender who was lonely, had never had sex or who hadn't had a relationship in a long time" due to marginalization, social discomfort, or mental health struggles. The community used the abbreviation INVCEL, which became "incel." Alana left the community she had created in 2000, and since then the culture around self-identified incels has devolved from an inclusive support community to one known for its rampant misogyny, with large groups on 4chan and Reddit, some of which have been banned but have resurfaced elsewhere.

The resulting echo chambers have encouraged online abuse and even encouraged physical violence against women, culminating in a mass killing in 2014, when 22-year-old, self-described incel Elliot Rodger killed six people and injured 14 others at a sorority house in a misogynistically motivated mass shooting. "Like a scientist who invented something that ended up being a weapon of war, I can't uninvent this word, nor restrict it to the nicer people who need it," Alana wrote on a private weblog following the shooting.*

Lesbian

As is commonly known, this term for women who prefer women draws its name from the Greek island Lesbos, whose name probably

* Cited in Peter Baker, "The woman who accidentally started the incel movement," *Elle*, March 1, 2016.

means "wooded," and which was famously home to Sappho (ca. 630–ca. 570 BCE), the erotic and romantic poet known for writing fondly about both men and women as lovers. The application of the term to love and sexual attraction between women came about retroactively, in the 1700s, though "Lesbian" was recorded with connotations of amorousness prior to that. It's recorded in English as early as the 1500s and 1600s, though primarily in reference to law and morality: In ancient times on the island of Lesbos, masons would use pliable lead measuring tools referred to later as a "lesbian rule," and, because it was pliable, it was figuratively extended to overly flexible regulations and morals. For better or worse, perhaps due to the voyeuristic interest of some men in women–women relationships, the term "lesbian" hasn't endured the same degree of weaponization that the term "gay" has—though it has certainly been used pejoratively in its lifetime by the less tolerant.

Queer

This term is from Germanic words meaning "off-center" or "oblique" and carried much the same meaning until fairly recent history. It has, however, been extended figuratively to anything or anyone strange, odd, or eccentric since at least the 1500s.

It was first used to describe gender identity and sexual orientation in the 1920s. Although this sense was at first pejorative and often a slur—basically saying that non-heterosexual people were strange—the LGBTQIA+ community reclaimed and reappropriated it as an empowering, community-focused term in the latter half of the 20th century. Its senses can be more specific, as in the term "genderqueer," or more broadly, as an all-encompassing adjective describing someone who identifies as part of an LGBTQIA+ community. It can, of course, still be used pejoratively, a sense that often manifests when the word is used as a noun rather than an adjective, but the degree of hurt or violence it's meant to cause has probably more to do with context than grammar.

Straight

The use of this word to refer to sexual orientation arose between the 1920s and the 1940s, right around the same time as the word

"queer" (*see* queer) and, in a literal sense, stands in perpetual contrast to queer's original sense of being off-center or oblique.

However, "straight" as a descriptor for sexual preference is predictably from the long-held assumption that heterosexuality corresponded with morality. Its usage is thought to be influenced by the phrase "the straight and narrow," which is an interpretation of Matthew 7:14 KJV:

> Because strait is the gate, and narrow is the way, which leadeth unto life, and few there be that find it.

… an incorrect interpretation, given that the word in that verse is actually "strait," not "straight." In addition to being a word for a geographic feature, a "strait" is any narrow space, from the Old French *estrait*, "narrow part, pass." So, in a sense, given the phrases it's derived from, "straight" somewhat appropriately implies "narrow" more than it does "upright" or "unbent."

⌖ More Terms for Sexual Preference

Asexual: Greek *a-* "not," no attraction to others

Allosexual: Greek *allo-* "other," a contrasting counterpart to "asexual" suggesting sexual attraction to any other person

Androsexual: Greek *andro-* "male, man," attraction to men and masculinity

Autosexual/autoromantic: Greek *auto-*, "self, same," attraction to themself or prefers masturbation over sex with a partner

Bicurious, Bisexual, and Biromantic: Latin *bi-* "two, twice," sexual or romantic attraction to both men and women

Cupiosexual: Latin *cupere* "to desire" (related to Cupid), potential interest in a sexual relationship even without attraction to a partner

Demisexual and demiromantic: Greek *demi-* "half," no sexual attraction to others without a close personal bond

Fluid: Latin *fluere* "to flow," in the context of sex and gender, people who may shift in their preferences, attractions, or identities depending on social context and other factors

Gynesexual: Greek *gynē* "woman, female," in contrast to androsexual, attraction to femininity and women

Heterosexual: Greek *heteros* "the other (of two)," attraction to people of the opposite sex

Homosexual: Greek *homos* "one and the same," attraction to people of the same sex

Monosexual: Greek *monos* "single, alone," attraction to people of only one gender or sex

Omnisexual: Latin *omnis* "all, every, the whole, of every kind," attraction to all or many forms of sexuality and sexual expression and to more than one gender identity, distinguished from pansexuality by the recognition of the gender of potential partners

Pansexual and panromantic: Greek *pan-* "all," attraction to all people of any gender identity, or sexual preference, distinguished from omnisexuality by universal attraction without gender as a consideration

Polysexual and polyamorous: Greek *polys* "much, many," attraction to multiple different sexualities and gender identities and with a preference toward relationships with more than one person at a time

Pomosexual: literally "postmodern sexual," descriptor for someone who prefers not to identify with other sexual orientation labels

Skoliosexual: Greek *skolios* "curved, bent," potentially problematic term for attraction to people who are transgender or nonbinary

Spectrasexual: Latin *spectrum*, attraction to a spectrum of sexes, genders, and gender identities

———

CHAPTER 4

WORDS THAT HURT

THE ART OF INSULTS

English is a great language for verbal evisceration, a practice predicated upon a long history of creativity in this arena. Poetry, theater, novels, and, of course, politics have made rich, recurring and visionary use of put-downs, mockery, and derision.

The word "insult" itself is cognate with "assault," with both tracing back to the Latin *salire*, "to leap." Both mean "to leap at," but in Latin *insultare* was used both as a word for a physical assault and for a verbal one.

Insults can, of course, very well resemble verbal assault. In the U.S., the Federal Communications Commission (FCC) prohibits "personal attacks" during broadcasts of "controversial issues of public importance." A personal attack in this context is defined as "an attack [...] made upon the honesty, character, integrity or like personal qualities of an identified person or group."*

These rules arose in the context of political debates in which candidates resorted to *ad hominem* arguments—that is, attacking an opponent's character rather than discussing core issues.

But in addition to their role in oppositional relationships, insults can be all in good fun, featuring in friendlier (albeit playfully combative) relationships. Indeed, they've played an integral part in poetic and playful debate for much of the history of the English language.

Let's start with a few types of insults, and then launch into some of the more entertaining terms of abuse themselves.

English writer and literary critic George Puttenham (ca. 1529–90) dissected many types of rhetoric, including dozens of ways of

* "Program Content Regulations," U.S. Federal Communications Commission. www.fcc.gov/media/program-content-regulations

communicating disdain, sarcasm, and mockery, in *The Arte of English Poesie* (1589). A few of the more entertaining varieties, with both their Greek-derived literary names and their more straightforward names, include:

Asteismus ("witty dialogue"), or the merry scoff, or civil jest: "when we speake by manner of pleasantery, or mery skoffe, that is by a kind of mock, whereof the sence is farreset, & without any gall or offence."

Charientismus ("expression of a disagreeable thing agreeably"), or the privy nip: "when ye giue a mocke vnder smooth and lowly wordes as he that hard one call him all to nought and say, thou art sure to be hanged ere thou dye."

Ironia ("irony, dissimulation"), or the dry mock: "as he that said to a bragging Ruffian, that threatened he would kill and slay, no doubt you are a good man of your hands."

Micterismus (literally meaning "a turning up of the nose"), or the "fleering frump": "when we giue a mocke with a scornefull countenance as in some smiling sort looking aside or by drawing the lippe awry, or shrinking vp the nose."

Sarcasmus ("sarcasm," literally meaning "to strip off the flesh"), or the bitter taunt: "when we deride with a certaine seueritie [… for example] I haue gone a hunting many times, yet neuer tooke I such a swine before."

Really, anything can be an insult.

Pretty much any word, gesture, phrase, or sound can be construed as an insult, or convey "an Insult Signal" under the right—er, wrong—circumstances, according to scholar Desmond Morris, who is primarily a zoologist but also publishes books about human sociobiology.

These "Insult Signals" fall into ten categories—ones that convey: "uninterest," "boredom," "impatience," "superiority," "deformed compliments," "mock-discomfort," "rejection," "mockery," and "symbolic signals."

In *The Naked Ape* (1967), Morris writes that, compared to animals, "the range and diversity of [humans'] derogatory signals are enormous—and that is even before we have begun to open our mouths."

He discusses the way posture, hand gestures, and subtle facial movements can convey each of those ten negative interaction signals, from Amy Cuddy–style "power posing" and ignoring handshakes to sneering, as well as gestures (which may have different meanings—or no meaning at all—depending on the culture in which one finds oneself). For example, "In France, the actions of playing an imaginary flute indicate that someone's talking is going on and on and is becoming tiresome. A more widespread version of this is the 'yakity-yak' gesture in which the hand opens and shuts like a gabbling mouth."

The Sport of Flyting

Presumably, if you're reading this book, you have a working knowledge of some Shakespearean basics—among them the particularly clever and *extensive* collection of insults from the Bard's plays.

The noble tradition of eviscerating one's friends and enemies with wordplay—also known as "flyting" (from the Old English *flitan*, "to quarrel") is a storied one in English. Flyting, earlier simply a word for an argument, refers to a poetic war of words or entertaining debate in which the two contestants attempt to "out-bard" each other, so to speak. (It's in some ways the predecessor to a rap battle.) The humor is often crude and escalates into rhythmic strings of insults.

Although it's thought to date back much farther, the recorded history of flyting begins in Scotland with *The Flyting of Dunbar and Kennedie*, which is thought to have been published around the year 1500 and details one such face-off between the court poet (makar) William Dunbar (ca. 1449–died by 1530) and the parson and poet Walter Kennedy (ca. 1455 – ca. 1508):

> Cursed croaping crow, I shall gar crop thy tongue croaking
> And thou shall cry cor mundum on thy knees.
> Durch, I shall ding thee till thou dryte and dung,
> And thou shall lick thy lips and swear thou liest.

Similarly, Old Norse Eddic poetry celebrated the exchange of insults with the form known as *senna*. A commonly cited example of an

insult in *senna* was a combatant describing the words of his opponent as "the mud of the old eagle"—basically, eagle shit, which is also a reference to a poetic myth in which Odin takes the form of an eagle and shits out "the mead of the rhymesters."

Shakespeare's plays boast an extensive, iconic, and often wildly entertaining collection of insults, often delivered in the same spirit (and with the same degree of punishing wit) as the practice of flyting. For just a few examples:

Thou sodden-witted lord! Thou hast no more brain than
I have in mine elbows!
Troilus and Cressida, Act 2, Scene 1, lines 33–4

Out of my sight! thou dost infect my eyes.
Richard III, Act 1, Scene 2, line 150

'Sblood, you starveling, you elf-skin,
you dried neat's tongue, you bull's pizzle, you
stock-fish! O for breath to utter what is like
thee! you tailor's-yard, you sheath, you bowcase,
you vile standing-tuck.
Henry IV Part 1, Act 2, Scene 4, lines 226–9

You scullion! You rampallian! You fustilarian! I'll tickle your catastrophe!
Henry IV Part 2, Act 2, Scene 1, line 60

ᴄ͢ More Shakespearean Abuse

Consider these Shakespearean phrases to hurl at your friends, enemies, and frenemies:

crusty batch of nature	bloody, bawdy villain
ragged wart	hateful wither'd hag
dissembling harlot	sanguine coward
three-inch fool	huge hill of flesh

rampallian

fustilarian

scurvy companion

trunk of humours

bolting-hutch of beastliness

swollen parcel of dropsies

huge bombard of sack

stuffed cloak-bag of guts

father ruffian

fat as butter

loathsome as a toad

cream faced loon

clay-brained guts

knotty-pated fool

whoreson obscene

greasy tallow-catch

damned and luxurious moun-
tain goat

lump of foul deformity

poisonous bunch-back'd toad

poor, base, rascally, cheating
lack-linen mate

the rankest compound of
villainous smell that ever
offended nostril

loathed issue of thy father's
loins

rag of honour

eater of broken meats

———

Words for Insults and Attitude

Aspersion

Often "cast," these attacks upon someone's reputation were originally called *aspercions* and belonged to the realm of theology, referring to the blood of Christ shed during the crucifixion. The Latin predecessor *aspersiomen* means "a sprinkling upon." (The related word "asperges" refers to the sprinkling of holy water upon someone. It is not related to Asperger's syndrome, the developmental disorder, which is named for Austrian psychiatrist Hans Asperger.) "Sprinkling" came to refer to a spattering with slanderous claims—as if casting the blood of Christ upon someone to blame them for the wrongdoing—in the 1500s.

Backhanded Compliments

We call compliments "backhanded" when they are used to disguise an insult (e.g., "Wow, I had no idea you could look so good!"). The phrase is a reference to a slap that is executed with the back of the hand rather than the palm, which is generally thought of as a less

forceful blow—more of an insult than an attempt at injury—and harks back to fictional, dramatic challenges that led to daring duels.

Calumny

This word, which now refers to slander or false accusations, is from the Latin *calumnia*, meaning "trickery" or "subterfuge." Related words in other languages range in meaning from "flattery" to "bewitch," giving today's English word "calumny" the sense that someone seeks to gain an advantage by bewitching or charming others into believing falsehoods about the person they are slandering.

Derogatory

This word's Latin root seems to imply cutting someone off, shutting them down, or rejecting them. It's from *derogare*, meaning "to take away" (*de-* "(take) away" + *rogare* "ask, question"), perhaps suggesting someone seeking an interaction, only to be ignored or rebuffed.

Contempt

The *con-* prefix in this word is thought to function as an intensifier for the Latin *temnere*, which might suggest "cutting." In 14th-century English, the word was first used for insubordination and disobedience—a flouting of laws and authority—but was quickly extended to general scorn. The word *contemptrix* was used for a woman who dislikes someone or something (presumably a suitor, given that its masculine counterpart was found less often).

Disdain

The word "disdain" is, literally and etymologically, an extremely bitchy word. It and its Old French predecessor *desdeigner* literally mean "to treat as unworthy." Its Latin source, *dignus* "worthy," connects it to the word "dignity," and "deign," which today means "to condescend," but was originally a kinder word, meaning "to treat someone with dignity," often despite a lower rank or other power imbalance. It was extended

to accepting something with grace, and therefore treating the presumably lower-ranking gifter or complimenter with grace.

 ## SAYING IT WITHOUT SAYING IT: EUPHEMISMS AND DYSPHEMISMS

You may know that a euphemism is a gentler, less vulgar, or less rude way of phrasing something, from the Greek *euphemismos*, literally "speaking good/well (of something)."

Euphemisms for "dead," for instance, might be "passed away," "departed," "shuffled off one's mortal coil," and so on.

A dysphemism is the opposite of a euphemism, literally "speaking bad or ill (of something)." A dysphemism is an insulting, irreverent, overly casual or mocking way of saying something—and actually, they're much more common than euphemisms.

Dysphemisms for dying, for example, include "croak" and "snuff it."

Many insults are dysphemisms. If you call someone by an animal name to insult them—like calling a cowardly person a "chicken," or a sneaky person a "snake"—that's a dysphemism.

In most cases, curse words are dysphemisms because they are more vulgar variations of other terms.

Pretty much any nonclinical name for your genitals or for sexual activity is a euphemism or a dysphemism. But euphemisms and dysphemisms can be difficult to classify as one or the other because whether you consider them vulgar is often a matter of perspective.

For example, the term "private parts" is pretty clearly a euphemism because it's a rather prudish way of describing them, and "naughty bits" is pretty clearly a dysphemism because it's irreverent and just a tiny bit dirty.

But you could make the case that "nether regions" is either or maybe even both because it's inoffensive but also a little tongue-in-cheek.

In recent years there have been some attempts to help differentiate between levels of dysphemisms through the introduction of the terms "cacophemism" and "malphemism," which both refer to especially derogatory dysphemisms, but in slightly different ways. For example, racist and homophobic slurs might be considered malphemisms because they are inappropriate and insulting.

Some writings about cacophemisms suggest that they're used to intentionally exaggerate in a negative way: For example, a euphemism for someone who is fighting for a cause might be "freedom fighter," especially if you agree with them, while a cacophemism for that same person might be "terrorist."

Ignominy

This word, meaning "public shame," and the adjective "ignominious" literally imply something that is a slight against or to one's name, from the Latin elements *in-* "not" and *nomen* "name."

Libel

Originally a word for any formal or legal writing of any kind, though often a list of charges against a defendant, this word is from the Latin *libellus*, a diminutive of *liber* meaning "little book," suggesting a brief written report or pamphlet. The sense of the word as a list of charges or a written statement of harm extended the word to refer to writing that could damage a person's reputation.

Negging

A neologistic shortening of "(giving) negative feedback," negging is a manipulative, abusive tactic popularized by pickup artists—that is, those who make a sport of "scoring" with as many sexual partners as possible

and who often manipulate the people they target. It is intended to elicit a reaction and prompt the victim's desire for validation.

It may also draw inspiration from the phrase "egging someone on," or encouraging them to do something ill-advised or dangerous. This term is from the Old Norse–derived Middle English word *eggen*, meaning "to incite," which is more closely related to "edge" than to "egg."

Negging can take the form of a backhanded compliment, implying that the victim could improve: "Great improvement on your test score! Maybe next year you'll do as well as me." Or it could be a straightforward insult qualified by justifications such as "brutal honesty," "constructive criticism," or "just joking": "That dress isn't the most flattering—I'm just being honest!"

Outrage

Want to know something outrageous? The word "outrage" isn't etymologically related to the words "out" or "rage." It has completely different roots. It technically does not even contain the words "out" or "rage." In fact, it's not even originally a compound word.

It originally comes from the Latin word *ultraticum*, which meant "excessive." The root is *ultra*, which in Latin means "beyond" or "extremely," just like in English. *Ultra* shares a PIE root with the English word "other," but not with the word "out."

When the Latin word *ultraticum* entered Old French, it became *oltrage*, and then evolved into *outrage*.

So this word isn't "out" plus "rage," it's the French *outre*, plus the noun-forming ending *-age*. That ending is in a lot of other Latin/ French-derived nouns like "postage" and "coverage."

So instead of meaning something that makes you rage, the word "outrage" literally means "ultra-ness" or "the state of being excessive" —something that goes beyond what is normal. And this word in Old French was used to describe, not necessarily things that inspire rage, but anything that was outside the bounds of normal or accepted behavior, like minor criminal activity, or even just acting strange or having a bad attitude.

Of course, if you see the word as an English speaker, it looks and sounds like "out-rage," or something that makes you outwardly express rage.

But you'll notice that sometimes when people call something "outrageous" or "an outrage," the French and Latin sense still emerges.

For example, when someone is wearing an "outrageous" outfit, it's not one that makes you rage. It's one that's wild and colorful, outside the norm of everyday fashion.

And even when someone says, "This is an outrage!" They usually mean that they are indignant at the situation, but not necessarily to the extent that they want to smash up the place—more that they are inspired to make a very impassioned speech.

Sarcastic and Sardonic

Sarcastic and sardonic are similar, but not precisely the same, in meaning:

sarcastic: "a sharp and often satirical or ironic utterance designed to cut or give pain."[*]
sardonic: "disdainfully or skeptically humorous : derisively mocking."[†]

The core factor in sarcasm is verbal irony—essentially saying the opposite of what you mean. Sardonic language overlaps but tends to be harsher and more scornful and may not necessarily be marked by irony. (Think "Oh, you're *so* pretty" vs. sneering laughter at someone's appearance.)

Regardless, both of them have interesting origins:

"Sarcastic" comes to English in the 1500s from the Late Latin *sarcasmus*, which in turn came from the Greek *sarkasmos*, meaning "a sneer, jest, taunt, mockery." But even earlier was the Greek *sarkazein*, which literally meant "to strip off the flesh" (with the word *sarx*

[*] "Sarcasm." *Merriam-Webster.com Dictionary*, Merriam-Webster, https://www.merriam-webster.com/dictionary/sarcasm. Accessed May 21. 2023.
[†] "Sardonic." *Merriam-Webster.com Dictionary*, Merriam-Webster, https://www.merriam-webster.com/dictionary/sardonic. Accessed May 21. 2023.

meaning "flesh"), suggesting cutting or biting humor that reveals the intention "beneath the skin," or beneath the literal meaning of the words.

"Sardonic," on the other hand, came to English a bit later via the French *sardonique*, which is from the Latin phrase *sardonius risus* (preceded by *sardonios gelos* in Greek), meaning "Sardinian laughter." The implication was bitter or scornful laughter because the Greeks believed that eating a plant they called "sardonion" (literally "a plant from Sardinia") caused facial convulsions resembling those of sardonic laughter, usually followed by death. There may also be a dash of the pejorative against Sardinians, who were victims of religious persecution and the slave trade into the medieval era.

Scorn

This word is thought to be a mashup of two Old French words: *escarn* "mockery, contempt," which is the most direct relative, and *escorne*, meaning "affront, disgrace." Its verbal form *escorner* literally means "to break off someone's horns," implying an act of humiliation, or making an aggressive person a bit less goatish in their behavior.

Scurrilous

The Latin source of this word is *scurra*, originally meaning an idle, city-dwelling, and fashionable man—a type of man whose name later became an insult meaning "buffoon." His speech became an adjective *scurrilis*, meaning "like a buffoon." From there we got *scurrile*, which in the 17th century was used to describe someone with coarse humor, someone prone to using indecent, buffoonish language.

Taunt

This word may be from the French *tanter* or *tenter*, meaning "to tempt," and therefore in English to tempt or provoke someone to fight. Alternatively, it might be from the French *tant pour tant*, meaning "so much for so much," suggesting an equally scathing reply to

an insult and used in the same way as the English "tit for tat" in confrontational settings.

A Few Interesting Insult Origins

Bastard

There's a lot to unpack with bastards—literally.

Let's start with the ending.

In most cases, the ending -ard or -art is used to intensify words. You could say it means "very" or "too much."

So …

A **drunkard** is someone who drinks too much or gets drunk very often.

A **wizard** is someone who is very wise.

A **braggart** is someone who brags too much.

A **dullard** is someone who is too dull or very stupid.

Interestingly, the base word of "mustard" is essentially the word "musty" (meaning damp and stinky), so the condiment's name literally means a very pungent or intensely musty substance.

Coward is a bit different. Technically, it comes from a Latin word *cauda* "tail," so it means someone who tucks their tail or turns tail and runs. But its spelling was influenced by the unrelated Middle English words "cower" and "cowed." Either way, it's someone who is too scared.

You'll notice that many of these words end up having negative implications, so the -ard suffix can also be used to make a word derogatory or pejorative.

That's the case with "bastard." The Old French *fils de bast* meant "packsaddle son." Saddles and horse blankets doubled as beds during travel, so a *fils de bast* was a son (or child) that a man conceived while he was traveling away from home with a woman who wasn't his wife or whom he had to travel to visit.

Chump

This early 18th-century word is related to the Old Norse *kumba*, both of which first meant "block of wood." So calling someone a chump is essentially the same thing as calling them dumb as a block of wood, or a "blockhead."

Dork

This mild insult is thought to be a variation of the word "dick," with the first appearance of "dork" in 20th-century school culture. Despite some assertions that "dork" refers particularly to the penis of a whale, it was never—beyond internet rumor—used for any other than the human appendage.

Dweeb

Unsurprisingly, this is student slang, thought to be a variation of the earlier word "feeb," short for "feeble-minded," and may have influence from other insults beginning with *d* (*see* dick, in Chapter 2; dork).

Geek

The original sense of "geek" is that of a person in a sideshow attraction—first a more general one, with the name thought to be from a Germanic source such as the Dutch *gek* "fool," originally from a Scandinavian term meaning to "mock."

It was refined in the 20th century to refer to an attraction in which the performer ate or bit off parts of live animals—such as biting the heads off of chickens or eating snakes—which was further popularized and cemented in pop culture by the novel and film *Nightmare Alley* in the 1940s. Such people were so stigmatized that the word entered teen slang for any sort of social outcast, including of the socially awkward variety.

This word was especially applied to tech enthusiasts in the 1980s, perhaps because their interests caused them to withdraw from society

and were less active than other traditionally masculine pursuits such as sports. (After all, the first "computers"—people who did calculations for a living—were women.) By the 1990s tech boom, tech geeks were empowered to reclaim the word as a badge of honor, followed by people with other niche interests (particularly of the technology, sci-fi, and fantasy variety) in the following decades.

Grotesque

This word is not related to "gross," which is simply from the Latin *grossus*, meaning "big" or "thick," and became an insult because it was first an intensifier, as in the legal and workplace phrases "gross misconduct" or "gross negligence."

Rather "grotesque" is from the Italian *grottesco*, meaning "of a cave," a word first used to describe paintings on the walls of underground ancient Roman ruins in the 15th century and then extending to fantastical styles of art and design, especially in interior decoration and (in the 19th century) typography. It was applied as an insult or a description of something off-putting from the 1600s for one of two reasons: It may have originally implied something monstrous, as if it emerged from a cave, or it may have been intended to reflect the fantastic, mysterious, and even monstrous imagery within the artstyle.

Hideous

This word did not originally refer specifically to ugliness, but to anything that inspired terror. It was usually applied to actual monsters rather than to humans of unfortunate countenance—an application that was at first hyperbolic. It's thought to be of Germanic origin, perhaps from a word meaning "horror" or "fear," but with a Gallicized ending and spelling variation. Another theory is that it's from the Latin *hispidus* "shaggy, bristly," but that idea has since been discredited, according to the *OED*.

Ignoramus

Originally a 15th-century Anglo-French legal term used when the prosecution's evidence was insufficient for a conviction, this word is a direct borrow from the Latin *ignoramus*, meaning "we do not know." Its use as an insult arose from the college farce *Ignoramus* (1615) by George Ruggle (1575–1622), which poked fun at the ignorance of lawyers (*see* maroon)

In a 1941 letter, J. R. R. Tolkien famously referred to Hitler a "ruddy little ignoramus" for "ruining, perverting, misapplying, and making for ever accursed" the Norse cultures Tolkien based his works on.

Nerd

This insult is recorded with the spelling "nert" in the early 1900s, thought to be a slang variation of the word "nut." By the mid-1900s, "nerd" had solidified in college slang as an insult for someone with intense, especially academic, interests. It also appeared in Dr. Seuss's book *If I Ran the Zoo* (1950) as a name for an imaginary creature, but the book is not thought to have influenced the frequency or use of the term.

Nimrod

Originally a compliment, this term reflected the biblical character Nimrod, a renowned hunter. His name was dragged through the mud not once, but twice. In Middle English, "Nimrod" (through the variation "Nembrot") became synonymous with the word "tyrant" because, according to the biblical lore of the time, he built the Tower of Babel. However, the Bible itself does not name him as the tower's builder, and it's unclear how this story came about.

The second misfortune to befall Nimrod's name was pop culture and the theater. First appeared the character Nimrod Wildfire, a caricature of Davy Crockett popular in several plays from the mid-1800s. This bombastic outdoorsman, named after the biblical character, likely contributed to the ironic use of the name Nimrod for Elmer Fudd in the Looney Tunes cartoons, which would then go on to be an insult for someone incompetent or clumsy, at least in part due to Bugs Bunny's dialogue.

Nincompoop

This word has a far more complex and culturally rich history than you might expect. This fairly mild insult is actually rather old, recorded as early as the 1670s.

The leading etymological theory about nincompoop is that it is a silly contraction of the Latin legal phrase *non compos mentis*, which means that you're mentally incapable of managing your own affairs, or literally "not having the power of the mind." This legal term is first recorded in the early 1600s. And this makes decent sense as an origin: You lack mental competence, you are *non compos mentis*, you are a nincompoop. And the timing lines up pretty well.

In fact, some dictionaries accept this at face value, but researchers at the University of Oxford believe that *non compos mentis* is not the source of nincompoop because it is first recorded without the second *n*—so nicompoop or nickumpoop. However, its earliest spellings may not say that much about the origin of the word, because a) at the time, spelling was creative at best and b) it is a childish slang insult and it has the word "poop" in it. It is not exactly the most scientific of terms.

But there are other theories that are *equally* serious and address the absence of the second *n*.

Etymologist Ernest Weekley believes that "nincompoop" is a fanciful twist on a name—possibly the biblical figure Nicodemus.

If you're familiar with the story of Nicodemus, he's not exactly what you'd call a nincompoop. He was a Pharisee, but he had a famously thoughtful conversation with Jesus and even prepared Jesus' body for burial after the crucifixion—so he's framed as a good man who's capable of critical thinking.

However, beginning in the mid-16th century during the height of conflict between European Protestants and Catholics, John Calvin framed Nicodemus as being duplicitous and objected to him being sainted because, even if he was friendly with Christ, he was still a Pharisee. Thanks to Calvin, the word "Nicodemite" came to refer to Protestants living incognito in largely Catholic areas—or vice versa— because they were considered similarly duplicitous for hiding their beliefs, even though, you know, they'd be *murdered* if anyone knew what

they actually believed. And in French, "Nicodemite" is subsequently recorded as a general insult for a "fool" as an extension of this idea.

So Weekley proposes that "nincompoop," and specifically the older spelling without the second *n*, could be a silly, casual variation of Nicodemite.

He alternatively suggests that it could be related to the name Nicholas, which in European folklore is an all-purpose name for the Devil ("Old Nick"), demons, tricksters, and foolish characters.

I have my own theory, not necessarily about the origin of nincompoop, but why it was popularized as a silly insult—and potentially why that second *n* was introduced. Regardless of the original source of this word, I posit the spelling and usage of "nincompoop" was influenced by the word "ninny," which was a very common insult starting in the late 1500s. Ninny is a shortening of the word "innocent," especially in the sense of someone being naively stupid.

Plus, there's poop in there, and that's always fun to say.

Prat

This British insult is likely from the Old English *præt*, "trick, prank," which, perhaps on the notion of someone being the "butt" of such a prank, gave it the sense of "buttock" in the 16th century. This sense was further solidified by the vaudevillian term "pratfall," first a term for a comedic on-stage or otherwise embarrassing fall (onto one's buttocks). Thus, in its insulting context, a "prat" may be interpreted as both an "ass," or someone who makes a fool of themself or is the victim of a prank.

Repulsive

This term literally describes something that "repels" others, ultimately from the Latin *repellere* (its past participle in Medieval Latin being *repulsivus*), meaning "to drive back." In the 1400s it was not an insult, but suggested the general ability to repel things (as a magnet) or to dissipate collected humors (as a drug). It matured into an insult in the late 1500s, but rather than inspiring disgust, it implied someone who is able to repel others by the coldness of their personality.

Today's sense is from the early 1800s, with several notable appearances in Mary Shelley's *Frankenstein*:

> I abhorred the face of man. Oh, not abhorred! They were
> my brethren, my fellow beings, and I felt attracted even to
> the most repulsive among them, as to creatures of an angelic
> nature and celestial mechanism. But I felt that I had no right
> to share their intercourse.*

Stinky

This word was milder in its Old English verb form, *stincan* (noun *stenc*, source of "stench"), which meant to emit a smell—and not just an unpleasant one. Granted, it was sometimes used to refer to unpleasant odors, while *swote stincan* "a sweet stink/smell" was used for pleasant ones. The unpleasant sense of "stink" and "stench" took over more wholly in the 1300s.

Sycophant

A sycophant is an obsequious flatterer, who bows and scrapes to earn the approval of someone they consider important. The word "sycophant" comes from the Greek *sykophantes*, literally meaning "one who shows the fig."

"Showing the fig" was a rude gesture made by pushing your thumb between your forked fingers. As you can see, the thumb doesn't look entirely unlike a fig … but the overall gesture was really meant to look more like certain intimate parts of the female anatomy. Indeed, the Greek word for fig, *sykon*, was also a word for vulva. So *sykophantes* more or less referred to the sort of person who might call other people "cunt" as an insult.

The gesture became associated with servile follower-types because ancient Greek politicians considered themselves to be above such rude gestures … but they weren't above encouraging their supporters

* Mary Shelley, *Frankenstein* (Oxford: Oxford World Classics, 2019).

to use them while taunting the opposition—which will sound familiar to anyone who observes the political arena today.

In the 16th century, the English word began to soften, shifting from describing partisan zealots to those who are overly ingratiating to anyone with power over them, which may reflect the way royalty of the time demanded to be treated.

Ugly

Despite being an adjective, "ugly" looks like it has an adverbial ending—and, in truth, it sort of does. It's thought to be from the Old Norse *uggligr*, a compound word meaning "inspiring dread" or "dreadful," or literally "dread-like" (*uggr* "fear, apprehension, dread" + *-ligr* "-like"). The second component of the Old Norse word is cognate with the English -ly ending, which is from the Old English ending *-lic*, meaning "like" or "having the form or appearance of." "Ugly" is a bit of an unusual word for unpleasant looks, because most of them in a variety of languages are not based on words meaning "fear" and "dread," but rather compounds meaning "ill-shaped," such as the Latin *deformis* (the source of "deformed"). This makes "ugly" especially insulting because it implies an appearance so horrendous that it strikes fear into others.

Vile

This word, which looks like it should be related to "villain" but surprisingly isn't, ultimately has to do with value. Its PIE root means "to buy" or "to sell," so someone who is "vile" is literally "cheap" and "worthless." It's related to the term "venal," which describes people and officials who are bribable—that is, their morals and loyalties are easily bought.

THE MAGIC OF COMPOUND INSULTS

Compounds such as "cocksucker" have led to creative variations includ-ing, but not limited to: wankbadger, cocklodger, twatwaffle, douchenozzle, shitgibbon, fucktrumpet, pisswizard, cuntmuffin, asswagon, and fartgoblin.

The unifying factor across all of these terms is undoubtedly how funny they sound, whether by virtue of calling up a particular mental image or simply sounding like verbal flatulence (and other less savory bodily functions).

In 2022, programmer Colin Morris selected a range of compound pejorative elements and mapped the pairings in this diagram by the frequency of their usage on Reddit, due to the site's "virtue of being uninhibited in its profanity, and on the cutting edge of new coinages."

The following activity is inspired by Morris's research, which he first generated and documented on software hosting service Github.*

Make Your Own

Match the word elements in each column to create your ideal compound insult:

fart	muffin
douche	sack
cunt	goblin
shit	waffle
fuck	nugget
piss	bag
wank	stick

* Colin Morris. "Compound pejoratives on Reddit – from buttface to wankpuffin." *Github*, June 28, 2022. https://colinmorris.github.io/

poop	sucker
butt	thumper
tit	stain
nut	nozzle
cum	clown
pussy	head
twat	bag
snot	spout
ass	blumpkin

CHAPTER 5

IT'S NOT US, IT'S THEM

THE BIAS AND BIGOTRY EMBEDDED IN ENGLISH

As we've discovered, insults can be entertaining, snarky sport—but they can also be quite harmful, and none more so than those that target people for their differences.

Despite the fact that most people fundamentally do not intend harm to one another, history writhes with instances of humans subjugating, ostracizing, mistreating, maligning, and belittling one another for their differences.

The American Psychological Association attributes the tendency to other or dehumanize people to an "ingroup" vs. "outgroup" or "us" vs. "them" mentality, which leads people to prefer people in their perceived "group."* Delineations between those groups vary in scale and specificity, from identifiers such as sexuality, gender identity, race, and religion to endless subsections.

This mindset worms its way into our language in the most pervasive and nefarious ways, some obvious—in slurs and overtly sexist language, for instance—and some less so.

This (by no means comprehensive) chapter will examine both: the origins and development of words that plainly communicate bias, bigotry, and prejudice, as well as words that may not seem as problematic until you look beneath their surface to find the wriggling rot in their history.

★ *APA Dictionary of Psychology,* 2023.

The Vocabulary of Bias

Let's start with the basics.

Bias

A bias is quite literally a "slant" or diagonal line, from the French term *biais*, meaning "slope" or "slant." As an interpersonal term, it can refer to any degree of preference for or against a person or concept, from a political or journalistic bias in favor of a party or institution to an individual bias against another person or group. In any sense, it evokes an imbalance in the scales of justice: At the institutional level, it creates systemic injustice; in journalism, it skews the accuracy of reporting; in relationships, it results in fear, contention, and segregation.

Its origin is uncertain, but the leading theory is that it is related (via a shortening of the Latin **(e)bigassius*) to the Greek *epikarsios*, which means "to cut diagonally or obliquely."

Its modern sense is a visual metaphor cemented by a 16th-century variation on lawn bowling in which balls were made heavier on one side to make them curve obliquely. They were therefore "one-sided" and could be used to avoid obstacles much like people of a one-sided mindset might avoid topics and people they have a prejudice against.

Bigot(ry)

This word is an etymological mystery, but there are several interesting theories.

Its first use was for a religious hypocrite or someone who is otherwise sanctimonious. After that, in the late 1600s, it was extended to refer to anyone who looks down upon others for any reason.

In Old French, *bigot* is recorded as an insult for the Normans. As a result, one theory is that the word is mockingly derived from Normans using the Germanic oath *bi God* (by God). The *OED* calls this theory "absurdly incongruous with facts," but this wouldn't be the first time in history that something like this has happened. For

instance, in Joan of Arc's time, the French referred to the English as *goddamns* due to their use of the oath, and in World War I the French were known to call Americans *les sommobiches*.

A milder variation of this theory holds that the insult is drawn from the surnames Bigott and Bygott, which are recorded among Normans in England following the Conquest. (So today's use of the word "bigot" would be a case of using that name as a metonymic stereotype for the high-and-mighty Normans.)

Another theory suggests that it may be from a variation of the word "Visigoth," evidently because people in southern Gaul displayed such attitudes. It is also considered unlikely.

Yet another is that it's from the Spanish *bigote*, meaning "mustache," but no one seems to have a credible theory about why mustaches were associated with bigotry so long before Adolf Hitler and other mustachioed villains made their horrible marks upon history and fiction.

Prejudice

The term "prejudice," which is also critical to conversations around bias, is more straightforward in its origin: It literally means "prior judgment," from the Latin *prejudicium*. In Latin its most common meaning was "injustice," which is certainly accurate when applied to prejudice in modern settings. When the term entered English in the 14th century, it also aptly meant "contempt" or "preconceived opinion," the latter of which is more relevant to the titular theme of Jane Austen's *Pride and Prejudice* than the way it is often used today in contexts involving racial or cultural bias.

The phrase "terminate with extreme prejudice," arose as a euphemism for execution (and later, figuratively, for firing someone with no intention of rehiring them), in connection to the Green Beret Affair during the Vietnam War. During the covert intelligence operation Project GAMMA, several U.S. Special Forces soldiers—green berets—identified South Vietnamese officer Chu Van Thai Khac as a double agent and extrajudicially murdered him on the advice of the CIA, which ordered him to be "terminated with extreme prejudice."

Although the officers were arrested, the charges were dropped when the CIA refused to submit witnesses.

Slur

The earliest sense of this word, which arose around the year 1600, is "to smear," both literally (as in smearing mud on something) and figuratively (smearing someone's reputation by making a disparaging remark).

While its root is unknown, it's related to other Germanic words for messy, muddy, sloppy, and gloppy materials and behavior, such as the Middle Dutch *sloren*, "to trail in the mud," and the Frisian *sluren*, "to be careless." (Middle Dutch also had *slore* as an insult for a promiscuous woman.)

The sense of verbally dragging people through the mud led to today's meaning of "slur"—that is, an insult directed at people of different races and religions.

These definitions are older than the sense seen in "slurring your words," which did not appear until the 19th century, though the muddiness is still there: Slurred speech is meant to imply pronunciation that sounds as if its slipping and sliding away from its intended course, like a person or vehicle on a muddy path. It may also draw inspiration from the musical sense of "slur," a symbol showing that two or more notes are to be played without any separation between them, figuratively slipping from one to the next.

Stereotype

Suppose you're a publisher called Ticknor & Fields in the 1800s, and you're printing a book called *The Scarlet Letter* by Nathaniel Hawthorne. Hawthorne is already a pretty popular writer for his essays and short stories, but this is his first novel. So you decide a nice large print run of 2,500 copies ought to do it. Normally you would produce only around 1,000. You assemble all the individual letters and design elements for each page into a block called a "chase" to make a "forme." You use the formes to print multiple copies of each

page, but after you had finished making all those copies you dis-assemble the formes so that you can reuse the type for something else.

Unfortunately, the book proves to be so popular that you find you're out of stock and you need to print *another* 2,500 copies.

You should have invested in stereotypes.

A stereotype is a single plate of type metal cast in one big mold. It literally means "solid type."

So in the 1800s a "stereotype" was a block of words and images printed and reprinted without change, with no implied biases whatsoever.

In 1922, reporter and political commentator Walter Lippmann (1889–1974) wrote *Public Opinion*, in which he explained that facts are never provided to the public completely and accurately—because they can't be. People in power who understand the most about a given situation, or at least claim to, construct their own mental picture of it. Lippman, who worked in media and publishing, called this mental picture a "stereotype"—a rigid facsimile of life that gets repeated over and over again. And this stereotype suits the needs of those who benefit from power systems, whether they know it or not.

Sounds familiar, doesn't it? Lippmann also applied this concept to narratives about people. Therefore, we call a biased and oversimplified depiction of a whole group of people a "stereotype."

Racism, Xenophobia, and Cultural Bias

Aboriginal

Due to the long-standing abuse of indigenous people in Australia, the Americas, and elsewhere around the world—and the association of indigenous people with the terms "aboriginal" and "aborigine"—there's been some discourse in recent years about whether this word has racist connotations or is inherently negative. Much of that chatter revolves around the prefix *ab-*.

The prefix *ab-* is not inherently negative. It means "off" or "away from." It does most often show up in words with negative connotations such as "abnormal," which literally means "away from or outside

of what's normal," and "abhor," which literally means "to shudder away from something." But it's also present in more neutral words like "absorb" which literally means to suck something away from something else, and it's even in the relatively positive word "abound," which means to rise up, like a wave, so high as to spill "out of bounds," so to speak.

"Aboriginal," means rising or moving "out of the origin," and therefore it is used to mean "the first people." (It has been interpreted as meaning "not original" by internet folk etymologists in recent years, but that is incorrect.)

In Latin, *aborigines* was a word meaning "the first inhabitants," or "the first ancestors of Rome," literally the people who were descended from the origin of Rome.

So while the term is not inherently racist or colonialist in its etymology, it's understandable why some indigenous people do not prefer "aboriginal": It's a Eurocentric concept and worldview that has been applied broadly to groups who have no connection to the term's earlier and more specific sense.

Antisemitism

One of the world's oldest and most pernicious biases, this word itself is born of an attempt to sterilize hatred and bias toward Jewish people. This word, first styled "anti-Semitism," was not in common use until the late 1800s—and it was antisemites who popularized it.

"Semitic" is the oldest portion of this term, ultimately from the Hebrew name Shem, one of the three sons of Noah and the supposed ancestor of people in the Semitic cultural and language group, which includes people united by languages such as Hebrew, Arabic, Aramaic, and Assyrian. It entered English in the late 1700s from the Medieval Latin *Semiticus*, and shortly thereafter "Semite" was back-formed to describe people of these backgrounds—many of whom were the victims of racism and classism across much of Europe in the following centuries.

This bigotry was not limited to Judaism, and "Semite" did not specifically describe Jewish people, so the term ended up applying in an overgeneralized way to people who might have been deemed general foreigners or outsiders by Western Europeans (and beyond).

Moravian Jewish scholar Moritz Steinschneider (1816–1907) is thought to have been the first to use the German *antisemitisch* to describe the broad, overreaching racism against people from these cultural groups.

However, prominent nationalists such as historian Heinrich von Treitschke (1834–96) and journalist Wilhelm Marr (1819–1904) appropriated the term (in German, which then spread to English), upholding and popularizing it as a term for supposedly scientific justifications for the superiority of the "Aryan" race.

In truth, the reasoning behind these justifications was built upon the same sort of scientific racist principles that sought to justify the mistreatment of Black and African people in centuries prior.

Prior terms for bias against Jewish people were blunter—"Jew-hatred" and "anti-Jewish" prevailed—so at the time "anti-Semitism" was meant to seem more scientific and less specific to Judaism, making it, in today's terminology, what one might call an example of a practice similar to "whitewashing."

Barbarian

The word "barbarian" comes from the Medieval Latin word *barbarinus*, a word for anyone who wasn't Roman or Greek, and is originally from the Greek *barbaros*, meaning "foreign, strange or ignorant." The root *barbar-* was used to imitate the unintelligible speech of foreigners, so, essentially, "barbarian" means "a person who says 'blah, blah.'" This word is also related to the toponyms Barbary and Berber, which were applied to North African regions and people by Europeans that also imply foreignness.

Buck Naked

The phrase "butt naked" has shifted from eggcorn to common usage, and while it makes sense, the original phrase was "buck naked," which referred to buckskin—and it's often still in use. In this case, it's an offensive term because "buck" was a slur for Native American men, and the phrase referred to their style of dress, which often showed more skin than European clothing.

Bulldose (bulldoze)

In what may be one of the more horrifying etymological facts in this book, the word "bulldozer" has a startlingly racist origin: It comes from the earlier "bulldose," which meant "a severe beating or lashing," used generally for physical coercion but glaringly used in reference to the beating of Black voters as an intimidation tactic (giving them "a dose fit for a bull"—e.g., using a bullwhip) in the 1876 U.S. presidential election. It didn't refer to machinery until 1930.

Chink

In its nonracist sense, a "chink" is a split or a crack, often found today in idioms such as a "chink in one's armor." It's 16th-century evolution of the earlier Middle English *chinne*, a word for a narrow valley, originally from Old English *cine*, "fissure." It became a slur for Chinese people at the turn of the 20th century in the U.S., as a comparison between the eye shape of someone with an epicanthal fold, which is common among people from many Asian countries including China (and probably because it sounds similar to "China"). Anti-Chinese sentiment of this period was fueled by legislation such as the 1882 Chinese Exclusion Act, which was a reaction to many Chinese workers migrating to the U.S., with many looking for opportunities in gold mines and factories and on farms.

Gook

This late 19th-century military slang word was first used to refer to Filipino people by American soldiers during the Philippine–American War (1899–1902). It may be a mocking variation of an unknown Filipino word (by the same logic as "barbarian"), or it could have been influenced by the term "goo-goo eyes," which in this case may have meant "soft" eyes, in the same meanspirited way "chink" refers to the eye shape of many Chinese people. The term was extended to other Pacific Islanders and Asian people over the next few decades.

Gypsy and Gyp

Roma or Romani people have long been subject to the derogatory name "gypsy," an othering term that was liberally applied to many (often nomadic) people with darker complexions who were not considered part of the European communities they visited or made their homes in. The English term, which was also spelled *gipsy* and was preceded by *gypcian*, is originally a variation of the word "Egyptian." The term is based on the medieval assumption that Egypt was the Roma people's place of origin. This notion was drawn from the biblical Book of Ezekiel, in which a wrathful God scatters Egyptian people among other nations. People who identify as Roma today are Indo-Aryan in heritage, though that certainly hasn't stopped the pejorative from being indiscriminately applied to many dark-featured people, regardless of their familial origin.

In other languages, Roma people and traveling, dark-complexioned communities have been accused of being from entirely different places and religions, such as *Bohémien* in French and *Flamenco* in Spanish, despite a general lack of firm association with Bohemia or Flanders. In the words of British philologist Ernest Weekley (1865–1954): "The gipsies seem doomed to be associated with countries with which they have nothing to do."

Furthermore, this pejorative also spawned the verb "to gyp," meaning "to cheat" or "to swindle" (or, in its noun form, a swindler), an association based on the idea that all Romani people, who have traditionally lived a nomadic and trader-focused lifestyle, are thieves and swindlers. (However, there is another story, once shared among students at Cambridge, that says it is from the Greek *gyps* "vulture," and was used to describe thieving servants—and thereby adding a dash of classism to the mix.)

Highbrow and Lowbrow

These terms for styles of humor—intellectually stimulating and sophisticated versus slapstick and silly—first appear in the late 1800s, and slightly earlier in quite literal contexts. For instance, an 1866 historical fiction novel describes a royal's countenance as such:

His noble face wore an expression of gentleness almost maidenly, though his highbrow revealed intellect and determination.*

By contrast, a low brow (sometimes one word even in the facial feature sense) was said to be a sign of primitive, simple-mindedness in men. This notion translated to—and was perhaps rooted in—notions that cultures in which a low brow was common were more primitive. A "low brow" may refer to a lower forehead and, in men, a more pronounced supraorbital ("above-the-eyes") ridge.

However, this dynamic is not present in descriptions of women: According to Harvard University's 1894 Medical Review,

A low brow and not a very high one is considered beautiful in woman, whereas a high brow and not a low one is the stamp of manhood.†

In this case, it meant a smaller forehead. But despite the lack of racism where women are concerned, the association is plenty sexist. The same passage from the article, which is titled "Woman Is Not Fit for the Practice of Medicine," implies that women are lacking in "intelligence proper" because the fronts of their brains are "less developed."

These terms were reflections of phrenology, an unfounded pseudoscience popular in the late 18th and 19th centuries ascribing intelligence and personality traits to skull shape, often in the interest of scientific racism and sexism.

Kowtow

In English, this verb describes "bootlicking" and submission, largely in a derogatory way. It's an 18th-century appropriation (originally spelled "kotoo" in English) of words in Chinese languages such as kòutóu (叩頭/叩头 in Cantonese), literally meaning "knock head," a term describing the respectful gesture of touching the forehead to the floor.

* Luise Mühlbach, *Frederick the Great and His Court.* trans. Mrs. Chapman Coleman (Fowle, 1866).

† F. W. Abeken "Woman is not fit for the practice of medicine," *Medical Review* 29 (1894).

Maroon

The first recorded appearance of "maroon" in English is from the 1590s as a word for a type of large, sweet chestnut from Lyons, France, perhaps from the Greek *maraon*, also a word for the nut. It was first used to refer to the color in 1791, referring to the color of the chestnut, from the full phrase *couleur marron* in French.

Today, *marron* in French and *marrone* in Italian can mean "chestnut" and "brown," while the Italian and French words for what we call "maroon"—a blend of the colors brown and rose—are *granata* and *grenat* respectively, which you might recognize in the name of the syrup "grenadine" and in "pomegranate" ("apple with many seeds").

But the word has a more nefarious sense as well: In the early 1600s, "maroon" (with the earlier variations *maron* and *symeron*) was used to refer to fugitive Black slaves in the Americas. This sense of "maroon" came to English via the French *marron*—but, in this case, the French word didn't mean "chestnut." *Marron* in this sense was thought to be a corruption of the Spanish *cimmaron* or *cimarron*, meaning "wild, untamed," from the Old Spanish *cimarra*, "thicket."

As early as the 1500s, the American Spanish *cimarrón* was used to refer to feral cattle in Hispaniola, then to enslaved native people who escaped, then to Black runaway slaves, as a comparison to the animals. When these escaped slaves banded together and formed independent communities with indigenous people in the 1600s, they were called "Maroons" in English.

It's possible that "maroon" as in "chestnut-colored" helped influence "maroon" in this fugitive slave sense, connecting it to their skin tone. But the latter is thought to be influenced more by the Spanish source and to be closely related to the concept of "wildness"—which is dehumanizing enough. This logic also resulted in the use of the English verb "maroon" as a nautical word for "put ashore on a desert island or coast"—to put in the wilderness, so to speak—a use that was first recorded in 1724. Before that, in the 1690s, it was also used more generally to mean "to be lost in the wild."

Bugs Bunny sparked debates around the use of this word in several Looney Tunes cartoons: When he cackles "What a maroon!" or "Poor little maroon!" at the misfortune of his antagonists, is it a callback to this racist history?

In other instances, the character mispronounces insults such as "imbecile" and "ignoramus." Therefore, it's possible he is simply mispronouncing "moron" as "moroon." But in the 1943 cartoon "Tortoise Wins by a Hare," he pronounces "moron" correctly, and "maroon" does have history as a derogatory term. Whether the writers meant it to be racist or not is unknown, but both interpretations are problematic for different reasons (*see* moron).

✑ More on the Ending -oon

This ending can be perfectly innocent, adding emphasis or implying size in words such as cartoon (which was originally drawn on heavy stock paper, or Latin *carta*), balloon (a ball of great size), bassoon (which makes a big bass sound), and cocoon (which looks like a big seed, from Greek *kokkos* "berry, seed").

But that augmentative sense can also be used for more nefarious purposes, such as in the words …

Baboon, which is from the Old French *baboin*, meaning "ape," but before that meant "simpleton," "fool," or "resembling a gargoyle"

Buffoon, originally a word for a dance in pantomime performances, from the Italian *buffone*, meaning "jester," and *buffa*, meaning "joke," originally from *buffare*, a word for puffing out the cheeks or otherwise pulling a silly face

Dragoon, a 17th-century word for a cavalry soldier equipped with firearms, with the name probably associating their muskets with dragons that "breathed fire," and the ending evoking the sense of casual drudgery found in other words for soldiers (e.g., grunt).

Poltroon, an insult suggesting someone lazy or cowardly, from the Italian *poltro*, meaning "lazy, cowardly," and originally from Latin *pullus,* usually applied to a young chicken

Quadroon, an 18th-century word for someone who was one-quarter Black and three-quarters white—or, more realistically, a mixed-race person with relatively light-toned skin

Shabberoon, an 18th-century word for a shabby or disreputable person

The N-word* (and when it's acceptable)

We've reached what might be the most racially charged and bias-filled word in English, at least when used by the wrong person or for the wrong reason. You know the word I'm talking about. I'm not one of the people for whom there will ever be a good reason to say it. That's why I'm not printing that word in this book.

In his book *Nine Nasty Words*, linguist John McWhorter, who specializes in creole languages, sociolects, and Black English, calls the N-word "twenty-first-century English's Voldemort term" (because it must not be named).[†]

The word traces back to the Latin *niger*, which was simply a word for the color black, and its adjective form *nigrum*, which led to the Spanish *negro*. The Spanish, of course, was adopted into English as a word for a person with dark skin, usually though not always of African descent. The spelling of the N-word as it appears today simply represents the way an English speaker might pronounce the Spanish word. In McWhorter's words, "*Negro* to *n****** is as *fellow* is to *feller*, or *Old Yellow* is to *Old Yeller*—*n****** feels more natural in the Anglophone mouth than *Negro*."

This word, of course, was used as a descriptor for much of history. Not that its power dynamics have ever been lost on most people, of course. For example, many white abolitionists chose to use the terms "black" (with a lowercase 'b'; capitalization of "Black" out of respect is a recent practice) or "colored person" because they acknowledged that the terms *Negro* and *n****** were inherently tied to slavery and race-specific subjugation.

("Negro" was the subject of debate from the late 1800s to the mid-20th century, and was still considered accurate and polite by many institutions and people including Booker T. Washington, who, according to a report in *Harper's Weekly*, said: "It has long been his own practice to write and speak of members of his race as negroes,

* After careful consideration of my position as a white writer, I have also chosen not to print the word in this book. It does appear in its full spelling, uncensored, in the book cited in this entry.

† John McWhorter, *Nine Nasty Words* (New York: Avery, 2021).

and when using the term 'negro' as a race designation to employ the capital 'N'.")*

Plenty of white writers in the 1880s acknowledged that n***** was inappropriate and that polite society "should know better" than to use it to refer to people of color. An 1895 edition of *Century Dictionary* said that "its use is now confined to colloquial or illiterate speech, in which it generally conveys more or less of contempt."

Still, even in the early 1900s, it was used by many white people with ill intentions. Even apart from that, it was still the subject of jokes and appeared widely in media for much of the rest of the 20th century. Even after the civil rights movement of the 1960s and 1970s, McWhorter notes, TV shows like *The Jeffersons* featured white characters using the term, aloud and uncensored on broadcast television—though with full awareness of how deeply insulting and problematic it was.

Its fully "unsayable" status is, perhaps surprisingly, recent. Long-standing Black activism has led most media in the 21st century to avoid its use entirely outside of all but the most specific contexts. But during that civil rights era it was also reclaimed (spelled ending variously with an -er or an -a) by the people it was most weaponized against as a term of affection or casual, personal acknowledgment.

McWhorter points out that the same reclamation allows words such as "fag" (as a shortening of "faggot") or "bitch" to be used fondly between people within communities and in-groups in comfortable, casual conversations:

> It is a tendency among humans to use slurs directed against them as equivalents to "buddy." This represents a warm real-ity among people. Hierarchy is inimical to intimacy; affection entails a degree of leveling, diminishment even. The Black man who calls his friend "n*****" is saying, "Hey, man, there are people who would call you that the same way they would call me that, and yet we know despite our susceptibility to that abuse and denigration that we're okay. In fact, to the extent that whites think of 'n*****s' as a nuisance, it's a kind of power we have."†

* Quoted in Tom W. Smith, "Changing racial labels: from 'colored' to 'negro' to 'black' to 'African American,'" *The Public Opinion Quarterly* 56:4 (Winter 2022), 496–514.

† McWhorter, *Nine Nasty Words.*

Orientation

Much like other words in this chapter, this word is embedded with a white Western worldview, and although it's not specifically racist, it is deeply Eurocentric.

To be "disoriented" is to feel confused or unable to determine where you are. Etymologically, it means that you do not know in which direction the sun will rise—that is, which way is East.

The base word comes from the Latin *orientem*, which means "the East." The Latin base word is *oriri*, meaning "to rise." So to orient yourself is to know which way the sun will rise, and an orientation helps you point yourself in the right direction.

You may also know that "the Orient" is a Eurocentric name for Asia because it lies to the east of Europe—so it's literally the place where the sun rises if your vantage point is, say, Paris.

The opposite of the Orient is the Occident, or the West, and its origin is therefore also the opposite: It originally comes from the Latin *occidere*, meaning "to fall down" or "to go down," as in the sun setting.

So if you're disoriented, and don't know which way is East, odds are that you're also disoccidented, and don't know which way is West.

Piccaninny/Pickaninny

This word, though nearly as problematic as the N-word is in the mouths of non-Black people today, didn't start out as a race-specific term and is unrelated to the Spanish *negro* or the N-word. It is, however, from either the Spanish *pequeño* or the Portuguese *pequeno*, both of which meant "little" or "small" and are related to the French *petit* (and therefore the English "petite").

In 17th to early 19th-century English, it was used as a term of affection for any child or baby, but perhaps thanks to its spelling or other associations with *negro*, over time it became applied specifically to Black children and took on its pejorative and offensive connotations.

There is a theory suggesting that this word is related to "picnic," but this is false. Rather, "picnic" is supposedly a reduplication—basically a cutesy rhyme or repetition—of the French *piquer* meaning "to pick or peck" as someone might nibble at food during a fashionable 18th- or 19th-century social affair. It may also be from the full phrase *pique-nique*, literally "to peck at little nothings," with the same gist.

Pidgin

This is an autological word, or one that describes itself. "Pidgin" is a tumult of Chinese, Portuguese, and Malay words that attempts to recreate the way Chinese people pronounce the English word "business."

Indeed, the word "pidgin" was used as an adjective meaning "business" from the mid-1800s to nearly the end of the 19th century: For example, "pidgin English" meant "business English," suggesting the way Chinese people and other foreigners, especially people from Asian countries, spoke during business transactions at international trade ports.

Pidgin languages and phrases are styles of communication that blend two languages, similar to creoles, but typically simplifying one of them grammatically, much in the way that a non-native speaker simplifies a language when communicating.

Contrary to a folk etymology theory that associates the word with the communication role of carrier pigeons in carrying messages, the word does not have anything to do with the bird.

Is it racist? It has been used with pejorative intent, and often mockery of pidgin terms is used in racist humor, especially Western humor depicting Asian and African cultures. Calling a language or term "pidgin," however, is generally considered to be neutral and factual.

Additional fact: Tok Pisin, or New Guinea Pidgin, is an official language spoken in Papua New Guinea. Its name literally means "Talk Pidgin," and therefore is itself pidgin: Tok is an adaptation of the English word "talk," and Pisin is an adaptation of the term "pidgin," making it doubly pidgin.

Slave

This word describes a horrific institution characterized by the dehumanizing, abusive, and cruel subjugation of some human beings by other human beings—variously fueled by war, by caste, or by race.

But the word itself is also pretty racist.

The Medieval Latin word *sclavus* meant "slave," but it originally meant "Slav" because so many Slavonic people were sold into slavery by their neighbors and invaders. (The ancient Roman word for a slave was the unrelated Latin *servus*, the origin of "servant.")

The stereotype among Hungarian, Byzantine, Greek, and even Asian and African slave-traders was that a Slavic person had "increased strength outside his marshy land of origin, hardened to the utmost against all privation," and was "industrious, content with little, good-humoured, and cheerful."*

By the time the word entered English in the 13th century, it had lost its association with Slavs specifically and simply described people sold as chattel.

Spic

Similar to the word "chink" for Chinese people, this early 20th-century slur for a Latino or Hispanic person sounds similar to words such as "Hispanic," but its real rationale is far more derisive: It's a shortening of the phrase "No spick English," a mocking replication of the phrase "No speak English" in a Hispanic accent.

The term **beaner**, which often specifically targets Mexican people, is a mid-20th-century shortening of earlier slurs such as "bean-eater" and "bean-bandit," both in reference to beans as a staple food in Mexican cuisine. This word follows the same logic as other, similarly childish ethnic and national slurs including "spud-muncher" for Irish people and "kraut" for German people.

* H. M. Gwatkin and J.P. Whitney, Eds., *The Cambridge Medieval History*; vol. II: *The Rise of the Saracens and the Foundation of the Western Empire* (Cambridge: Cambridge University Press, 1913).

Thug

In many ways, this word functions similarly to the N-word, but it remains marginally more socially acceptable in a wider array of contexts. However, it is certainly imbued with bias in its usage and, to some degree, its origin.

When white people use the word "thug," bundled with it comes a world of power imbalances, bias, exclusion, and pain.

"Different races have different ways of using language," John McWhorter said in a 2015 interview on NPR. Words like "thug" and the N-word "[end] up straddling different subcultures."

Well, the truth is that thug today is a nominally polite way of using the N-word. Many people suspect it, and they are correct. When somebody talks about thugs ruining a place, it is unlikely today that they are referring to somebody with blond hair. It is a sly way of saying there go those Black/Brown/Other people ruining things again. And so anybody who wonders whether thug is a coded equivalent to N-word doesn't need to.

"Thug" has racist connotations in English—especially American English—and this sense infuses every aspect of its history.

The term is originally from a Sanskrit term for "cunning," especially in deceptive or criminal contexts, and therefore also meant "fraudulent." It was popularized in English in the early 19th century during the British occupation of India, when a variation of the term—*thag*—was appropriated from the name of a first-century Indian gang said to cheat and strangle their victims with an unbound turban.* The PIE root in this scenario meant "to cover."

Much like "assassin," the term was applied far beyond its original use. Indeed, people in India would instead use the term *phanseegur* (literally "noose-user").

Uncouth

This word, which today describes someone who is rude or rough around the edges in their appearance and manners, has a dash of

* *Journal of the Royal Central Asian Society* 21:1–4 (1934).

xenophobia. It literally means "not known," from the Old English *uncuð*, which described unfamiliar people and things, especially foreigners.

Classism and Economic Privilege

Blueblood

This term for people with old money first arose in early 19th-century Spain as *sangre azul* and referred to families whose bloodlines (apparently) had not mixed with—or, from their perspective, been contaminated by—those of Moorish or Jewish people, and therefore remained so white that their veins were visible through their skin.

Ciao

This Italian term of farewell (or sometimes greeting) literally means "slave." It's a variation on *schiavo*, which is from the Medieval Latin *sclavus* "slave," implying a brief version of "your obedient servant."

Corny

"You should never tell secrets in a cornfield—there are ears everywhere."

Now that's a corny joke, both literally and figuratively, but why do we say puns and dad jokes are corny—even when they don't actually contain the word "corn"?

Well, let's think about that corn field. It's probably out in the country where rustic people live who maybe have a sense of humor that isn't considered as fancy or cosmopolitan as city folk's.

So a silly joke or simple pun is "corny."

This sense first showed up in 1932—right around the same time as the term "corn-fed," which can be used to describe people who are built a little thicker and have good-ol'-boy attitudes, either in a playful or an insulting way.

Concierge

In the U.S., a concierge typically helps hotel guests out with reservations, destination recommendations, and tour bookings. In France (because the English is a French borrowing), the word usually refers to a caretaker, doorkeeper, or manager of a hotel or apartment complex. Either way, the word implies a degree of authority and knowledge while also focusing on serving others' needs.

Its origins, however, are a bit more disturbing.

It's from the Latin word *conservus*, which literally means "fellow slave."

Its transition from slave to hotel or apartment employee is a bit of a rollercoaster, however, because it took a feudal turn in French: It was adapted as a word for a top-level royal official (with the name communicating the idea of a servant to the ruler), before it toned down again to refer to the "servant" of high-end hotel guests. Anything to amp up the luxe experience.

Cracker

This derogatory term for a lower-class white American person dates back to the 1700s—and it has more to do with class than race. It was essentially the equivalent of "white trash" before that term was popularized.

This usage of the word "crack" is thought to be the same as its sense in the phrase "crack a joke" or "not what it's cracked up to be," both of which drew upon the 16th-century sense of "cracker," meaning "a boastful person" or "a braggart." This sense led to "cracking a joke," suggesting "prattling" or "making a big deal out of" something.

The idea is that of a swaggering, rural, uneducated person who thinks themself superior, and was especially applied to "rascals on the frontiers of Virginia, Maryland, the Carolinas and Georgia, who often change their places of abode."

Another possibility is that it's from the term "corn-cracker," a pejorative for a poor Southern farmer. This would make it a synonym for

"sand-hiller," a term that was applied to lower-class white farmers in sandy areas of Georgia and South Carolina and compared their skin color to the sand-hills near their farms.

> They are small, gaunt, and cadaverous, and their skin is just the color of the sand-hills they live on. They are quite incapable of applying themselves steadily to any labor, and their habits are very much like those of the old Indians.
>
> Frederick Law Olmsted, *A Journey in the Seaboard Slave States*, 1856

Galoot

This word first appeared in English in 19th-century nautical slang, at which point it referred to an inexperienced recruit who didn't know the ways of a ship just yet—or perhaps it was a sailor's insult for soldiers and marines, for the same reason. However, it's thought to originally be from the Spanish *galeoto*, meaning "galley slave."

Hobo

There are two theories about the origin of this word for a houseless person or vagrant—particularly one who took part in the culture and society associated with so-called "tramps" (named for their "tramping" across the country) in the U.S. in the 19th and 20th centuries. It may be from the call "Ho, boy!" which was a common call to workers on railroads, which hobos would use for shelter and travel or to pick up work, or it could be related to the term "hawbuck," a word for a person who lives in the country that implied loutish behavior and lack of education. ("Haw" here could be in reference to a cry or call such as "ho," as seen in "yee-haw" and "hem and haw," with "buck" used in the often pejorative sense of a man.)

Lackey

This word is thought to come from a word in some French dialects implying "licker" (perhaps in the sense that we use "bootlicker" today). It has been a word for a footman, valet, or assistant since the 1500s.

Luxury

Today we tend to associate luxury with high-priced products and lavish experiences—living to excess and drinking life to the lees. (This idiom literally means drinking wine until there's only sediment, or "lees," at the bottom. For more on drunkenness and debauchery.

But the base Latin word of "luxury" is *luxus*, which is a variation on a word meaning to "dislocate," as if you've bent a joint too far. It's related to the word *luctari*, meaning "to wrestle, struggle, or strain," which, by the way, is also the source of the word "reluctant," literally "to struggle against."

But despite this literal meaning, even in Latin the words *luxus* and *luxuria* held a meaning similar to today's English word: pleasant opulence, excess, and magnificence—essentially implying over-the-top, literally hyperextended spending.

When this Latin word migrated to Old French, though, it became pejorative. It still meant excess and extravagance, but more in the frowny, judgy way, implying debauchery, dissolute behavior, and lust—expressing (perhaps religiously fueled) disapproval of extravagant behavior.

And that carried over into English, too: In the 14th century, luxury was actually a word for sex (again in the kink-shamey way). And more generally it was a word for lasciviousness and sinful self-indulgence.

It took 300 years in English before "luxury" lost that inherent negativity, and describing your lifestyle as "luxurious" was considered a good thing again, or at least something you might reasonably want to attain.

Proletarian/Proletariat

The proletariat, or *proletarias* in Latin, were so named in ancient Roman culture because they lacked property, were exempt from

taxes, didn't serve in the military, and their only purpose, according to the state, was to have children. That's what the word means: *proles* means "offspring" or "progeny."

In the 1600s the adjective "proletarian" was synonymous not only with qualities belonging to the lowest class of people in a given society, but also with words such as "vile" and "vulgar."

Marx and Engel's *Communist Manifesto* (1848) did much of the work of redefining the sense and tone of the word. Clearly, Karl and Friedrich saw an opportunity to revalue a classist term to serve their political objectives.

Rascal

To call someone a "rascal" now implies mischief and has a charming edge of fondness to it, possibly thanks to the influence of pop culture appearances (think Bugs Bunny, the "wascally wabbit"). But initially there was little pleasantry to it: The Middle English *rascaile* referred to the "rabble," or the lowest of the low—the lowest-class people, the masses, the mob, or the expendable foot soldiers in an army. In other words, it was incredibly dehumanizing. (And just to hammer that point home, it was also used in Middle English to refer to animals so weak and pitiful that they weren't worth hunting.) The sense of mischief came from the classist idea that "the poors" were also liable to rob you blind because their poorness made them shitty people. Its original source isn't entirely clear, but it's a French adoption, and may have come from the Vulgar Latin **rasicare* "to scrape," suggesting people who scraped the bottom of the moral and social barrel.

Robot

The word "robot" more or less means "slave." It first appeared in English in a 1923 translation of the 1920 Czech play *R.U.R.*, which stood for Rossum's Universal Robots. In Czech, *robotnik* means "forced worker," originally from an Old Slavonic word for "slave" (for a horrific connection, *see* slave). The play was by Czech writer Karl Čapek (1890–1938), though it was his brother Josef who came up

with the term. The robots in the play aren't mechanical devices, but are artificially made of flesh and bone, much like we see in *Westworld*.

Before that, robots were all called automatons. Automaton was a broader word than robot, referring to any supposedly self-operating machine. Now, robot more specifically refers to a programmable machine built to carry out complex tasks.

Automaton is a surprisingly old word, first used by Homer to describe the automatic movements of doors and wheels. *Automaton* is a Greek word meaning "self-acting." Automatons were all over Greek mythology. Talos was an automaton giant made to defend Crete from pirates, and the blacksmith Hephaestus built them to work in his workshop. Real-life automatons in the ancient world in Greece, China, and the Middle East included toys, tools, and religious spectacles.

The word "android" arose as a word for a human-shaped automaton in the 1830s in relation to devices like the Mechanical Turk, which was built in the 1770s and was said to be a chess-playing automaton—before ultimately being revealed to be a hoax.

Snob

This word started out in the 1700s as an entirely general, non-pejorative term for a shoemaker or their apprentice. Exactly where it came from is unknown, but by the late 1700s it had become a somewhat derogatory term for any local, small-time (particularly lower-class) merchant or artisan—especially one who supposedly creates or attempts to create inferior products that are modeled after higher-quality items, or one who, through their trade, pretends at a higher social standing.

That last sense solidified "snob" as a pejorative by the 1840s, when it became associated with people of lower classes who pretended to be of higher classes to fit into society, often through a poor attempt at mimicking their behavior.

The Book of Snobs (1848) by William Makepeace Thackeray (1811–63) lists many types of snob in this vein. This work—though written with tongue firmly in cheek, and claiming to identify snobs

"in every rank of this mortal life," not just "among the lower classes merely"—relies on fairly classist assumptions and humor. It mocks people for their pronunciation, accents, vocabulary, fashion choices, habits, utensil usage, spelling, income, culture, region, occupation, and more—all means by which Thackeray wryly implies that people in British society derive feckless self-importance.

It does, with heavy self-awareness and irony, contain a segment on so-called "literary snobs" like Thackeray himself: "The fact is, that in the literary profession THERE ARE NO SNOBS. Look round at the whole body of British men of letters; and I defy you to point out among them a single instance of vulgarity, or envy, or assumption." (Although passages like this are evidence of some self-deprecating humor and good-natured equal-opportunity mockery, it's also worth noting that Thackeray's works have a strong undercurrent of racism throughout, and that, at the time of his death, he himself was an out-spoken supporter of slavery and the Confederacy.)

The Book of Snobs includes variations of the word "snob," including "snobling," "snobbish(ness)" and "snobore" (ore of snobbery that one digs out of society as if mining).

Thackeray's piece did the work of popularizing the term "snob" in the sense of someone who pretends to be of a higher rank or importance than they are, a sense that evolved over the next 60 years or so into today's sense—that of someone with unwarranted self-importance who looks down on others.

Urchin

In the 1300s, "urchin" (*yrichon*) was a word for a hedgehog. It was an evolution of Old French (*herichun*) and Latin (*ericius*) words for hedgehogs. The word's PIE root (**ghers-*) means "to bristle"; it's also the root of other bristly words like "horror" and "arugula."

The term "street urchin" for an impoverished child was a semi-insulting, semi-endearing term based on the hedgehog sense.

"Urchin" became the word for the sea creature in the 1590s due to its resemblance to a hedgehog.

On a less classist note: You would think the word "hedgehog" is simply a blend of "hedge" and "hog," but it's also possible that this

word is a mishearing and corruption of Slavic words for hedgehogs like the Czech *ježek*. Interestingly, though, the root of these Slavic words is the same root as the word "urchin."

Just to make this even more baffling, the Old English word for a hedgehog which was used before "urchin" was *igl*, and it's more closely related to Germanic and Norse words for hedgehog (German *Igel*; Dutch *egel, igelkott*)—but it still has that same Indo-European root meaning "bristle."

So it's possible that, while they entered English in completely different ways, urchin, hedgehog, and the Old English *igl* all have the same root.

But it's also possible that they're just called hedgehogs because they're little piggy creatures who live in hedges.

Vernacular

This word is fairly neutral today, referring to the particular dialect or language of people in a given region. In 16th-century English, it meant "native to a country," describing things beyond (but also including) unique dialects and speech patterns.

Its literal meaning is … less neutral.

The Latin *vernaculus* was used to refer to native or indigenous people (born within a region), but literally meant "home-born slave"—that is, a person in slavery who is from or born in the region in which they are enslaved.

Villain

A "villain" was originally simply a word for a peasant or poor farmer in Old French. It's originally from the Latin *villanus*, meaning "farmhand," from *villa*, "country house, farm." It evolved to mean "the bad guy" because people started using it as a classist pejorative. It was a way of calling someone trashy and low-class, and therefore implying that they were a scoundrel—much in the way someone might use "hick" or "redneck," terms that some people now use to evoke meth trailers and moonshiners.

Sexism, Homophobia, and Gender Bias

Boy and Girl

Armchair etymologists in recent years have claimed that, until the late 15th century, the word "girl" referred to a child of either sex, while male babies were called "knave girls" and females were called "gay girls."

The theory has some truth to it—but not much.

Basically, the part about "girl" referring to a child of any sex is true—though only for a little while in the early 1300s.

That said, the word "girl" (then spelled *gyrle*) did not exist before the 1300s. And even during the short period when *gyrle* was used as a word for any young child, it was more often used for female children. The original root of "girl" is unknown, though the -le ending on *gyrle* may imply that it is a diminutive.

"Gay" was not specifically a gendered word, though, because it meant "happy", and was often applied to happy children.

What about before that?

The word "boy" (spelled *boie*) did exist slightly earlier than the word "girl," appearing in the 1200s, but it was usually used as a word for a young male servant or commoner. And for the most part it wasn't a nice word—it was often a name used for men and boys of the lower classes, to emphasize their servitude.

The word "boy" is even thought to be related to other Germanic words for yokes or collars. Other evidence points to a relation between "boy" and "babe."

Both echo the way "boy" has been used as a diminutive or weapon against Black men in American history, with white people in power using the word for adult Black men to belittle them.

In Old English the most common word for a young boy was *cnihtcild*, literally "knightchild."

"Knight" didn't refer to a warrior in shining armor until at least the 1100s, but simply meant a young man, or male attendant or servant. *Cnafa or cnafacild* ("knave," "knave child") was also a word for a boy or a male servant. (Old English had many ways to demean your manservants.)

Girls, meanwhile, were called *mædencild* ("maid child"). "Maid" originally just meant any unmarried woman—young unless otherwise specified ("old maid"), and therefore calling a servant a "maid" was originally like calling her "girl." Much like "boy," this sense bears some embedded classism.

Bint

This British insult for a woman comes with a side of racism. It's from the Arabic *bint*, meaning "girl" or "daughter." When it was first borrowed into English by British soldiers in Egypt in the 19th century, it was used as a term of endearment, meaning "girlfriend," but in the 20th century—perhaps inspired by its association with the word "cunt," plus, likely, anti-Arab and Islamophobic sentiment—it ultimately shifted to a pejorative.

Broad

This pejorative sense of the word "broad," which is from the Old English *brad*, "wide," may be a reference to women's broad hips. Alternatively, though, it could be a shortening of the slang term *abroadwide*, an early 20th-century term for a woman who lives or travels without her husband and is therefore assumed to be promiscuous and adulterous.

The pejorative sense of "broad" was so pervasive in the 1960s—also a time when women's sports were on the rise—that the "broad jump" in track and field events was renamed the "long jump," which is still what we call it today.

Bugger

This word, originally an insult for someone who engages in anal sex, or "sodomy," is predated by the term "buggery," made infamous in Britain in 1533 with the Buggery Act, which prohibited anal sex with men, women, and animals. Curiously, it is derived from the Medieval Latin word for a Bulgarian, *Bulgarus*, due to false and bigoted assumptions that Eastern Orthodox Christians in general, and a sect known

as the Bogomils in particular, engaged in forms of heresy, especially sodomy. As these cultural biases faded and British buggery laws were repealed, unfortunately as recently as 1967, "bugger" softened over time, achieving at times the vagueness of "fuck" in its range of meanings, and is even in use as a term of friendly albeit vulgar endearment between men in British English. "Sod" as a shortened term for a so-called "sodomite," has been on a similar journey, though it is, perhaps obviously, inspired by the biblical story of Sodom and Gomorrah.

Chauvinism

The word "chauvinism" refers to excessive nationalism, or blind and exaggerated fanaticism. Today it's usually associated with the phrase "male chauvinism," or the belief in the superiority of men and all things masculine.

But this connotation wasn't popularized until the 1960s.

It's first recorded in the 1830s, and is said to derive from the name of one of Napoleon's most loyal soldiers. Even long after the Napoleonic Wars concluded, Nicolas Chauvin supposedly remained an absurdly staunch Bonapartist. He loudly and unrelentingly professed his devotion to the cause for the rest of his life, which mostly resulted in ridicule from everyone else in Restoration France.

The thing is, Nicolas Chauvin may not have existed at all. There's no concrete historical record that shows he was a real person. Instead, it's possible that he was just a caricature of this Bonapartist attitude— a fictional mashup of former soldiers who glorified the war.

Similarly, the stock character called the *miles gloriosus*, or braggart soldier, always represented fanatical nationalism or militarism in Greek and Roman plays. The *miles gloriosus* was first the title and central character of a comedy by Roman playwright Plautus (ca. 254–184 BCE), in which a pompous and libidinous soldier, Pyrgopolynices, is tricked by a slave and a courtesan.

The character is also similar to the strutting Capitano from the *commedia dell'arte*—the Italian comic theater. It seems this trope was given the name Nicolas Chauvin in French vaudeville, cementing the name in the popular culture of the time and contributing to the spread of the word chauvinism. Although masculinity is often a core

aspect of that braggart-soldier personality type, "chauvinism" was ultimately associated with excessive masculinity when the full phrase "male chauvinism" was adopted by the mid-20th-century feminist movement.

Dyke

The word "dyke" as a word for a lesbian (originally especially a "butch," or masculine-presenting, person) dates back to the 1800s when it was part of a slang term for a hairy vulva—a "hedge on the dyke" (an alternate spelling of dike as in a ditch or waterway). It appears in other now rare or obsolete compounds for lesbian women such as "bulldyker" (or "bull dyke," in British English), as well as the word "morphadike," which was a pejorative term for intersex people, probably meant as a twisting of "hermaphrodite."

Faggot

This word was initially a misogynistic one, but later evolved into an emblem of homophobia. The earliest sense of this word is that of a bundle of sticks bound together, first recorded in the 1300s and thought to originally be from the Latin *fascis*, meaning a "bundle of wood."

Therefore, the original implication of the term—which was initially used for women—has the same implication as the word "baggage" for a spouse or partner, implying they are a useless burden. It was especially applied to women who were seen as less sexually desirable due to age, appearance, or behavior.

This word is also related to "fascist," with the "bundle" sense manifesting in Italian as *fascio*, meaning "group" or "association" before it goose-stepped into right-wing extremist territory.

The term was extended to men who prefer men in the early 20th century, essentially as a means of comparing them to women. It may, perhaps, also include the idea that gay men contribute less to society and are more of a burden because (at the time) they were less likely to start families. Femininity is often folded into homophobic language used against gay men; this form of hate is often infused with the

implication that gay men or men who behave in a way considered effeminate are lesser because they are like women—so it comes with an extra side-dish of misogyny as well.

It may have additionally been inspired and reinforced by the Yiddish term *faygele*, which literally means "little bird" and was also used for gay men.

The bundles of sticks called "faggots" were also used for burning people at the stake, a practice that led to the etymological myth that gay men were first called faggots because they were often burned at the stake if they were found out. This is untrue, not only because the term didn't become an insult for gay men until well after burning at the stake had largely died out as a practice by the time the word was popularized as a homophobic slur, but also because, while burning at the stake was not unheard of for the offense, hanging was the preferred option in England. On the other hand, heretics were very often burned at stakes piled with faggots, and indeed the phrase "fire and faggot" implied the fate awaiting a heretic, while those who were spared the fate wore an embroidered faggot symbol on their sleeves.

"Faggots" is also the name of a U.K. dish of meatballs made of offal, and it's thought to imply the same sense of "bundles of odds and ends put together."

More on homophobic terms: Due to the fragility of hypermasculine self-expression, relations between men have stirred up a profusion of pejoratives throughout English history, ranging from those that imply delicate or effeminate qualities, such as "sissy," "poof(ter)," or "fairy," to more crude and self-explanatory terms such as "fudge-packer." Some, much like "gay," have been applied to both sexually promiscuous men and women, with "fruit" as a notable example, in some contexts insinuating "easy pickings" for predatory people seeking casual sex. Some, of course, such as "queen" have been reclaimed and infused with both Pride and power.

🔥 GENDERED CONFUSION: FEMALE AND MALE, WOMAN AND MAN, 🔥 WIFE AND HUSBAND

Perhaps surprisingly, neither "woman" nor "female" is especially sexist, at least as far as their etymologies go.

"Female" is unrelated to "male," and the fact that they overlap in spelling is due to ignorance about their etymology in the late 14th century.

The word "female" originally comes from the Latin word for a female person, *femina*. The diminutive of *femina* is *femella*, which means "young female, girl." The Latin word was adopted into Old French as *femelle*, and then was adopted directly into Middle English with the same spelling.

In the late 14th century, the spelling changed because people thought it was a variation on the word "male." But it's not. The word "male" comes from the Latin word *masculus*, which is totally unrelated to the word *femina*.

When *masculus* entered Old French, it became *masle*. And when Old French words carried over into Modern French, they had a habit of dropping the *s* in certain circumstances and adding an accent. So *masle* became *mâle*, which yielded the English spelling "male."

The Latin *femina* is from a PIE root meaning "she who suckles." This root connects it to words like fetus, fawn, felicity, affiliation, and fellatio. But it doesn't share a root with the Latin words for man (*vir*) and male (*masculum*).

Masculum is an adjective form of *mas*, which described males of any species. *Vir* described male humans, and comes from a PIE root meaning "man," which is also the root of words such as virile, virtuoso, and virtue.

As for the word "woman": In Old English, the word for "man" was *wer*, and the word for woman was *wif*. The former is cognate with the

Latin *vir* and appears in the word "werewolf" (literally "man-wolf"), and the latter is the source of the modern word "wife" (*see* werewolf, in Chapter 10).

The word *man*, meanwhile, was more commonly used to mean "human" or "humankind," but much like today it doubled as a word for a male human.

While the Old English *wif* is the source of the modern word "wife," the Old English didn't specifically refer to wives, but to women in general. (Therefore a female werewolf could logically be termed a *wifwolf*.) Another variation was the word *wifman*, literally "woman human."

Over time there was some shuffling: *Wifman* shifted to become *wimman* and then "woman." *Man* became the standard word for a male person while also retaining that "humankind" sense. "Husband" replaced *wer* as the word for "married man" in the 1200s, and *wer* generally vanished except in "werewolf," which is tragic because "wer and wif" sounds much better than "husband and wife."

Curiously, it makes more etymological sense for husbands to be the ones who commonly care for the home because "husband" literally means "house-dweller" or even "house-peasant" (Old English *hus* "house" + *bondi* "dweller, peasant"). Over time the word somewhat illogically came to imply "house-master." (Yay, patriarchy.)

Guy

The word "guy" as a generic word for any man is from the men's name, Guy—and specifically Guy Fawkes. The name itself is from the Italian name Guido, which means "leader" and shares a root with the word "guide."

In case you've avoided recent popular media and the history of the Gunpowder Plot, Guy Fawkes was part of an effort by English

Catholic dissidents to bomb the House of Lords and assassinate the Protestant King James in 1605. This whole misadventure became the basis for Guy Fawkes Day, which began as a celebration of the failure of the plot with participants burning effigies of Fawkes. And it was a result of his infamy—at least according to Protestant royalists—that the name Guy became embedded into the English language. In the 1600s and 1700s, "guy" was a pejorative, meaning a "grotesque-looking or poorly dressed person."

Its derogatory sense faded with popular usage, especially after it entered American English in the 1840s. Separation from the historical event defanged the term.

But part of the reason that "guy" has been so genericized was that the word "gal" was already used as early as the 1790s as a casual alternative to the word "girl"—and English loves alliteration and parallelism, so gal and guy paired pleasantly in an aesthetic sense.

This isn't the first time a name has been genericized. "Jack" functioned similarly as early as the 1200s, and still appears in many English terms including jack-of-all-trades and jack-o'-lantern.

Handsome

This word typically refers to men today, but was once a compliment primarily reserved for women and animals. The ending -some implies either causality, a tendency toward something, or something done to a notable degree. As an example of the last, in the word "awesome," it initially implied something that inspires awe.

In the word "handsome," it suggests tendency: In the 1400s, the word originally meant "easy to handle" and therefore fit and agreeable to be a spouse (to be a wife, for example, though the term was also commonly applied to other agreeable creatures such as horses), which was extended to looks based on that suitability for marriage or purchase. The shameless objectification embedded in this word is absurd, but there's some wry humor to be found in the fact that the word is now more often applied to men.

Hysteria

Today, "hysterical," "hysteria," and "hysterics" have slightly different meanings: "Hysterical" can describe something funny or intense laughter itself; "hysteria" is usually associated with the phenomenon of "mass hysteria"; and "hysterics" describes uncontrollable negative emotions.

The base word is the Greek *hystera*, or "womb," and for much of history hysteria was given as a medical diagnosis for almost any kind of psychological distress in women—because it was believed to be caused by the uterus.

These are some of the 75 pages' worth of hysteria symptoms documented by American physician George Miller Beard (1839–82) in the mid-19th century: heartburn, anxiety, vertigo, headaches, choking, depression, poor attention span, jealousy, problems with the veins in the nose, laziness, egotism, death, uncontrollable laughter*.

This last one, uncontrollable laughter, is why we use the term "hysterical" to describe something funny or laughter itself—though that sense was rare until the 1930s and 1940s, when it started appearing in novels.

This concept has roots in ancient Greek medicine including the "wandering womb" theory, which suggested that many women's ailments were caused by the uterus moving of its own accord—and I'm not talking about light shifting around, which actually does happen. The second-century physician Aretaeus described the uterus as "an animal within an animal," advancing toward and fleeing from smells it likes or dislikes.

Plenty of physicians understood that this was utter bullshit, but the concept of the wandering womb lingered like a bad case of chlamydia (*see* Chapter 2) almost until the Enlightenment.

But the idea of crazed uteruses causing psychological distress remained frustratingly unkillable until the late 1890s, when experts like Jean-Martin Charcot (1825–93) and then Sigmund Freud (1856–1939) finally took an actual look at the psychological causes

* George Beard, "Neurasthenia, or nervous exhaustion," *The Boston Medical and Surgical Journal* 80 (April 28, 1869), 217–21.

of stress-related symptoms in women and girls. Obviously, they didn't get it all right (not even close), but at least it was a start.

This research was advanced by developments in psychology and gynecology, more women in the medical field, and the study of shell shock and (what we now know as) PTSD following World War I. Surprise surprise, men can suffer from psychological distress, too!

And obviously some people in power still attempt to claim that having a uterus prevents you from being a competent leader. So we still have a way to go.

Misogyny and Misandry

It's easy to associate "misogyny" and "misandry" with the Old English prefix mis-, meaning "bad" or "wrong," as in words such as "misnomer," "mistake," and "misapplication"—words that also indicate that a misapprehension (mis-apprehension) or error has occurred.

Instead, "misogyny" and "misandry," respectively meaning "hatred of women" and "hatred of men," use the unrelated Greek element *miso-*, which, logically enough, implies hatred. (*Gynē* means "woman" and *andros* means "man.") Perhaps predictably, "misogyny," whose predecessor *misogynia* also existed in ancient Greek, appeared in English over 200 years before "misandry," which is a modern construction from the 1870s, first attested in the U.K. publication *The Spectator*. (However, despite sharing the same roots as "misandry" and "misogyny," "misanthropy," "hatred of humankind" in general, appeared in the 1560s and does have an ancient Greek counterpart in *misanthrōpos*.)

The prefix miso- also appears in many less commonly used English words for various types of hatred that have surfaced over the years. For instance:

Misogamy: "hatred of marriage"
Misotheism: "hatred of God"
Misocyny: "hatred of dogs"
Misoneism: "hated of novelty"
Misology: "hatred of knowledge"
Misophonia: "hatred of sound"

Greeks also loved this prefix and had words such as *misoagathia*, "hatred of goodness," and *misoponia*, "hatred of work" or "laziness."

The Greek-derived opposites of "misogyny" and "misandry" and are "philogyny," meaning "love of women," and "philandry"—which ought logically to mean "love of men."

The words "philandry" and "philanderer" and the name Philander have, since the 18th century, been misinterpreted—perhaps intentionally in many cases—as implying "a loving (and therefore seductive) man" or a "womanizer," rather than its actual meaning, "love for humanity" or "love of men" (both in the sense of "men" as humanity and as a word for male persons).

Andros can, of course, mean "human" rather than "male person" in Greek in the same way that "man" can mean "humankind" in English. It is interesting, though, that in English it has so heavily become associated with the pursuit of women when in Greek that would not have been the case.

Paraphernalia

Today the word "paraphernalia" more or less means "odds and ends" or miscellaneous items. And that's what it originally meant, too, but it used to be more specific, and more gendered.

It literally means "beside the dowry."

Dowries exist—or have existed in the past—in many cultures around the world, each with their own rules, but in simple terms a dowry is money or property that's transferred from a bride and her family to a groom and his family when they are married.

Originally, "paraphernalia" was a legal term for everything that a woman brought with her to the marriage *besides* the dowry—the odds and ends that were actually hers and not part of the business transaction between the families.

The word was borrowed into English in the 1600s from the Medieval Latin phrase *paraphernalia bona*, or "paraphernal goods," and then it was extended to mean any collection of miscellaneous items starting in the 1700s thanks to that idea of "odds and ends."

Slut

This word, which has most often been applied to women throughout its history, originally did not carry a sexual connotation. Starting in the late 1300s, someone called a "slut" was grimy, slovenly, messy, or idle—most often a woman, though one of the earliest known references is in Chaucer's *The Canterbury Tales*, when he uses the word "sluttish" to describe a slovenly man in the Prologue to "The Canon's Yeoman's Tale":

> Why is thy lord so sluttish, I thee pray,
> And is of power better clothes to bey

The word "sluttery" is recorded starting in the late 1500s as a word describing an untidy living space.

A bit later, it was used to describe women of lower classes, or in the playfully insulting way one might use the word "scamp" for a child, as in this reference from the diary of Samuel Pepys (1633–1703), known for his writing and his role as a naval administrator:

> My wife called up the people to washing by four o'clock in the morning; and our little girl Susan is a most admirable slut, and pleases us mightily, doing more service than both the others, and deserves wages better.
>
> Sunday, February 21, 1664

In fact, it didn't fully take on its sexual sense until the 20th century—though in some instances there was the suggestion that a woman who is untidy might also have loose morals.

Its exact origin isn't known, but it is a Germanic word and is likely related to words like the German *Schlutt*, also a "slovenly woman," and the Dutch *slodde* and *slodder* for "loose women" and careless men, respectively.

In the 15th century, the word *sloven* was used in much the way "slut" is today, though it more broadly described an immoral woman. It's related to other pejoratives in other Germanic languages, including

the Middle Flemish *sloovin* (a woman who is a "scold"), German *sloven* ("put on clothes carelessly"), and Dutch *slof* ("careless, negligent").

Similar words in English that likely influenced one another include "slattern," "slummock" (a 19th-century word for an untidy person), and "slammakin" (an 18th-century word for a loose-fitting dress).

 ## MORE INSULTING WORDS FOR WOMEN WHO HAVE SEX

Bimbo

First the name of an alcoholic beverage (1830s), also a proper name for racehorses, dogs, monkeys, elephants, and jesters (1860s–90s), and apparently an actual surname noted in vaudeville. Also, unrelated, an Italian word for a small child or doll, probably from *bambino*. In the early 1900s it was a word for a stupid person, but especially a man. It wasn't applied to women until just before the 1920s, a sense popularized by Jack Conway of the theatrical trade paper *Variety* and by the Frank Crumit song "My Little Bimbo Down on Bamboo Isle."

Floozie

First appeared around 1902, and thought to be an adaptation of *flossy*, which meant "fancy" or "frilly," likely thanks to a kind of silk called floss.

Harlot

In the 1200s a word for a male vagrant or tramp, from the Old French *herlot* or *arlot* of the same meaning. In the 1300s and 1400s it was often used for performers, especially of the clownish variety. It was applied to women and their sexuality in the 1500s, a usage reinforced when it was included in 16th-century translations of the Bible.

Hussy

Originally not insulting, but in fact simply a 16th-century contraction of the Middle English *husewif*, or "housewife." As a result it was pronounced "huzzy" until the original meaning was lost and the pronunciation adapted to the spelling. It remained a nonpejorative term for women and girls until the mid-17th century, when the term "pert hussy" became

popular first for a woman who talks back or behaves improperly. The phrase was shortened over time, and a century later all that remained was the insult.

Skank

A relatively recent term, showing up in the mid-1900s, maybe a spinoff from "skag" which has variously been a nickname for cigarettes, heroin, and sexually active women.

Tramp

From the German *trampen*, "to stamp, walk heavily," first the name of the action of heavy walking in English (1300s), then a nickname for a vagrant (1600s), then for a promiscuous woman (1900s), presumably based on walking the streets or sleeping her way "around the block."

Spinster

Originally a word for a woman who spins thread for a living, "spinster" is structured in the same way as words like "teamster" or "punster"—it's the word "spin" with a feminine agent noun ending. Its association with women who never marry (especially, but not exclusively, those of non-noble birth) is based on the tradition that those who are unwed should take up a "women-appropriate" profession such as spinning.

The -ster ending was originally an Old English suffix that specifically referred to actions and professions of women, corresponding to the masculine ending -er (e.g., butcher, cobbler).

In Middle English, a seamstress was called a "sewster," a "whitester" was a woman who bleaches cloth, and "webster" was a woman weaver.

Indeed, the Old and Middle English surnames Webster, Brewster, and Baxter (literally bake-ster) all very possibly first denoted tradeswomen, because those trades—weaving, brewing ale, and baking—were often performed by women. Meanwhile, their male counterparts would be Weber, Brewer, and Baker, which are also common names from that

era. (It is a topic of some debate among linguists whether the surnames Webster, Brewster, and Baxter were originally meant to be feminine, because—as is unsurprisingly often the case, given patrilineal naming conventions—there are more records of men with those names and in those professions from that time period. But it would be unusual for a word at that time to use the ending -ster and *not* have an association with women. They would have *sounded* feminine at the time.)

The mildly pejorative edge in "spinster" also appeared in Middle and early Modern English words for women such as "chidester" and "scoldster."

The ending lost its association with women starting when it began to be displaced by the French-derived ending -ess (e.g., actress, seamstress) and the Latin-derived -trix (e.g., dominatrix), while the previously masculine ending -er ending became more gender-neutral.

Once the ending was more firmly gender-neutral in the 1600s and 1700s, it was tacked on to all sorts of words—a "rodster," for example, was another word for an angler of any gender, a gamester was a person who gambles, and, before it was the name of a car, a "roadster" was a person or a horse who travels frequently.

Twat

This word has been a general term for the female pudenda since the 1600s, perhaps implying the area between ("twixt") the legs. It was extended as a general, all-purpose insult much in the way "dick" and similar words have in the early 20th century.

Wench

This is basically the Middle English equivalent of calling grown women "girls."

In the 13th century, a *wenche* was a girl or unmarried woman, or even a baby girl. It's a shortening of the Middle English *wenchel*, meaning "child," most often a girl. Its Old English predecessor, *wencel*, is thought to mean "unsteady," "fickle," or "weak," from a PIE root meaning "to bend."

Given that it has always functioned in a diminishing capacity, it's no surprise that by the 14th century it had evolved into a pejorative, insinuating a woman of lower class or rank who may also be less than selective with her sexual partners.

But wait—there's more! Add some racism to the mix: "Wench" was popularly used in the American South during the 1800s as a word for a Black slave girl or woman of any age.

DEFYING EXPECTATIONS: "RULE OF THUMB" WASN'T ORIGINALLY ABOUT DOMESTIC ABUSE

Folk etymology can occasionally infuse perfectly innocuous terms with a more horrifying history than they originally had. One such theory is that the phrase "rule of thumb" derives originally from laws that allowed husbands to beat their wives with whips or sticks if they were smaller than the width of a thumb.

Horrible, right? But legal experts believe that no such law containing that phrase ever existed.

In truth, the first known usages of the phrase "rule of thumb" are in reference to measuring other stuff and not for violent purposes. For example there's a 1685 reference to the phrase "rule of thumb" criticizing foolish builders who build "by guess and by rule of thumb and not by square and rule."

That said, the phrase did later become associated with domestic violence, and that association was then perpetuated by lawyers and wound up in legal documents.

By the late 1600s in England, spouses already had some protections against domestic violence, sometimes called "security of the peace." The law said that women could leave abusive husbands, and more official protections were introduced in the 1860s. Obviously, spousal abuse existed and continues to exist, and there are many cases in which abusers have been

acquitted despite those laws. But in the earliest laws that allowed "moderate physical corrections," no mention of measuring sticks with thumbs has been found.

In the 1700s, an English judge named Sir Francis Buller supposedly said that a husband could beat his wife with a stick no wider than his thumb, but a) he did not say so in the context of making a law or deciding a case and b) there's no record of him actually saying it at all. Whether it was a rumor or not, the reason we know about it today is because the comment was picked up by the satirical press, and he was absolutely lambasted for this apparent statement because it was, of course, cruel and ridiculous. They even called him "Judge Thumb."

But don't worry, the American legal system saw all of this happening across the Pond and said, "Hold my beer."

There are American court rulings from the early 1800s that refer to an "old common rule law" involving sticks and thumbs. Trouble is, none of them ever cite what this ancient doctrine actually was—but that didn't stop it from impacting actual cases.

In the 1820s, a ruling in Mississippi said that a man could enact "domestic discipline" against his wife by striking her with a whip or stick no wider than the judge's thumb. In the 1860s in North Carolina, a man was acquitted for hitting his wife with "a switch about the size of his fingers."

This is all obviously awful, and "wife beating" was not officially illegal in all U.S. states until the 1920s. (Sigh.) But in none of these situations did the actual phrase "rule of thumb" appear, and the phrase did not exist in any resulting laws.

It was actually reports about domestic violence in the 1970s and 1980s that officially, albeit incorrectly, associated the phrase "rule of thumb" with problematic laws of the past.

The biggest one was a 1982 report by the United States Commission on Civil Rights which uses the heading "Under the Rule of Thumb" in a section on domestic violence.

Since then, both legal scholars and domestic rights advocates have tried to discourage the use of the phrase "rule of thumb" in legal contexts related to domestic abuse due to the fact that it was never truly a codified parameter limiting the severity of domestic violence.

✍ More Words That Are Surprisingly Less Etymologically Problematic Than They May Seem

Niggard(ly)

Given what it sounds and looks like, I would not recommend saying this one, origin be damned, but etymologically it does not have any relation to racist slurs. This word is from the 14th-century word *nig*, which meant "stingy" with the pejorative -ard suffix tacked on (*see* bastard, in Chapter 4).

Sir

There's a commonly cited myth that "sir" is an acronym for "slave I remain," referencing the fact that knights pledged fealty to kings and suggesting that "sir" is a reaffirmation of that pledge.

This is a historical impossibility. Not only does this word pre-date nearly every acronym by hundreds of years but, beyond that, "sir" is recorded in English roughly three centuries before "remain."

The truth: "Sir" as a title for a knight is first recorded in the 1200s or 1300s. Originally, it was a variation of "sire," which denoted knighthood before it was a term of respect for a king. It has always been a term of high rank and is ultimately from a root meaning "senior" or "elder."

———

CHAPTER 6

ANYTHING YOU CAN DO . . .

ABLEISM AND THE STIGMATIZATION OF MENTAL HEALTH

'But I don't want to go among mad people,' Alice remarked.
'Oh, you can't help that,' said the Cat: 'we're all mad here. I'm
mad. You're mad.'
'How do you know I'm mad?' said Alice.
'You must be,' said the Cat, 'or you wouldn't have come here.'
 Lewis Carroll, *Alice's Adventures in Wonderland* (1865)

Historically, the English language has a rocky track record of describing mental and physical differences with respect, often using extremely broad strokes or otherwise blatantly stereotyping and stigmatizing people with physical and mental disabilities, as well as neurodivergent people.

Many words that have, in the past, been clinical terms for physical and mental illnesses and disabilities have devolved into insults and offensive terms, largely because people weaponize them against people with the conditions they describe. Another factor is a continued shift toward precision in describing conditions as they are differentiated from one another over time.

For instance, a condition described as "madness" in the 18th century may have been any number of psychological conditions, as serious as debilitating schizophrenia or as mild as a short-lived spell of anxiety. These labels have also been used to control and marginalize people with disabilities, women, racial and ethnic minorities, and more.

The collection of origins in this chapter is far from a comprehensive list, but focuses on many of the most nefarious, intriguing, and, dare I say, *mad* facts about the words we use for disabilities and multifaceted mental states.

Ambivalence

When you have mixed feelings about something, we say that you are "ambivalent."

The word "ambivalence" was coined by Swiss psychiatrist Paul Eugen Bleuler (1857–1939) in 1910 as a medical term. Bleuler formed the word from the Latin elements *ambi-*, which as we know from the word "ambidextrous" means "on both sides," and *valentia*, meaning "strength." *Valentia* is related to words like valid, valor, value, and valence.

As he did with many psychological terms, Austrian neurologist Sigmund Freud (1856–1939) popularized the word "ambivalence," and added his own ideas to the concept—which Bleuler was pretty ambivalent about.

Bleuler associated ambivalence with **schizophrenia**, a word which he also coined using Greek components that together mean "a splitting of the mind." Unfortunately, Bleuler believed schizophrenia to be a completely incurable physical disease and advocated for people diagnosed with it to be eugenically sterilized.

He also coined the term "autism," which he used to refer to symptoms that he believed were caused by schizophrenia. The meaning of "autism" changed in 1938 when it was adopted by Hans Asperger (as in Asperger's syndrome), who applied it to child psychology.

Conniption

This word and the phrase "conniption fit" appeared in the 1800s as a word for a moment when a woman lost her temper or expressed intense emotion that earned the label "hysteria" (*see* "hysteria"). Its use has always been pejorative and often sexist, with nonclinical usage often describing "nagging" women. It was later applied to people with epilepsy or experiencing mental or physical health crises. It's probably a creative spin on "captious" (prone to finding fault) or "corruption," which was often used as a synonym for "anger" in the 1800s.

Coprolalia

This word refers to an obsessive and/or compulsive use of obscene language, and more or less means "dung-talk," from the Greek elements *copro-* "dung, filth" and *lalein* "to speak, prattle." It was coined by a person whose name is closely associated with the condition: French neurologist Georges Gilles de la Tourette (1857–1904). Despite the prevailing stereotypes, only a small percentage of people with what is called Tourette's syndrome today also suffer from coprolalia.

Crazy

When it first arose in the 1500s, "crazy" was a word for physical diseases and ailments, with a secondary sense of something "broken" or "full of cracks," and was not generally used for mental states. It wasn't until the 1600s that this sense of brokenness or crackedness extended to mental distress or mania.

The base word here is, of course, "craze," which is much older as a verb, appearing in the 1300s as *crasen*, meaning "to shatter or crush."

The "broken" sense still remains in the term "crazy quilt" which is recorded as early as the 1800s and suggests the scrap pieces from which it is made, as well as "crazing" in pottery, which results in a crackled pattern in glaze.

Additional fact: In the mid-1800s, the tingling feeling that shoots down your arm when your ulnar nerve is abruptly pressed against your humerus in your elbow, often called hitting your "funny bone," was called hitting your "crazy bone."

✑ More Words Used to Pejoratively Describe Mental Unwellness or Emotional Intensity

Nuts, nutty, 1785, originally in the sense of intense fondness (i.e., "nuts for someone/something"), intensified to reflect the same sense as "crazy" in the mid-1800s.

Psycho, 1920s, first used as a nonpejorative shortening of "psychological," then within the next decade, a shortening of "psychopathic," whose Greek roots give it the meaning "suffering in the mind."

Spaz, mid-1900s, short for "spastic," an 18th–19th-century medical term for a person who suffers from spasms.

Deranged, 1790s, past participle of the earlier verb "derange," which meant "to create confusion" or "to disorder."

Cuckoo, kooky, both 20th-century terms in this sense, likely from the repeating call of the cuckoo bird.

Batty, early 20th century, short for "bats in one's belfry," suggesting an empty or scattered.

Demented, 17th century, past participle of the 16th-century verb "dement" (Latin *de-* + *mens* "mind") meaning "drive mad." "Demented" originally meant "affected by dementia" but, given the madness implied in "dement," quickly became associated with insanity as well.

Screwy, 1820s, first used to describe a state of drunkenness, with the psychological sense following later in the century and implying a similar degree of "not-rightness."

Bonkers, 20th century, first meaning "tipsy," then "crazy" based on a comparison to having been hit over the head.

————

Crippled

In addition to its problematic tendency to reduce someone with a physical disability to their differences or distinct way of moving, this word also fundamentally reduced someone to a beastlike status. Someone called "cripple," or *crypel* in Old English, was literally a noun for "one who creeps," from the Old English *creopan* "to creep." It was primarily used to refer to animals and creatures that lived in low openings and burrows.

Related: One explanation for the name of the street gang alliance known as the Crips is that it gets its name from the word "cripple," thanks to members' penchant in the early 1970s for carrying so-called "pimp canes" as status symbols and weapons. Another theory

* "Crips," *Britannica*, www.britannica.com/topic/Crips

is that it is a portmanteau of "crib" as a word for "home" and "RIP," or "rest in peace."*

Deaf

This word, which was spelled the same in Old English, originally was not only limited to loss or lack of hearing—though that was a common implication. Its other sense was "empty" or "barren" more broadly. (In Old English, "deaf" rhymed with "beef," a pronunciation that persisted until the 1700s.) In Middle English, it had already taken on the sense of deliberately not listening, as in "falling on deaf ears" or "deaf to" a particular topic. Deaf or hard-of-hearing nonverbal people, who were called "deaf-mutes," were sometimes included in sideshows and fortune-telling performances, possibly because they were able to navigate their environments using their other senses and communicate nonverbally using gestures.

Delirious

To say someone is delirious or in a state of delirium is the classical equivalent of saying someone is "off the rails." The Latin noun *lira* means "furrow," so the verb *deliriare* is literally "to go off the furrow" and was used in reference to mental illness.

It appears in medical terminology starting in the 1800s in the writings of British physician Thomas Sutton (1767–1835), who used the term *delirium tremens* to describe a "trembling delirium." He and subsequent medical practitioners connected the condition to alcohol abuse … but also suggested opium as the treatment, which obviously worked great with no adverse consequences whatsoever.

Other names for "the shakes" from alcohol abuse include barrel-fever, gallon distemper, blue Johnnies, bottle ache, pink spiders, quart-mania, snakes in the boots, triangles, uglies.

Dumb

This word is thought to ultimately come from a PIE root meaning "dust, mist, or smoke," though the word itself is recorded with the

same spelling in Old English first as a word for muteness, either by choice or due to a medical condition. The root also seems to imply the sense of being in a physical or mental haze or being muffled. Mute, which was spelled *mewet* in Middle English, was similarly a word for silence by choice or for medical reasons, and is ultimately from the Latin *mutus* "silent, speechless, dumb." In the 1600s obmutescence was an alternative term for staying silent by choice and literally means the act of "growing mute against (something)." The practice was prevalent enough among religious people that it warranted a word.

Animals were also often called "dumb," because they lacked speech—which, in turn, was taken as evidence of their lack of intelligence. This is what ultimately gave "dumb" its insulting sense, implying "stupid."

Dunce

This word has been an insult since the 1570s—but it originally didn't imply someone lacking in intellect so much as someone overly pedantic or who employs logical fallacies. The word comes from the name of Scottish scholar and priest John Duns Scotus (1265/66–1308) who gained academic followers called Scotists, whose influence upon medieval philosophy and theology lasted for the next few centuries. Duns (now in the Scottish Borders) is the name of the town where he was born, and his most devoted followers came to be called "Dunsmen."

Scotus and the Dunsmen were well known for their pointed hats, which were said to stimulate thought, acting as a reverse funnel for wisdom.

In the 1500s the humanist movement took issue with their approach, which relied on complicated, metaphysical logic that seemed outdated for the time. Thus, the Duns came to be associated with backward, archaic reasoning—and therefore lacking in intelligence, resulting in the word "dunce" for people deemed to be slow-witted.[*]

[*] "dunce, n.", *OED* Online. December 2022 (Oxford University Press).

The first known mention of a "dunce cap" is in Charles Dickens's 1840s novel *The Old Curiosity Shop*:

> Displayed on hooks upon the wall in all their terrors, were the cane and ruler; and near them, on a small shelf of its own, the dunce's cap, made of old newspapers and decorated with glaring wafers of the largest size.

However, the hats clearly predate the book and are thought to mimic the hats of the Dunsmen.

Dickens and his popular serialized novel may have made the punishment more popular, though, because they were a common Victorian form of punishment, and the practice persisted at least until the 1950s in both Europe and the U.S.

Fool

This word has been on quite the ride. It's originally from the Latin *follis*, a word for a bellows or a leather bag. In Vulgar Latin it was applied to people who might be called "windbags" today—lots of talk and little substance—which then came to mean someone whose head was similarly empty.

In Old French it retained these senses and was also applied to court jesters who behaved in an eccentric, silly, or "mad" way for entertainment—or, more darkly, who were considered entertaining because of real psychosocial disabilities. This complexity—humorous wittiness blended with madness and mischievous misbehavior—contributed to the fools of Shakespearean lore and beyond, whose banter cuts through the more dramatic characters' lack of self-awareness for the benefit and entertainment of the audience.

This would make the original notion of "fool" that of someone with a disability, though an alternative theory suggests that it's inspired by a sense of "puffed cheeks" (Latin *folles*), which would make the "jester" sense the earlier one. It became a much more insulting word in Modern English, though in Middle English it was also applied to rascals and sinners, albeit more gently.

Frail

This word is from the Latin *fragilis*, which means "easily broken" and is—perhaps obviously—the source of the word "fragile," which itself is directly borrowed from French. On its journey through Old French, "frail" (or *fraile*) was applied to humans, implying physical weakness and sickliness, but when it entered English, its first recorded sense described a moral weakness, typically in religious contexts—though the sense of both physical and mental weakness or lack of development followed shortly thereafter.

It has been broadly used to diminish people of smaller builds and heights, as well as ages, for generations, from Shakespeare's "Frailty, thy name is woman" (*Hamlet*, Act 1, Scene 2, line 146) to the sense commonly applied to older individuals.

This is, of course, absurd—most people wouldn't stand a chance against Grammy in wrangling a garden to her will or educating a classroom in home economics, from personal finances to baking to the perfect job interview.

Frenzy

"Frenzy" is similar in structure to "frenetic"—and that's no coincidence. A "frenzy" is quite literally a "frenetic" state. Both are ultimately from the Greek *phrenitikos*, which similarly described mental diseases and a state of mental franticness, and which literally means "an inflammation of the brain." It is made up of the elements Greek *phrēn* "mind, reason" and the ending *-itis*, which appears in the English names of many afflictions such as appendicitis or tendonitis because it means "inflammation" or "swelling."

Handicap(ped)

This word, which is generally not used by people in disability communities to describe themselves, is from the 17th-century phrase "hand in cap," the name of a betting practice used for setting the odds for a wager, first described (though not by that name) in the Middle English narrative poem *Piers Plowman* (ca. 1377?) by William Langland.

In *Word Myths: Debunking Linguistic Urban Legends*, author David Wilton explains how it works:

> Two bettors would engage a neutral umpire to determine the odds in an unequal contest. The bettors would put their hands holding forfeit money into a hat or cap. The umpire would announce the odds and the bettors would withdraw their hands—hands full if they accepted the odds and the bet was on, hands empty if they did not accept the bet and were willing to forfeit the money. If one bettor forfeited, the money went to the other bettor. If both agreed on either forfeiting or going ahead with the wager, the umpire kept the money as payment.*

"Handicap" was extended to refer to the practice of equalizing disadvantages in sports when this betting practice was applied to horse racing: In a "handy-cap match" as early as the 18th century, a better horse would carry extra weight, or a "handicap," reflecting the unequal odds of the earlier "hand in cap" game.

That sense of encumbrance or disadvantage was applied to people with disabilities only in the early 20th century.

Idiot

Like many insults that focus on intelligence or cognitive development, this term was not originally exclusively a pejorative. It is derived from the Greek *idiotes*, which was a word for a layman or someone without a progressional skill such as that performed by an artisan, writer, philosopher, soldier, or politician. Its literal meaning is "private person" and seems to have carried an "everyman" connotation for the most part. This sense extended to the Latin *idiota* "ordinary person, layman," then to Old French "layman, uneducated person," and then to Middle English, "uneducated person, layman."

However, despite its otherwise neutral usage in many contexts, in Greek, Latin, Old French, and Middle English it was *also* used as an insult for an ignorant person.

* David Wilton, *Word Myths: Debunking Linguistic Urban Legends* (Oxford: Oxford University Press, 2004).

Still, its usage in neutral and even legal contexts persisted for centuries: For many years according to English law, an "idiot" was someone who was born with a mental disability, while a "lunatic" was someone who exhibited mental illness or disability later in life.

Imbecile

This word, which was used starting in the mid-1700s for people with mental disabilities, intellectual and developmental delays, and differences in learning style, first appeared in the 1500s as an adjective meaning "weak" or "feeble" (not specifically in the mental sense, and indeed, more often in the physical sense). Although some experts consider it to be "far-fetched," one popular suggestion is that the word is an assimilated form of the Latin prefix *in-* (as im-) "not" combined with *baculum* "walking stick," giving "imbecile" the sense of "without a walking stick."

The shift to the mental use of "imbecile" occurred in the 1700s, building on the notion of someone who is "feeble-minded." At the same time, a similar shift happened with the word "frail" which was used for both physical and mental infirmity (*see* frail).

Much like "idiot" and "moron," "imbecile" was used in clinical contexts through the 1800s. Generally, an "imbecile" was defined as someone who is as intellectually developed as a six- to nine-year-old, and was considered to be more intellectually advanced than an "idiot" but not as advanced as a "moron"—all of which, of course, have turned into pejoratives as the study of mental disabilities and psychology has grown more nuanced (*see* moron).

✑ Additional Words Referring to Intellectual and Mental Developmental Disabilities

Daft, 13th century, originally meaning "gentle" or "mild," but extended to mean "soft-witted" or "dull" within the following two centuries. Also used to mean "insane," based on the notion of a "fool" being either witless or witty, but eccentric in speech. Also the inspiration for "daffy" as an insult for insanity.

Derp(y), a 21st-century term mocking people with intellectual disabilities based on the cruel mimicry of some speech patterns.

Mouthbreather, early 20th century, originally describing a child
with a condition that resulted in them breathing through their
mouth, their jaw hanging open, then extended to a schoolyard
insult for people who were considered unintelligent.

———

Irrational

This word started out as a fairly innocuous way to describe the sup-
posed difference between humans and animals, implying that ani-
mals are "irrational," or literally lacking the ability to reason (*ir-* "not,
opposite of" + *racional* "pertaining to reason").

As you can imagine, then, its application to humans was problem-
atic from the start because it implies that a person who is irrational
is beastly or has the mental capacity of an animal. This sense, which
began in the 17th century, persisted and evolved with modern phi-
losophy and psychology as scholars sought to make sense of violence,
war, and mental instability.

Lame

This word, which existed in Old English as *lama*, described—both
then and into Middle and Modern English—any type of weakness,
paralysis, or physical disability that caused difficulty walking and
moving. Its PIE root, which means "broken," connects it to the word
"lumber," which was a verb meaning "to move clumsily" (as if lame)
before it was used for logs and wood, an extension suggesting some-
thing disused, heavy, or useless.

The implications folded into these words make it clear why the
casual sense of the word "lame" to mean "uncool" is considered
ableist by many people with physical disabilities now.

Lunatic, Lunacy, Loony, Moonstruck

All of these words imply mental states—typically of the less-than-stable
variety—influenced by phases of the moon. Someone who is a "luna-
tic" or experiencing "lunacy"—or is pejoratively called a "loony"—is

said to be impacted by insanity during the full moon, ultimately from the Latin *luna* "moon." The concept also existed within Latin, with the word *lunaticus* meaning the same thing—"moon-struck" (literally influenced by the moon)—a phrase that in Old English was rendered more literally as *monseoc*, "moon-sick," or *monaðseocnes* "month-sickness." The modern English "moonstruck" is recorded somewhat later, and is first attested in Milton's *Paradise Lost* (1667). (German, Greek, and many other languages also associated both mental illness and distress, as well as epilepsy, with the moon.)

As a result, lunacy was often associated with women due to the monthly rhythm of menstruation and the association of the moon with femininity. (For more ways men go out of their way to call women crazy, *see* "hysteria.")

"Lunatic" (ca. 1200s, from Old French *lunatique*) is older than the noun "lunacy" (1500s) which was used in legal contexts to describe the state of people who were mentally unable to manage their own affairs.

The variation "loony" first appeared in American English as a shortening of "lunatic," perhaps with influence from the bird called a loon, which is from an unrelated Scandinavian source.

Mad(ness)

This word, whose original sense described someone with a mental illness or the perception of one—or the sense we typically see in the word "crazy" today—is a shortening of the Old English word *gemædde*, literally meaning "out of one's mind," often with excitement or distress. The Old English word is ultimately from the Germanic element **ga-*, an intensifier, and PIE **mei-* "change," suggesting someone who is "made changed" in personality or mental capacity.

In 1781 Founding Father John Witherspoon (1723–94), president of the College of New Jersey (now Princeton University), objected to the use of "mad" as a synonym for "angry" in an essay about "Americanisms." His timeline was incorrect, however: "Mad" had been used this way since the 1300s, with its "angry" sense implying that one is out of one's mind with rage.

Mania

The word "mania" is, very simply, a borrowing from the Greek *mania*, meaning "madness," originally from the Greek verb *mainesthai*, "go mad," and from the root *mantis* "seer," suggesting soothsayers' use of psychoactive concoctions to incite visions. (As usual, it all comes back to drugs. See Chapter 3.)

"Maniac" emerged later, in the 1600s, as an adjective describing people experiencing mania or madness, with influence from the French *maniaque* (which was also the original English spelling). This word became a noun for someone influenced by mania in the 1700s.

The variation "manic" was introduced in the early 1900s in medical psychological vocabulary in terms such as manic depressive, which were first used around the same time.

Moron

Despite some popular claims to the contrary, the word "moron" is not thought to be related to the word "Moor," a word for people from North Africa and was often applied broadly to anyone with dark skin.

"Moron" is from the Greek word *mōros* "foolish, dull, sluggish, stupid" and had no particular racial connections. "Moron" is, however, ableist: It was used in clinical and academic settings to refer to people with psychosocial disabilities as recently as the early 1900s.

That said, the word "maroon," which is unrelated to "moron," is absolutely racially charged (*see* maroon, in Chapter 5).

Ninny

This word is thought to be short for the word "innocent" and was applied liberally to people with cognitive disabilities (and other people who were thought to simply be acting foolish) in the 1600s. It may also have been influenced by the Italian *ninno* or Spanish *niño*, both words for babies and children.

Retard(ed), Retardation

This word is composed of the Latin *re-*, here meaning "back" and *tardare*, meaning "to slow." For many years this was considered a

neutral term. The verb "retard" (with the emphasis on the second syllable) means "to make something slower" or "to hinder or delay." (Indeed, the word "tardy" has the same root.) So, for example, to retard someone's progress along a path is to prevent them from following it.

This usage has grown less common as the participle "retarded" has become associated with mental disabilities and been twisted into a pejorative by those with ill intent. The mental sense is meant to be more or less the same, suggesting the development of skills at a different pace than average, and starting in the early 1900s it (along with "retardation") was a psychological term used in childhood development research for people whose educational progress is slower in areas than their peers.

Only after the 1960s did its popular usage—as well as more robust understanding of neurodivergent and disability-centric learning styles—prompt the psychological community to shift fully away from the term.

Stupid

"Stupid" is from the Latin *stupere* "to be stunned or amazed." The implication in the Latin adjective *stupidus* was simply to be struck silent with awe (as "in a stupor" or "stupefied"), and it was in French and then 16th-century English that it was applied as both an insult and a means of describing people whose rates of cognitive development are deemed to be slower than average. That said, the word is also recorded as recently as the 18th century with that same sense of being stunned by strong emotion or surprise.

In Old English, the most common words for the way we currently use stupid (as an insult) included the word *unwis*, the predecessor to the now gentler term "unwise," as well as *dol*, the predecessor to "dull." "Foolish," which is ultimately from the Medieval Latin *follus*, took over in the 1300s.

CHAPTER 7

INTOXICATING ETYMOLOGY

DRUGS, BOOZE, AND BEYOND

It is a rare man who will walk five blocks for a first-rate meal.
But it is equally a rare man who, even in the old days of
freedom, would not walk five blocks for a first-rate cocktail.
To-day he would walk five miles.

H. L. Mencken, *Prejudices: Second Series* (1921)

We've ventured into some dark places with this book so far. Let's liven things up with a drink or two, shall we?

Humans have a complicated relationship with drugs and intoxicants.

Some make for a calming night at home or a riotously enjoyable evening with friends and family. Some are life-saving treatments that sometimes come with life-changing side effects. Some are an escape from the trials of existence that can have serious consequences.

We haven't been the best at differentiating among these factors: Often we overindulge, resulting in deep and damaging addiction. Sometimes clinical trials and testing fail to unveil the negative outcomes of drugs meant for treatment, resulting in drug epidemics. And sometimes politics and capital gains result in the arbitrary control of some substances, but not others.

But substances sure can be a good deal of fun—and the words for them offer a delectable tasting for the curious etymellier.

So cleanse your palate, pick your poison, pour a pint, take a hit, and enjoy.

Cheers!

Absinthe

This French word is short for *extrait d'absinthe*, meaning "wormwood essence (or extract)." The green liqueur was distilled from wine mixed with wormwood, which contains a chemical known as thujone that can be poisonous but may cause hallucinogenic effects in lower concentrations. Wormwood was also often called *absinth* in the 1500s in English. The word "absinthe" itself is probably ultimately Persian, but came to English via Greek and Latin.

Alcohol

Like several words in English beginning with "al-," the word "alcohol" is from Arabic, wherein that syllable functions as the definite article "the." Therefore, alcohol is *al-kuhul*, or "the kohl," a substance used as dark eye makeup up to 5,000 years ago, historically made of antimony sulfide or lead sulfide.

Kohl was produced through the sublimation of the mineral, which yields a powder deposit.

Sublimation produces a vapor from the mineral which then deposits as a powder—considered the "essence" or "spirit" of the mineral. From there, European alchemy borrowed the term "alcohol" to refer to fine powders and other products similarly produced by sublimation.

This process was compared to the distillation process starting in the 16th century, when "alcohol" was applied to fluids obtained by distillation, including "alcohol of wine" or ethanol—eventually becoming the word "alcohol" we're familiar with today.

In the 1600s the word "alcohol" also referred to volatile liquids such as ether. Although it was first used in the context of wine and its intoxicating effects, the English sense of "alcohol" is meant to imply that alcoholic beverages of any kind are the purest "spirit" of a liquid.

Ale

This word has been part of the English language since its earliest days. It's from the Old English *ealu*, which referred to any type of ale

or beer and is thought to be from a PIE root meaning "bitter"—or perhaps from one that subtly implied possession or sorcery (a connection to intoxication).

According to historian Peter Mathias, "ale" referred to "unhopped fermented malt liquor" native to England until the 17th century, while "beer" was hopped and from the Continent. Even long after the two were conflated (and then "ale" taken in a different direction in the modern craft brew space), "beer" tended to be the term for the beverage enjoyed in town, while "ale" was brewed in the country.

✑ A Drunken, Deceptive Word: Bridal

"Bridal" is lying about being an adjective. It actually means "bride ale."

We have the noun "bride," and we have the corresponding adjective form "bridal." And we have the noun "groom" and the adjective form ... "groomal"?

We do not have the adjective form "groomal."

And the reason we do not have this word is because the adjective "bridal" has been *lying* about being an adjective for 800 years. This word looks for all intents and purposes as if it is the Old English–derived word "bride" with the Latin and French-derived adjective-forming ending -al on it. Just like "logical," except this isn't.

So what's the truth? "Bridal" doesn't have that suffix on it. It doesn't have a suffix at all. Well, in a sense it does, because it functions that way now. But it didn't originally.

Instead, it was a noun—and a compound word. Before the 1200s, a "bridal" was a wedding feast. You might attend a bridal, an event that gets its name from this Old English word, literally meaning "bride ale" (Old English *brydealo, bryd ealu* "marriage feast," literally "bride ale").

In Middle English, when French and Latin-derived words and word-forming elements flooded into English courtesy of the Normans, along with that -al ending, people looked at the compound noun "bridal" and very understandably thought it looked a lot like an adjective—so they made it one.

Ayahuasca

Today, many Western ayahuasca users journey into deserts and other natural environments to experience spiritual and often psychedelic enlightenment. The name of this psychoactive concoction is borrowed from the Quecha family of languages, spoken by indigenous people of Bolivia, Chile, Colombia, and Ecuador. Its components, *aya* and *waska*, variously give it the meaning "soul-vine" or "vine of the dead," with many translations calling it specifically "liana of the soul" or "liana of the dead," where liana is the name of the category of woody vines to which the ayahuasca plant belongs.

Beer

Beer is thought to be older than tanned leather, irrigation, and sailboats, with evidence of the beverage being brewed 13,000 years ago near Israel. It's the third-most popular beverage in the world, after water and tea, and variations have been produced for millennia on six continents.*

But much like any topic addressed in a group setting over beers, this word's history is bubbling with debate, with its most likely origin lying in the Latin *bibere*, "to drink," which was adopted into Germanic languages in the sixth century. (The predecessor to "ale" was primarily used for beers prior to that point.) An alternative but less likely theory is that it could be from a Proto-Germanic root meaning "barley."

* Max Nelson (2005). *The Barbarian's Beverage: A History of Beer in Ancient Europe.* London: Routledge.

Booze

This word looks and sounds like a neologism, but it has existed since Middle English as *bous*, a word for any liquid intoxicant, and originally comes from the Germanic word *buse*, a word for a cup or vessel for imbibing such liquids. It wasn't fully popularized until the 1800s, and the *z* spelling may have been influenced by the name of Edmund Booz, a popular Philadelphia-based distiller who opened the E. G. Booz Distillery in 1840 and first manufactured the iconic Log Cabin Whiskey bottle. The first appearances of "booze" in poetry imply that it was originally meant to rhyme with "carouse."

Brandy

This word is more specific than it was in the past, for while it refers to distilled wine now, it was once a word for spirits distilled from pretty much any liquor. It's a shortening of the full phrase "brandy-wine," which is from the Dutch *brandewijn*, meaning "burnt-wine," with the "burning" referring to the distillation process.

Carouse

The now obsolete French word *carousser* is a corruption of a German phrase referring to drunkenness: *Gar austrinken* means to "to drink up completely" or "to guzzle." (The German word *gar* has a number of meanings: really, quite, entirely, completely, thoroughly, done, cooked. As a result, these German terms and the word "caroused" reflect English epithets for drunkenness like "sloshed," "done," "stewed," "out," "tanked" and "lit.")

Chartreuse

This color and the liquor that shares its name both derive from the Grande-Chartreuse, the chief monastery of the Carthusian order located in the French Alps. (For all their commitment to austerity, monks certainly are responsible for creating great alcoholic beverages. One has to pass the long, quiet days somehow.) The liqueur was made

starting in the early 1600s, and the name of the color, which is first recorded in the late 1800s, is from the hue of the beverage.

Cocaine

In its most recent list of slang terms and codewords for controlled substances and illicit drugs, the U.S. Drug Enforcement Administration lists 26 categories of intoxicants.

The entry for "cocaine" alone lists almost 500 street nicknames for the drug from the fancifully familiar (devil's dandruff, reindeer dust, Snow White) to the obscure or niche (Henry VIII, ski equipment, pantalones).

This drug is made from the leaves of the coca plant, and it's from the plant that its name is derived, with the chemical suffix -ine tacked on. The ending speaks to its original usage as a local anesthetic in the late 1800s, with the -ine ending echoing drug names such as "morphine" (*see also* heroin).

The rock form of cocaine, called crack, is thought to be named after the crackling-like sound produced when it's smoked.

It may come as no surprise that the addictiveness of crack cocaine contributed to the use of the word for things that are similarly enticing—for example dessert foods termed "crack pie." However, that trend may be on the decline because it is heavily charged: In 2019 the famous New York City bakery Milk Bar chose to change the name of its "crack pie" because the crack epidemic disproportionately targeted communities of color. Indeed, the U.S. Department of Justice has revealed that in the 1990s the CIA contributed to the creation of the crack epidemic—not to mention destabilizing Latin American populations—by selling tons of cocaine to the Crips and Bloods street gangs and the communities surrounding them and funneling funds to Latin American guerrilla armies.

Cocktail

One of history's greatest trolls made it really hard to tell where the word "cocktail" comes from.

It all started with a 1908 article in the *Baltimore Sun* called "The Secret History of the Cocktail."

There was no byline, but it is largely thought to have been written by *The Sun*'s editor, Henry Louis Mencken (1880–1956), better known as H. L. Mencken—journalist, cultural critic, English-language scholar, known to many as the "Sage of Baltimore"—and also an unrepentant troll. He was the orchestrator of some particularly iconic satire or, as he called it, "the great art of synthesizing news." (Which smacks of the "fake news" of today, but more in the name of mischief than political gain.)

For instance, in 1917 Mencken fooled many of his readers into believing that bathtubs did not exist in America until the 1850s. It didn't take long for people to point out that bathtubs have existed for literally thousands of years, and Mencken's stunt came to be known as the "great bathtub hoax."

Mencken convinced readers that his satirical pieces were true by infusing fiction with just enough fact, which is why "The Secret History of the Cocktail" is suspect at best. Some scholars believe it to be totally made up, while others believe it to contain at least a drop of truth.

The claim that Mencken makes that is most likely to be at least partially true is that "cocktail" is from the French *coquetier*, a word for an eggcup. This theory is supported by the fact that Creole apothecary Antoine Amédée Peychaud made mixed drinks with his famous Peychaud bitters and served them in an eggcup. From there, the word *coquetier* was Anglicized as *cocktay*, and then as *cocktail*.

Mencken also proposed several other theories that have no supporting evidence whatsoever:

One is that "cocktail" dates back to the Middle Ages, when an English army regiment with feathered caps was known as "The Cocktails." The drink was supposedly named after them by Scottish distillers. We know this one is untrue, a) because "cocktail" isn't recorded as a word for the drink until the late 1800s, and b) because Mencken says it's originally cited in a work called "*Die [sic] Alkoholismus* by Dr. Ferdinand Braun of Halle, Germany," which doesn't exist. (Braun existed, but was a physicist and inventor who

did not write a book with this garbled title and is not associated with Halle.)

He also later suggested (without basis) that "cocktail" comes from the phrase "cock ale," a combination of stale beer and bread made for roosters training for cockfights, or that a mixed drink was originally made with the last little bit, or "tail," of liquid from a bartender's tap, or "cock."

Quite apart from Mencken and his mischief, others have suggested that "cocktail" is from a word for a horse's docked tail, particularly in a style that makes it stand up like a rooster's comb. This style was commonly seen on ordinary, mixed-pedigree horses, therefore a cocktail drink is similarly mixed.

Dope

The earliest recorded meaning of the English word "dope" is neither drug nor dunce.

Indeed, in 1807 "dope" was a name given to a thick sauce or gravy, and an adaptation of the Dutch word *doop* for a dipping sauce, which is from the Dutch verb *doopen* "to dip" (also a cognate of the English word "dip"). "Dope" was extended to opium in the early 1800s, a reference to the process of smoking semi-liquid opium, which had a thick consistency like a dip or a sauce.

Only later, in the 1800s, did "dope" and "dopey" become words referring to foolish people, from the idea of someone who is impaired by opium usage.

This means that the dwarf in Disney's *Snow White* called Dopey is technically named after the drug, whether his creators knew it in 1937 or not.

Other uses of the word also emerged from drug usage and terminology, including "the (straight) dope," referring to insider information, which is thought to have emerged in the context of horse racing—that is, knowing which horse was "doped" to perform.

Interestingly, the word "dopamine" is unrelated, instead taking its name acronymically from component letters in the full name dioxyphenylalanine. It is also unrelated to the word "dip" meaning chewing tobacco (also known as chaw or rub), which is named after the

practice of chewing a twig to a soft and brushlike consistency, which is then dipped in snuff before it's applied between the lip and the gums. This sense arose as a contrast to dry snuff, which is snorted (and named after the sound your nose makes when you snort it).

Drug

Originally (and still) a term for any substance used to make medicines, this word is likely Germanic in origin and may simply mean "dry" thanks to phrases such as *droge-vate* "dry barrels" or *droge waere* "dry wares," both terms that were used to describe the shipping of items like spices, herbs, and medicinal substances.

⌖ Drugs, Poisons, or Both?

It is a curious trait of Indo-European languages that substances meant to cure people, get them high, and kill them all share overlapping names. We already know that this is true of the word "drug," which is both a word for a medicine and an intoxicant—or sometimes both in one.

Additionally, "potion" and "poison" are what are called etymological doublets. They share roots, but entered English through different routes and at different times. Both are from the Latin *potionem*, meaning "a drink," "a potion," or the act of drinking, and are ultimately from the root *potare* "to drink."

"Poison," being the more nefarious of the two, entered English first, in the 1200s, at which point it had already taken on the sense of a deadly beverage after traveling through Old French, where it picked up the confusing additional sense of a medicinal (and therefore not poisonous) drink.

But *potion* was already hot on its heels and also referred to medicinal drinks produced in the time period when magic and witchcraft were considered as effective as more clinical aspects of medicine.

This sort of conflation is all over the place in English and its relatives.

The Greek *pharmakeus*, from which the word "pharmaceutical" is derived, meant both "preparer of drugs" and "poisoner." And *pharmakon*, the Greek word for medicine, was also used to mean "poison," "charm," or "enchantment."

The Latin *venenum*, source of the English "venom," was similarly a word for a poison (though in English "venom" and "poison" now have distinct meanings), but the Latin word's earliest recorded sense was that of a medicinal potion or drug. This obscurity of sense among these terms reflects the fact that medicines and drugs of any era may result in complications and side effects, or simply may be ineffective—or may have exhibited results attributed to the occult.

Drunk

"Part of the pleasure of drunkenness is the pleasure involved in destroying everyday consciousness. The unceasing stream of forceful and violent words signifies that."*

This past participle of the word "drink" (Old English *drincan*) simply implies that one's drink has overpowered the imbiber's typical personality. English regional dialects have many slang terms for inebriation, many of which tend toward simile. Here are just a few:

Drunk as a boiled owl (1848): Intentionally absurd, first recorded in the Indiana newspaper *The Democratic Pharos.*

Drunk as Cooter Brown: Cooter Brown is a fictional character who, rather than being drafted by the Union or the Confederacy during the American Civil War (1861–5), supposedly opted to remain drunk for its entire duration.

* Harry Gene Levine, 'The vocabulary of drunkenness,' *Journal of Studies on Alcohol* 42:11 (1981).

How-came-you-so or **how-come-you-so** (1827): A smirking minced oath for drunkenness, as in "Please excuse her, she's a bit how-came-you-so."

Lap-legged drunk (1930s): "Lap-legged" implied someone who had legs of uneven lengths—and to be "lap-legged drunk" implied that you were so drunk you couldn't walk straight. Similarly, "legless" is a British slang term for drunkenness.

Plotzed (1920s): from the Yiddish term *platsn* "to burst, explode or crack."

Pifflicated (1920s): First recorded in *Harper's Magazine*, probably fanciful or imitative of other words for drunkenness.

Three sheets to the wind (mid-1800s): A nautical-inspired term referring to the fact that a "sheet," or the rope that controls the trim of a sail, is loose, making the sail flap uncontrollably, so three sheets "to the wind" would make a ship sail with a lurching motion, as if drunk.

English also boasts a vast range of often violent terms for heavy drunkenness that imply just how dramatic an impact alcohol can have on a person's state of mind. Pick your favorite:

bagged	hooted	shit-faced
battered	juiced	shot
blitzed	laced	sloshed
boxed	lit	smashed
buried	looped	stewed
busted	ossified	swacked
buzzed	packaged	tanked
canned	paralyzed	tore down
clobbered	pickled	tore up
crocked	pissed	totaled
damaged	plastered	twisted
flushed	plowed	wasted
forfeit	potted	whipped
gassed	screwed	wiped-out
glazed	shellacked	

There are even a host of phrases for when you need to call it a night and stop drinking. One particularly colorful one is "acknowledge the corn," an American expression appearing in the 1970s but possibly dating back to the mid-1800s.

Gin

The name of this alcohol is a shortening of the term "geneva"—no relation to the city. Instead, it's a shortening of the Dutch word for the beverage, *genever*, which literally means "juniper" (which was and still is used to flavor it). Ultimately, the name of the plant and the alcohol are from the Latin *juniperus*.

The name of the liquor is unrelated to the name of the cotton gin, which is a shortened form of "engine." "Engine," interestingly, dates back to the Old French term *gin* meaning "machine" or "device."

Fun fact: To "gin (someone, something) up" is to make them/it livelier, and was commonly applied to the practice of putting ginger, eels, or other startling items up the rear end of a horse to make it act sprightlier during a sale. This use of the phrase is probably more associated with "ginger" than "gin" but may have some cross-reference to it.

Hallucinogen/Hallucinate

"Hallucinate" comes from the Latin *alucinari*, and originally the Greek *alyein*, both meaning "to wander (in the mind)." It shares a root with the word "amble," which connects neatly with the idea of a "trip," first recorded in the 1950s and 1960s as a word for a psychedelic journey or experience on the same notion as a road trip.

Heroin

The Greek basis of the word "heroin" is indeed the same one that gave us the word "hero," but the ending is not thought to be the feminine ending seen in the word "heroine." Rather, much like the ending of "cocaine," the ending of the drug "heroin" is perhaps counterintuitively a spin on the chemical ending *-ine*.

This word is a proprietary eponym (or genericized trademark) originally coined by the German company Friedrich Bayer & Co., predecessor to the modern-day pharma and biotech giant Bayer, which first sold the drug as an alternative to morphine in 1898. Thus, commercialized Heroin is a nod to the word "heroine," supposedly implying a drug that supposedly comes to your rescue or makes you feel (euphorically) heroic when you're in pain, a term also chosen because the ending of the word for a heroic woman horribly, serendipitously aligns with that of other drugs such as morphine. The *-in* ending similarly reflects the 1816 German brand name for morphine, "Morphin," named for Morpheus, god of dreams.

Hooch

This word, which often refers to illicit spirits, is a shortened form of the word "hoochinoo," which is a Klondike gold rusher's interpretation of Hutsnuwu, the name of a village of indigenous Tlingit people on what is now Admiralty Island, Alaska.

In the Tlingit language, the name of the people and the language means "People of the Tides," and the name of the village means "grizzly bear fort."

These folks apparently made some spectacular booze—a rum-like liquor that became so wildly popular among the gold rushers in the late 1800s that it permanently embedded itself into American English terminology.

Jägermeister

This name for an elaborate spiced digestif (a drink enjoyed at the end of a meal to promote digestion) means "master hunter" or "hunt master" in German, a word that had long been used for officials in forestry and game wardens. The liqueur was named by the German entrepreneur Curt Mast (1897–1970), son of vinegar manufacturer Wilhelm Mast, who inherited his father's business and was himself an avid hunter.

After the product was introduced, many Germans also called it Göring-Schnaps after Hermann Göring, the Nazi official who, among other titles, was called Reichsjägermeister (Reich Hunting Master) of the official state hunting society.

The spirit gained widespread popularity in the U.S. as a fixture of party culture in the 1980s thanks to importer Sidney Frank, who made millions promoting Jägermeister and Grey Goose brand vodka.

Kahlúa

This coffee-flavored liqueur was first produced in 1936 by alcohol purveyor Pedro Domecq, who came from a Spanish sherry-producing family and coined its name, which means "House of the Acolhua people" in Nahuatl after a group of allies of the Aztec people. It was first imported to the U.S. by southern Californian real estate and imports mogul Jules Berman, nicknamed "Mr. Kahlúa" due to the product's popularity. The spirit has little to do with the original culture and is essentially a marketing ploy that romanticized an Aztec-adjacent culture.

Khat

This drug, made from a plant native to Africa, *Catha edulis*, is named after the plant's genus name and is known for containing the similarly named alkaloid cathinone—which in turn is a Latinized form of the Arabic *qāt*, also a commonly recorded spelling in English prior to 2000. The stimulant causes euphoria, reduced appetite, an energy boost, and more. In Southern Africa, where it is produced, it's also called *jimaa*, *miraa*, *muhulo*, and *muirungi*.

In English, it's often given tea-centric names including Abyssinian tea, Somalian tea, and Arabian tea.

Much like coca leaves and the betel nut, it has historically been chewed by the people who originally produced it. It can cause dependence, but isn't considered to be concerningly addictive.

Marijuana

Borrowed from the Mexican Spanish *marihuana* in the late 1800s, this term for all or part of the cannabis plant and many products made from it has been subject to a fair amount of etymological speculation.

It's thought that, in English, the word and others of similar spelling ("mariguan" and "marihuma") were first used for a species of tobacco.

While marijuana is widely associated with the woman's name María Juana (and therefore Mary Jane), there is no evidence that the name is the origin of the word. Many attribute the word's origins to the Nahuatl *mallihuan*, "prisoner," but most linguists contest this theory, and pointed out that it was most likely fabricated by—or at least popularized by—former U.S. Federal Bureau of Narcotics commissioner Harry J. Anslinger in the 1930s to villainize the drug. In fact, due to its postcolonial appearance, the word is probably not an indigenous word.

It could be a Hispanicization of the Chinese *ma ren hua*, meaning "hemp seed flower," which in turn is probably partially borrowed from a Semitic root for hemp, which is thought to be one of the first plants ever cultivated—up to 50,000 years ago. The same root is found in the English word "marjoram" (which is related to and sometimes used synonymously with oregano) and the Spanish word for the plant, *mejorana*, which are likely related to the word "marijuana" through this root. Indeed, a Mexican slang term for marijuana was, at least for a time, *oregano chino* "Chinese oregano."

Others speculate an African origin—perhaps words like the Kimbundu (Angolan) word *mariamba*—given that many of the earliest users in the Americas were enslaved Africans who were forcibly relocated to the Caribbean and South America.

The popularity of the word in English is probably due to the failure of 1930s antidrug advocates like Anslinger to make it sound threateningly exotic compared to "cannabis," which entered English in the early 1700s as the Latin genus name for the hemp plant, drawn from the Greek word for the plant, *kannabis*.

☙ Nicknames for Cannabis

In addition to widely known terms for marijuana such as "weed," "herb," "skunk," "broccoli," "grass," and "Mary Jane," this drug boasts a kaleidoscope of creative nicknames that have suffused pop culture and beyond. These are the stories behind just a few of them.

Cheeba

Although the precise reasoning isn't known, this term, like "dope," is thought to have originally been associated with heroin. It is proposed to have come from the Spanish *chiva* or *chivo*, meaning "young goat." *Chiva* is also a word for a type of bus, and the verb "cheebulate" is recorded as a word for smoking in a group—so perhaps it suggests a party bus on its way to a music festival.

Chronic

According to Snoop Dogg, this word for high-grade canna-bis—which was widely popularized by Dr. Dre's 1992 album *The Chronic* and features appearances by Snoop—was a result of him mishearing the term "hydroponic" as "hydrochronic."

Ganja

One of the oldest words in consistent and common use in English for recreational cannabis, ganja is a borrowing from a name of the drug in Hindi and Urdu. It entered official use in English in the 1850s when the British government codified a tax on the trade of ganja.

Hash

Short for hashish or hasheesh, which appeared in English as early as the late 1500s as a borrowing from Arabic, in which it referred to any powdered hemp. In Arabic, it referred to the drug as early as the 13th century, and is recorded in English

travel logs from the turn of the 17th century, but was rare until the 1800s.

Pot
This word, dating to the 1930s, is thought to be a shortening of the Spanish *potiguaya*, a word for cannabis leaves. *Potiguaya*, in turn, is derived from *potación de guaya*, a Mesoamerican drink made from buds soaked in wine or brandy, literally "drink of grief."

Reefer
This word for a marijuana cigarette or joint is either from the Spanish *grifo*, a slang word for pot or someone who smokes it, or from *reef*, a nautical term for a rolled sail or the act of rolling it up. It was first used in the 1920s.

Weed
This word was first used in the 1920s, in reference to its botanical shape and classification.

———

Moonshine

Moonshine, as you might expect, has referred to the literal light of the moon since around the 15th century. It has also been used figuratively in literature to refer to something ephemeral, or something that appears beautiful but lacks substance because the glow of the moon offers light but no heat.

Its boozy sense ignited in the 18th century. Today, moonshine typically refers to unaged corn-mash whiskey produced in the southern Appalachian Mountains in the U.S., but it was once a bit broader, and today the term "moonshiner" can apply to anyone who home-distills spirits of any kind.

As you might expect, the term "moonshine" became especially popular in the 1920s during Prohibition. There are still some laws

against moonshining without the proper permits, partially because of the health risks, but also because home distillers avoid paying taxes on what they make, and we can't have that, can we, says the government. Granted, the health risks are very real—moonshine can become tainted to the degree that it causes blindness and death, and it also has a nasty habit of exploding while it's being distilled.

The most likely explanation for the word "moonshine" is simply that, because it is illegal, you must do the work of distilling your spirits "by the light of the moon."

But before the word "moonshiner" was popularized, the term "moonraker" is recorded with the same meaning, and it has a great story behind it.

In the mid- to late-1700s the English county of Wiltshire was situated along the secret route of a booming brandy smuggling business. According to legend, the locals would hide contraband barrels of French brandy from customs officers by sinking them to the bottom of ponds. When they were caught attempting to retrieve the brandy from the bottom of the pond with long rakes by the light of the moon, they played dumb, pointing at the reflection of the moon in the pond and saying they were trying to rake in a wheel of cheese. The revenue men laughed at their supposed ignorance and went on their way.

Narcotic

This word for a drug that treats pain is originally from the Greek *narkē*, meaning "numbness," "deadness," or "stupor."

By the way, "nark" and "narc" are not ultimately related, but they heavily overlap in meaning and usage. The word "nark" as a word for a police informer first showed up in the 1800s and is thought to be related to a Romany word for "nose," ultimately from Hindi and/or Sanskrit. The idea here is "you're a nosy motherfucker who should keep that schnoz of yours out of my business unless you want to lose it." Narc, meanwhile, is short for "narcotics agent," but thanks to the context, its usage is almost certainly influenced by the older term, "nark," and its "snitch" sense.

Opium

Opium has mellowed the world for millennia—while also playing a factor in conflicts from the 19th-century Opium Wars to the American "War on Drugs" to the ongoing, worldwide opioid epidemic. This powerful narcotic has been around since at least 3400 BCE, when Sumerians cultivated the opium poppy, called *hul gil*, or the "joy plant." Demand swept the world, carried on the current of the Silk Road to China and the Mediterranean.

The English word is an adoption from Latin and is ultimately based on the Greek word for a poppy, *opion*, which in turn is a diminutive of *opos*, a word for any plant juice. The word has been in English since the 14th century, but first occurred in medicine as a drug used for pain relief and to induce sleep.

The suffix in "opioid" is the same one found in words like "asteroid" ("starlike, star-shaped") and "humanoid" ("humanlike, human-shaped"), from the Greek *eidos* "form, shape."

Peyote (and mescaline)

This cactus-like plant, which contains mescaline among other psychoactive ingredients, promises psychonauts a trip of up to ten to twelve hours, characterized by powerful visual and auditory experiences often described as being deeply spiritual or philosophical. Archaeological evidence suggests people in the Americas have been tripping the peyote fantastic for more than 5,000 years.

"Peyote" is from the Aztec *peyotl*, the name for a small, spineless cactus (*Lophophora williamsii*) which contains mescaline. The Aztec word is thought to mean "caterpillar cocoon," based on the appearance of the cactus, and from the root *peyoni*, meaning "to glisten."

"Mescaline" means a drug or substance made from buttons that grow on mescal cacti, or plants from the genus *Agave*. It is also the main ingredient in traditional mezcal.

Beat novelist Jack Kerouac (1922–1969) famously dabbled in a variety of psychedelics, including mescaline, and shared his experiences with poet Allen Ginsberg:

When on mescaline I was so bloody high I saw that all our
ideas about a 'beatific' new gang of worldpeople, and about
instantaneous truth being the last truth, etc. etc. I saw them
as all perfectly correct and prophesied, as never on drinking
or sober I saw it—Like an Angel looking back on life sees
that every moment fell right into place and each had flowery
meaning.*

Psilocybin (magic mushrooms/shrooms)

This psychoactive compound found in more than 200 species
of mushrooms—commonly called "magic mushrooms" or just
"shrooms"—especially those from the cognate genus *Psilocybe*—
literally means "bare-headed" in Greek (*psilos* "bare" + *kybē* "head").

The name compares the loose skin, or pellicle, over the often tan-
colored cap of the mushroom to a bald head. That same cap and their
long stem also contributed to the name of the shroom variety called
"Penis Envy," with other entertainingly named varieties including
"Flying Saucers" (so called after their shape and effects) and "Blue
Meanies" (after the *Yellow Submarine* villains and because they, like
other magic mushrooms, turn bluish when cut).

Psychedelic

This word was coined in 1956 by Canadian psychiatrist Humphry
Osmond (1917–2004), who researched and experimented with mes-
caline and LSD.

The word literally describes the sensation of tripping, meaning
"to reveal in the mind," from the Greek *psykhe* "mind" + *deloun* "to
make visible, reveal." But the first recorded use of the word also has
an interesting literary connection:

Osmond first used the word in a letter to Aldous Huxley (1894–
1963), author of the dystopian sci-fi classic *Brave New World* (1932).

* Jack Kerouac, *Selected Letters, Volume 2: 1957–1969*. ed. Anne Charters (New York:
Penguin, 2000), p. 292.

Huxley wrote to Osmond to ask about his research. Osmond provided Huxley with a dose of mescaline and observed his experience, and afterward Huxley would go on to write the book *The Doors of Perception* (1954) based on his experience.

> To be shaken out of the ruts of ordinary perception, to be
> shown for a few timeless hours the outer and inner world,
> not as they appear to an animal obsessed with survival or to
> a human being obsessed with words and notions, but as they
> are apprehended, directly and unconditionally, by Mind at
> Large—this is an experience of inestimable value to everyone
> and especially to the intellectual.*

Like, whoa, dude.

Rum

This word really wants to be short for something, such as the 17th century fanciful terms *rumbullion* and *rombostion*, which have been incorrectly associated with the word, but it's probably just from a cant term meaning "good," "fine," or "excellent." For example, it may be related to words such as "rum," "rom," and "rome," which appear in Romany phrases such as *rum kicks*, "embroidered or fancy trousers." (Granted, it's also recorded with the opposite meaning—not so fine, excellent, or pleasant—possibly because traveling people used it to refer to themselves, and the communities they visited were often quite racist.)

It was connected to the beverage through phrases such as *rum bouse*, meaning "good liquor," and that phrase yielded longer English words such as *rumbullion* and *rumbostion*, which were later said to be the "original" and longer forms of the word "rum."

During Prohibition (and before that as well) a "rum runner" didn't just run rum, but any illicit or low-quality liquor, which for a time was referred to generally as "rum."

* Aldous Huxley, *The Doors of Perception: and Heaven and Hell* (Harper & Row, 1963).

Salvia

This word is simply the Latin name for the sage plant. The one consumed as a psychoactive drug is specifically *Salvia divinorum*, "sage of the diviners" or the "seer's sage," native to Sierra Mazateca of Oaxaca, Mexico.

Schnapps

This word, originally referring to a type of gin from the Netherlands, arose in the early 1800s as a borrowing of the German *Schnaps*, meaning "a mouthful," as in (and related to) the word "snap," which is here used much in the same way as the word "nip" is (a "nip of brandy"). Essentially, it implies enjoying the beverage in a single gulp from a small glass. The German word was originally used for many types of strong liquor you'd enjoy from a shot glass.

The highly sweetened American version, which can range dramatically in quality and ABV, was popularized in the 1980s, starting with the peach flavor.

Sherry

This word is a bit of a misunderstanding. It's originally from the Spanish term *vino de Xeres*, a fortified white wine from the city Jerez de la Frontera in Andalusia, Spain. The term *Xeres* entered English as *sherris* in the 1500s, at which point it was misinterpreted to have been a plural, and therefore rendered as "sherry." This wouldn't be the first time that drinking a bunch of wine made people get a little fuzzy about their diction.

Stimulant

This word and related ones such as "stimulate" are from the Latin word *stimulus*, which literally means "a pointy stick," while its verb form *stimulare* meant to "prick or goad" something into action, as if with a pointy stick. In English it was originally adopted as a medical term for something that used to incite an organ to start working

again, either physically or through the use of drugs and other substances, and since has been extended to a range of contexts from drugs to economics.

In the realm of controlled (and not controlled but certainly stimulating) drugs, meth, cocaine, nicotine, and caffeine are among today's most ... er, exciting stimulants.

Vermouth

This fortified wine, which is flavored with botanicals, is named after the German word *Wermuth*, meaning "wormwood," which was traditionally used to aromatize it. That's the same wormwood present in absinthe, which can have both poisonous and hallucinogenic effects (*see* absinthe).

Vice

A "vice" describes something to which we succumb despite our better judgment—guilty foods, adult beverages, recreational drugs, and other ostensibly reprehensible habits. Although vices may obviously be resisted, the word's Latin source, *vitium*, meaning "defect, blemish or imperfection," implies that a vice is an inherent character flaw.

Waters of Life

Whiskey (or **whisky**) is from the Gaelic phrase *uisge beatha*, literally translated as "water of life" (Old Irish *uisce* "water" + *bethu* "life"). If that seems like a stretch, past recorded variations of the term include the somewhat more similar *usquebea* and *iskie bae*.

The "water of life" concept is one "whiskey" shares in common with the Latin *aqua vitae*—source of "aquavit"—and indeed many intoxicating drinks throughout history.

There's the French *eau de vie*, originally a term for any spirit but commonly used in English to refer to a fruit brandy.

Meanwhile, **vodka** literally means "little water" in Russian and indeed shares a PIE root with whiskey" (**wed-* "water; wet").

The precise reasoning behind this common theme is unknown: Perhaps it's figuratively "livelier" than water or "livens" up a gathering. Alternatively, it could be from spirits' use in medicine, or a reference to the distillation process.

This is also a key concept in the Irish-American comic ballad "Finnegan's Wake" (1864) (which was the basis of James Joyce's novel of the same name, sans the apostrophe) in which the eponymous character drunkenly falls from a ladder to his death but is resurrected when his mourners—also drunkenly—douse his corpse in whiskey during his wake.

Wine

Some ancient etymology for your refined palate:

The Old English word *wine* is so closely related to the word "vine" (with both sharing roots and overlap with the Latin *vinum*) that etymology dictionaries consider them "essentially the same word." In English, "vine" was first applied specifically to grape plants before it was extended to other types of vines.

These words' ultimate root may simply mean "wine"—which speaks to just how ancient it is as a staple intoxicant—or may suggest bending, like a grape vine drooping under the weight of its fruit.

Although beer may be a few thousand years older (and nowhere nearly as snobby), wine has certainly been around long enough to earn the term "vintage," with archaeological evidence suggesting people got sloshed on fermented grape juice at least as far back as 6000 or 7000 BCE. The first evidence of viniculture is thought to have been in Georgia, though it's possible that grapes were used in a predecessor to rice wine a bit earlier in China.

CHAPTER 8

LET'S MISBEHAVE

THE LANGUAGE OF CRIME AND SCANDAL

In this chapter, we'll talk about what it truly means to misbehave—that is, to break laws. But first, what does it mean to "behave" in the first place?

Etymologically, it's pretty much exactly what it looks like.

Think of the word "have," specifically in the sense of possessing something or displaying a quality—as in "you *have* a kilo of cocaine in your trunk," or "you *have* a wicked sense of humor."

Despite its pronunciation difference, the *have* in "behave" is the same.

Meanwhile, the prefix *be-* is truly a workhorse. It can remove things, as in "behead." It can make nouns into verbs implying doing terrible things to people, as in the word "bedevil." It can be an intensifier or a word that implies "thoroughly," as in words like "bethwack"—a real word, recorded as early as the 1550s and meaning "to thoroughly thrash someone"—and "betongue," where the thrashing is done verbally. (Words like this show up all over the place in the 16th and 17th centuries, with gleefully chaotic effect.)

The reason *be-* comes in and thwacks up the place in this way is that its most prominent role is to imply "around," as in the word "beleaguer," which literally means "to camp around" or "to besiege" and has since evolved to mean "to put in a difficult situation." Although it may at first seem counterintuitive, in the case of "behave," be- is an intensifier that advances the meaning of "have." That is, when you behave, you not only have yourself and your shit together—you *really* have your shit together, so that all of the people around you beholding your conduct are beguiled by just how unbalanced you aren't.

Another instance in which be- serves as an intensifier is "befuddle." Fuddle is a 16th-century word for getting drunk. So, if you're befuddled, you're behaving as if you're well and truly sloshed.

Point being, tack on the additional prefix mis-, meaning "bad" or "wrong," and misbehaving means that you're making quite an ass of yourself—and everyone can see.

Assassin

This word literally means "hashish-user"—sort of.

"Hashishin," the "Order of Assassins," and "Assassins" alone are Western European names for the Nizari Isma'ili state, a sect of Shia Muslims who lived in a network of mountain strongholds across Persia and Syria from the 11th to 13th centuries. Because they were surrounded by enemies, they established a reputation for employing tactics such as psychological warfare and the covert murders—or assassinations—of rival leaders.

The founder of the sect, Hassan-i Sabbah (ca. 1050–1124), reportedly called his followers Asasiyyun, meaning "principled people" or "people who are faithful to the foundation [of the faith]."* In the 12th century the Fatimid caliph al-Amir bi-Ahkam Allah derogatorily referred to them as *hashishi*, "hashish-users." (He was later assassinated by Nizari agents.)†

Crusaders and other Western Europeans blended this information into a claim that the Nizari were called *hashshashin* because they carried out assassinations after smoking or consuming hashish. Marco Polo notably journaled about this process in the 13th century, describing a young man who was put into a trance by a potion made from hashish and sent to assassinate a target.‡

Beyond these tales, there is no historical evidence that they ever used hashish at all, and especially not that they were involved in any

* Amin Maalouf, *Samarkand* (New York: Interlink Publishing Group, 1998).

† Farhad Daftary, *The Ismailis: Their History and Doctrines* (Cambridge: Cambridge University Press, 1990).

‡ Marco Polo, *The Book of Ser Marco Polo, the Venetian, Concerning the Kingdoms and Marvels of the East*, vol. 2, trans. Henry Yule and ed. Henri Cordier (London: John Murray, 1875).

ritual assassinations, but nonetheless the word quickly traveled to Italy and France and then to England.

The term *hassais* cropped up in Middle English, with the spelling evolving and the sense extending, by the 16th century, to today's general sense of someone who kills based on political or religious motives.

Assault

To assault someone is literally to "leap at" them. Its Latin components are *ad-* "to, toward" and *saltus* "a leap." You might recognize the latter word from the word "somersault" (originally *sobresaut*) literally an "over-leap." In Middle English, "assault" was spelled *asaut*, reflecting the Old French spelling, but the Latin 'l' reappeared later as Latin continued to infuse itself into English legal terms.

The difference between "assault" and "battery" in its first legal contexts was the difference between an incitement to violence (assault: behaving like an aggressive asshole) and the violence itself (battery: actually decking someone; *see* battery).

This is also more or less where we get the related words "assail" and "assailant."

Battery

This word and its cognates, from battle to debate, share the Latin root *battuere*, "beat." Most senses of the word "battery" in English—physical violence, a bombardment by artillery, or the artillery itself—were all recorded in French (*baterie*) before they entered English. Founding Father and polymath Benjamin Franklin (1706–90) is credited with extending the word to electrical cells, and it's thought that he drew the idea from "discharges" of electricity, much like discharges of artillery.

Blackmail

The word "blackmail" originally had nothing to do with mail as in letters, or for that matter, anything else we'd call mail today.

In the 1500s and extending through the mid-1800s, clan chieftains and other officials in Scotland and northern England were known to run protection rackets against farmers. The practice was called blackmail, with the "black" part referring to the evilness of it.

As for the *mail* part, in Middle English *male* meant "rent" or "tribute." It is from the Old English *mal* meaning "agreement," a term originally adopted from Old Norse. So "blackmail" essentially means "evil rent" or "evil tribute."

This type of "mail" is not at all related to the words "mail" as in letters, "mail" as in armor, or "male" as in gender. The postage type of mail is from the Frankish-derived, Old French *male*, meaning "wallet, bag or bundle." "Mail(le)" armor is originally from the Latin *macula*, meaning "mesh," comparing the links in the armor to a net. "Male" as in gender is from the Latin *masculus* (*see* male and female, in Chapter 5). All of these words first appeared English several centuries after the "mail" that's in "blackmail."

However, the mail in blackmail *is* related to the word "meet," as in to meet another person, and "meal," an appointed time for gathering and eating.

The spelling likely evolved through the influence of folk etymology, perhaps associating the extortion with correspondence meant to intimidate or exploitative written agreements. By the mid-1800s blackmail had evolved to today's sense, referring to threats that the offender would publicly expose secrets unless paid.

Caper

The verb "caper" evokes the endearing antics of otters and small children, from the Italian *capriole*, meaning "to leap or skip." (This is unrelated to the Latin *capparis*, the source of the edible caper.) The verb extended to adventurous pranks in the 1840s, implying that same degree of playfulness, and then to apparently entertaining criminal activity in the 1920s thanks to crime fiction and film.

Convict, con artist, and con

"Con" can be short for "convict" or for "confidence artist," but the etymological relation between the two longer terms lies only in their shared prefix.

Judging by its Latin source, *convincere*, "convict" (both of the verb "convict," with the emphasis on the second syllable, and the noun "convict," with the emphasis on the first) literally means "to conquer together" or "to thoroughly overcome." The idea, therefore, would be to thoroughly prove someone guilty of their wrongdoing and force them to face it.

Meanwhile, a "confidence artist" is someone who scams you by exploiting your confidence in them. The Latin source, *confidere*, literally means "mutual trust" or "trust together" (*con-* "together" + *fidere* "to trust").

Connive

This word knows exactly what it's doing. It literally means "to wink together" at a crime with a conspirator, from the Latin *com-* "with, together" and *nictare* "to wink." Both in Latin and in English (which it entered in the 17th century), it implied knowing about a crime, but either concealing that knowledge or encouraging the person who committed it. Today in English, the verb "connive" is still defined as allowing something illegal to occur, though "conniving" typically describes someone who is prone to illegal or immoral behavior.

Crime

The PIE root of the word "crime" very likely means "to sieve" in the sense of deciding or distinguishing degrees of legality or morality. Some etymologists have suggested that its root could imply crying out in distress, but earlier usages of the word make this less likely: In 13th-century English, "crime" was less legal and more religious—though these concepts have often been conflated—implying "sinfulness" rather than unlawfulness.

Corrupt

This word, which is practically synonymous with abuses of power from politicians and police, literally means that the person in question is ruptured or broken.

It's from the Latin *corrumpere*, meaning "to destroy" or "to spoil," but in Latin it was also used for moral and political corruption as well: It could mean "to seduce" or "to bribe." "Corrupt" can also more physically mean "rotten" in English today, but moral corruption came first, reflecting the Latin term, in the 14th century.

Its components are the prefix *com-*, which probably didn't specifically mean "together" as it often does, but instead was an intensifier, and *rumpere*, meaning "to break"—the same source as words such as "rupture," "erupt" (literally to "break or rupture forth"), "interrupt" (literally "to break in between"), and "abrupt" (literally "broken away").

Counterfeit

This word was initially as much about pretending to be another person as it was about forged documents and currency.

Its French source, *contrefaire*, means "to imitate," literally "to make against" thanks to the elements *contra-* "against," and *faire* "to make." In English, if your behavior was described as "counterfeit," it meant you were either putting on an act or you were behaving hypocritically.

That said, the practice of counterfeiting coins is understandably about as old as minting the real thing. Amgueddfa Cymru (the body overseeing the national museums of Wales) reports that "In Roman Britain … at some periods there may have been as many fake coins in circulation as real ones," much to the chagrin of treasure hunters who often discover early counterfeit coins today.[*]

Cruel

To be cruel is literally to be "raw" and "bloody." This surprisingly horrifying word initially described incidents that involved great suffering

[*] Rhianydd Biebrach. "Counterfeit coins," *Amgueddfa Cymru*, 2017. https://museum.wales/articles/1722/Counterfeit-Coins/

and was shortly thereafter extended to people bent on causing such suffering. It's cognate with the Latin *crudus*, "rough, raw bloody," and is therefore related to "crude," which carried those senses (along with "raw").

Note: Dropping a *d*—no, not that kind, you reprobate—was fairly common in transitions between Latin and French. English words including "chance," "obey," and "seance" are all ultimately from Latin words that contained a *d* before it was ditched in French: *cadentia, obedire, sedentia*.

Debauchery

To "debauch" someone is to lead them astray, evidently from some mythical moral path. Its precise origin is unknown, but it's borrowed from French, and the "bauch" portion may be a word for a wooden beam. So debauchery might literally be stepping off a balance beam, cutting away at someone's morality, or it might imply the space in which the cutting is done, such that with the prefix, "debauchery" is what one does when one is led astray from a workshop or other rightful place of work.

Delinquent

We often think of delinquents as being teen offenders, but its literal meaning is someone who abandons their duty and thereby fails to perform it, a sense that remains in "delinquent payments." The word's elements are an intensifying *de-* and the Latin *linquere*, meaning "to leave."

Notable relatives include relinquish, loan, eclipse, derelict, and ellipsis.

Deplore

This word has seen an uptick in recorded usage since the 2020 election, when Hillary Clinton used the term "deplorables" to describe many members of Donald J. Trump's cultlike following.

You know, to just be grossly generalistic, you could put half of
Trump's supporters into what I call the basket of deplorables …
The racist, sexist, homophobic, xenophobic, Islamophobic—
you name it.*

"Deplorables" was an uncommon plural noun form of "deplorable"
at the time, but it remained in use beyond the election cycle when
the voters in question appropriated the term as a badge of pride,
fancying themselves to be noble victims targeted—mystifyingly—
for their commitment to marginalizing people from underprivileged
and oppressed demographics.

But the word "deplore" has been in use since the mid-16th cen-
tury, also appearing in Shakespeare's *Twelfth Night*:

And so adieu, good madam: never more
Will I my master's tears to you deplore.

Act 3, Scene 1, lines 151–2

And as an adjective, "deplorable" followed shortly thereafter.
Untimely and tragic deaths were especially deemed "deplorable."[†]

This common context, as well as the Shakespearean lines from the
character Viola, reveal the original sense of this word: Although it's
often used to imply disapproval now, "deplore" etymologically has
more to do with despair.

The root is the Latin *plorare*, meaning "to cry out" or "to weep,"
with the de- prefix here acting as an intensifier. Similarly, the related
"implore" literally means to tearfully plead with someone in order to
evoke their sympathy.

* Katie Reilly, "Read Hillary Clinton's 'basket of deplorables' remarks about Donald
Trump supporters," *Time*, September 10, 2016. https://time.com/4486502/hillary-
clinton-basket-of-deplorables-transcript/

† As seen in works such as Pierre Matthieu's *The heroyk life and deplorable death of
the most Christian King Henry the fourth Addressed to his immortall memory; by P: Mathieu,
counceller and historiographer of France*, translated by Edward Grimeston.

Depraved

To be depraved is literally to be "completely crooked." The Latin word *depravare* meant "to distort or disfigure," from *pravus*, literally meaning "bent" or "crooked," but also figuratively meaning "wrong" or "bad." Therefore, to be "depraved" is to be led or twisted away from righteousness or a moral path into corruption. (The de- prefix acts as an intensifier—and indeed "pravity" is recorded a century earlier in English with the same sense. So a depraved person is extra-praved.)

Theologians including the prominent 13th-century clergyman Thomas Aquinas (1225–74) have argued that, after humanity's Fall in Genesis, people have an inherent predisposition toward sin, which came to be known as "total depravity" in the following centuries.*

Despicable

Even when expressed through Daffy Duck's lisp, "despicable" and its verb form "despise" literally mean "to look down upon" someone for their behavior. The de- portion of the word implies "down," while the *spicable* and *spise* share roots with words implying visibility and perspective, including "spectacle," "inspect," and "conspicuous."

Diabolical

To be "diabolical" is literally to be associated with the devil, from the Greek *diabolos*, meaning "devil" generally, or Satan himself specifically.

Dissolute

Someone who is dissolute is like, totally chill, bro, and needs you to cool your jets about their lack of morals. It's from the Latin *dissolvere*, meaning "to loosen up," and even in Latin its past participle *dissolutus* meant "morally lax," "licentious," or "careless."

* Robert R. Williams, "Sin and evil," in Peter C. Hodgson and Robert H. King, Eds., *Christian Theology: An Introduction to Its Traditions and Tasks* (Minneapolis, MN: Fortress Press, 1994).

Embezzle

Embezzling is stealing for rich people: making away with money from corporations or employers. It's pretty bad, but it's usually considered a nonviolent white-collar crime these days.

Today's sense has nothing on its literal meaning. The word's Old French origin is *enbesilier*, which meant "to steal," but *besilier* ranged in meaning from "torment" to "destroy" to "gouge."

The term "price-gouging" also reflects this same sort of oddly violent analogy between money and physical torment.

Escape

Imagine yourself hurrying down a street, evading the law, when suddenly an officer seizes a fistful of your cape. But you, being the wily and agile villain that you are, nimbly slip out of your cape and deftly dodge down a dark alley, leaving your pursuer cursing, with only your cape in their hand.

That is exactly the implication of the word "escape," which is from the Latin elements *ex-* "out of" and *cappa* "mantle, cape."

For a short time in the 1500s, "outscape" was an alternative English variation of the same word.

Exploit

As a verb, "exploit" (with the emphasis on the second syllable) means to take advantage of something. As a noun, an exploit (with the emphasis on the first syllable) is usually an accomplishment, achievement, or adventure (sometimes in the sense of a sexual conquest).

The pronunciation difference is an example of initial-stress derivation, which moves the stress to the first syllable of a verb when you use it as a noun or an adjective. It also shows up in words like re*cord* and *re*cord, per*mit* and *per*mit.

Regardless of the part of speech, though, the word "exploit" originally comes from the Latin *explicare*, which means "to unfold, unroll, or disentangle." That means that exploit is very closely related to the word "explain."

The English verb "exploit" originally meant "to accomplish, achieve or carry out a task," from the Latin sense of a process or task unfolding or a problem being solved or untangled. From there it makes sense that the noun "exploit" would mean an achievement, a task, or even an adventure unfolding.

So why does the verb "exploit" now mean "to take advantage of"? For that we have to look at the word "exploitation."

Exploitation was originally a positive word, meaning productive work, which still lingers in a way in the sense of "exploiting" a gaming cheat, a natural resource, or another advantage. But then in the 1830s, French socialists started using it to refer to the way many laborers worked in terrible conditions for very low incomes. After that, abolitionists adopted it to describe the forced work of enslaved people. It was later shortened to exploit, meaning that the verb "exploit" is both the base word and a back-formation of the word exploitation.

Evil

The word "evil" had significantly more range in Anglo-Saxon England, as well as other Germanic cultures. It could encompass any form of disapproval or distaste, meaning everything from straight up "cruel" to "you suck at your job." In fact, "evilty" was as common a word as "cruelty."

If you were "evil-favored," you were just plain ugly. It also had a range of meanings beyond human behaviors: Misfortunes, diseases, and general harm were described as "evil."

This is largely because the word's root somewhat vaguely means "bad," and because people tended to view misfortune through the lenses of cosmic fate and religion.

Felon

A felon is from the Latin *fellonem*, meaning "evildoer." Beyond this Latin source, its roots are unclear. It could be from a Frankish term for a "scourger," from a Latin term for a bitter poison, or from the Latin *fellare*, meaning "to suck" (*see* fellatio). In the latter case, that would mean that a "felon" is, at least etymologically, a "cocksucker."

Forbidden

Something forbidden is "commanded against." This Germanic-derived word is made up of the Old English components *for-*, here meaning "against," and *beodan* "to command." It is cognate with, and pretty much etymologically identical to, the German *verboten* of the same meaning.

Fugitive

A fugitive is literally "one who flees" and has been used to refer to criminals on the lam and enslaved people running away from their enslavers since it was the Latin *fugitivus*. The Latin root verb *fugere* was a bit broader in meaning, however, and also referred to any degree of departure, disappearance, avoidance, or even exile.

It's related to the name of the musical composition called a fugue, which leans into the "flight" sense, "from the idea that one part starts on its course alone, and that those which enter later are pursuing it," according to 19th-century music theorist Ebenezer Prout.*

Gamble

Essentially, the word "gamble" is just a variation on the word "game" and other related Germanic words. That *b* is thought to have snuck in there with a little bit of influence from the homophone "gambol," which puts some playfulness back into playing poker, so to speak, because it means skipping about or generally getting up to frolicsome shenanigans.

Heinous

A heinous crime is, literally speaking, a hate crime. It's from the Old French word *haine*, meaning "hate." While many French words that entered English following the Norman Conquest are from Latin, this

* Ebenezer Prout, *Fugue* (London: Augener & Co., 1891). https://archive.org/details/fuguepro00prouuoft

one is ultimately Germanic: It was originally a Frankish word, pre-dating Roman influence over Germanic people in the region. As a result, it's relatively closely related to the Old English predecessor to "hate," *hatian*, which described extreme aversion or enmity.

The integral association between the word "hate" and crimes specific to protected groups (specifically the phrase "hate crime" as we use it today) is relatively recent, emerging in the latter half of the 20th century (*see* malice).

Heist

You know how in thieves' slang you hear the word "lift" instead of "steal," as in "the impish pickpocket lifted a wallet from the gentleman's pocket?"

The word "heist" is the same idea: It's a variation on the word hoist as in to lift in the air. It originally comes from the Middle Dutch word *hyssen* (Dutch *hijsen*).

But of course hoist implies lifting something particularly large or heavy, so a heist is a much bigger and more involved theft than simply lifting wallets.

Hoax

This word surfaced in the late 1700s in reference to scandals like that of the Mechanical Turk, which was supposed to be a chess-playing automaton, but was ultimately revealed to be controlled by a hidden puppet master (or chess master, as the case may be).

The word "hoax" is ultimately a shortening of the word "hocus" as in "hocus pocus." In the 1600s, the word "hocus" referred to a street performer (often of wily reputation). "Hocus pocus," then, was a fanciful term for their often-extraordinary performances, magic tricks, and entertaining antics.

Illicit

We know that drugs, sex, and other activities can be "illicit," but can it just be ... licit? Actually, yes. Something "licit" is "lawful," from

the Latin *licitus* of the same definition. It's cognate with the word "license," literally the act of making something lawful or a document showing lawfulness.

Therefore, something illicit is literally "illegal." The ill- prefix is an assimilated form of the prefix *in-*, meaning "not," because that *l* at the beginning of "licit" likes to get frisky with the *in-*. It does the same thing with the *l* in "legal/illegal" and "legitimate/illegitimate," all of which are similarly from the Latin *lex*, "law," and ultimately from *legere* "to gather," based on the idea of a collection of rules.

Incorrigible

Similar to "licit," you can, in fact, be "corrigible." While this word isn't in use as much as its antonym is today, it's recorded as early as the 1400s and describes someone who can be reformed, something broken that can be fixed, or a situation that can be resolved. It's from the Latin *corrigere* "to correct" (*com-* as an intensifier + *regere* "lead, rule").

Therefore, to be "incorrigible" is literally to be beyond help or totally unfixable. So, to say "you're incorrigible," even playfully, is to imply "you're hopeless." While its most common modern contexts are descriptions of roguishly charming characters, it was once quite a serious accusation. In the 13th century you might use "incorrigible" to describe extreme monetary losses, incurable diseases, dramatic interpersonal rifts, and irreparably broken hearts.

Infraction

An infraction is literally a "breaking off," originally from the Latin *frangere*, "to break." In English, the word specifically referred to breaking an agreement, a sense that has now been metaphorically extended to breaking the social contract of following laws.

Etymological relatives of "infraction" include fracture and fragment.

Jail

You may know that this word is typically spelled jail in the U.S. and sometimes gaol in the U.K., which is a fairly dramatic difference when you consider that three-quarters of the letters are different.

"Jail" more closely reflects the Middle English *jaile* and the Old French *jaiole*, from which the Middle English word was adopted.

But if you're the sort of Brit who likes feeling superior, you'll be pleased to know that "gaol" more closely reflects the Middle English *gaile* and *gaiole* (because Middle English gives no fucks about spelling), the Old French *gaiole* (because Old French gave even fewer fucks about spelling than modern French), and the Medieval Latin *gabiola*.

But neither have much of a claim to spelling superiority here, because it's originally from the Late Latin *caveola*, which means "little cage" (or stall or coop or hollow).

To add yet another level of pomposity to this complicated origin, one of the reasons "gaol" once stubbornly persisted in British English is because Americans spell it "jail": The *OED* reports that legal style guides justify it due to "official tradition."*

Malfeasance

Sometimes legal terms simply boil down to overly fancy, Latinized or "flowery" ways of saying Germanic words. In this case, "malfeasance" often implies crimes committed by public officials, but its literal meaning is exactly the same as "wrongdoing." The elements are *mal-* "badly" and *faisant*, present participle of *faire*, which is ultimately from the Latin *facere*, "to do."

Malice

The term "malice" is an extension of the Latin *malus*, meaning "bad" or "unpleasant," with the latter half of the word adopted from the Latin form *malitia* "badness or ill will."

* "gaol," *OED Online*. March 2023 (Oxford: Oxford University Press).

In 14th-century English, it was also part of the legal term *malice prepense*, which describes premeditated crime and has also been termed "actual malice," "express malice," or "malice in fact."

Mischief

This word and its variants imply puckish, humorous behavior now, but the sense was far more nefarious in the past. In Middle English "mischief" held a wide array of French-influenced meanings, including "misfortune, hardship, wickedness, and evil." The Old French components behind the word unite to mean "unfortunate happenstance": *mis-*, here meaning "badly," and *chever*, literally meaning "come to a head," ultimately from the Latin *caput* "head." It's unrelated to the words "miser" and "misery" but was associated with them in Middle English due to their similarities.

The meaning of "mischief" softened over time, with today's meaning solidifying in the 1800s with "Mischief Night," which happened twice a year—before May Day and before the "Fifth of November" (Bonfire Night or Guy Fawkes Day)—and was marked by stealing items for bonfires the following day (*see also* guy, in Chapter 5).

Misdemeanor

This word is satisfyingly literal. You may know that someone's "demeanor" is their appearance as it regards their bearing or behavior toward others. It literally means "to completely direct (oneself)" so as to give off a particular vibe, as we might say today. Here, de- is an intensifier, and the French base word *mener* means "to drive," with the original sense being to drive a herd of animals. So much in the way you'd guide a herd of animals, you'd marshal yourself and your emotions toward a proper (or improper) presentation.

Slap *mis-* onto it and you get "ill behavior" or someone conducting themselves very poorly indeed.

Notable relatives include: menace, amenable, and eminence.

Murder

This name for the crime of unlawful killing is an evolution of the Old English *morðor*, which carried the same meaning but also conveyed any type of crime or mortal sin—or even the result of these crimes, including "punishment," "torment," and "misery." (*The Lord of the Rings* fans will notice the similarity to the evil realm of Mordor. While J. R. R Tolkien never mentioned the Old English word as an inspiration, the similarity certainly can't have been lost on the Oxford philologist.)

In Old Norse, the related *morð*, or "secret slaying," was a more heinous crime than *vig*, which referred to regular old slaying, because the former involved a killing in the dead of night or while a victim slept, as well as an attempt to conceal the crime.

The PIE root *mer-* means "to rub away," "to harm," or "to die," and appears in words like mortal, morbid, and mortuary. (It's also related to "mortgage," literally a "dead pledge," not because you may pay a mortgage until you die, but because the deal "dies" when the property is paid off or when the payments can't be made and the property is seized.)

The letter *ð* (called "eth" and typically making a soft *th* sound as in "those") shifted to *d* in modern-day "murder" thanks to influence from the Old French *mordre* and Medieval Latin *murdrum*, which are all ultimately from the same PIE root. However, the alternative spelling *murther* is recorded occasionally as recently as the 1800s.

Unexpected relatives include: mortar, mortify, remorse, amaranth, and ambrosia.

✍ But What about a "Murder of Crows"?

You've probably heard of collective nouns for animals like a herd of cattle or a murder of crows—or perhaps a prickle of porcupines, a flamboyance of flamingoes, an ambush of tigers, an exaltation of larks or a dazzle of zebras.

These are called nouns of assembly or terms of venery, where "venery" is a word for the sport of hunting (from the Latin

venari, meaning "to chase" or "to pursue"). Venery is also a word for the pursuit of sexual pleasure, and it was used with great joy as a double entendre in 15th-century hunting culture.

Many terms of venery are first recorded in the 1486 *Book of Saint Albans* (a.k.a. *The Book of Hawking, Hunting, and Blasing of Arms*), which was a gentleman's handbook of hawking and hunting. However, it is thought to have been written (or partly written) by a woman—Juliana Berners (b. 1388), a nun who wrote many treatises on hunting and field sports.

The book contains about 150 collective nouns, including what may be the first recorded instances of phrases like "gaggle of geese" and "pride of lions," and "litters" of baby animals, terms meant to be imitative of the behavior of the animals they describe. In the case of crows, "murder" is a reference to their longtime association with death and mortality in legends and folklore.

The book also lists a peep of chicks, a leap of leopards, an unkindness of ravens, a murmuration of starlings, a shrewdness of apes, a skulk of foxes, and a sleuth of bears. But it doesn't stop at animals: It includes terms like a "melody of harpers," a "blast of hunters," a "sentence of judges," a "subtlety of sergeants," and a "superfluity of nuns."

If these sound funny, it's because they're supposed to. They were all part of the wordplay and banter of gentlemen's hunting culture, and it was a mark of your knowledge as an experienced hunter to be able to name all of the collectives.

————

Nefarious

Although the term "nefarious" is occasionally used in somewhat tongue-in-cheek or fictional contexts today, it long described acts

that were truly abominable and horrific. In the 17th century it described extreme evil, and it quite literally implies "Oh shit, that ain't right": It's made up of the Latin elements *ne-* "not" and *fas*, meaning "right" or "lawful" in the sense of a "rightness" spoken by the gods or by the law.

✑ The Opposite of Innocent?

The opposite of "innocent" is "guilty." But shouldn't there be a word that correlates more directly? The base word of "innocent" is *nocent*, which comes from the Latin *nocentem*, meaning "harming." So innocent literally means "not harming" or "harmless." But "nocent" doesn't appear in English—making it what is called a "lexical gap" (*see* virgin, in Chapter 3).

————

Pilfer

This word typically refers to petty theft, and its origin is the Old French *pelfre*, meaning "booty" or "spoils" (*see* spoils). Although its origin is unknown beyond that, it's thought to be related to other English words including *pelf* "thief," which appears in *The Merry Devil of Edmonton* (1600–4), an Elizabethan play which was originally attributed to Shakespeare but has since been relegated to the Apocrypha.

And pity she is so! Damnation dog thee and thy wretched pelf!

Pilfer is also thought to be related to *pulfrour*, a word for a "thief" that's recorded in the 1300s.

 TALK LIKE A PIRATE

Many of the terms and phrases we associate with pirates were not recorded during the Golden Age of Piracy, which extends roughly from the 1650s through the 1730s or 1750s, depending on your historian of

choice. Rather, the way we imagine pirates talking is a result of writers like Robert Louis Stevenson (1850–95), author of *Treasure Island* (1883).

From there, film adaptations further cemented the "pirate accent" and related terms. Notably, the 1950 adaptation of *Treasure Island* featured Robert Newton as Long John Silver, who played up his Cornish accent and added features like the iconic "arrr."

The word "pirate" itself is originally from the Greek word for a pirate, *peiratēs*, which literally means "one who attacks."

Before this word entered English, the Old English term for a pirate was a *sǣsceaða*, or "sea-scather," and a pirate ship was called a *ðeofscip*, or "thief-ship."

Ahoy

This word is just a sound similar to "ho!" or "hey!" for getting some-one's attention from a long distance. The full, original greeting was likely longer: "Ho, the ship, ahoy!"

Incidentally, the Scottish-born inventor Alexander Graham Bell (1847–1922) preferred this term as the standard telephone greeting, another instance in which one hailed folk from afar. It was his American rival Thomas Edison (1847–1931) who recommended (and in the process coined) the word "hello" as an alternative, a variation on the earlier word "hallo!" or "hollo!," also long-distance greetings. (And yes, that does mean that no one used the word "hello" in standard conversation prior to the invention of the telephone, with most people instead favoring greetings such as "good day/morning/evening.")

Avast!

Although "Avast!" has lost its specificity in recent centuries, it is from the Golden Age of Pirates. This nautical interjection means "hold fast" and may have been inspired by the Dutch term of the same meaning, *houd vast*.

Buccaneer (and privateer)

The swashbuckling pirate type we call a "buccaneer" literally means "one who cures or roasts meat on a *boucan*," which was a type of grill used by the Tupi people, who were native to what is now Brazil and whose language blended with European languages during the Golden Age of Pirates.

The ending of the word "privateer" follows in buccaneer's footsteps and first referred to a privately owned armed ship and, shortly thereafter, came to refer to the sailors on it.

Landlubber

The "lubber" portion of this word isn't a weird pronunciation of "lover" but is instead an insult referring to someone who is large, clumsy, unintelligent, and idle. Originally thought to be a Scandinavian term, early variations in English included *lobre* and *lobi*, both of which more or less meant "lazy lout." Although "lubber" was frequently used by sailors, one didn't lazily "lub" on land exclusively—a lazy monk might be an "abbey lubber." The word also appears in terms like "lubberwort," a fictional laziness-inducing plant, and "lubberland," a mythical land of pleasant idleness akin to the Big Rock Candy Mountain.

Parley

To parley, or initially *parlen*, originally (in the 14th century) simply meant to have a chat, from the Old French *parler*, "to speak." "Parley" took on the sense of talking to or negotiating with an enemy in the following centuries.

The French term, intriguingly, is from the Latin *parabola*—yes, the same as the math term—which meant "speech, discourse, or comparison" (or literally "a throwing beside" or "a juxtaposition"). This is also the source of the word "parable," a story that presents a moral lesson by comparing the situation of the characters to real life.

Savvy

This word, which is first recorded shortly after the Golden Age of Pirates in the late 18th century, is a slangy adaptation of the French *savez-vous?*,

or "do you know?" It was, however, popular in the French Caribbean and Louisiana, making its use in Disney's *Pirates of the Caribbean* series not inaccurate, if a trifle anachronistic. Everything else in that film is, of course, 100 percent archivally true.

Scalawag

This word is usually associated with pirates. However, the word was not recorded until 1848, so it was probably never used by a real pirate of the eyepatch and pegleg variety. Its origin isn't 100 percent certain, but it's most likely a combination of the Germanic word *wag* and the Scottish word *scallag*.

Just like today, the Old English *wag* referred to a back-and-forth motion, just like a dog's tail or a wagging tongue, but it also meant "waver" or "lacking in steadfastness." Someone who was a *wag* was a rascally disreputable type or a mischievous child. A clock with a pendulum was sometimes called a "wag-at-the-walls," and someone destined to swing from the gallows was known as a "waghalter."

The "scala" portion of "scalawag" comes from Scalloway, one of Scotland's Shetland islands. In the 1800s many of the poorer people in Scalloway traveled to America looking for work. There they were called "scalawags" with the "wag" ending added because they were considered low-class and disreputable, due to the same kind of stereotyping and discrimination immigrants face today.

Over time "scalawag" simply came to be a word for any disreputable person. Following the Civil War, it was especially used as an insult in the American South for white people who opposed the Confederacy and supported racial equality.

Scalawag was then used in books and plays about rascally and disreputable pirates, including Gilbert and Sullivan's 1879 comic opera *The Pirates of Penzance* and adaptations of Stevenson's *Treasure Island*.

Scuttlebutt

"Scuttlebutt" was first a nautical term for a cask (butt) of drinking water with a hole (scuttle) for drawing it out. It came to mean "rumor" or "gossip" because sailors would idly chat around the cask. In fact, it's the piratical version of "watercooler talk" in the office.

Shiver

The word "shiver" originally referred to a small piece, fragment, or splinter of something, or to the act of breaking something into many small pieces. Hence, "shiver my/me timbers" refers to the splintering of wooden ships upon rough seas.

Thus you'll notice "shiver's" relation to the contemporary word "shiv," an often-makeshift razor or knife used as a weapon.

The trembly sense of "shiver" possibly comes from an entirely different origin. Arising around 1400 as an alteration of *chiveren* ("shake"), it may come from the Old English *ceafl*, meaning "jaw," suggesting chattering teeth.

"Shiver me/my timbers" is a fictional cry that likely arose after the Golden Age of Pirates. However, the phrase can be found in print as early as 1795, in a serial publication called *Tomahawk, or Censor General*:

"Peace? Shiver my timbers! what a noise ye make – ye seem to be fonder of peace than ye be of quiet."[*]

And naturally, the phrase was widely popularized by Long John Silver in Robert Louis Stevenson's *Treasure Island*.

"So," said he, "here's Jim Hawkins, shiver my timbers! Dropped in, like, eh? Well, come, I take that friendly."

"My timbers!" alone, however, was supposedly an actual nautical oath that was euphemistic in nature, as so many idioms are.

[*] "The Tomahawk! or, Censor general." September 7, 1795 – via Google Books.

Swashbuckler

Although "swashbuckler" is from the appropriate era, it wasn't specifically associated with seafarers initially. In the 1500s it meant any swaggery fighter who carried a sword (with the word "swash" referring to the heavy blow of a weapon) and a shield, or buckler. Basically, it was poking fun at shouty types who made their whole identity about combat.

Rape

Rape is an atrocious, violent violation of another person.

Unfortunately, it's absolutely fucking everywhere in the English language.

It is absurd how many of the words we use—even those ostensibly unrelated to sex or genitalia—ultimately boil down to sexual assault, either figurative or literal. "Rape" is related to words including rapid, ravine, rapt, rapacious, surreptitious, ravish, raptor, usurp, and ravenous.

All of these words are united by the Latin word *rapere*, which means "to snatch" but also, in all of these contexts, implies seizing, carrying off by force, and abducting—particularly "spoils of war," which shittily often includes women (*see* spoils, in Chapter 9).

(Despite the connection to "ravenous," the bird called a "raven" is not related. Its name is from the unrelated Old English word *hræfn* whose PIE root is meant to imitate their harsh calls and is also ultimately the root of the word "crow.")

But sometimes the word "rape" involved religious weirdness: For a time in Middle English, it was used not just for carrying off plunder, prey, and people in conflict and war, but also in the same way as the word "rapture" is today—as in the power of God raping you (or, in its past participle form, you'd be "rapt," i.e., raped) off to heaven.

There is only one form of "rape" that isn't actually awful, and that's in the word "rapeseed," the plant from which rapeseed oil, also known as canola oil, is derived. The term "rape" in the context of this plant is unrelated to the plundery, sexually terrible type, but instead

gets its name from Latin *rapa*, meaning "turnip." Green-thumbed gardeners might even cultivate "winter rape" and "summer rape," which both sound much worse than they are.

Reprobate

To call someone a "reprobate" is often said with a bit of a wink and a nudge these days, but the implication was originally pretty brutal. Its Latin source, *reprobare*, literally means "unworthy" or "rejected as worthless" (*re-* "back, opposite of" + *probare* "prove (to be worthy)"). You may recognize that root from the term "probate," which in legal contexts implies "a thing to be proved"—like confirming the details of a will.

Sabotage

The word sabotage comes from the French word *saboter*, which originally meant "to clumsily bungle something," but carried the literal meaning "to walk noisily." The base word *sabot* arose in the 13th century as a word for a wooden shoe, and it in turn is a variation of the older *savate*, meaning "old shoe."

There's a common folk etymology that says sabotage first appeared in the French and English industrial revolutions and referred to the idea that during labor disputes workers would throw shoes into machinery as a form of rebellion. Sabotage was indeed associated with labor strikers in both French and English—and it's possible that workers did chuck shoes into machinery to stick it to the man. It even seems that the idea of throwing shoes into machinery may have been symbolically associated with workplace rebellion.

But the word "sabotage" is not derived from this act because it's recorded with other meanings before it was ever associated with workers. The earlier meaning is just messing up or bungling something clumsily or unintentionally—like playing music badly, for example. So the initial sense may have been something like tripping over your own feet, or just generally not being very nimble and graceful, as though you're clomping about in wooden shoes.

It was extended to workers later. Even then, the meaning of "sabotage" was mostly general: Sabotage referred to doing your work badly and pretending it was unintentional, thereby causing problems for your employer without getting fired.

Scam

"Scam" is a relatively recent term, first appearing in the 1960s, but it's thought to be a variation of the older "scamp." Although the latter is an affectionate nudge reserved for mischievous children now, in the 18th and 19th centuries it was a word for a full-fledged criminal, typically a highway robber or a swindler. At the time, it was also a verb referring to half-ass, or low-quality, hastily completed work, and as a result it may be related to the words "skimp" or "scant."

Scandal

A scandal is literally a trap laid by an enemy for their opponent.

In Greek, *skandalon* referred to a stumbling block or a trap laid for an enemy, a sense that was first recorded in a Greek translation of the Old Testament. Its PIE root is thought to mean "to leap," suggesting specifically a trap with a springing device.

The word "slander" is ultimately from the same source, but morphed into its current form by means of the French *esclandre*, meaning an inflammatory or false statement meant to, in essence, act as a trap to discredit someone by way of causing a scandal.

One of the earliest appearances of "scandal" in English is in the 13th-century *Ancrene Wisse* (Guide for Anchoresses) with the spelling *scandle*, which in context described a moral stumbling block or potential temptation for religious hermits.

The term took on its fully gossipy sense by the late 16th century. Shakespeare employed it shortly thereafter in Sonnet 112, one of a series in which he alludes to an unknown bit of scandal that damaged his reputation:

Your love and pity doth the impression fill
Which vulgar scandal stamp'd upon my brow.

Scapegoat

What does blaming someone for something that isn't exactly their fault have to do with goats?

If you're Jewish, you might already know.

There's a portion of Leviticus that addresses the Day of Atonement, or Yom Kippur. Basically the tradition was to select two male goats. Someone draws lots on behalf of the two goats. One of them gets sacrificed to God; the other is presented to God and then sent into the wilderness bearing the sins of the people as sort of a proxy for their wrongdoing. That second one, the one that gets sent away, is the scapegoat.

But the English word "scapegoat" was, obviously, not the word used in the original text. It was the Hebrew word *'azazel*.

In Hebrew it's often read as a proper name of a demon, presumably the demon to which the goat was sent carrying all the sins. That name is Azazel, which you may recognize as the name of a demon who shows up in a good deal of literature and even pop culture derived from Judeo-Christian lore.

But historically it hasn't always been read as a proper name. Sometimes it was read as a variation of the phrase: *'ez azal* (the goat that departs, the goat that is expended). So another way to read the original text is not that the goat is sent to a demon called Azazel, but that Azazel is simply the goat that's leaving rather than the goat that stays and gets sacrificed.

Fourth-century theologian Saint Jerome of Stridon (d. 420 CE) was the first to translate the Hebrew term to the Latin *caper emmisarius*, or "emmisary goat."

And from there it was translated into French and German and Greek. All of these refer to the goat fucking off into the wilderness:

French: *bouc émissaire* "emmisary goat"
German (first recorded by German theologian Martin Luther): *der ledige Bock* "the single goat"
Greek (first recorded by Symmachus): *tragos aperchómenos* "the goat that goes out"

In English, the goat is "scaping," which is short for "escaping."

There are a few other words from English linguistic history that include "scape" as a shortened form of "escape." For example, someone who is a scapegrace has avoided the grace of God, and a scapegallows is someone who deserves to be hanged but isn't.

(The type of scape found in "scapegoat," "scapegrace," and "scapegallows" is not related to the scape in words like landscape or cityscape. That type of scape is from a Middle Dutch word denoting conditions, qualities, and shapes. It is cognate with the ending –ship, as in friendship or dictatorship or censorship, so in much the same way as a landscape is a scene depicting land, a friendship is friend-shaped or has the quality of being friends, a dictatorship is dictator-shaped or has the quality of being ruled by a dictator, and censorship describes the practice or quality of censoring things.)

Scoundrel

In English, this word was originally spelled *skowndrell*. Its origin is uncertain, but it might be related to the word "shun" (as in someone who should be shunned for spelling "scoundrel" like that), or to the Old French *escondre*, meaning "to hide (oneself)," suggesting someone sneaky and hidden.

Shark

Sharks were named after terrible people.

That's right. "Shark" was a word for a human before it was a word for a fish.

Old English didn't have a general word for the broad group of cartilaginous fish species that we now call sharks. It did have some more specific names. Some were often called "houndfish" or "sea dogs," which survives in the shark species now known as "dogfish." Hammerheads were originally and less scarily called "balance-fish" in English until at least the 1740s.

Meanwhile, the Old Norse word for a shark was *har*, related to other Germanic words for sharks such as the Dutch *haai* and German *Hai*.

The word "shark" (or "sharker") first appeared in English in the 1400s, and at that time it meant "scoundrel," "villain," or "swindler." It wasn't a word for the animal in English until the 1700s. Its exact origin isn't known, but it may be from the Middle High German *schürgen*, meaning "to poke" or "to stir" and related to the German *Schurke* "villain."

The switch is thought to have been due to a comparison between predatory pickpockets and thieves and the behavior of the animals.

It has also been theorized that the Mayan word *xoc* may have been a word for "shark" that made its way to English via colonization. After all, English did briefly use the word "tiburon" for sharks in the 16th century, and that is thought to be from an indigenous South American word. But the *xoc* theory falls apart because the timeline doesn't add up: "Shark" is recorded in reference to people before English could have reasonably adopted a Mayan word for the animal.

All of the above means that the term "loan shark" for a lender who offers loans at dramatically high interest rates (then often uses illegal tactics to collect moneys owed) is closer to the original sense of the word. However, though the practice has been infamous for centuries, the term may not have arisen until the 20th century, so whether it's inspired by human predators or aquatic ones is unknown.

Meanwhile, the unrelated Greek and French words for "shark" (as in the animal) are terrifying:

French **requin**, literally "grimacer"
Greek **karcharías**, literally "sharp/jagged biter."

Author Herman Melville (1819–91) has a deeply entertaining discussion about different shark species with humanoid (and disturbing) personalities in his 1849 book *Mardi: and a Voyage Thither*, including:

the **brown shark**, or "sea attorney, so called by sailors; a grasping, rapacious varlet"
the **tiger shark**, who has a "rude, savage swagger," as well as "a distended mouth and collapsed conscience, swimming about seeking whom he might devour"

and, of course, "the ghastly **White Shark** … a ghost of a fish" that moves
with "horrific serenity of aspect" and sports a "bottomless white pit of
teeth."

Shenanigan

The word "shenanigans" is first recorded in California in the 1850s.
It's thought to be a slangy or dialectical variation of the Spanish
chanada/charranada "trick, deceit," which is related to "charade." And
although it's certainly a colloquial term, its origin is debated: It could
also be from the Irish *sionnach*, meaning "fox," reflecting the devious
foxes of folklore.

Swagger

The word "swagger" (or rather the verb "swaggering") is first recorded
in Shakespeare's *A Midsummer Night's Dream* (ca. 1595):

What hempen home-spuns have we swaggering here,
So near the cradle of the fairy queen?

Act 3, Scene 1

The word also appears without the -er suffix in *Henry IV Part 2*
(1596–9), written a year or so later. It was probably a variation on the
Middle English verb "swag" meaning "to sway."

Swindle

The derpiest of criminal terms, "swindle," is from the Old High
German *swintilon*, meaning "to be giddy," which is related to simi-
lar Old English terms for dizziness. It entered English from mod-
ern German in the 18th century, an adoption of the German term
Schwindler, describing both cheats and giddy people, perhaps from the
idea of the giddiness of gambling. Some sources say it was introduced
by German Jewish people, but given the racist/xenophobic associa-
tions between Jewish people and money handling, this attribution
may just be based in bias.

Thief

The word "thief" is Germanic and has existed since Old English (as *þeof*), but beyond Proto-Germanic its origin is not known. Nineteenth-century dictionaries distinguished between thieves and robbers, with a thief stealing things without the knowledge of the victim, while a robber stole or plundered things openly and with the victim fully aware that they were being shaken down. The word "rob" (Old English *robben*) is related to words including "reaver," "rover" (originally a word for a pirate or sea-robber), and, distantly, "corrupt" (*see* corrupt).

Transgression

To "transgress" is literally to cross a line between morality or lawfulness and the immoral or criminal world beyond. The Latin *transgressionem* is "a going across" or "a doing over," from the elements *trans* "across, beyond" and *gradi* "to walk, go."

Unscrupulous

A "scruple" is literally a "sharp stone." Its first known appearance in relation to morals is in *De re publica* (On the Commonwealth; 54–51 BCE), where Roman statesman Marcus Tullius Cicero (106–43 BCE) used it to mean a prickling of conscience, perhaps like a sharp pebble in one's shoe. It entered English as *scrupul* in the 14th century.

Today, "scrupulous" can mean both "careful" or "diligent," or "particularly moral." The idea that led to the former is that of someone who carefully or exactly follows their conscience and doubts.

Therefore, an "unscrupulous" person has no metaphorical moral stones troubling the soles of their conscience, and instead chooses to behave immorally.

CHAPTER 9

THIS MEANS WAR

THE VOCABULARY OF VIOLENCE, WRATH, AND WEAPONRY

In addition to insulting, violating, institutionalizing, stereotyping, and oppressing one another, humans are well known for just straight-up killing one another. As you probably can guess, we have plenty of words for that, too.

The concept of war is as old as civilization, as is the word itself. One might suspect that its root means something like "to fight" or "to do battle," but it is far truer to the nature of war than either of those senses: Its root is the PIE *wers-, meaning "to confuse" or "to mix up." In fact, the original sense of the Old English versions of this word—*wyrre* or *werre*—is thought to be "to bring into confusion."

It's a Germanic word, but also has cognates in Romance languages: French has *guerre*, and Spanish, Portuguese, and Italian all share *guerra*. It's possible that these languages favor the Germanic term because the Latin word for war, *bellum*, literally "struggle" or "strife," too closely resembles words for beauty in Romance languages.

English has also borrowed *bellum* for its own purposes, however, as seen in words like bellicose and belligerent, both describing people prone to conflict, and antebellum, literally "prewar" or "before the war," often referring to the period before the American Civil War.

As a general term for war, Old English often used *gewin*, which is a translation of the Latin *bellum* and related to the word "win."

Old English also used many Germanic words for "war" in people's names: Any time you see *wig* (as in Hedwig—*hadu* "battle, combat" + *wig* "fight, duel") or *hild* (as in Brunhilda—literally "armed for battle") in a name, you're looking at a word for war.

"War" added "fare" to become "warfare" in the 15th century. It's modeled after the earlier "seafarer," in which the Old English *faer* meant to go on an epic journey or an expedition—so "warfare" adds

a sense of grand adventure and conquest to the confusion and chaos. This "fare" is also the same one that implies food or tolls, suggesting food that is conveyed to someone or payments required to proceed on a journey.

Warriors get their name from the Old English and Old French *werre*, particularly the verb *werreier*, meaning first "to wage war," and then, as a noun, the person doing so.

The term "warlord" is relatively recent, not appearing in English until the 1850s, though it was originally an English translation of the German word *Kriegsherr*, which means more or less the same thing (war-man). The Chinese word *junfa* is also typically translated into English as "warlord."

But war, wrath, and violent conflict range far beyond these words. Read on to discover the lives behind the words that bring death and destruction.

Aggressive

To be aggressive is literally to "step toward" someone, from the Latin elements *ad-* "to, toward" and *gradi* "stepping." The Latin *aggredi* wasn't quite so confrontational as its English and French descendants; although it could refer to an attack, it also meant "an attempt" or "an approach."

Sigmund Freud was one of the first to use "aggression" as a personality trait or disordered behavior rather than a physical act in conflict or battle, with the English word appearing in this sense in a 1912 translation of his work.

Altercation

This word looks like a compound of some kind, but the main root at play here is the Latin *alter*, meaning "the other." The Latin *altercari* was used to mean "to dispute or quarrel" but literally implies "(speaking) alternately with another," and therefore quarreling.

Although the noun "altercation" is about two and a half centuries older in English, there is a back-formed verb that comes from it as well: "Altercate" is recorded as early as the 1520s.

Anger

This is an Old Norse–derived term: The noun *angr* carried a whole range of senses, from vexation to grief and sorrow to physical afflictions. Similarly in Middle English, "anger" was broader than it is today. It was not only used for emotional hostility and frustration, but also for any form of distress, physical pain, or suffering. (So when, in *The Phantom Menace* (1999), Yoda says, "… anger leads to hate … hate leads to suffering," that was a bit of Middle English thinking.) The reason for the shift is likely because someone who has been injured or wronged often feels resentment as a result of that injury or wrong.

Animosity

You might think that this word has to do with animal-like behavior—and indeed it does share the Latin root *animus*, meaning "life" or "breath," with the word "animal"—but beyond that the two words diverged, and "animosity" does not specifically imply beastly ferocity. Indeed, the first recorded meaning of this word in English is "vigor" or "bravery," and it had laudatory rather than negative connotations. Indeed, its Old French predecessor, *animosité*, similarly meant "boldness." The turn toward today's sense of hostility didn't emerge until the 1600s, nearly 200 years after "animosity" entered English.

Annihilate

To annihilate means to completely destroy—and that sense is quite literal in the word. The Latin *annihilare* means "to reduce to nothing," from the Latin *nihil* "nothing at all," also seen in the word "nihilism."

This word hasn't always been the worst thing: Religious Annihilationists, for example, believe that, rather than going to Hell, the wicked are reduced to nothing—which doesn't sound quite so unpleasant as eternal damnation.

Antagonist

As most writers are well aware, your protagonist is the major player, hero(ine), or primary actor in your story—the one around whom the narrative revolves and whose journey readers are following. Think of Elizabeth Bennet in *Pride and Prejudice*, Jim Hawkins in *Treasure Island*, or the unnamed narrator in *Invisible Man*.

The word "protagonist" was originally a theatrical term, from the Greek *protagonistes*, a word for the main actor in a play. It is made up of the words *protos*, meaning "first," and *agonistes*, meaning "actor" or "competitor."

So wherefore "antagonist"?

Swap *protos-* with the English prefix ant-, meaning "against" or "opposed to," and you get your antagonist, or villain—the character acting against your primary actor. Ant- is a variation on anti-, which you find in words like antibiotic and anticlimactic.

Famed antagonists from theater and literature include Shakespeare's Iago and Lady Macbeth, Tolkien's Sauron, and the White Witch of C. S. Lewis's *Chronicles of Narnia*.

Perhaps unexpectedly, "antagonist" is older than "protagonist," at least in English. (Twist: The bad guy wins!)

While "antagonist" was adopted in the late 1500s as a word meaning "one who contends with another" in any sort of sport or contest—so potentially a real person—a "protagonist" was always a performer or a fictional player in a story.

Similarly, in Greek, *antagonistes* was a word for any sort of rival or competitor, while *protagonistes* was a word for a stage actor. The Greek base word of both, *agon*, meant "a struggle" or "a contest," and also forms the base of the word "agony."

Atrocity

The word "atrocity" has a nightmarish vision hidden within it: Its PIE elements (*ater-* "fire" + *okw-* "to see") give it the literal meaning of something "of a fiery appearance" and therefore something that is threatening and frightening. This meaning extended into the Latin *atrox*, meaning "fierce," "cruel," or "frightening," before the

word entered French (*atrocité*) and then English with the sense of "terrible, unthinkable wickedness."

Barricade

Soldiers and rebels build barricades to protect bases during battles or block off streets when, say, in Victor Hugo's *Les Misérables* the Republican hero Jean Maximilien Lamarque dies and you and your fellow students must rise up against the monarchy and fight Inspector Javert and his cronies.

"Barricade" literally means "made of barrels," from French and Spanish origins, because during a riot, or a big public uproar, people fighting would set up blockades, or a wall, made of barrels filled with rocks and dirt. Today, we use the word informally, too. You can barricade your door with pillows or your treehouse with a pile of leaves.

Berserk

If you've ever participated in a role-playing game with a class capable of "berserker rage" or nonstop superhuman violence, that character is named after Norse warriors.

The Old Norse *berserkr* (or *berserkar*) wasn't commonly seen in English until Sir Walter Scott's 1822 novel *The Pirate*. In Old Norse, the word implied a raging, powerful warrior but likely literally meant "bear-shirt," or a warrior clad in bearskin. (However, Scott incorrectly believed it to mean "bare-shirt," and therefore a warrior who fights without armor.)

Bomb

The word "bomb" is surprisingly old. While it arose in English in the 1580s, its origins are Greek, from the word *bombos*, meaning "deep and hollow sound." This somewhat onomatopoeic word then came to us by way of the Latin *bombus*, the Italian *bomba*, and the French *bombe*.

So "bomb" essentially means "boom."

In English, the word first referred to mortar shells. One of the earliest and most famous uses of mortars is thought to be the 1453 siege

of Constantinople by the Ottoman sultan Mehmed the Conqueror (1432–81), whose victory there brought about the end of the East Roman (Byzantine) Empire, as well as the widespread use of the word "bomb" (and its multilingual variants) to refer to mortar shells across Europe. (However, the first mortar technology was probably developed in Korea in the early 1400s.)

The word "bomb" did not come to carry the modern sense of "explosive device placed by hand or dropped from an airplane" in English until 1909. (Before, terms for explosive weapons were more specific.)

Additionally, the phrase "the bomb," as in "great" or "awesome," is from the 1950s, though at the time it was used as an adjective (e.g., "that's bomb," which eventually became "that's the bomb"). And yes, that's an uncomfortable reaction to the threat of nuclear war.

Bullet

In a curiously adorable etymological connection, the word "bullet" comes from the Middle French word *boulette*, the diminutive of *boule* or "ball"—specifically, in the context of war, "cannonball." So, a bullet is a "small cannonball."

Cannon

The origin of word *cannon*, which arose in English around 1400, lies in the Latin word *canna* (Greek *kanna*), which meant "reed" and came to refer to any sort of tube. *Canna* became the Italian *cannone*, or "large tube, barrel," which became the Old French/Anglo-French *canon*, which was then appropriated in English.

This origin is very likely related to the term "canon" in the sense of "church law" or literary canon, which comes directly from the Latin *canon*, "measuring line, rule" as in a measuring rod. This sense came from the Greek *kanon* ("straight rod or bar, rule, standard of excellence"), which also came from *kanna* (again, "reed")—the implication being that church canon was a measure or standard of excellence and straightforwardness.

Carnage

If you're familiar with the word "carnivore," it will come as no surprise that "flesh" is the crux of this word. The Latin *carnem* means "flesh," and *carnaticum* described the slaughter of animals. The word was extended to the bloody fates of humans in Old Italian with *carnaggio*, which became *carnage* in 17th-century French before it was adopted into English.

Casualty

Why are deaths in war "casualties"?

Really, there's nothing "casual" about it, at least not in today's sense. But the meaning of "casual" as we know it today—that is, informal, did not arise until the late 19th century. Prior to that, the word "casual" referred to something that happened by chance, from the Latin *casus*, meaning "chance," "accident," or "opportunity."

This sense carried over into of the vocabulary of war and other situations perilous to life through the idea of misfortune—people killed incidentally or as a random byproduct of battle and disaster. The words "casuel" and "casuality" also similarly referred to chance occurrences of any kind from the 14th into the 17th century.

"Casual" made its way to today's meaning of "informal" through the idea of a person who is unmethodical or undependable.

Catapult

This word, introduced in English in the 16th century, literally means "to throw against" or "to throw through," from the Greek *katapeltēs* (elements: *kata-* "against, across" + *pallein* "toss, hurl"). The earliest machine of war given a name like this was a Roman construction used to throw massive darts, similar to a ballista.

Claymore

The name of this two-edged broadsword, known for its use by Scottish Highlanders, is from the Gaelic *claidheamh*, a word for a great sword, and

ultimately *claidheb*, meaning "sword." All of these words are likely composed of elements that give them the literal meaning "great-striking."

This word faded from usage for a time but was reawakened by Sir Walter Scott (1771–1832) in his historical novels, a genre that he played a strong role in shaping with works such as *Ivanhoe* (1819) and *Rob Roy* (1817).

The landmine known as an M18 Claymore was named after the sword by its inventor, Norman MacLeod, and his company, the Calord Corporation, which developed the pellet-scattering anti-personnel weapon in the 1950s and 1960s, with its first uses in the Vietnam War.

Combat

Combat (or the act of combatting) is literally "fighting together," from the Latin elements *com* "together" and *battuere* "to beat, fight."

Conflict

By now you can likely guess that the prefix in this word is con-, an assimilated form of Latin *com-*, meaning "together" or "with." But what's -flicting—which of course we know from words including "inflict" and "afflict" as well? The Latin *fligere* means "to strike." So things that conflict strike together; inflicting pain is striking pain into someone; and to be afflicted by a disease is to have its ill effects directed at you.

The difference between the noun "*con*flict" (with the emphasis on the first syllable) and the verb "con*flict*" (with the emphasis on the second) is due to what's called initial stress derivation, in which the emphasis changes syllables between parts of speech.

Contention

This word, along with "contend" and "contender," is composed of the Latin elements *com-* (assimilated), meaning "together," and *tendere*, meaning "to stretch." The word is intended to imply a violent struggle toward a goal against an opponent.

Notable relatives include: tendon, tension, extend.

Controversy

A controversy is literally "a turning against." Its Latin source, *controversus*, is composed of the elements *contra* and *versus*, both of which exist with similar meanings in English today. The root verb *vertere* means "to turn" and appears in words like "vertigo," "introvert/extravert," and "advertisement" (literally something that makes you turn toward a product, as anyone on Madison Avenue can tell you).

Cutlass

This word has nothing to do with cutting or lasses, even etymologically. It was adopted into English from the French *coutelas*, which is thought to be from the Italian word *coltellaccio*, which means "a large knife" thanks to that *-accio* ending, which implies augmentation or size. The curious part of this word is that the Italian word is from the Latin *cultellus*, meaning "small knife." So, ultimately, the Italian *coltellaccio* means "big small knife."

Debate

A debate is literally a verbal beating. When it entered English in the 14th century, the word debate meant to quarrel, fight, or make war. It comes from the Old French *debatre*, literally "to beat down." The sense of a more formal dispute came around soon after, in the early 15th century.

Decimate

Today the word "decimate" is often used to mean "to totally destroy," but its source, the Latin *decimare*, is about 90 percent less egregious—though its history is still pretty horrifying. The Latin verb means "the destruction of one-tenth," from *decem*, or "ten."

When large groups of Roman soldiers exhibited mutinous or cowardly tendencies, the group's punishment was decimation: They were forced to form groups of ten and draw lots. The unlucky soul among them who drew the shortest straw would be executed by the other nine.

Defenestrate

If you are an insatiable word enthusiast, you probably know that the word "defenestrate" means "to throw someone out of a window."

It's based on the Latin word *fenestra*, or window. But Romans didn't go around saying that they defenestrated people—defenestrate was developed in the 1600s using Latin elements. In fact, the word "defenestrate" was coined to describe a very specific instance of fenestral expulsion.

In 1618 two Catholic deputies to the Bohemian national assembly, together with their secretary, were tossed out the window of Prague Castle by angry Protestants. (Fortunately, they landed in a pile of dung and survived.) This defenestration kicked off the Thirty Years' War (1618–48), which killed between 4.5 and 8 million people.

This has been called the Third Defenestration of Prague.

Yes, the *third* defenestration of Prague. There were two more before that—though the word was retroactively applied to them after the third one. The first defenestration occurred 200 years earlier in 1419, and in that case seven members of the Prague city council were tossed out the window by protestant Czech Hussites. These folks were not so lucky, and all of them died after landing on angry protestors. This incident triggered the Hussite Wars (1419–34). During the second defenestration in 1483, a magistrate and the already-dead bodies of seven councilors were ejected from town hall windows in various city centers around Prague. The second is considered less significant and sometimes not an official defenestration due to its failure to trigger a full-fledged war; indeed, it helped cement three decades of peace in the country.

Maybe stay away from windows in the Czech Republic for your own safety.

Discord

This word isn't just the name of a server-based platform for chatting about video games and leaking CIA documents. In fact, its literal meaning is curiously tragic. It literally implies a heart being torn apart or broken, or even two hearts parting ways—from the Latin

dis- "apart" and *cordis* "heart"—and therefore evokes the emotional toll of conflict.

However, it is worth noting that the Latin *discordia* may have originally implied intellectual differences and disagreements rather than emotional conflict, because it took a while before Western civilizations reached a widespread consensus on what exactly the heart did. According to Egyptian and Greek philosophers including Aristotle and Praxagoras (b. ca. 340 BCE), the heart was thought to be the center of logic and reason.

Enemy

We often associate the verb "unfriend" with social media, but not only does this word appear in Shakespeare as a verb ...

Sir, will you, with those infirmities she owes—
Unfriended, new-adopted to our hate,
Dowered with our curse and strangered with our oath—
Take her or leave her?

King Lear, Act 1, Scene 1, lines 220–3

... and even earlier as a noun meaning "enemy" in the Middle English epic poem known as Layamon's *Brut* (ca. 1190–1215) ...

Vther bead ferde; ouer al þeos eorþe,

and wend to oure **onfreondes***; and drif heom of londe.*

In translation:

Uther, summon forces over all this land,

And march to our unfriends [enemies] and drive them from land.

... but it is also the literal meaning of the Latin-derived word "enemy."

Its Latin source, *inimicus*, is composed of the elements *in-*, here meaning "not," and *amicus*, meaning "friend."

In Old English, it wasn't necessarily a word for an adversary or opponent, but someone generally hateful and interested in doing harm toward another person. In Middle English, it carried a heavily religious connotation, suggesting an unbeliever, someone hateful to

God or someone opposed to Christianity. In fact, the Devil himself carried "the Enemy" as an epithet.

The word didn't take on its fully adversarial meaning—as in "enemy forces," for example—until the 14th century.

Explode

Today we think of an explosion as a fiery blast, but etymologically, the word "explode" means to clap your hands. It blends the prefix ex-, meaning "away or outward," with the Latin base word *plaudere*, meaning "to clap" (same base word as "applaud"), so more precisely "explode" means "to clap away."

In fact, it was kind of the opposite of applaud, which means "to clap to or toward someone." In the 1500s the English word "explode" meant to angrily clap at a performer and boo them off the stage.

So, initially, an audience exploding with applause was definitely not a good thing, although in Latin *explodere* was also a word for the Roman theatrical practice of the actors clapping at the end of a performance merely to tell the audience the show was over and it was time to go.

About a hundred years after the word first appeared in English, it became associated with the loud thunderclap sound of mortar shells going off, which became more common in England following the 16th century.

Exterminate

You're likely aware that words such as "terminate" and "terminal" imply endings. But the root in "exterminate," the Latin *termen*, usually meant "boundary" or "end." Therefore, the Latin *exterminare* didn't mean "to wipe out" but instead meant to "drive out" or "expel"—literally to send someone out beyond a boundary. Less genocide, more expulsion.

It came to be synonymous with "eradicate" (literally "pull up by the roots" and related to "radish") in English in the 1540s during the Boulogne campaign. At that time, the Tudor monarchy adopted a policy of mass violence intended to wipe out the native population

of Boulogne in northern France with the intention of repopulating the area with English people.*

Gladiator

A gladiator is literally a "swordsman," from the Latin *gladius*, meaning "sword"—though it's probably ultimately from a Germanic language. It's probably as a result of the power dynamic between Romans and Gauls, who were often enslaved by the Empire, that the word was applied specifically to arena fighters—often slaves and criminals—rather than swords people of a higher tier.

Gun

The word "gun" traces back to the Old Norse word *gunnr*, or "battle," but the relation between these two words took an interesting detour: The word "gun" came to refer to a weapon via the shortening of a woman's name: Gunilda.

The name Gunilda comes from the Old Norse woman's name Gunnhildr (formed of *gunnr* and *hildr*, both meaning "war" or "battle").

One of the first documented connections between the female name and the name of the weapon is in a 1330 munitions inventory of Windsor Castle, which referred to a specific, particularly large ballista ("una magna balista") named "Domina Gunilda"—that is, "Mistress Gunilda" or "Lady Gunilda."

From there, *gonnilde* became the common Middle English term for "cannon," followed by the shortened *gunne* in the mid-14th century. The meaning of the word expanded with the evolution of weapons technology from cannons to handheld firearms through the late 14th and early 15th centuries.

Havoc (especially wreaking havoc)

One could theoretically wreak many things, but what one typically wreaks is havoc, vengeance, or ruin, making "wreak" a fossil word.

* Neil Murphy, "Violence, colonization and Henry VIII's conquest of France, 1544–1546," *Past & Present* 233:1 (November 2016), 13–51.

Wreak is from an Old English word meaning to drive out or to avenge, and curiously it was only extended to the sense seen in the phrase "wreak havoc," where it means "cause" or "inflict," starting in the early 1800s thanks to the Romantic poet Percy Bysshe Shelley (1792–1822), who used it in a line paired with the word "ruin."

> With thee, if thou desirest, will I seek
> Through their array of banded slaves to wreak
> Ruin upon the tyrants.
>
> *The Revolt of Islam*, Canto 2, 1818

In fact, Google's Ngram Viewer doesn't show havoc and wreak together until the 1920s, and the *OED* cites the first appearance of the phrase "wreak havoc" in Agatha Christie's 1926 novel *The Murder of Roger Ackroyd* (1926): "Annie is not allowed to wreak havoc with a dustpan and brush."* Given Christie's tone, the phrase was very probably used before this, but it does appear to be the first published instance of the word pairing. So while "wreak" is a fossil word, it didn't take very long for it to fossilize.

By the way, because both are now used in similar contexts to mean "cause," "wreak" is sometimes misunderstood to be the present tense of "wrought," in which case the past tense of this phrase would be "wrought havoc," and while everyone will understand what you mean if you said "wrought havoc," the word "wrought" is more closely related to the word "work," and the past tense of "wreak" is simply "wreaked."

Another point of confusion: Throughout its history the word "wreak" has been mixed up and conflated with words like "wreck" as in a shipwreck, and "rack" as in "racking sobs," which has sometimes been spelled with a *w* and sometimes not. The annoying part here is that all of these words are used fairly distinctly: one "wreaks havoc," "wrecks a ship," and "racks one's brains" or is "racked with pain."

To make this even more annoying, "wreck" and "wreak" are ultimately related, but now mean distinct things so that the phrase "wreck havoc" is an eggcorn—that is, a word that is commonly misused in

* Agatha Christie, *The Murder of Roger Ackroyd* (London: Collins, 1926).

place of another, especially in an idiom. "Rack" is the unrelated word here and originally referred to cloth being stretched to dry, or people being stretched for heresy (as in "on the rack").

Havoc, which is not a fossil word, was originally an Anglo-French war cry that gave soldiers the command to pillage a place, which is why Marc Antony says, "Cry 'Havoc!', and let slip the dogs of war," in Shakespeare's *Julius Caesar* (Act 3, Scene 1, line 272).

Holocaust

Long before the Holocaust with a capital H, a holocaust was a sacrifice by fire. In Greek, *holokaustos* means "burned whole" (*holos* "whole" + *kaiein* "to burn"), and in biblical contexts it referred to any burnt offering—not necessarily requiring killing, but often involving it. Compare these two passages, both recorded with the word "holocaust" in its earliest English translations, though the word "sacrifice" is often used now, given its modern associations:

> 2 Chronicles 29:31: And all the multitude offered victims, and praises, and holocausts with a devout mind.

> 2 Kings 3:27: So he took his first-born, his heir apparent, and offered him as a holocaust upon the wall.

The genocide of Jewish people by the Nazis was labeled "the Holocaust" after World War II, in 1957, and before that (and still in some contexts today) it was called "the Shoah," meaning "the catastrophe" in Hebrew.

Twelfth-century English monk and chronicler Richard of Devizes would foreshadow the future of the word when he used "holocaust" to describe a horrific pogrom in 1189, when Londoners went on a two-day anti-Jewish killing spree during the coronation of Richard I. (Pogrom is a Yiddish word, originally from Russian *pogromu*, meaning "devastation" or "destruction," from the elements *po-* "by, through" + *gromu* "thunder, roar.") Richard of Devizes was deeply anti-Semitic, though: He meant it in the "sacrificial offering" sense and clearly did not see the mass murder as a problem.

On the very day of the coronation, about that solemn hour in
which the Son was immolated to the Father, a sacrifice of the
Jews to their father, the Devil, was commenced in the city of
London, and so long was the duration of this famous mystery
that the holocaust could scarcely be accomplished the ensuing
day. The other cities and towns of the kingdom emulated the
faith of the Londoners, and with a like devotion dispatched
their bloodsuckers with blood to hell.*

Joust

The idea of it being "your turn" in a game is from the idea of turning
your mount in a joust. Both the term and jousting culture arose in
the 1300s. Indeed, jousting and other horseback war games were the
first to be called "tournaments," from Latin *tornare* "to turn."

The word "joust" itself is originally from the Latin *iuxta*, which
you might recognize as the root of the word "juxtaposition" (in which
things or concepts are presented in contrast with one another). The
Latin word means "beside" or "next to," so a "joust" is a competition
in which two combatants either approach alongside one another or
fight next to one another.

It would make sense that "tilting" as a synonym for jousting would
also refer to the motion of leaning into an attack, but a "tilt" is also
a word for the divider between the two jousting opponents, and it's
unclear whether the verb or the noun was first used for the sport.

Maim and Mayhem

Both of these words are from the Old French *mahaigner*, mean-
ing "to injure, wound, or mutilate." In English and Anglo-French,
"mayhem" (or *maihem*) was originally a legal term referring to the
act of injuring a person in order to make them less capable of
defending themselves, while in general usage it referred to any sort

* Modern English translation found in Sergio Bertelli, *The King's Body: Sacred Ritu-
als of Power in Medieval and Early Modern Europe*, trans. R. Burr Litchfield (University
Park, PA: Penn State Press, 2003), p. 45.

of intentional violence or damage. "Maim" (or *maimen*) was also a legal term referring to the act of injuring or removing someone's limb to make them less fit to fight.

Malevolent

Someone who is "malevolent" wants you to have a very unpleasant time indeed. First recorded in the 16th century, this word is made up of the Latin components *male*, meaning "badly," and *volentem*, "wishing." It often appears in 17th-century astrological writings in association with celestial bodies and phenomena thought to cause ill fortune: "Malevolent Mars" was said to wreak havoc, for example, and certain eclipses were dubbed "malevolent Conjunctions of the Planets."*

Massacre

Much like the word "butcher," this word first described the slaughter of animals for food. The Old French *macacre* described the act of butchering or the physical slaughterhouse itself, though in English it has always described the indiscriminate killing of many humans as well.

Menace

You know how the sort of asshole who's looking for a fight behaves? The big talk, the aggressive thrust of the head. That motion is embedded into this very word. To be a menace or to menace someone literally means to "jut" or "project" yourself at someone—and thereby threaten them, from the Latin *minae*, meaning either "threads" or points or objects that project out. In Latin, of course, this could also imply the brandishing of a weapon or spear.

Mercenary

This word is related to words including "market" and "commerce," all involving trade, buying, and selling. The root here is the Latin *merx*,

* Richard Edlyn, *Præ-Nuncius Sydereus: an astrological treatise of the effects of the great conjunction of … Saturn and Jupiter, October 10, 1663, and other configurations concomitant, etc.*, 1664.

"wares, merchandise." Although a mercenary is today most often associated with soldiers for hire, from the 14th to the 17th centuries, it referred to anyone who worked for hire, and especially someone motivated solely by profit. It may also be related to the name of Mercury, who in addition to his role as a god of messengers and travelers, also represented merchants and sellers.

This word's least expected relative, perhaps, is "mercy," which specifically implies heavenly rewards earned by good, devoted servants of God.

Military

Inhuman as its activities can be, this word is built on the backs of the people carrying it out—the soldiers. The Latin *militaris*, which carries a similar meaning to its English descendent, is built on the word *miles*, meaning "soldier." The root of this word is thought to imply someone who marches in a large group of their fellows. Although it's thought to be unrelated to the Latin *mille*, meaning "thousand," it does imply great numbers and may have connections to Sanskrit and Greek words for assemblies and crowds.

Petard

The phrase "hoist with your own petard" (sometimes "hoisted by your own petard") essentially means that you're caught in your own trap, or something unfortunate has happened to you, but it's a misfortune of your own making, especially when you intended to hurt someone else in the first place. It most famously and perhaps originally appears in Shakespeare's *Hamlet* (Act 3, Scene 4).

To hoist, of course, means to propel or lift upward, away from the ground. In the context of this phrase, "hoist" is a past participle, which is why some people add -*ed* today (*see* heist).

A petard is a small conical bomb used for blowing up gates and walls, but they were extremely dangerous and had a habit of backfiring. So basically the phrase means that the bombmaker is blown up by their own bomb.

But this phrase gets a bit funnier if you look at the origin of the word "petard." It was adopted from French and comes from the Middle French verb *péter*, meaning "to break wind"—that is, to fart.

Don't you just hate when you're blown up by your own fart bomb?

Rampage

This word is closely related to the word "ramp," as is the word "rampant." The idea is an elevated raving or wild rushing about, and initially evoked animals rearing up on their hindlegs.

Ruckus

It appears that the American colloquial word "ruckus" (ca. 1890s) is a rowdy blend of "rumpus" and the archaic "ruction," meaning "disturbance."

Rumpus—a fanciful 18th-century term for a general hullabaloo—is thought to be a playful variation of the earlier term "robustious," which is first recorded in *Hamlet* meaning "boisterous" or "noisy":

O, it offends me to the soul to hear a robustious periwig-pated
fellow tear a passion to tatters, to very rags, to split the ears of
the groundlings, who for the most part are capable of nothing
but inexplicable dumb shows and noise. (Act 3, Scene 2)

In the 17th century, "robustious" was also used in the same way as "robust," which is from the Latin *robustus*, literally "as strong as oak," from the PIE root *reudh-*, "red," as in the heartwood of a red oak.

The term "ruction" first appears in print in an 1825 collection of short stories by Irish writer John Banim (1798–1842). In the story, it's presented as a slang term—and likely was a real one before that. The word means "a fight" or "an altercation," and is probably a colloquial variation or mashup of "insurrection" or "eruption," both of which entered English in the early 15th century.

"Insurrection" is from the Late Latin *insurrectionem*, "a rising up" ultimately from the Latin *surgo* ("rise, get up, arise")—which is also

the origin of "surge" and "insurgent" as well, and is made of the elements *sub-*, here meaning "up from below," and *rego* meaning "lead, rule." Even the earliest forms of the word held a political connotation.

"Eruption" is ultimately from the Latin *erumpere* (*ex-* "out" + *rumpere* "break, burst, rupture"), which surprisingly is unrelated to "rumpus."

Revolt and Revolution

Both of these words come from the Latin *revolvere*, which, of course, is also the origin of the word "revolve," which gives these words the sense of an overturning of power or overthrowing of those who hold it. The Latin word literally means "to roll back" (*re-* "back" + *volvere* "to roll").

Although "revolve" in English could refer to things that physically turn, it was also a word for figuratively turning something over in the heart or the mind through meditation or consideration.

A few centuries before it became a word for great societal change or upheaval, "revolution" was also a physical revolving, or anything that happened on a recurring or cyclical basis. The first instance in which the word was applied to a political revolution was in 1688, when rule of England transferred from James II to William and Mary—the Glorious Revolution.

Rival

A rival is literally someone who uses the same stream as you. The Latin *rivalis* was a word for someone who is either your neighbor or your adversary, but literally means "of the same brook." The idea was that a stream would often divide neighboring properties, and both neighbors would use it, but just like today adversarial relationships would crop up. These rivalries were probably quite literal in some cases—disputes over the use of the stream—but the word evolved to mean any dispute over common resources.

From this context "rival" came to mean "one who pursues the same thing as another."

"Rivalry" is recorded with today's meaning, implying a persistent feud between two people or factions, as early as the 1540s. However, the idea of sharing an objective or pursuit influenced the somewhat antonymous use of "rivality" in Shakespeare's *Antony and Cleopatra*:

> Caesar, having made use of him in the wars 'gainst Pompey, presently denied him rivality, would not let him partake in the glory of the action.
>
> Act 3, Scene 5

Here, "rivality" more or less means "partnership," implying two people with a common goal, but without opposition involved.

Pugilist

A pugilist is a fistfighter of any sort, and its meaning is quite literal. It's ultimately from the Latin *pugnus*, meaning "a fist," a root that played a role in shaping the word "punch" itself. You may also recognize this word from the term "pugnacious," which describes someone prone to fighting.

Rage

This word, which means the same thing as its Old French predecessor, *rage* or *raige*, is ultimately from the Latin *rabere*, meaning "to rave" or "to be angry or furious." You may then be able to guess one of its closest cousins: The word "rabies" is a direct borrowing from Latin and shares the same root.

Welsh also connects terms for intense anger with dogs and/or rabies: *cynddaredd* means "rage, fury or madness" and combines an element meaning "dog" with the word for a "tumultuous din."

Rebel

A rebel and the rebellion they wage both get their name from the Latin verb *rebellare*, which in practice meant much the same thing as the English verb "rebel" does today, but literally meant "to wage war

against" (composed of *re-*, here meaning "against" or maybe "again," suggesting an attempt to overturn power, and *bellum*, "war"). On its way to English, this word stopped in Old French (as is often the case) with the word *rebelle*, which also meant "stubborn" or "obstinate," a sense that also carries over to common uses of the English word "rebellious" today.

The American Confederacy also coopted this word and certain quarters of the South continue to take far too much pride in it, leaning in with phrases like "rebel yell," which the Confederacy itself did not coin, but which has been leveraged as a name for their rallying war cry.

Resent

This word once simply meant "to feel pain or distress" and didn't take on its deep-seated, brooding sense until the mid-1600s. Its French predecessors, *ressentir* or *resentir*, carry the literal meaning "to feel again." The sense was extended to today's more subtle anger likely due to that *re-* prefix, suggesting a constant revisiting of a wrong or hurt.

Ruin

This late Old English word, which first described structural collapses, is ultimately from the Latin *ruina*, meaning "to rush (down)" or "to fall violently." It shares a PIE root with the word "rough." The broader idea of ruin as a state of total obliteration or (as a verb) generally fucking something up so that it's unfit for use didn't arise until the 1600s.

Ruthless

Today we primarily use "rue" as a verb meaning "to regret," as in "I rue the day I let my Grammy read this book."

But before the 13th century "rue" was both a verb and a noun: You could rue something, or you could feel the emotion known as *rue*, meaning "sorrow" or "regret." But then, in Middle English, *ruth* became the noun form of *rue*. The -th ending being the same ending that crops up when you make the verb "grow" into the noun "growth" or the adjective "strong" into the noun "strength."

Ruth also had a slightly more specific meaning: It tended to be used when describing sorrow for someone else, or sympathy for their misfortune. You might feel ruth if something unfortunate happened to someone you know, which is why we say someone who is "ruthless" has no sympathy or mercy for others.

Note: The Hebrew name Ruth is unrelated, and literally means "companion," which also fits the biblical story of Ruth, who stays with her mother-in-law Naomi after being widowed.

Slay and Slaughter

These gory words both mean "to kill" but sometimes show up in different contexts—slaughtering livestock vs. slaying a dragon, for instance. Both are from Proto-Germanic roots meaning "to strike" or "to hit."

The Old and Middle English forms of "slay" (*slean* and *slēn*, respectively) involved the killing, striking, beating, or smiting, primarily of humans, including in cases of murder. However, it could also refer to striking in the sense of stamping or minting coins or forging weapons.

As far as the sense of "yass, queen, slay"—that's a quite a bit older than you might expect. Even in 14th-century English, the word "slay" was regularly recorded as meaning "to overwhelm with delight or humor," as in "you slay me."

"Slaughter" is a 14th-century term that, like today, was most often associated with butchering animals. Its Old English predecessor was *sliht* or *sleiht* (a pig raised for meat was called a *sliehtswyn*), which became *slaught* before it was influenced by the *r* in its Old Norse cognate *slatr*, "butcher meat."

But the comparison between butchery and the mass and dispassionate killing of animals has infused this word for most of its English life: Just like it is now, this word was also used to refer to the mass killing of people or a particularly heartless murder.

"Manslaughter," however, has had a confusing and contradictory history, implying not the dispassionate mass slaughter of humans but the unlawful killing of as few as one person. *Manslaught* and *manquelling* were fairly interchangeable with "murder" in Middle English,

but "murder" has always implied an elevated degree of malice, secrecy, or sinfulness (*see* murder).

In both the U.K, and U.S legal systems, manslaughter is classified as a lesser degree of homicide than murder, implying lack of "malice aforethought." Voluntary manslaughter is a classic "crime of passion"; the classic example is a bar fight that starts after it's been revealed that a partner has been unfaithful, and the jilted lover kills someone. Involuntary manslaughter is unintentional but caused by recklessness such as drunk driving.

All of the above are considered forms of homicide, from the Latin *homo* "man" and *caedere* "to kill, to cut down." The fact that "manslaughter" is nearly identical to "homicide" in structure and meaning—but with Germanic elements instead of Latin ones—may have contributed to its use as a step below more nefarious forms of murder.

Soldier

In case being one more body to throw at the enemy weren't dehumanizing enough, the word "soldier" comes down to money—but hey, at least it's a decent amount of money. The word comes from the Latin *solidus*, a Roman gold coin (literally a coin that is "solid" or "thick"). The literal sense of the word, then, is that a soldier (Latin *soldarius*) is "one who is paid"—or implicitly, one who serves in an army for pay.

The *l* in this word is understated in English pronunciation, and in both English and French it has phased in and out: In Old French it was most often spelled *soudier*, and in 16th- and 17th-century English it's often recorded as *sojar*, *soger* and *sojour*. Although English most often included the Latin *l*, the letter more firmly solidified itself in both the Modern French *soldat* and the English "soldier" during the Italian Wars (1494 to 1559).

⚔ English Slang Terms for Soldiers through the Years

Brigand: originally a word for a light-armored foot soldier, from Latin *brigare* "brawl, fight," 14th-century English

Camper: starting in the 1600s, a word for a soldier who "camps"

Charlie: nickname for Vietcong soldiers during the Vietnam War, from Victor Charlie, military communication code for V.C., Viet Cong

Chasseur: mobile soldier, literally "chaser" or "huntsman," 18th century

Doughboy: in the mid-1800s, a word for a U.S. soldier, possibly from the Mexican–American War, probably because of the big buttons on their uniforms or because they were pale and doughy

Dragoon: starting in the 1600s, a cavalryman who carries a firearm, a twist on "dragon," a nickname for a carbine or musket, which, to 17th-century eyes, "breathes fire"

Fly-slicer: specifically a cavalryman, 19th century

Grunt: starting in the early 20th century, any low-level laborer, and then later applied to infantry soldiers. Same idea appears in "drudge"

Ghazi: Muslim warrior in the 1700s, from Arabic *ghazi* "warrior, champion, hero"

Hoplite: heavily armored and armed ancient Greek soldier, from the Greek *hoplites*, "heavy-armed," *hopla* "arms, armor," used in English in the 1700s in writings as a false singular. Related to the word "panoply," a complete suit of armor (*pan* "all" + *hopla*)

Johnny: Famously a name for Southern soldiers during the American Civil War ("Johnny Reb") but earlier a name for English soldiers according to Mediterranean and Arab people, and for Turkish soldiers ("Johnny Turk") according to the English during the Crimean War

Jolly gravel-grinder: marine, 19th century

Leatherneck: originally a British sailor's term for a soldier (1800s), then a U.S. marine (1900s), both known for leather collars on their uniforms

Lobster: starting in the 1600s, a word for a British soldier, first after the armor of Roundhead cuirassiers, then for redcoats; also "lobsterback," but not until the 1800s

Mud-crusher: specifically an infantryman, 19th century

Peon: a foot soldier, from the Medieval Latin *pedonem*, "foot soldier" (cognate with "pawn" and "pioneer"), 18th century and earlier in Spanish

Rapparee: pikeman, from Irish *rapaire* "half-pike," 17th century, later a word for a freebooter (someone who literally collects "free booty," a loan-translation from the Dutch *vrijbuiter*, meaning "plunderer")

Sammy: World War II U.S. soldier, from Uncle Sam, 20th century

Slinger: soldier armed with a sling, 14th century

Tommy: nickname for a British soldier starting in the 1880s, short for the name Thomas Atkins, which was used as a sample name for filling in army forms (much like "John Doe")

———

Spoils

The oldest meaning of "spoil" in English had nothing to do with rottenness or food gone bad, but instead referred to raiding corpses or otherwise stripping off someone's (or a whole city's) valuables or clothes—which, of course, tracks with the plural noun form "spoils." It's from the Latin *spoliare*, meaning "to strip" or "to lay bare," a concept that encompassed both general plunder and, say, stripping the hide off of a hunted animal. It entered English in the 1300s, and didn't take on the sense of tainted food or rotten children until the 1600s, based on the idea that something or someone "spoiled" is rendered useless, with everything valuable having been removed.

Strike

This word is quite violent in most instances today—or, at the very least, implies conflict—but the Old English word from which it evolved, *strican*, was a gentler word, meaning to "stroke," "smooth," or "rub," as one would a cat or a lover. It also carried the meaning to "go forward" or "to move," which we still see in the phrase "to strike out" on a journey or adventure. The more aggressive senses of the word began with the idea of "striking a blow" in Middle English, perhaps based on the idea of the movement of the assailant's hand. From there it just went downhill, from labor strikes to missile strikes to striking out in baseball—though that last one is only devastating to fans.

Struggle

Although the root of this word is unknown, it's thought to be related to other Germanic words meaning "ill will" or "to stumble." The -le ending we see on this word is the same as the one we see in words

like "trample" and "wrestle," which are frequentative words—essentially implying recurring movements. So to struggle implies to fight repeatedly and continually toward something.

Sword

Like the weapon it represents, the word "sword" is ancient, with its PIE root *swertha-* ("the cutting weapon") unsheathed as early as 3500 BCE.

The word slashed its way into Old English as *sweord* or *swyrd* via the Proto-Germanic **swerdam*, which was also related to the Old High German verb *sweran*, "to hurt."

Taser

TASER stands for "Tom A. Swift's electric rifle," a fictional weapon wielded by the character Tom Swift, who first appeared in fiction in 1910. He was created by American children's author Edward L. Stratemeyer (1862–1930), who wrote more than 1,300 books and published many more (including The Hardy Boys and Nancy Drew series) through his company, the Stratemeyer Syndicate.

Tom Swift, a teenage genius and inventor, was created by Stratemeyer, though the 40 books in the original series were produced by multiple ghostwriters under the pseudonym Victor Appleton until the early 1940s.

Tom Swift and his fictional adventures inspired a number of real 20th-century inventors including Jack Cover (1920–2009), the NASA researcher who developed the Taser in 1974 and named it after one of the character's inventions. (Tom doesn't have a middle name in the book series, so Cover originally named it the TSER but added the A to cement the acronym.)

The real-world device was originally sold by the company Taser International, which is now Axon.

But wait—there's a more problematic side to this story:

The book the word "Taser" is based on is called *Tom Swift and His Electric Rifle, or Daring Adventures in Elephant Land*, published in 1911, and it is breathtakingly racist. In it, Tom goes on an adventure to Africa to slaughter dozens of elephants for their ivory using his

electric rifle. Along the way, he and his group of primarily white companions meet many indigenous Africans, including both Black African people and so-called "red pygmies," who are depicted as animal-like and uncivilized: For example, at one point a group of Black Africans is described as "hideous in their savagery, wearing only the loin cloth, and with their kinky hair stuck full of sticks" while the "pygmies" are variously called "imps," "fiends," and "dwarfs." The narrative is stuffed with "white savior" tropes and racist stereotypes.

While the origin of the word doesn't directly play on these tropes, it's firmly rooted in this story. And against the backdrop of racist police abuse using Tasers today—32 percent of all Taser-related deaths in the U.S. are Black people, compared to 29 percent white—the connection is certainly disturbing.[*]

Threat

In Old English, a threat—or, rather, a *þreat*—was primarily a word for a crowd of people. But of course, because a crowd of people might also be a troop of soldiers or a mob, it grew into a word for what you might feel about that crowd if it were headed your way. It is related to words such as "torque" and "contort," and is ultimately from the Latin *torquere*, which—both predictably and thumb-screwishly—means "to twist." In 15th-century English, "torture" carried both today's sense and, more broadly, that of any sort of twisting or contortion.

Vicious

Someone or something that is "vicious" is literally full of "vice," which in Old French meant a "fault" or a "failing." The adjective reflected this sense in Old French (*vicios*), too, implying wickedness as a result of a failure to resist vices, and only took on the sense of "savage behavior" in 18th-century English, especially in reference to

[*] Linda So. "Black Americans disproportionately die in police Taser confrontations." Reuters, 2020. www.reuters.com/article/us-minneapolis-police-protests-tasers-in/black-americans-disproportionately-die-in-police-taser-confrontations-idUSK-BN23M16E

horses and other domesticated animals, suggesting that they reverted to a wilder nature (*see also* vice).

Violence

Whether it's violence, a violation, or the act of violating, these words are from the Latin *violare*, which is ultimately from *vis*, meaning "strength, force, power or energy." The oldest variation of this word in English is "violence," which entered in the 13th century and meant more or less the same as it does now: using physical force against someone or something with the intent to do them/it harm. The Latin *violare* was fairly flexible, referring to the act of physical violence, but also to the act of causing outrage or dishonor.

"Violation" evolved in the early 1400s from French and Latin noun variations (*violacion* and *violationem*) of the verb root—that is, before the later, back-formed verb "violate." Today, a "violation" has a range of senses in English from a violation of the law to a violation of boundaries, and the Latin noun was similarly broad, referring to injuries and profanities, or even to general irreverence.

The first sense of "violate" in English was to break your word, and was later extended to sexual crimes and the pushing of other boundaries.

Weapon

The word "weapon" is from the Old English *wæpen*, which not only meant "instrument of fighting and defense," but—*quelle surprise*—also meant "penis." Its predecessor was the Proto-Germanic *wæpnan*, which carried the same meanings and is also the root of the same word in pretty much every other contemporary Germanic language.

Wrath

This word is derived from the Old English *wræððu*, meaning "anger," though it's closer in spelling to the adjective form *wrað*, or

"angry." The -th noun ending is the same one you see in words like "strength."

The PIE root, *wraith*-, means "turn" or "bend" (and deceptively is not thought to be related to the word "wraith," though it would be appropriate in today's terms). This root lends "wrath" a heightened degree of brutal rage, implying a "twisted" expression or "tormented" emotional state.

✐ The Seven(ish) Deadly Sins

Wrath is one of the Seven Deadly Sins, which, although they're largely associated with biblical morality, are not spelled out in the Bible itself. They were documented later, in the fourth century CE, first by Evagrius Ponticus (345–399 CE), who recorded and systematized the oral beliefs of a sect of monks in early Christian Egypt called the Desert Fathers.

Evagrius spelled out eight deadly sins—or patterns of thoughts that were deadly because they led to sin—which vary in translations from the original Greek and subsequent Latin, but are more or less as follows: gluttony, lust or fornication, greed or avarice, sorrow or despair, sometimes at others' fortune, anger or wrath, acedia, meaning apathy or listlessness (literally "lack of care," from Greek a- "not" and *kēdos* "care, concern, grief"), boasting or vainglory, pride or hubris.

In the sixth and 13th centuries, a series of theologians, including the monk John Cassian (360–435 CE), Pope Gregory I (ca. 540–604), and Thomas Aquinas (1225–74), would eventually shuffle and adapt them. Gregory blended sorrow and acedia to make sloth; extracted sorrow at others' fortune to add envy to the list; and folded vainglory into pride.

Through all of this, pride was regarded as the principal sin over all others. C. S. Lewis explains the logic in *Mere Christianity* (1952):

It was through Pride that the devil became the devil: Pride leads to every other vice: it is the complete anti-God state of mind.*

———

* C. S. Lewis, *Mere Christianity* (London: Collins, 2011), p. 122.

CHAPTER 10

SPELLBOUND

THE ETYMOLOGY OF HORROR, WITCHCRAFT, AND THE SUPERNATURAL

Monsters, ghosts, goblins, dragons, witches, warlocks, and other mythical entities of the more malevolent variety are often manifestations of anxieties, losses, hardship, cruelty, and instability. They claw their way out of the darkest recesses of our minds for many reasons: to teach us lessons, help us make sense of the senseless, ease the pangs of mourning, face scattered fears in a more solid, sensical form—or even to give us that thrill of fear as entertainment.

Let's talk about the things that make our teeth rattle, our bladders wobble, and our guts quaver.

The word **monster** itself is from the Latin *monstrum*, which held a range of meanings including "divine omen" or "sign"—something wondrous or horrifying.

The verb form of *monstrum* is *monstrare*, meaning "to point out" or "show," so at its fundamental level a "monster" is a creature or other unfortunate individual that makes you jab a finger at it and go "Holy fuck, what *is* that thing?"

Like many things that couldn't be explained at the time, monstrous creatures in the ancient world—for example, real animals that were unusually large or had deformities—were considered to be omens from the gods. This contributed to the word's extension to any supernatural beast or creature.

In Old English, the word for monster was *aglæca*, which literally meant something that caused calamity, terror, or distress. The monster Grendel specifically was described as an *aglæca* in *Beowulf*.

Read on to find out how some of the most culturally impactful monsters of our time got their names—along with the origins of some of the most magical and spine-tingling words in English.

Abominable

As much of a mouthful as the word "abominable" (as in the snow-man) is, the word is quite ancient. It was a direct 14th-century borrowing from Old French, but originally derives from the Latin verb *ambonimari*, which literally means to be repelled by an omen: Latin *ab* "off, away from" + *omen* "foreboding."

This word did have a bit of an etymological crisis, however. From the 1300s to the 17th century, the spelling *abhominable* was more common, due to the folk-etymology-fueled notion that the word was actually from the Latin phrase *ab homine*, meaning "away from man" and therefore "like a beast."

The word became associated with snow-dwelling creatures in the 1920s when British–Irish explorer Charles Howard-Bury (1881–1963) set off on an Everest expedition. He found tracks in the snow that he thought belonged to a large wolf, "which in the soft snow formed double tracks rather like those of a bare-footed man." His Sherpa guides said they must have been caused by *metoh-kangmi*, "man-bear snowman."

In a story about the expedition in the Calcutta newspaper *The Statesman*, writer Henry Newman mistranslated *metoh* as "filthy" and somewhat creatively swapped in the word "abominable."*

Afraid

Did you know that the word "afraid" is a past participle of a Middle English verb that we no longer use? The verb is *afray*, which meant "to frighten."

So if you wanted to say you were frightening your friend, you would say you "afray" your friend, and as a result your friend is "afrayed"—afraid.

The origins of "afray" are a curious mishmash. *Afray* was originally Anglo-French, but the Old French word it comes from had trouble landing on a consistent spelling: Variations are recorded as *effrei*,

* Cited in Ralph Izzard, *The Abominable Snowman Adventure* (London: Hodder & Stoughton, 1955).

esfrei, *esfreer*, and more. The Old French is ultimately from the Latin *exfridare*, which literally means "to take out of peace." That root, in turn, is a Germanic one for "peace" or "forbearance."

So to "afray" someone is to literally "scare the peace out of them"—which I suppose is better than having the piss (or shit) scared out of you.

These words evolved into *affrai* or *afray* when the Old French was smashed together with the Old English word "afeared."

If it were more common in today's parlance, you'd use "afear" the same way: I *afear* my friend. My friend is *afeared*. "Afeared" stuck around in English and was actually more popular than "afraid" until Shakespeare's time.

The two instances in which you'll see variations of this "afray" outside of "afraid" in modern English are the legal term *affray*, which refers to disruptive public fighting, and "fray," as in "above the fray" or "into the fray," which also refers to conflict.

Although it doesn't technically use the same Germanic *a-* prefix (meaning "on") as words such as "awake," "alive," "abroad," and others, its similarity has made it behave the same in a sentence. These all function as predicate adjectives, which appear after a linking verb rather than before a noun: You might say "I am afraid" or "she is afraid," but you don't usually describe someone as an "afraid person," just as you wouldn't usually call a dozing relative an "asleep person."

Alchemy

This term often calls to mind potion-making and philosopher's stones, but until the 1600s it was a scientific term.

It's from the Greek *khemeioa*, which was either from *Khemia*, a name for Egypt meaning "land of black earth," or *khymatos*, "that which is poured out."

The *al-* prefix is the definite article ("the") in Arabic. The Greek *khemeioa* is first recorded in a decree from the Roman emperor Diocletian against "the old writings of the Egyptians," around the year 300 CE. This suggests that the original practice that would come to be called alchemy was detailed in these "old writings," but perhaps had another name until Roman influence spread across Upper

Egypt as Diocletian suppressed a regional uprising there and instituted Roman policies.

This supports the idea that the practice was so named because it was "of Khemia," or the work of Egyptian (primarily Alexandrian) pharmaceutical chemists (though "pour" makes equal sense and may have had equal influence). Alexandria was, after all, very likely the birthplace of alchemical thought, which blended technology, religion, mythology, and philosophy into the study of the perfection of the human body, experimental metallurgy (e.g., transmuting baser metals into gold), the search for a universal solvent, general physical and chemical reactions, and the creation of a true panacea—such as a philosopher's stone.

(Related is the word "elixir," originally a Medieval Latin word for a philosopher's stone. Elixir was thought to be able to cure diseases, prolong life, and turn baser metals into gold. It's probably from the late Greek *xerion* "powder for drying wounds," which is in turn from *xeros* "dry.")

In the early medieval period, the Arabic *al-kimiya* was used, which would give rise to the Medieval Latin *alkimia*, then the Old French *alquemie*—later *alchimie*, which would be adopted into English in the mid-14th century.

In the 1560s the word *chymist* (later "chemist") would arise as an English word for a scientific alchemist—dropping the Arabic prefix—and by the early 1600s "chemistry" would replace "alchemy" as a word for physical and chemical processes and the scientific study thereof, with "alchemy" retaining the mythical and philosophical side of things.

Augur

Taken literally, the word "inauguration" may have had more to do with prophetic birds than it does with politicians.

The base Latin word is thought to be *augur*. An augur was a Roman religious official who watched natural signs to determine what the gods thought of proposed actions (and potential leaders).

It is thought to be related to the word *avis*, or bird, because the augur's role largely involved watching the behavior of birds to look

for omens of divine approval or disapproval. Indeed, the Latin verb *inaugurere* literally meant "to take omens from the flight of birds," but also held the meaning "to consecrate or install someone in a role when the omens are favorable."

As the practice of asking magic birds who should be in charge faded, the word stuck around, simply coming to refer to the consecration or installment of people in leadership roles—first in religious roles and then in government.

Today, "augur" is also a verb meaning "to portend" or foretell a good or bad outcome. But note that this type of augur is not to be confused with the tool called an "auger," which is used for boring holes in things.

Banshee

The spirit called a banshee originally appears in Irish folklore as a type of fairy who was believed to foretell death with her eerie song. The word is a phonetic spelling of the Irish *bean sidhe*, meaning "female of the elves."

Bear

Bears are scary as hell, which is why the word "bear" is a euphemism. In many Germanic languages, including English, the word for bear literally means "the brown one" or "brown thing," a hunters' taboo word for the animal. The PIE root of the word is the same as that of the word "brown." When it comes to bears, we straight up do not speak the name.

Meanwhile, words like the Greek *arktos* and the Latin *ursus* share a PIE root that actually means "bear." Incidentally, this root is also the root of the words "Arctic" and "Antarctic" —literally "of the Bear" and "opposite the Bear" due to where you can and where you can't see the constellation Ursa Major, the Great Bear. (The fact that there are polar bears in the Arctic but not the Antarctic is a serendipitous coincidence.)

Beast

The word "beast" has been around in English since around the 13th century and is derived from the Latin *bestia* "wild animal." The Latin-derived word replaced the Old English *deor*, which simply meant any wild creature—and that older term still exists today as the word "deer." (Meanwhile, the more specific word for a deer in Old English was *heorot*, now still in use in the form "hart.")

In Middle English, "beast" (or *beste*) was also periodically used to translate the word "animal" in Latin texts, though "animal" in both English and Latin was initially broader: It meant any living, breathing creature—and breathing is the key here, because the root *anima* means "breath" or "soul."

One phenomenon that helped solidify the role of the word "beast" in the English language was the medieval bestiary, or "book of beasts." Although these compendiums of creatures both real and mythological have existed since ancient times, they were wildly popular in the Middle Ages as illuminated manuscripts that aimed to explain religion, humanity, morality, and more by connecting stories and moral attributes to the creatures within.

Brooding

The word "brooding," which evokes surly, Heathcliffian men today, was initially a comparison to a mother bird who hovers over her nest, much like a person's mind might linger over a dark thought.

Its first known instance is in Mary Wollstonecraft Shelley's *Frankenstein* (1818), whose bleak tone may have lent it an additional association with dour moodiness. Dr. Frankenstein's father writes his son in a letter:

> Come, Victor; not brooding thoughts of vengeance against the assassin, but with feelings of peace and gentleness, that will heal, instead of festering, the wounds of our minds.*

* Mary Shelley, *Frankenstein* (Oxford: Oxford World Classics, 2019 [1818]), p. 49.

WHAT'S THE DIFFERENCE BETWEEN ...

... a cemetery and a graveyard?

Although "cemetery" and "graveyard" are often used interchangeably, in more formal settings, the former tends to be used in reference to a burial ground that is its own entity, while a graveyard is typically adjacent to a church.

First appearing in English in the 14th century, "cemetery" entered English via Old French (*cimetiere*) and Latin (*cemeterium*), but is originally from the Greek *koimeterion*. This word is as much a euphemism as the word "resting place," for the Greek word referred to any place you'd sleep, or a dormitory (which also means a place where you sleep)—though it is also recorded in metaphorical reference to death as well.

... a tomb and catacomb?

Both of these refer to underground burial spaces, but a catacomb typically refers to a whole meandering collection of remains, while a tomb can range from a single occupant to several. It was the Romans who made catacombs cool, and they were basically a whole damn "sepulchral" vault of bones and bodies, with the first, famous ones located along the Appian Way.

The gist of "tomb" is all about its shape. The original Greek *tymbos* was a word for a mound in general, but especially a burial mound, and its root likely implies a "swelling" in the ground or a "small hill."

But in a weird, uncomfortable, nesting-doll way, "tomb" is secretly hiding within "catacomb."

It's thought to be made up of the Latin elements *cata*—which, like many prepositional elements, is chaotically inconsistent in its meaning (*see* cataclysm, catapult, catastrophe) but in this context means "among"— and *tumba*, "tomb." The "comb" has nothing to do with hairbrushes or honey, but instead, the *tumba* element was probably morphed via a folk

etymological association with the element *-cumbere*, meaning "to lie (down)."

... a coffin, a casket and a sarcophagus?

Today the terms "coffin" and "casket" are distinguished by shape: Coffins have that distinctive, Dracula-esque tapered shape, wide at the shoulder and narrow at the foot. Caskets, on the other hand, are like the luxe box in which your rich grandma was displayed—rectangular, polished, and comfy.

Etymologically, however, they both just boil down to containers. "Coffin" didn't refer specifically to corpse boxes in English until the 1520s, and before that it could mean anything from a chest to a pie crust (yes, really). Its Latin and Greek predecessors meant "basket" or even "hamper."

"Casket" is from the French *cassette*, meaning "little box," and that was its primary meaning until the 1800s in American English—a usage that was probably first meant to be a little tongue-in-cheek, as evidenced by the chagrin of people like Nathaniel Hawthorne, who called "casket" a "a vile modern phrase" compared to "coffin."

The word "sarcophagus" is significantly more harrowing than either of these terms, etymologically speaking. It literally means "flesh-eating" (Greek *sarx* "flesh" + *phagein* "to eat"), thanks to a type of limestone from an area of what is now Turkey that was said to advance the rate of decomposition.

Chimera

The Chimera (also spelled Chimaera or Chimaira) is a female monster from Greek mythology featuring a lion's head, a goat's body, and a dragon's tail. Her name literally means "year-old she-goat" or "she-goat who has lived one winter." According to Pliny the Elder

(23/24–79 CE), she was associated with the fire-spewing gas vents found on Mount Chimaera (named for the myth) in the ancient Mediterranean region of Lycia.

In French and English poetry and literature dating back to the 13th century, the term "chimera" (with various spellings) has been extended to any wild fantasy or imagining, implying something assembled in the mind like the hybrid creature.

In biology, chimerism is when one twin embryo is absorbed by the other, resulting in one child with cells or genes from both embryos, resulting in appearance variations in the child such as two-toned skin or eye color. This terminology reflects the multispecies appearance of the mythological Chimera, but is scientifically called tetragametic, meaning that it comes from four gametes—two sets of maternal and paternal chromosomes, or two egg cells and two sperm cells. That is, genes from two fraternal twins appear within one individual.

Chupacabra

Chupacabra literally means "goat-sucker" after this American monster's penchant for drinking the blood of livestock (Spanish *chupar* "to suck," and *cabras* "goats"). The name of this beast is (perhaps) surprisingly recent, only coined in 1995 by Puerto Rican comedian Silverio Pérez, though monsters like this have appeared in Mexican folklore for a long time.

Creep

The word "creepy" unsurprisingly refers to things that creep along the ground, like reptiles or insects, which have been creeping people out for centuries. The word is thought to originally come from a root meaning "crooked," maybe like the crooked legs of an insect or the bend of a snake's body.

Death

For such a weighty concept, this word is so critical to the human experience that its origin is fairly simple. In Old English, *deaþ* was used in the same way we use it today, and that history extends into its deepest Germanic roots: The Proto-Germanic root **dauthuz* is also the source of every other Germanic word for the concept, from the Old Norse *dauði* to the German *Tōd*. In Old English, the plural form *deaþas* was also a word for ghosts.

But, ultimately, this word describes an ending—the most relatable one we experience as sentient humans. In this sense, "death" has also reached beyond the mere end of mortal life in English to describe anything from a simple ending of ideas, movements, and governments (e.g., the "death of democracy") to a disease that leads to that final moment (e.g., the Black Death).

☞ Additional Phrases and Terminology Surrounding Death

Dead in terms of emotions or awareness, as in "dead to the world," appeared as early as the 1200s.

Dead letter has referred to ineffective laws and undelivered mail since the early 18th century.

Death knell first appears in Walter Scott's 1814 narrative poem *The Lord of the Isles*, which details Robert the Bruce's fight for Scottish independence from England.

Dead Men Tell No Tales is the name of an 1898 adventure novel by E. W. Hornung and several thriller films following it. In the 1940s a Looney Tunes cartoon called "Buccaneer Bunny" parodied these earlier stories when Bugs Bunny cried "Dead rabbits tell no tales!" After that, the 1967 *Pirates of the Caribbean* ride fully popularized the phrase in fictional pirate-adventure lore.

Death penalty was first applied to capital execution in 1844 when the Rhode Island General Assembly abolished capital punishment for everything except murder and arson. However, John Gordon (1815–45) was the final person executed by the state in 1845 for the murder of Amasa Sprague, the brother of former Rhode Island Governor William Sprague. He was posthumously pardoned in 2011.

Dead–on, meaning "accurate," is first recorded in the 1880s, shortly after the invention of the automatic pistol.

To death, as in "put to death" or "beaten to death," is first recorded in the 14th century.

Dead has meant "utterly" or "absolutely" since the 16th century, first appearing in terms such as "dead drunk," but extending to the 20th century in terms such as "deadass" which conveys an intensified version of terms such as "straightforwardly" or "bluntly."

(Be) death on, in American English, to be devastatingly effective at something, as in "the editor is death on typos," is first recorded in the 17th century.

Demon

Did you know that demons were once gods? The original Greek source of the word "demon" wasn't a word for an evil creature at all, but instead was a word for a deity, usually a lesser god. Even in Latin, the word *daemon* simply meant "spirit," and not necessarily an evil one.

The word came to be associated with malignant spirits because this Greek word was eventually used in translations of Christian texts to describe the gods of non-Christians, heathen idols, and unclean spirits.

By the time the word arrived in English in the 12th century, it was associated entirely with evil spirits and devils. Before that, a demon was usually called a "fiend" (*feend*), "devil" (*deuil*), or "hell-knight" (*hellcniht*).

Words from Hell indeed.

Dracula

Bram Stoker's novel *Dracula* (1897)—along with earlier blood-sucking fixtures such as John William Polidori's *The Vampyre* (1819) and Sheridan Le Fanu's *Carmilla* (1872)—unleashed a subgenre of Gothic horror that would change fiction forever. Stoker drew the

name of his title character from Prince Vlad III of Wallachia (1428/31–76/77), also known as Vlad the Impaler or Vlad Dracula. It's an aptly intimidating name, meaning in Romanian "son of Dracul," or "son of the dragon," with Dracul as a moniker given to Vlad's dad upon his instatement in the Order of the Dragon in the 1430s. And yeah, of course, it was a weird culty religious thing.

Dragon

While dragons aren't always presented as malevolent beings, they have often been the target of "slayings" in European folklore. Poor dragons, eh?

The word "dragon" comes from the Latin *draconem*, meaning "huge serpent, dragon," which in turn is from the Greek *drakon*, "serpent, giant seafish." The PIE root of these words means "to see," which the *Barnhart Concise Dictionary of Etymology* says means that the literal sense of *drakon* was "one with a (deadly) gaze," echoing other Greek monsters with murderous eyes such as basilisks and Gorgons.

In Greek and Latin mythology, the term sometimes referred to any great serpent, even those that weren't mythological. For example, in *The Iliad*, Agamemnon wears a blue dragon (*drákōn*) motif on his sword belt, but it's just as likely that the Greek *drákōn* is used here to refer to a snake.

Dragons started to grow legs in the Middle Ages. Most dragons at the time had four legs and additional wings, with two-legged dragons known as wyverns. The word "wyvern" comes from the Old French *guivre* meaning "snake" and doubling as a word for a light javelin (originally from Latin *vipera* "viper").

Wyverns often had more distinctive characteristics like an arrow-shaped tail tip. Of course, you'll still see wyverns in heraldry and fiction today, and many nerds—no judgment; I imagine many nerds are reading this book—argue that any dragon with two wings and two legs, like those in *Game of Thrones*, are technically wyverns.

Chinese dragons, with their long bodies and mammalian faces, are the oldest in recorded mythology, with depictions of dragons

appearing on artifacts from the Shang and Zhou dynasties, all the way back to the 16th century BCE. The Mandarin name for dragon, *lóng*, is thought by some historians to be onomatopoeic, echoing the sound of thunder. These wingless, flying dragons are also called *tian-long*, meaning "heavenly dragon" or "celestial dragon."

Dragon-like creatures also appear in Indian religious stories, notably the three-headed Vedic serpent Vritra, whose name means "the enveloper" and who is the personification of drought.

Exorcism

Horked out any demons lately? To exorcise something, typically a demon or evil spirit, literally means to swear it out by way of an oath. It's a hybrid word that combines the Latin prefix *ex-* "out" and the Greek *horkizein*, meaning "to cause to swear," originally from *horkos*, "oath."

So while it's typically read as a calling or driving out of evil spirits, and all the oaths and swearing here are of the religious rather than the profane variety, it's not much of a leap to entertain the notion that demons are muttering "Ah fuck!" as they flee their victims.

Fell

"Fell" as in "one fell swoop" or a "fell beast" is recorded in English starting in the 13th century and means "cruel."

This sense of "fell" is thought to be unrelated to the past tense of fall, but it's possible that there was some folk-etymology influence between the two thanks to phrases like "to fell a tree," meaning to cause it to fall down (though it would be pretty hard to fell a tree in one fell swoop unless you're a fell beast). This type of "fell," however, is related to the word "felon" (from Medieval Latin *fellonem*, "evildoer"),

The phrase "one fell swoop" was popularized thanks to Shakespeare's *Macbeth*, in this line delivered by Macduff. The fell swooping in this context refers to the diving attack by a bird of prey, which Macduff uses as a metaphor for Macbeth murdering his wife and kids.

He has no children. All my pretty ones,
Did you say all? O hell-kite, all?
What, all my pretty chickens and their dam
At one fell swoop?

<div align="right">Act 4, Scene 3, lines 215–18</div>

Frankenstein (and his monster)

Mary Wollstonecraft Shelley's 1818 Gothic novel *Frankenstein, or The Modern Prometheus* played a huge role in kicking off the popularity of the modern horror genre. As I'm sure one of your English major friends has explained to you at a party, Victor Frankenstein is the name of the creator, not the monster. Victor considers naming the creature Adam after the first man in Genesis, but is so terrified by his own creation that he changes his mind and simply calls him "demon," "monster," and "wretch"—which, it turns out, really hurts the big guy's feelings and creates problems for everyone. Mary Shelley also calls the character "Adam" in the book's epigraph, and this is often accepted as his actual name.

And by the way, in the book, the monster is not explicitly stitched together from corpse parts and animated by electricity—that image comes from the movies. In the book the actual creation process is a bit ambiguous, but it involves both chemistry and alchemy. The stitched image we think of today is likely derived from one line in which Victor writes that his raw materials came from "the dissecting room and the slaughterhouse."

Shelley came up with the story and the name "Frankenstein" when she and her husband and fellow wordsmith Percy Bysshe Shelley were visiting poet and politician Lord Byron. The trio held a competition to see who could come up with the best horror story. Mary claimed to have had a vision about the monster and the name Frankenstein that very night.

Apparently, however, Mary and Percy had also visited Frankenstein Castle, which overlooks the city of Darmstadt in Germany, a few years earlier. In Frankenstein Castle, a theologian and alchemist named Johann Conrad Dippel (1673–1734) had experimented with human bodies, so the idea may have come in part from that experience.

Whether she simply repressed the memory or was protecting her claim of originality from hordes of indignant Darmstadtians is anyone's guess. The name Frankenstein means either "Franconian mountain" or "stone of the Franks" in German.

Gargantuan

This word is from the name of the giant Gargantua from *The Lives and Deeds of Gargantua and of Pantagruel*, a 16th-century series of very R-rated novels by the humanist and monk François Rabelais (1483/94–1553). It was censored in its time for its crude, over-the-top, scatological humor, as well as its violence. It includes entire chapters made up of vulgar insults.

According to the story, Gargantua himself had a codpiece—one of the first garments he ever owned—that was a yard long. At one point, he pisses on Paris and accidentally drowns more than 200,000 people. (Throughout the story, he, his horse, and his son carry out many more acts of destruction by urination—sometimes deliberately.)

The name of the character supposedly originated from the Spanish and Portuguese word *garganta*, meaning "gullet" or "throat," which is from the same root as the word "gargle."

Gargoyle

The word "gargoyle" literally suggests that these creatures "gargle," largely due to the fact that their earliest architectural role was that of decorative—yet also functional—waterspouts. The word is from the Old French *gargoule*, which was both a word for a throat and for a "carved downspout" (*see* gargantuan).

Ghost

The word "ghost" comes from the Old English *gast*, which had many meanings, all of which centered around breath, life, and the spirit. These concepts included the idea of humanity and the human spirit and, with the arrival of Christianity, the Holy Spirit or Holy Ghost.

These spiritual concepts are quite a bit older than the idea of a ghost as an apparition of a deceased person, which arose in the 14th century after the word was extended to mean any supernatural being. In fact, spirit most likely became a word for a ghost partially because the Latin *spiritus*, meaning "breath," or more specifically "breath of a god," was translated into English as "ghost."

Predictably, ghost shares a root with the words "aghast" and "ghastly," which come from the Old English *gæstan*, meaning "to frighten," probably in the sense of something that takes your breath away in fear.

Ghost also shares the same Proto-Germanic root with the German word-forming element *Geist* (*see* Poltergeist).

Ghoul

What's the difference between a ghost and a ghoul? Well, it depends on the lore you're reading, but etymologically they're quite different.

The word ghoul was adopted from the Arabic *ghul*, which referred to a pre-Islamic evil spirit known for robbing graves and consuming human flesh. It originally comes from the Arabic word "*ghala*," meaning "to seize." The Arabic *ghul* refers to a male ghoul, while the female is called *ghulah*.

"Ghoul" (or *goul*) made its way into English in 1786 in an English translation of William Beckford's novel *Vathek*, which was originally written in French. It was an orientalist novel, meaning it imitated aspects of the Eastern world, in this case Arab culture. Today we might call this cultural appropriation. It tells the story of the Caliph Vathek who renounces Islam and tries to gain supernatural powers through a series of terrible and licentious deeds including sex, drugs and human sacrifice:

> … the Caliph, who had just heard the tragical catastrophe,
> arrived. He looked not less pale and haggard than the goules
> that wander at night among graves.*

* William Beckford, *Vathek* (Oxford: Oxford World Classics, 2011 [1786]), p. 61.

Goblin

The word "goblin" originally comes from the Medieval Latin name of a specific spirit, Gobelinus, who haunted the region of Évreux in Normandy. It's first documented by Orderic Vitalis (1075–1142), an English Benedictine monk who recorded a great deal of Anglo-Norman history.

Gore

In Old English, *gor* as a noun meant "dirt," "filth," or even "shit," while the noun *gar* was a word for a spear. Both influenced the modern-day word "gore" as both a noun (blood and guts and whatnot) and as a verb (the stabbing with pointy objects that yields the blood and guts and whatnot).

Grave

Despite Mercutio's famous (and famously foreshadowing) puns on the word "grave" in *Romeo and Juliet*, the words "grave" as in six feet under and "grave" as in the somber tone or mood are from different sources. The pit where you dump a corpse is related to the word "engrave," and both are from a PIE root implying digging or scratching into a surface. Meanwhile, to say someone's tone or bearing is "grave" is to compare their vibe to "gravity," which comes from the Latin *gravis*, meaning "heavy."

Grim

The Old English *grimm* was packed with meanings and none of them were pleasant. Much like today, it could describe dire circumstances and terrible injuries, but it also doubled as a word for an extremely nasty attitude, meaning "fierce" or "cruel" in addition to the more generally ominous sense we have today. Its PIE root is thought to echo the sound of rumbling thunder.

Although this word has been associated with death since at least the 1600s, and personifications of death—occasionally even with

scythes—were all the rage from medieval times onward, "grim" wasn't formally married to "reaper" until relatively recently. The first recorded instance is in a translation of an 1847 book called *The Circle of Human Life* by German theologian August Tholuck.

Grinch

The word "grinch" was of course popularized by Dr. Seuss (Theodor Seuss Geisel; 1904–98) in 1957 with the publication of *How the Grinch Stole Christmas*. But he was not the first author to use the word "grinch"—or at least a variation of it.

Rudyard Kipling (1865–1935), the author of *The Jungle Book* (1894) and the *Just So Stories* (1902), included the word "grinching" in his 1888 poem "The Lament of the Border Cattle Thief." In the poem, "grinching" is used onomatopoeically to refer to a harsh grating sound:

It's woe to bend the stubborn back
Above the grinching quern,[*]
It's woe to hear the leg-bar clack
And jingle when I turn!

But whether Dr. Seuss drew inspiration from Kipling's poem or independently imagined the word as an aptronym for his antihero is anyone's guess.

Halloween, All Hallow's Eve, and Samhain

You probably know "Halloween" is short for "All Hallow's Eve," but there's also a bit more to it than that.

The first recorded spelling, *Allhallow-even*, is Scottish, and so is the shortening to *Hallow-e'en*. It was also called Holy Eve. You probably know that hallow is a verb used in Christian prayers, as in the Lord's Prayer—"hallowed be thy name." In Old English (*haliga*, *halga*) it was also a noun, another word for a saint.

[*] A quern was a handmill for grinding grain.

November 1 became All Hallows Day or All Saints Day when Pope Gregory III expanded a previously existing martyr's day to celebrate all saints.

The shortened "Hallowe'en" was used as the festival's name in a few Scottish songs as early as the 1720s, but it became more widespread in 1781 when Scottish poet Robert Burns (1759–96) published a popular poem of that name.

Much like Christmas, Halloween is celebrated at the time of what was originally a pagan holiday—and naturally these pagan traditions were given a coat of Christian paint.

Before it turned into All Hallow's Day eve, the last night of the Old Celtic calendar year was called either Old Year's Night, or in Irish, Samhain, literally "summer's end."

It was believed that on this night the boundary between the worlds of the living and the dead became more permeable. Revelers lit bonfires, made sacrifices, and wore costumes made of animal heads and skins to ward off these specters.

Then the Romans rolled in and added a couple of their own traditions to the mix: Halloween traditions include elements of the Feralia, which honored the spirits of the dead, as well as celebrations honoring Pomona, the Roman goddess of orchard trees and fruits, who especially liked apples and apparently bobbing for them.

Haunt

This word initially had nothing to do with the supernatural.

The original meaning of "haunt" was more along the lines of a bar being your "old haunt"—a habitual location. In Middle English, the phrase *haunte scole* meant "to attend school," and to "haunt" someone was occasionally used as a euphemism for having sex with them.

It's from the French *hanter*, meaning "to visit frequently," but it's thought to originally be from a Germanic source, perhaps the Old Norse *heimta*, meaning to "bring home."

Of course, it's not at all illogical to extend the idea of a place frequently visited to the regular return of a ghost to its home or place of death. The first recorded use of the word "haunt" to refer to spirits or ghosts is in Shakespeare's *A Midsummer Night's Dream*.

Here comes my messenger.
How now, mad spirit!
What night-rule now about this haunted grove?

<div align="right">Act 3, Scene 2, lines 4–5</div>

Hell

At last, we've arrived at the etymological gates of this book's namesake. Although it's largely associated with Jewish, Christian, and Islamic concepts of the punishments souls endure after death for the bad shit they did while they were alive, Hell is a massive, multicultural mashup all of those three, plus elements from Norse, Greek, and Roman mythology.

The word "hell" itself is a Germanic one. It's ultimately from a PIE root meaning "covered or hidden place" or "cave," which in Germanic languages including Old Saxon, Old Norse, German, and Dutch came to refer to the underworld. In Old Norse myths, Loki's daughter Hel (a name of the same origin) ruled over the cruelest souls in Niflheim ("mist-world" or "dark-world"), the lowest of the nine worlds.

Like many other pagan concepts, this one meshed with Christian concepts of the afterlife in Roman Britain (43–410 CE). Although what we might call Hell today isn't mentioned by that name in the Bible, there are several passages that shaped today's lore in the New Testament. Greek versions of the New Testament use the terms Tartarus (the name of the prison of the Titans), Hades, or the Hebrew *Gehinnom*, which was originally a word for a grave but later came to describe something like Purgatory.

Hocus Pocus

Although nobody does it quite like Bette Midler, the phrase "hocus-pocus" has been around since at least the early 1600s.

The name Hocas Pocas was a common nickname that jugglers would give themselves, and a general word for a juggler's tricks. Variations of these names included *hiccus doccius* and *hiccus doctious*. Over time it was adopted as the words that accompanied the marvelous feats of other street performers, including magicians.

There are a couple of theories about its origins, mostly suggesting that hocus pocus is a corruption of various Latin phrases. The predominant theory is that it was a modification of the sacramental blessing *Hoc est corpus meum* (This is my body).

Another is that it comes from *hicce es doctus*, meaning "Here is the learned man." Yet another possibility is that it's entirely made up and just modeled after Latin to add a bit of mysticism to the performance. This is thought to be the case for another street performer's phrase, *holus-bolus*, which was usually shouted as someone swallowed something unnaturally large in one gulp.

☞ Horror vs. Terror

The word "horror" is derived from that hair-raising feeling of fright you get when you're thoroughly creeped out. It was adopted directly from Old French, and its original Latin source literally means "to shudder" or "to bristle with fear." In Latin it also carried the meaning of veneration or awe for the power of the gods.

Its meaning has been pretty varied in English. At first, in the 14th century, its implication was disgust rather than fear. The sense of "disgust" sort of lingers in the word "horrid," which originally literally meant something very hairy or shaggy.

A horror was also another word for a shudder that runs over you, or a rippling of a water's surface.

Horror as a word for a genre of entertainment, like an exhibition of horrors or a horror novel appears to have cropped up around the 1850s, incidentally after the Gothic horror novel genre had already been popularized (*see* Frankenstein).

The earliest horror stories—or at least spooky stories about monsters and ghosts and the supernatural—date back to ancient times, including but not limited to Ancient Greece and Rome. In one particularly famous account, Pliny the

Younger told a story about a fellow philosopher and educator who purchased a house haunted by a ghost and had to locate the bones of the deceased in order to put him to rest.

Although terror is not directly related to horror, it's certainly of the same ilk. Not only is it structurally similar but also comes from Old French and Latin, all with similar spellings. It comes from a different Indo-European root, one that meant "to tremble" or "to fill with fear."

So if you're horrified, you're shuddering and bristling, and if you're terrified you're trembling and overwhelmed with fear. A subtle distinction, but one that remains in the difference between words like terrified, which always implies fear, and horrified, which can also mean scandalized or disgusted.

The most dramatic difference you see in 21st-century English is obviously between horrific and terrific: Something horrific inspires horror, but something terrific is … great?

In the 1660s something "terrific" did inspire terror. "Terror" is a big, all-encompassing, highly distracting feeling. By 1809 the word "terrific" had been extended to encompass anything or any experience that had a huge and distracting impact on you—like a terrific headache—and then by 1888 it first appeared as a word for a person or experience that had a massive but positive impact on you.

———

Jack-o'-lantern

Jack-o'-lantern literally means "jack of the lantern." When it originally appeared in the 1660s, it was a word for a nightwatchman, as in a literal man with a lantern. Jack was a generic name for any fellow, in the way we use the word "average Joe" or even "guy" today (*see* guy, in Chapter 5).

In some regions of the U.K., jack-o'-lantern also became the name of a creature similar to a will-o'-the-wisp, which is a ghostly spirit or light seen by travelers at night that lures them into the darkness. The overlap between jack-o'-lantern and will-o'-the-wisp was that you might mistake this light for the lantern of the nightwatchman as you approached a town—but, of course, it was all a ghostly ruse that led you to your doom.

Indeed, if you take it literally, will-o'-the-wisp almost means the same thing as jack-o'-lantern. Will was another generic man's name, and a wisp was a bundle of straw used as a torch, so a will-o'-the-wisp, or "Will with the wisp," was a man who held a torch.

As for the carved pumpkin, in Ireland it was common practice around the festival of Samhain to carve faces into turnips and illuminate them with candles, either to represent supernatural spirits or to ward them off. Because they were fairly generic human faces and functioned as lanterns, the jack-o'-lantern concept was applied to them. The tradition extended to pumpkins in the Americas, where pumpkins were plentiful and colorful during the harvest season.

There's a folktale about the jack-o'-lantern. It's not the actual source of the word, because the story came after the name, but it's still a fun story. (In addition to being a generic name for any old guy, Jack was also often used in stories as the name of a clever trickster protagonist.)

Stingy Jack was a drunkard and a particularly nasty fellow. One night Satan overheard Jack boasting of his evil deeds. Satan told him the time had come for Jack to pay the price. Jack begged Satan to let him have one last night at the tavern before being dragged off to Hell, and Satan agreed. After a night of heavy drinking, Jack suggested that Satan transform himself into a coin so he could pay off the tab. Satan did so, and Jack put the coin in his pocket where he kept a cross, thereby trapping Satan inside the coin. He promised to release Satan if he gave Jack an additional ten years of life. Satan had no choice but to agree.

Ten years later Satan came calling while Jack was sitting under an apple tree. Jack begged Satan to allow him to enjoy one last apple. Satan, being pretty stupid for an immortal king of Hell,

climbed the tree to fetch one. Jack had come prepared with more crosses, and these he now placed around the base of the tree, trapping Satan again. This time Jack made Satan promise that he would never have to go to Hell. Furious but stuck and probably late for his daily round of torturing lost souls, Satan agreed.

Unfortunately for Jack, when he did eventually die, his soul wasn't pure enough to make it into Heaven, but could not be consigned to Hell, so he was sent back down to Earth for all eternity. Satan came to mock poor Jack, who was all alone on a dark night with no light to find his way. Satan tossed him a burning coal, which Jack put inside a carved turnip to make a lantern. Some say he roams the land to this day, looking for a resting place.

Leprechaun

The Irish word *leipreachán* or *luchorpán* has for many years been said to be a hybrid word, combining the Old Irish *lu* "small, little" with a diminutive variation of the Latin *corpus* "body"—hence, "very small body." This aligns with Irish folklore describing leprechauns variously as small, solitary fairies "who always [carry] a purse containing a shilling," or, later, tiny shoemakers who hide their gold at the end of a rainbow.

But recent research suggests the word may be connected to the Luperci, the nude young aristocrats who ran through the streets of Rome during Lupercalia.* In fifth-century texts, these youths were compared to Greek werewolves, and in the seventh century, those writings are thought to have been misinterpreted by Irish scholars as describing Luperci as a nonhuman race—the "little Luperci."

The word's various spellings make it tricky to trace: It has also appeared as *lubrican* and *leithbragan*—the last of which is an Irish folk etymology meaning "half brogue," reflecting stories of the creatures making brogues, or leather shoes.

* Jacopo Bisagni, "Leprechaun: a new etymology," *Cambrian Medieval Celtic Studies* 64 (Winter 2012), 47–84.

LANGUAGE OF THE LICH

You may have encountered the word *lich* before, though today it's often relegated to fantasy names. The word literally means "corpse," from the Old English *lic* of the same meaning and pronunciation. This word appears in English terms of various eras including:

Lichburg or **licburg:** a cemetery but literally "corpse town"
Lichhaemleas: meaning "incorporeal," but literally "body homeless"
Lich-owl: a screech-owl, which was thought to be a death omen
Lych bell: a handbell rung over a corpse
Lychgate or **lichgate:** a roofed gateway into a churchyard or church-side graveyard
Lyke-wake: an overnight watch over a corpse
Lych way: the path down which corpses were carried to burial.

Macabre

This word is derived from Danse Macabre, also known as "The Dance of Death"—though that's not a direct translation. The Danse Macabre was a recurring trope—even genre—in the arts of the medieval period, based on the idea that everyone, regardless of wealth or station, is taking part in a merry dance toward death. If you're envisioning skeletons waltzing toward a tomb or the Grim Reaper, you've more or less got the gist of it. It appeared in art, music, and literature, and it was even a fixture of courtly entertainment during Allhallowtide (the season of All Hallow's Eve) when partygoers dressed as corpses. Cheerful, eh? But in truth, this notion may have been comforting to people who regularly endured war, famine, and diseases like the Black Death.

Images of the Danse Macabre are shown in wall paintings as early as the 1420s, but a mural painted in 1430 may have prompted the name. The painting, displayed at Old St Paul's Cathedral in London, was accompanied by French texts translated into English by monk

and poet John Lydgate (ca. 1370 – ca. 1451). Macabré may have been the name of the original French author of Lydgate's texts, or it may have been a variation on Maccabees, a powerful Jewish family of the second century BCE that rebelled against the Seleucid king Antiochus IV and gave their name to various books of the Bible.

The word took on its more general meaning of "creepily preoccupied with death" in the wake of 18th century Romanticism amid an uptick in morbid Gothic literature.

Mummy

This word in English (as *mummia*, 1300s) was first a name for the powder scraped from embalmed Egyptian corpses—either the corpse dust itself or dried petroleum bitumen sometimes used as an embalming fluid—used to make medicine that was supposed to heal wounds and fractures. The English word was extended to the whole embalmed corpse in the 1600s. It is a borrowing from the Arabic *mumiyah*, an embalmed body, ultimately from a word for "wax" or "asphalt" probably originally referring to embalming fluids in Persia. (In addition to being the name of the paving material, "asphalt" is also a word for a type of pitch or resinous petroleum.)

The medicinal substance, specifically powder from an embalmed witch, is mentioned by the witches in *Macbeth* as one of the ingredients in their cauldron:

Scale of dragon, tooth of wolf,
Witches' mummy, maw and gulf
Of the ravined salt-sea shark ...

Act 4, Scene 1, lines 22–4

Nightmare

Unsurprisingly, nightmares have nothing to do with nocturnal female horses. But if not a horse, then what is a mare?

In Old English, *mare* was a word for a goblin or incubus, and probably comes from a root meaning "to harm," "to rub out"—no, not like that, you filthy beast ... well, OK, maybe a little bit like that—or "to die."

An incubus is a demon or monster said to visit people in the night and either suffocate them or have sex with them—or both. The word "incubus" is from Latin *incubare*, meaning "to lie upon" (related to incubate). And as you may have already guessed, a succubus is a female incubus whose name means "to lie under."

Incubus and succubus replaced the Old English *mare* in the 1600s in all uses except the word "nightmare." The Old English term was also a little less alluring and a little more suffocatey, and it may have been blamed for people having breathing problems in their sleep—as when you wake up gasping for breath, either from an actual medical condition or just plain old night terrors.

Occult

This word's source, the Latin *occultus*, meant "hidden" or "secret," a sense that was extended to things beyond or hidden from understanding in the 1500s before it was applied to the supernatural a century later.

Omen

Although the word "omen" can imply anything foreshadowed—good or bad—it originally foretold only unpleasantness. It's directly borrowed from Latin *omen*, meaning "foreboding" or "augury" (*see* augur, inauguration).

Phantom

Much like many words for ghostly presences, the word "phantom" originally simply meant an illusion—though its earliest recorded variations in the 1300s were spelled a bit differently: *Fantum* and *fantome* echoed Old French (*fantosme*) and Vulgar Latin spellings. However, the ph- is from the older Latin and Greek *phantasma*, which could mean anything from an apparition to any sort of image or unreality.

Words such as phantasm and phantasmagoria (thought to mean "crowd of phantoms"; Greek *agora* "assembly") share the same element.

That ph- reentered English in the 16th century, when many English words shifted spelling to reflect the Classics. The meaning of the word homed in on proper ghosts relatively early, though—it's recorded as a term for a spirit in the late 14th century.

FEAR AND PHOBIAS

The English term or word-forming element "phobia" is from the Greek *phobos* meaning "fear," "terror," or literally "flight" from something.

Phobias existed in Greek medical contexts first, but one of the earliest "phobia" words to appear in English was hydrophobia, which is recorded as early as the 14th century as another word for rabies because one of the classic symptoms is a contraction of the swallowing muscles that makes victims avoid drinking water.

Psychological research of the late 19th and early 20th century also ported that terminology into more public discourse around fears, including those of other nationalities, gender identities, and sexual preferences (e.g., xenophobia, homophobia).

An interesting twist: The word "homophobia" originally meant "fear of humans" and most commonly was used in the context of animals. Before the mid-20th century a homophobic horse was one that did not like humans. And this is because it reflected the Latin sense of *homo* seen in the species name *Homo sapiens*; it means "human" and is related to the word "hominid." However, most English words that incorporate *homo-* (homonym, homogenous) are using the unrelated Greek *homos*, meaning "same," which is why homophobia's meaning shifted to describe first a clinical fear of people who sexually and/or romantically prefer the same sex, and then fear-fueled hatred of them.

Many phobias, however, are still primarily found in psychological health contexts. Much as the *American Psychiatric Association's Diagnostic and Statistical Manual of Mental Disorders* (5th ed.) has a list of official *-philias* (*see* paraphilias), it also lists phobias.

These are just a few interesting phobias and their origins:

Amaxophobia or **hamaxophobia:** fear of riding in a car (Greek *(h) amaxa* "carriage")

Arachibutyrophobia: fear of peanut butter (Greek *arachi* "ground nut" + *butyr* "butter")

Atychiphobia: fear of failure (Greek *atukhes* "unfortunate")

Barophobia: fear of gravity (Greek *baros* "weight," related to "barometer," which measures the pressure or weight of the atmosphere)

Cacophobia: fear of ugliness (Greek *kakos* "ugly, bad, worthless," possibly related to the PIE root **kakka-* "defecate")

Caligynephobia: fear of beautiful women (Greek *kallos* "beauty" + *gynē* "woman")

Catagelophobia: fear of being ridiculed (Greek *cata* "down, away from" and *gelo* "laugh")

Chronomentrophobia: Fear of clocks (Greek *khronos* "time" and *métron* "measure")

Coulrophobia: fear of clowns (Greek *kōlobatheron* "stilt-walker")

Hippopotomonstrosesquipedaliophobia: fear of long words. Made up of the word "sesquipedalian," meaning "a foot and a half long" (Latin *sesqui-* "half as much again" + *pes* "foot"), enhanced by enlargening elements *monstrum* ("monster") and *hippopotamus*. (This one is intentionally tongue-in-cheek, first recorded in the early 2000s.)

Paraskavedekatriaphobia: fear of Friday the 13th (Greek *paraskeví* "Friday") + *dekatreís*, "thirteen"

Phobophobia: fear of phobias (a repetitive phrase)

Wiccaphobia: Fear of witchcraft (Old English *wicca* "male witch," a modern construction using the 20th-century concept of the religion Wicca)

Poltergeist

This word, a relatively recent borrowing from German circa 1838 at the outset of the Spiritualist movement, means "noisy ghost" or "knocking ghost."

Satan, the Devil, and Lucifer

Old Nick, the serpent, the Devil, the archfiend, the great adversary, Beelzebub, Mephistopheles, Iblis, Satan, Lucifer, the Morning Star … The list of names that have, at some point or another, been used for the biggest asshole in the afterlife goes on and on—and so do the various accounts of what he/it/they look like and he/it/they want from us.

The lore behind all of these iterations would take up an entire book—and have, as it happens, taken up many books written by people with a far more discerning eye for religious lore—so let's stick to the etymological basics of the big three:

The name **Satan** traveled to English by way of Latin and Greek, but is ultimately from the Hebrew word *satan* (שָׂטָן), meaning "adversary" or "accuser," from a verb meaning to oppose or obstruct.

The Septuagint Bible, a 3rd-century Greek translation of the Hebrew Bible, translates this word as *diabolos*—the original source of the English words "**devil**" and "**diabolical**" (literally "devilish"). Like the Hebrew, the Greek word functions as an epithet: *Diabolos* means "slanderer," or literally someone who throws something across your path (*dia* "across, through" + *ballein* "to throw").

The Old English variation of "devil," *deofol*, was also used in Christian theology, but was of the indefinite article variety: It referred to any devil (small D) or an evil spirit that preyed on humans.

The names Lucifer and "morning star" were first associated, not with Satan, but with the planet Venus in reference to its rise in the morning sky. The name literally means "light-bringing," from the Latin *lux* "light" and *ferre* "to carry." The association between the name Lucifer and the head honcho of Hell began with some biblical translation shenanigans, specifically Isaiah 14:12–15: "How art thou fallen from heaven, O Lucifer, son of the morning!"

The "Lucifer" in that line is a translation of the Greek *Phosphoros* ("torchbearer," "morning star," also the source of the word "phosphorous," which is flammable as fuck), which in turn is a translation of the Hebrew *helel ben shachar*. *Ben shachar* means something like "son of dawn," but *helel*—and even what part of speech it is—is debated. It generally has been translated as "cry," "wail," "howl," or "yell."

So suffice it to say that this re-retranslation is creative at best. In general, the Bible is pretty vague about Satan, who sort of does and sort of doesn't exist in it, but that passage is very specifically talking about the King of Babylon, not Satan. Nevertheless, subsequent Christian lore just ran with it.

To make a long story short: Not even the Prince of Hell is sure what his own damn name is.

Scare

The word "scare" is an Old Norse addition to English, from the word *skirra*, similarly meaning "to frighten." An adjective variation, *skjarr*, described "scaredy-cats," so to speak. It meant "timid" or "afraid."

Sinister

Are you sinister or dexterous? Most people are one or the other—though some people are both.

And that's because *sinister* is originally a Latin word meaning "left-handed" or "on the left side," and *dexter* is a Latin word meaning "right-handed" or "on the right side."

Because most people are right-handed, the right side was associated with strength and skill—hence the words "dextrous" and "dexterity."

Left-handedness is less common and the world is designed mostly with right-handed people in mind, so the left was associated with weakness, bad luck, and malice. It was also associated with the West, and therefore darkness because the sun sets in the West. That's why, starting in the 15th century, we got today's English meaning of sinister—something evil, dark, or threatening.

"Ambidextrous," meanwhile, comes from the Latin word *ambidexter*, and it literally means "right-handed on both sides."

Obviously, today we know that lefties are just as brilliant and may even tend toward exceptional out-of-the-box thinking and creativity. But the same kind of nonsense happened in Old English, before these Latin-derived words entered the language.

In Old English, the right and left were called *swiþra*, meaning "stronger," and *winestra*, meaning "friendlier." Friendlier sounds more positive—but *winestra* was used euphemistically because people superstitiously wanted to avoid invoking any bad luck associated with that hand.

The words "right" and "left" were applied to the hands in Middle English. Right because it was considered to be the "correct or proper" hand, and left because it comes from an Old English word meaning "weak" or "foolish."

In the 1600s there was also a word, *ambilevous*, meaning "clumsy" or literally "left-handed on both sides." The "levous" part is based on the same root as the word "left." Lately, the term "ambisinister" has also emerged as a play on "ambidextrous" and the original Latin *sinister.*

Ursula K. Le Guin (1929–2018) knew what she was doing in her science fiction novel *The Left Hand of Darkness* (1969), with these especially telling passages:

Light is the left hand of darkness
and darkness the right hand of light.*

And:

It had been entertaining and fascinating to find here on Gethen governments so similar to those in the ancient histories of Terra: a monarchy, and a genuine fullblown bureaucracy. ... It was odd that in the less primitive society, the more sinister note was struck.†

Siren

Sirens, another musical supernatural creature (*see* banshee), are famous thanks to Homer's *The Odyssey.* The name of these mythical sisters—who took the form of bird-women—called *seirenes* in Greek,

* Ursula K. Le Guin, *The Left Hand of Darkness* (New York: Ace Books, 1976).
† Ibid., p. 143.

is thought to literally mean "binder" or "entangler," from the Greek *seira*, meaning "cord" or "rope." The "rope" connection also adds an interesting degree of dramatic irony to Odysseus binding himself to the mast of his ship to avoid being bound by the sirens' song.

Sorcery

This word refers to magic that influences fate and fortune, from the Latin *sors* "lot, fate, fortune." In Medieval Latin, a *sortiarius* was originally specifically someone who tells fortune by casting lots, now called "sortition" in English whether for magical purposes or not. (For example, in governance it can refer to the random selection of people such as jury members.)

"Sorcery" (and its Old French and Medieval Latin predecessors) was also applied to the power of influencing fortune and fate, which led to the broader use of "sorcerer" and "sorceress" as people who are able to wield this power, then to a powerful magic-wielder of any kind.

Another word similar to the original sense is cleromancy (Greek *klēros* "lot" + *manteia* "oracle, divination"), which especially involves the throwing of dice to divine the future. The second element, -mancy, is from the Greek root *menos* "passion, spirit," related to "mania," and appears in other intriguing terms such as:

Alectryomancy: divination by means of a rooster surrounded by grains or corns on letters, with the diviner spelling words based on the order in which the grains are eaten—from Greek *alektryon* "cock"

Astromancy: divination based on the positions and behavior of celestial bodies—from Greek *astron* "star"

Bibliomancy: divination by opening a book, especially the Bible, to random pages—from Greek *biblion* "paper, scroll," later "book" or "Bible"

Catoptromancy: divination using a mirror—from Greek *katoptron* "mirror"; also called enoptomancy, from Greek *enoptos*, literally "seen in"

Gyromancy: divination performed by a person walking in a circle of symbols and signs until they fall from dizziness—from Greek *gyros* "circle"

Ichnomancy: divination by means of footprints—from Greek *ikhnos* "a track, footprint"

Necromancy: death-magic, originally divination using dead bodies—from Greek *nekros* "dead body"

Specter

It's no coincidence that "specter" resembles "spectacle" and "spectrum"—all concern vision(s). Indeed, *specter* (by way of the French *spectre*) comes from the Latin word *spectrum*, meaning "vision" or "apparition." In fact, "spectrum" and the plural "spectra" are recorded in the early 1600s as alternative words for hallucinations and phantasms. The term became the technical term for a range of colors in the 1600s and to similarly multifaceted concepts—like gender—in the 1930s. Prior to the 1600s specters weren't specifically frightening, but could refer to visions of any kind.

WHAT IS THE "COB" IN COBWEB, AND HOW IS IT DIFFERENT FROM A SPIDER WEB?

Today, a cobweb usually refers to an abandoned, dusty spider web that makes houses look appropriately haunted, while a spider web usually refers to a tidier one that is presently occupied by one of our eight-legged friends.

One exception (because in English there always has to be at least one): There is a family of spiders called Theridiidae, also known as tangle-web spiders or cobweb spiders, that create thicker and more tangled-looking webs that biologists call cobwebs even if they're currently occupied by a spider.

But what does "cob" mean?

Etymologically, a cobweb and a spider web are the same thing. And they were pretty much interchangeable until Gothic fiction differentiated cobwebs as a fixture of spooky scenes. *Coppewebbe* is the Old English word

for a spider web. The coppe or "cob" part is an abbreviation of the Old English word for spider, *atorcoppe*, which literally means "venom head."

This won't come as a surprise to anyone who has read J. R. R. Tolkien's *The Hobbit* (1937), in which Bilbo drew the giant spiders of Mirkwood away from the Dwarves by singing a song full of insulting epithets including "Attercop."

Much like many things that are creepy as fuck, Old English and Middle English had a *lot* of words for **spider**.

- The word "spider" itself is Old English and literally means "spinner."
- Chaucer used the word *loppe* or *lobbe* in *The Canterbury Tales*. This Middle English term was widely used to refer to anything lump-shaped or bulbous.
- Another Old English word was *gangewifre* "a weaver as he goes."
- There was also *araine*, "spider," introduced from Old French and originally from Greek *arakhnē*, which is where we get the word "arachnid."

Spooky

This word and "spook" manifested in English in the late 18th century, from the Middle Dutch *spooc*, meaning "ghost" or "apparition," and is related to other Germanic words for creepy, lifeless things such as the German *Spuk* "ghost, apparition" and the Swedish *spok* "scarecrow."

"Spook" was extended to spies and undercover agents during World War II because they operated in secret—metaphorical ghosts sharing intelligence in the shadows of enemy organizations.

Around the same time, the word also became a slur for Black people, based on the idea that darker skin is difficult to see in the dark. One context in which it was not a slur was in the term "Spookwaffe," a nickname for the Black pilots of the Tuskegee Institute, which these airmen reclaimed and used with pride. "Spookwaffe," which is a play

on the German air force, the Luftwaffe, can also literally be read as "ghost weapon."

Supernatural

Although this word is largely associated with ghosts and science fiction, it was initially a religious term. The literal meaning of its Latin predecessor, *supernaturalis*, is "above nature," suggesting something divine, heavenly, or otherwise created or given by God. The ghostly, paranormal sense is a 19th-century development that likely owes its popularity to the rise of Gothic fiction.

Thrall

Often associated with the servants of vampires in Gothic fiction, this word is from the Old English *þræl*, meaning "bondsman," "serf," or "slave." It derives from an Old Norse source that shared the same meaning as the Old English term, but also carried the sense of a "wretch" or a "scoundrel." Ultimately, its source is a Germanic root meaning "to run," such that a thrall is a "runner." Whether that implies a servant whose job is to be a "runner" or messenger, a fugitive from the law, a slave bent on running away, or something else is unknown.

Vampire

One of the most mysterious things about vampires is the exact origin of their name. What we do know is a lot about its etymological journey over the past several centuries:

We know that English adopted the word from either French (*vampire*) or German (*Vampir*), probably due to German literature.

We know that vampires became a fixture of German literature due to the "vampire craze" of the 1720s, when two suspected vampires (Petar Blagojevich and Arnold Paole) were exhumed in Serbia (then part of the Habsburg Empire) and their bodies found to be quite intact with blood on their mouths.

We know that the word was also adopted into German from Serbian (вампир—*vampir*), and that the Serbian word came from Hungarian (*vámpír*).

Many Slavic languages have words for vampire that can be traced back to the Old Church Slavonic *opiri*. also the source of French, German, Serbian and Hungarian words for this particular type of monster. But what *opiri* really means and where it comes from is unclear. Some Slavic linguists say it comes from the Tatar word *ubyr*, meaning "witch," but others suggest that it's related to the Slovak *vrepit' sa*, meaning "to stick or thrust into," suggesting someone who thrusts or bites. That, at least, tracks with the prevailing interpretation of vampire lore as an expression of cultural anxieties around sex and lust.

In English, the word *vampyre* first appeared in 1734 in an anonymous manuscript called "The Travels of Three Englishmen from Venice to Hamburgh." This manuscript went unpublished until 1745 when it was compiled into *The Harleian Miscellany*, which was edited by Samuel Johnson (1709–84), who, as you know, also wrote one of the most influential dictionaries in the English language and squints at newspapers in internet memes.

The manuscript quotes a passage from a German text that details much of what would come to shape English Gothic vampire fiction, including sleeping in graves, sucking blood, and death by staking and burning.

Warlock

Warlocks have nothing to do with war, or with locks. And in fact, being a warlock back in the day didn't mean quite what it does today.

In a good deal of fiction and fantasy gaming today, warlocks are often portrayed as dark magic users—the male equivalent of witches. In Old English the word for a female witch or sorceress was *wicce*, while the word for a male witch or sorcerer was *wicca*. (Look familiar? That's no coincidence. More on this under "witch.")

However, the word "warlock," or *wærloga*, did exist in Old English, but it meant "traitor, liar or enemy."

The first element, *wær*, meant "faith, fidelity, agreement or covenant." (It is unrelated to the word "war," it but does share a root with

the word "verify.") The second element, *loga*, is from the Old English *leogan*, "to lie."

So a warlock was literally someone who lies about their covenants—an oathbreaker.

There was also a related Old English term, *wordloga*, or "word-liar," that meant a deceiver.

We got from "oathbreaker" to warlocks as male witches or sorcerers because *wærloga* was used to describe the devil when Christianity came to England. By extension, someone who was in league with the devil or practiced devilish witchcraft came to be known as a warlock.

Fun fact: The equivalent of "witchcraft" for warlocks is "warlockery."

Weird

The Old English predecessor to this word, *wyrd*, has been revived in fiction of the past century or so, calling upon its original meaning: "fate" or "destiny." It was often used as a word relating to witches and other supernatural beings who had the power to control fate. Germanic and Greco-Roman mythology both included a group of witchlike sisters—usually three women—who were thought to have power over human destiny. They were called the Norn in Norse, the Moirai in Greek, and in English the "Weird Sisters" or the Fates.

Werewolf

As we explored in our chapter on gender, the first element of this mythical beast's name is *wer*, meaning "man" in Old English, so a werewolf is literally a "man-wolf." (Shout out to my fellow wifwolves.)

Werewolf lore is truly ancient, appearing first in Proto-Indo-European mythology between 4500 and 2500 BCE. Lycanthropy has appeared in almost every culture around the world with any proximity to wolves, but many werewolf legends in the Western world come from Germanic pagan lore.

In fact, the second part of the French word for werewolf, *loup-garou*, is Germanic in origin, which is somewhat unusual for largely Latin-derived modern French words. Incidentally, *loup-garou* is also

redundant. It literally means "wolf-man-wolf" because *loup* is from the Latin *lupus* "wolf," and *garou* breaks down into Germanic elements meaning "man-wolf."

The "man" element of *garou* is cognate with the "were" part of werewolf. This element literally means "man"—not "man" in the non-gendered human race sense, but literally "male person." By contrast, the Greek-derived lycanthrope means "wolf-man" as well, but *anthropos* has historically been used to mean "human" or humanity more generally, too.

More about Wolves and Why Werewolves Exist

"Wolf" is an ancient word that has gone practically unchanged since well before any version of English existed. Wolves had a complicated relationship with Anglo-Saxons as they vied for the role of apex predator, which presented an especially vexing problem when humans began encroaching on their habitats. Wolves were systematically hunted to extinction in England by the end of the 15th century, but the fear of them remained.

Since wolves were feared and hated—and yet also revered as being powerful predators—you'll see the word "wolf" appearing in many aspirational surnames. In fact, Beowulf literally means "bee-wolf." This is an example of a kenning, which was a metaphorical compound word that meant something else entirely. The word "bee-wolf" actually meant "bear"—perhaps because bears are like big fluffy wolves who like honey.

The idea that wolves are ravenous hunters has led people to associate them with insatiable sexual desire since ancient times. At first, this characteristic was specifically associated with women. In fact, in several European languages including Latin and Middle English, "wolf" was another word for a prostitute. In the 1500s they became more a symbol of male lust, which was encouraged by stories like "Little Red Riding Hood"—and would eventually contribute to the idea of the wolf-whistle.

Witch

The Old English word for a woman who practices sorcery or witch-craft was *wicce*, pronounced *witch-a*, and it was a feminine form of *wicca* (pronounced *witch-aw*), the word for a man who practices sorcery or witchcraft. This is, of course, where the name of the nature- and occult-centric Wicca religion gets its name—and although it is shaped by pre-Christian lore, the word itself was first applied to the neopagan belief system in the 20th century. The verb form—the act of practicing witchcraft—was *wiccian*.

In fact, "witch" remained a nongendered word for both male and female practitioners of sorcery until the 1600s, when the word became more associated with women and male witches came to be referred to as "he-witches" or "men-witches."

To call someone a "wicked witch" is a bit redundant—more or less like calling someone a "witchy witch"—because the word "wicked" itself is an adjectival variation of the Old English *wicca*.

Also, because women are apparently mysterious, mystical, and devious beings—insert exhausted eyeroll—"witch" (*wicce*) was just one type of magical woman in Old English. She was a soothsayer or one who could divine fate or see the future.

A few of the other recorded types of witches included:

a **gealdricge** or **gealdorcræftigan**, who practices "incantations" or even necromancy
a **scinlæce**, who calls upon phantoms and spirits
a **lybbestre**, who works with drugs, potions, poisons, and charms.

Wizard

In the 15th century, the word "wizard" referred to a philosopher or a sage. It comes from the Middle English *wys*, meaning "wise." The ending -ard is an intensifier, which gives "wizard" the literal meaning of someone who is not just wise, but very wise. (Normally, however, that ending is also a pejorative—*see* bastard, braggart, dullard, in Chapter 4; "wizard" is a rare exception.)

The word came to imply a magic user in the mid-16th century. Around that time the legends of King Arthur, first told centuries earlier, were being reimagined and rewritten, which helped popularize stories about enchanters like Merlin, influencing the shift in the word's meaning.

Zombie

This word is most likely of West African origin and was originally used as the name of a god or spirit associated with rural Haitian folklore and Vodou (or Voodoo). The god in question was a serpent spirit sometimes known as Li Grande Zombi (the great spirit/god) or Damballah, though different sources dispute which god/spirit was known as "Li Grande Zombi" and which was most associated with serpents.

Another early Louisiana Creole sense of the word, "phantom" or "ghost," may have been influenced by the Spanish *sombra*, meaning "shade, ghost." This theory is supported by an account of the shamanist practices of the indigenous Caribbean Taíno people, written by a monk who traveled with Christopher Columbus.

However, the African origin seems more likely, not only because the Vodou religion itself is of African origin, but also because the earliest recorded occurrence of the English word, then spelled "zombi," was in the 1819 *History of Brazil* by the poet Robert Southey. Southey wrote about the Afro-Brazilian anti-slavery rebel leader and king of a runaway slave settlement, Zumbi dos Palmares, whose name came from the Kikongo word *zumbi* ("fetish") or the Kimbundu *nzambi* ("soul," but also "god" or "divine spirit" in Kikongo), and who was rumored to be immortal. It seems that the story of Zumbi and the West African words associated with his name most heavily influenced the rise of the word "zombi" in the Caribbean.

The English "zombie" was used to refer to a reanimated corpse in 1871. The earliest forms of today's zombie mythos gained popularity at the same time as Vodou, but zombies are not typically part of true Vodou religious practices and are more accurately associated with non-Vodou rural Haitian folklore.

According to this folklore, zombies are dead people who have been reanimated via necromancy, usually by a Vodou sorcerer or a witch called a bokor. The zombie has no will of its own and becomes a slave to the bokor. These practices can also involve incorporeal zombies—temporary parts of human souls—that can be captured, stored, and used by a bokor for sorcery. Supposedly, these two types of zombie reflect the dualism of Vodou, the flesh and the spirit comprising the two halves of the human soul.

The concept and the word grew popular in the U.S. during the occupation of Haiti from 1915 to 1934. It's debatable when the first fictional description of contemporary zombies appeared; there are undead characters across many religious myths and classic literature, from Percy Bysshe Shelley to Edgar Allan Poe, but most of these aren't quite the mindless undead we see today. A notable zombie tale is the 1922 "Herbert West–Reanimator," a short story by H. P. Lovecraft (1890–1937). It does not contain the word "zombie," but does describe the "grisly masses of flesh that had been dead, but that [Dr. Herbert] West waked to a blind, brainless, nauseous animation."

The 1929 novel *The Magic Island* by American occultist William Seabrook (1884–1945) does contain the word "zombie" and is credited with popularizing fictional Haitian zombies more broadly in (white) American culture. The 1932 Bela Lugosi film *White Zombie* included undead Haitian Vodou slaves, still retaining connections between Vodou and zombies. Zombies would then appear in 1950s comic series such as *Tales from the Crypt* and *Vault of Horror*, evolving into the less culturally specific zombies we see today.

Lugosi's film and these comics would greatly influence George Romero's films, including both the 1964 *The Last Man on Earth* (based on the 1954 novel *I Am Legend*, which was technically about vampire-esque monsters) and, of course, the iconic 1968 *Night of the Living Dead*. *The Living Dead* movie script itself does not refer to the undead as "zombies," but uses the word "ghoul" instead (*see* ghoul). In fact, it was press coverage using the word "zombie" that cemented the association between the film and Romero's undead. Romero himself only began using "zombie" in later interviews, fully adopting it in his 1978 *Dawn of the Dead* script.

Zombie-centric TV series such as *The Walking Dead* TV series (2010–22) also avoid using the word "zombie," with the logic being that zombie fiction is nonexistent in-universe. However, the word does appear in the comics (*Walking Dead* Book 7 [2011] shows the word "zombie"); supposedly creator Robert Kirkman meant to exclude it in the comics, too, but kept writing it unintentionally and eventually just started leaving it in.

EPILOGUE

WORDS AT THE END OF THE WORLD

Well, this has been a hellish ride. And what better way to wrap up a journey of misery, mayhem, disgust, and titillation than with the words that will carry us into the inevitable end of all things.

Before you exit (pursued by a bear), enjoy these terms of utter destruction.

Apocalypse

This word, perhaps unsurprisingly given its biblical usages, is etymologically synonymous with the word "revelation." It's ultimately from the Greek *apokalyptein* "uncover, disclose, reveal" (*apo* "off, away from" + *kalyptein* "to cover, conceal"). Indeed, the original name of the Book of Revelation, authored by John of Patmos, was Apokalypsis.

English butchered this word, interpreting it as *pocalipsis* in the eleventh century before it was updated to "Apocalypse" in the 1200s and then the more Latinized "Revelation" by John Wycliffe in the late 1300s.

The word "apocalypse" was also used in Middle English outside of biblical contexts, but it originally meant "vision" or "hallucination," often still of a religious variety. It took on its non-religious, end-of-the-world-y sense in the 20th century, though the connection was established in the 19th century with words such as "apocalypticism," which referred to the belief that the revelation was nigh.

Armageddon

This word is from a Greek transliteration of a Hebrew placename, Har Megiddo, whose ruins crown Mount Megiddo or Tel Megiddo

today. This city, in central Palestine, was positioned along an important trade route in the days of the Fertile Crescent, and it was the site of many Israelite battles. It took on its association with the end times in the 19th century due to its mention in the Book of Revelation as the site of the great and final battle. One of its first known usages in this sense was in a letter by the poet Percy Bysshe Shelley (1792–1822):

> Hideous, hated traits of Superstition! Oh Bigots! how I abhor your influence! They are all bad enough. But do we not see Fanaticism decaying? Is not its influence weakened, except where Faber, Rowland Hill, and several others of the Armageddon heroes, maintain their posts with all the obstinacy of long-established dogmatism? How I pity them! how I despise, hate them!*

This figurative association with the end times was firmed up over time, such that by 1896 Rudyard Kipling (1865–1936) wrote:

> So long as The Blood endures,
> I shall know that your good is mine: ye shall feel that my strength is yours:
> In the day of Armageddon, at the last great fight of all,
> That Our House stand together and the pillars do not fall.
> "England's Answer," from *The Seven Seas* (1896)

Bedlam

This word for chaos and confusion also includes a dash of ableism and mental health bias. It's a contracted mispronunciation of "Bethlehem," short for the Hospital of Saint Mary of Bethlehem, London's (now legitimate) psychiatric hospital with an infamous history of taking in—and abusing and exploiting—patients suffering from conditions such as insanity or lunacy since as far back as the 15th century. The term "bedlam" evokes the "madness" of the patients within the hospital.

* *Letters from Percy Bysshe Shelley to Thomas Jefferson Hogg*, with notes by W. M. Rossetti and H. Buxton Forman (1897).

Calamity

Beyond the Latin *calamitas* "damage, loss, misfortune," the origin of this word isn't known for certain, but two theories have arisen: One is that its Latin root is *calamus* "straw," perhaps suggesting the devastation of crops during a famine, but this may be folk etymology. Another is that it's related to *incolumis* "uninjured"—but its opposite—with the root of this word currently unknown. The word "calamity" gained additional renown in American English in the second half of the 19th century due to frontierswoman Martha Jane Cannary (1852–1901), also known as "Calamity Jane."

Cataclysm and Catastrophe

The element *cata-* here is a Greek (*kata-*) directional word-forming element that can mean "across, through, away from, down, or among."

In the case of **cataclysm**, it means "down": The second element is from the Greek *klyzein* "to wash," so the original sense of "cataclysm," is "to wash down," giving it the sense of a massive, devastating flood. The word first referred to destructive rainstorms and was then extended to other devastating circumstances.

The second element in **catastrophe** is the Greek *strephein* "turn," giving the word the literal sense, "to overturn," which speaks to its earliest uses in literary contexts. The catastrophe in a play or novel is the fatal turning point or a reversal of what is expected—literally a plot twist. It was first applied to real-life unexpected disasters starting in the 18th century.

Chaos

This word, which today evokes spaces full of activity, or even one's moral alignment (e.g., "chaotic" vs. "neutral" or "lawful"), is from the Greek *khaos*, which meant "abyss" or "vast emptiness," as in the phrase "the chaos of space"—the idea that the fundamental state of the universe is primal emptiness or disorder.

The Greek opposite of *khaos* is *kosmos*, the source of our modern-day word "cosmos," which now typically refers to the universe, but in Greek meant "order" or "an orderly arrangement."

Fun fact: The Greek *kosmos* was also a word for an arrangement of decorations, especially on fabric, and some early references to the night sky as the cosmos involved comparisons between the stars and galaxies and the decorations on the fabric of a woman's dress. Therefore, *kosmos* is also the root of the word "cosmetic," literally "the art of dress and ornament."

Destroy and Destruct

Destroy originally comes from the Latin *destruere*, "to tear down, demolish," which literally means to "un-build" or "to build down" (*struere* "to build"). *Struere* is also the root of structure, construct, obstruct, destruction, obstruction, and construction.

So why does "destroy" have a different ending? It's all about the way these words traveled from Latin to English.

"Destroy" is by far the oldest word here. It came to English in the 1200s, shortly after the Norman invasion of England. So while it's originally from the Latin *destruere*, its spelling is influenced by the Norman French form *destruire*.

Structure, construct, and obstruct came around a bit later, and are all back-formations (ca. 1300s) of destruction, construction, and obstruction from the Latin nouns *destructionem*, *constructionem*, and *obstructionem*, from Latin *structus*, "built," past participle of *struere*. Latin also had verb forms of these words: *destruere, construere*, and *obstruere*— but because English adopted the nouns first, we hung on to that "struct" part when creating the English verbs.

The verb "destruct" is a back-formation of destruction, just like the other verbs, but because we already had "destroy," we usually say that we "destroyed" something rather than we "destructed" it. In fact, "destruct" didn't appear in English as a verb until the 20th century.

Indeed, the phrase "self-destruct" first appeared 1966 in the voiceover at the beginning of the TV show *Mission: Impossible*.

Devastate

This verb is a back-formation of "devastation"—and a rare one that wasn't used frequently until the 1800s—its earliest recorded form

(ca. 1530s) was *devast*. The Latin root is *vastare*, meaning "to lay waste," and the prefix acts as an intensifier.

Disaster

When you call something a disaster, you are literally saying that this misfortune has been foretold by the stars. The word "disaster" etymologically means "ill-starred."

The base word, *aster*, is the Greek word for star, which means that disaster is related to words like astronomy, astrology, asteroid, and asterisk.

Doom

Originally *doome* in Middle English and *dom* in Old English, this word's predecessors were terms for decrees, judgments, and legal sentences. The Old English word *dombec* "book of laws," literally "doombook," is also a relative.

Similarly the verb forms—*deman* in Old English and *domen* in Middle English—meant (respectively) "to deem" and "to pass judgment upon." (Indeed, "deem" also originally meant specifically "to pass or pronounce judgment on" in a more formal sense as well.) Thus one's doom (as a noun) is the judgment deemed to be fit—and, naturally, that judgment might be a fatal (or fate-al) one. It was extended to refer to ruin and destruction (the judgment or doom of many) starting in the 14th century and was then folded into Christian Judgment Day lore.

Obliterate

To obliterate something is, quite literally, to remove it from history—specifically, from the historical record. The word's Latin components (*ob* "against" + *littera* "letter, script") create a word that both referred to the act of blotting out writing or erasing it, and of eliminating it from memory.

Pandemic and Epidemic

Originally adjectives, these words described any (unpleasant) incident afflicting an entire community. The root is *demos*, meaning "people."

The Greek prefix *epi-* means "among" or "upon," so that an epidemic is one that spreads "among" a people or the people of a given community, while *pan-* means "all," implying an incident that impacts all people and communities.

Pandemonium

This word, first recorded in John Milton's *Paradise Lost* (1667) as the name of Satan's palace in Hell, literally means "all demons." It was extended to general chaos and mayhem in the late 1700s.

Tribulation

The Latin source of this word *tribulare* used to mean "oppress" or "afflict," but in a figurative sense. Its literal meaning is "to thresh out" using a *tribulum*, or threshing sledge (and therefore "to press").

Turmoil

This word is thought to be from the French term *tremouille*, for a grain or mill hopper, evoking the motion of the hopper as it rattles the grain. The French term is made up of the Latin components *tri-* "three" and *modius*, a Roman measure of grain.

Volcano

The word "volcano" comes from Vulcano, a volcanic island in the Aeolian Islands of Italy which was named after the Roman fire god Vulcan. The study of volcanoes is called volcanology or sometimes vulcanology. Of course, you'll also recognize this as the inspiration for the Vulcans from *Star Trek*.

THE

#@%&ING

END

GLOSSARY OF ETYMOLOGY TERMS

ANGLO-SAXON The Anglo-Saxons were a cultural group that inhabited England beginning around the year 410 CE. The end of the Anglo-Saxon period is typically marked by the Norman invasion of England in 1066. The Anglo-Saxons' language was Old English (also known as Anglo-Saxon), which was spoken and written in Anglo-Saxon Britain from around 450 CE until around 1150.

ASSIMILATION (prefixes) When a prefix changes to fit the root it's attached to. For instance, when the prefix ad- is added to a consonant, the consonant it is attached to is often doubled, while the "d" is dropped: ad- + count = account; ad- + fluence = affluence

AUGMENTATIVE AND DIMINUTIVE "Augmentative" describes when a word has an element that expresses largeness or enhanced size, often an ending such as -on (e.g. galley/galleon, squad/squadron). "Diminutive" describes when a word has an element that expresses smallness, often an ending such as -et(te), -let, -y, or -ie (e.g. statue/statuette, pig/piglet).

AUTOLOGICAL VS. HETEROLOGICAL WORDS An autological word describes itself, while a heterological word does not describe itself. The word "heterological" causes a paradox called the Grelling–Nelson paradox: If "heterological" is a heterological word, that would mean it does not describe itself, and is therefore not heterological; if "heterological" is an autological word, it describes itself, and is therefore not heterological.

BACK-FORMATION When a word enters a language with a suffix but is backformed to a simpler form. This is particularly common for English nouns ending in -tion, which are typically adopted, more or less intact, as nouns from French. For instance, the verbs "evaluate," "regurgitate," and "exploit" are back-formations from the older nouns "evaluation," "regurgitation," and "exploitation," which entered directly from French and Latin.

DOUBLET Etymological twins, or when two or more words in the same language have different forms but share the same root.

EGGCORN A common mishearing of a word or phrase that results in incorrect but understandable usage and/or spelling. For example: "old-timer's disease" rather than "Alzheimer's disease," or "ex-patriot" instead of "expatriate."

ETYMOLOGY The study of the origins of words, from the Greek *etymologia*, "study of the truest sense (of words)," from *etymos* "true."

FOLK ETYMOLOGY When a word's spelling or meaning is impacted by assumptions about its origin, often due to similarities to other words in spelling or pronunciation. *See* outrage.

FOSSIL WORD A word that generally does not appear outside of an idiom or common turn of phrase, typically because it is archaic, such as "ado" in "much ado about nothing" or "without further ado."

HYBRID WORD When a single word's elements derive from two different languages, such as Old English and Latin, or Greek and Latin.

IMITATIVE WORDS Words that are intended to mimic or evoke the sound, creature, or motion that they describe.

INTENSIFIER When a word element, such as a typically negative prefix, does not denote its usual meaning, but instead adds emphasis to the base word.

NORMANS A cultural group that inhabited Normandy in France, made up of Norse Vikings, West Franks, and Gallo-Romans. They spoke and wrote Old French, a Latin-influenced predecessor to French, from the eighth to the 14th centuries. Following the Norman invasion in 1066, the Old French-speaking Norman ruling class introduced many Latin-derived words to English, producing Middle English, which was spoken and written from around 1150 to around 1470.

OLD NORSE A North Germanic language spoken in Norway, Iceland, Denmark, and Sweden from the seventh century to the 14th or 15th century. Old Norse influence on English occurred during the occupation and colonization by Norse peoples of northern England from the ninth to the 11th century.

PROTO-GERMANIC The reconstructed proto-language from which languages in the Germanic branch of the Indo-European family are derived. Modern Germanic languages include English, German, Dutch, Afrikaans, Swedish, Danish, and Norwegian.

PROTO-INDO-EUROPEAN (PIE) The reconstructed proto-language from which languages in the Indo-European family are derived. Modern Indo-European languages include Spanish, English, Portuguese, Hindi, Urdu, Bengali, Russian, Punjabi, German, Persian, French, Marathi, Italian, and more.

ROMANCE LANGUAGES Modern languages that evolved from Late Latin, including Spanish, Portuguese, French, Italian, and Romanian.

ROOT The etymological source of the base element of a word.

UNPAIRED WORDS Words that are never or rarely used without a prefix or suffix, or do not have a natural opposite, often because the base word is antiquated. For example, "whelm" is an Old English word that is now rarely used without under- or over-. The same is true for "reck" in "reckless" and "gust" in "disgust."

BIBLIOGRAPHY

Ayto, John, *Dictionary of Word Origins* (New York: Arcade Publishing, 1990).

Bammesberger, Alfred, *English Etymology* (Heidelberg: Carl Winter, 1984).

Barnhart, Robert K., Ed., *Barnhart Dictionary of Etymology* (New York: H. W. Wilson Co., 1988).

Barnhart, Robert, Ed. *Chambers Dictionary of Etymology* (Edinburgh: Chambers, 2002).

Barrère, Albert, *Argot and Slang* (London: Whittaker & Co., 1889).

Beekes, Robert, *Etymological Dictionary of Greek* (Leiden: Brill, 2010).

Boutkan, Dirk, and Sjoerd Michiel Siebinga, *Old Frisian Etymological Dictionary* (Leiden: Brill, 2005).

Buck, Carl Darling, *A Dictionary of Selected Synonyms in the Principal Indo-European Languages* (Chicago: University of Chicago Press, 1949, reprinted 1988).

Cassidy, Frederic G., and Hall, Joan Houston, Eds., *Dictionary of American Regional English* (Cambridge, MA: Harvard University Press, 1985–2002).

Chapman, Robert L., and Kipfer, Barbara Ann, Eds., *The Dictionary of American Slang*, 4th edn. (New York: Harper, 2007)

de Vaan, Michiel, *Etymological Dictionary of Latin and the other Italic Languages*, vol. 7 of *Leiden Indo-European Etymological Dictionary Series*, ed. Alexander Lubotsky (Leiden: Brill, 2008).

Dictionary.com. 2023. www.dictionary.com/

Eide, Denise, *Uncovering the Logic of English: A Common-Sense Approach to Reading, Spelling, and Literacy* (Pedia Learning Inc., 2011)

Etymonline—Online Etymology Dictionary. www.etymonline.com/

Farmer, John S., *Slang and Its Analogues Past and Present* (London, 1890).

Fowler, H. W., *A Dictionary of Modern English Usage* (Oxford: Oxford University Press, 1926).

Fowler, H. W., *A Dictionary of Modern English Usage*, 2nd edn., revised by Sir Ernest Gowers (Oxford: Oxford University Press, 1965).

Grose, Francis, *A Classical Dictionary of the Vulgar Tongue* (London, 1785; 2nd edn., London, 1788; 3rd edn., London, 1796); expanded by others as *Lexicon Balatronicum: A Dictionary of Buckish Slang, University Wit, and Pickpocket Eloquence* (London, 1811).

Johnson, Samuel, *A Dictionary of the English Language* (London, 1755).

Klein, Dr. Ernest, *A Comprehensive Etymological Dictionary of the English Language* (Amsterdam: Elsevier Scientific Publishing Co., 1971).

Lyovin, Anatole V., *An Introduction to the Languages of the World* (Oxford: Oxford University Press, 1997).

McWhorter, John, *Nine Nasty Words* (New York: Avery, 2021).

Mencken, H. L., *The American Language*, 4th edn. (New York: Alfred A. Knopf, 1965).

The Oxford Dictionary of English Etymology (Oxford: Oxford University Press, 1966).

The Oxford English Dictionary, 2nd edn. (Oxford: Clarendon Press, 1989).

Oxford English Dictionary online (2023). www.oed.com/

Merriam-Webster.com (2023). www.merriam-webster.com

Palmer, the Rev. Abram Smythe, *A Dictionary of Verbal Corruptions or Words Perverted in Form or Meaning, by False Derivation or Mistaken Analogy* (London: George Bell & Sons, 1882).

Rawson, Hugh, *Wicked Words* (New York: Crown Publishers, 1989).

Ringe, Don, *From Proto-Indo-European to Proto-Germanic* (Oxford: Oxford University Press, 2006).

Smith, William, ed., *A Dictionary of Greek and Roman Antiquities* (London: John Murray, 1878).

Thornton, Richard H., *An American Glossary* (Philadelphia, PA: Lippincott, 1912).

Wedgwood, Hensleigh, *A Dictionary of English Etymology*, 3rd edn. (New York: Macmillan & Co., 1878).

Weekley, Ernest, *An Etymological Dictionary of Modern English* (London: John Murray, 1921; reprint New York: Dover Publications, 1967).

Whitney, William Dwight, ed., *The Century Dictionary and Cyclopedia* (New York: The Century Co., 1902).

INDEX

Smithers, L. C., *Manual of Classical Erotology,* 63
'smut', 86
'snob', 139–40
Snoop Dogg, 190
'snot', 37
Snow White (1937 film), 182
social class, xi, 1, 134–41
'social evil', 81–2
'sod', 144
'soldier', 253–5
'sorcery', 293–4
'sourpuss', 82
Southey, Robert, *History of Brazil,* 301
'spaz', 164
'specter', 294
'spectrasexual', 94
'sperm', 49
'spic', 132
'spider web', 294–5
'spinster', 155–6
'spleen', 24
'spoils', 222, 255
'spooky', 295–6
Sprague, Amasa, 270
'sprinkling', 99
'spunk', 49
'squat', 18
Star Trek (series), 310
Steinschneider, Moritz, 122
'stereotype', 119–20
Stevenson, Robert Louis, *Treasure Island,* 218, 220, 221
stigmatization of mental and physical differences, 161
'stimulant', 196–7
'stinky', 112
Stoker, Bram, *Dracula,* 271–2
'stomach', 38

Stopes, Marie, 54, 55
'straight', 92–3
Stratemeyer, Edward L., *Tom Swift and His Electric Rifle,* 256–7
'stream', 29
'strike', 255
'struggle', 255–6
'stupid', 174
'succubus', 287
'supernatural', 296
Sutton, Thomas, 165
'swagger', 228
'swashbuckler', 222
swear words, 1
swearing
 vs. cursing, 2
 minced oaths, 16–19
'swindle', 228
'swivel', 11
'sword', 256
'sycophant', 112–13
'syphilis', 30

Tales from the Crypt (series), 302
'tarnation', 19
'Taser', 256–7
'taunt', 105–6
'terror', 282
'testicles', 49–50
'testify', 49–50
Thackeray, William Makepeace, *The Book of Snobs,* 139–40
Theodora (Roman senatrix), 80
Theophrastus, 22
Thibodeau, Dr. Paul, 20
'thief', 229
Thirty Years' War (1618–48), 239
Tholuck, August, *The Circle of Human Life,* 278
'thrall', 296

ABOUT THE AUTHOR

Jess Zafarris is the author of the etymology books *Words From Hell, Useless Etymology* (Chambers 2024) and *Once Upon a Word* (Rockridge Press 2020). Jess is an educational content creator and blogger who focuses on etymology and word-history-focused deep dives and explanations on her TikTok channel @jesszafarris and website uselessetymology.com.

Her master's and undergraduate degrees focused on the development of English through literature, as well as journalism, anthropology and language studies. She contributed to the tabletop game *League of the Lexicon* and the *Writer's Digest* Daily Calendar 2020.

She has appeared on podcasts including *Dear Hank and John, Social Pros, Failing Writers, Yeah That's Probably an Ad,* and *Author2Author.* By day, Jess is a content and engagement director, journalist, editor, and social media strategist responsible for developing multimedia content for brands, publishers and media outlets such as *Adweek, Ragan Communications, Writer's Digest, and Script.*

ACKNOWLEDGMENTS

It (presumably) takes an army of demons to run Hell, and similarly it took an army of humans to summon this hellish book from the darkest recesses of my brain and its many, many sources.

Primary among these legions are my spouse, Drew Zafarris, who accommodated the insanity of this project at a personal level; Melissa Farris, who put an enormous about of work, artistry, and thought into this; and Emily Hightower, my ultimate writing consultant who prompted many of these dreadful and magical facts.

Additionally, thank you to ...

- My mom, dad, grandparents, Aunt B, the Garretts, Jacki and Tim and other family members and family-adjacent humans who cheer me on in every endeavor but are hopefully appropriately scandalized by the salty language they definitely didn't teach me.
- The Z clan, who have been endlessly supportive, and especially Vanilla Chill, who I hope will find inspiration for his next track in these pages.
- Madame Quinn, who would not approve but would cackle anyway.
- Mollie Cahillane, Jameson Fleming, Shannon Miller, Gail Amurao, Al Mannarino, and Luz Corona for the endless encouragement and support, and for riding with me through a different kind of Hell.
- Marian Allen, Marisa Rouse, Lee Anderson, Aunt Sheryl, Christina Garnett, Jiya Jaisingh, Sonia Baschez and many more for eternally helping me keep the word magic alive.
- Sarah Cole and Jenny Campbell for making this whole thing work; Saimah Haque for the promotional magic; Joshua Williams

and Robert Anderson for polishing it to perfection; and Noemí Martínez Turull for ensuring it hits the right notes and pisses off the right people.

- My friends and connections on TikTok and in the LingComm community who have both educated me and supported my work.
- My various enemies and rivals, who may find all the words for themselves in the chapter on insults.